MICHELANGELO

THE COMPLETE
SCULPTURE, PAINTING, ARCHITECTURE

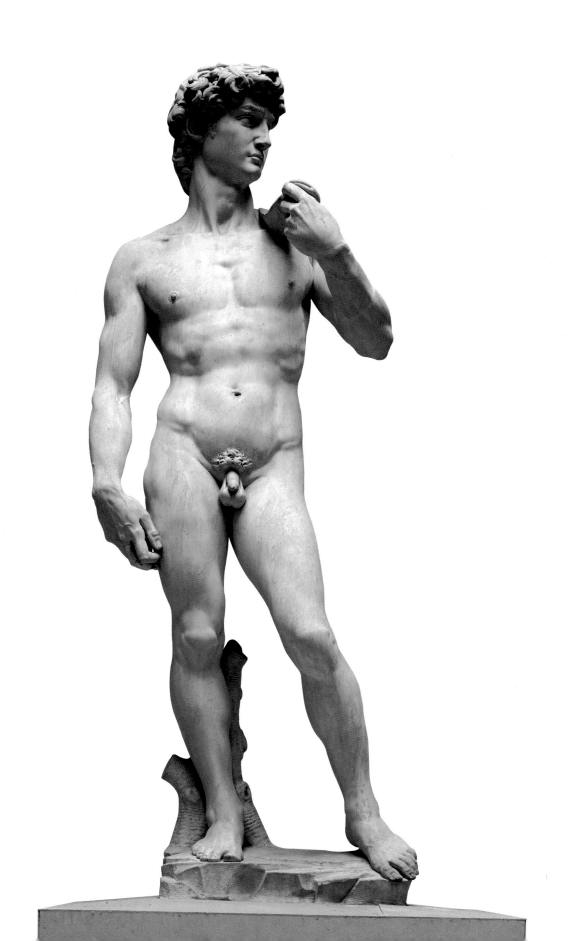

WILLIAM E

MICHEL
THE COMPLETE SCULPTURE

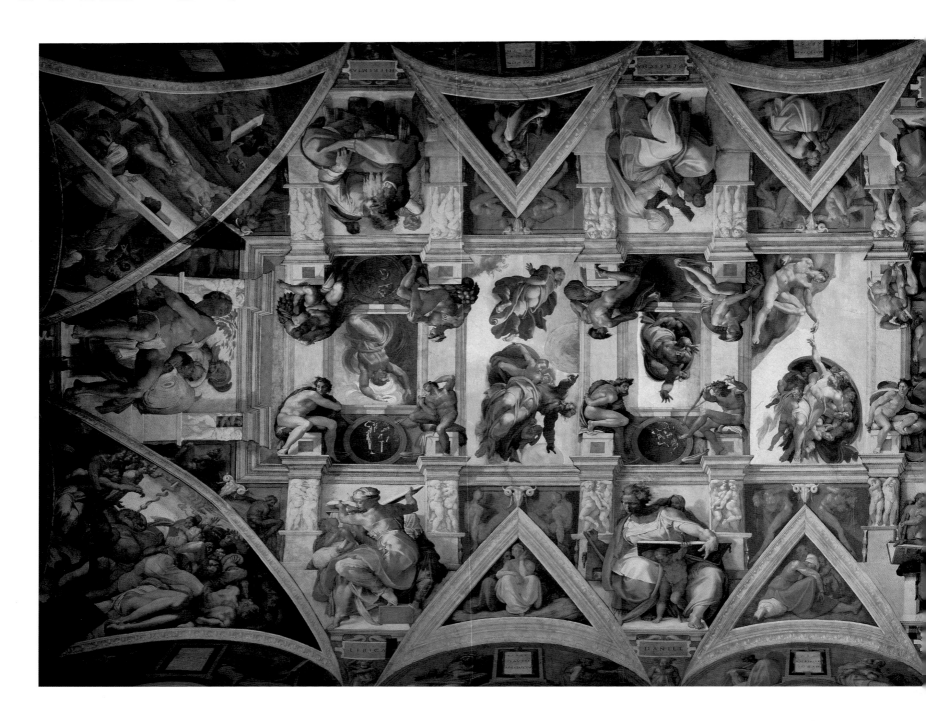

HUGH LAUTER LEVIN

WALLACE

ANGELO
PAINTING · ARCHITECTURE

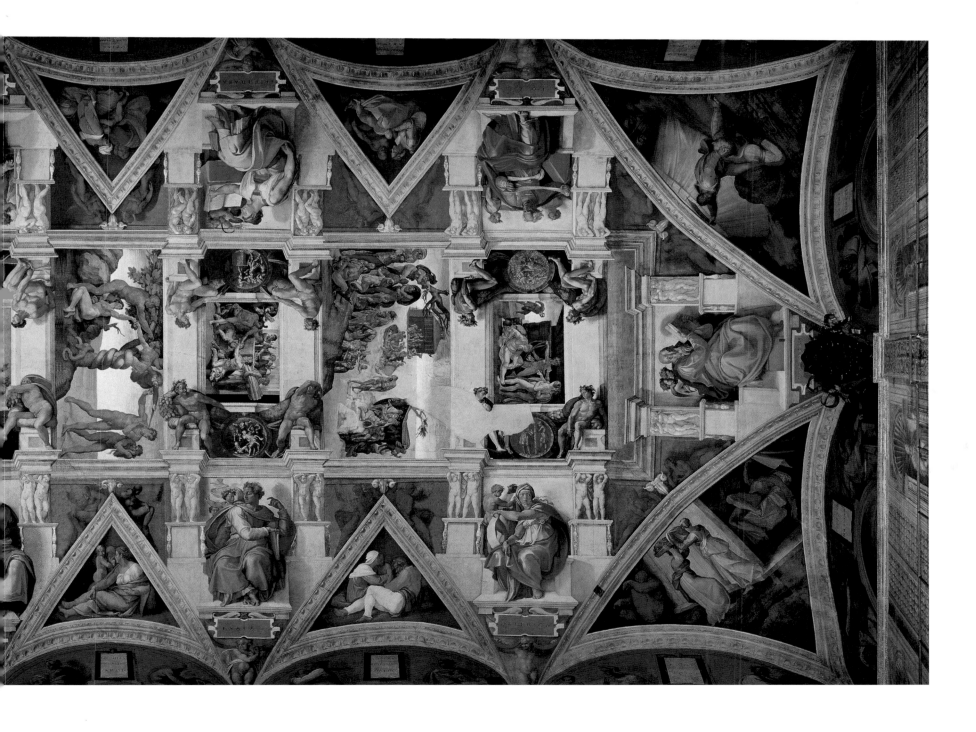

ASSOCIATES, INC.

COPYRIGHT © 1998, HUGH LAUTER LEVIN ASSOCIATES, INC.

DESIGN BY NAI CHANG
PHOTO RESEARCH BY CYNTHIA HOROWITZ
EDITORIAL PRODUCTION BY DEBORAH TEIPEL ZINDELL

DISTRIBUTED BY PUBLISHERS GROUP WEST

PRINTED IN HONG KONG
ISBN 0-88363-207-1

CONTENTS

PREFACE

My foot slipped and sent a shower of loose rocks sliding down the long slope. The entire mountain above Seravezza, near Carrara, was marble, heavily worked but barely scarred by nearly two thousand years of marble quarrying. From this marble, the emperor Augustus transformed Rome, a city of brick, into a city of marble. From here, Michelangelo removed monolithic blocks of astonishing size and purity. And here I was trying to make the arduous climb to the remote quarry site favored by the artist.

Later I looked down and felt that sublime sensation known to mountain climbers. I understood the attraction of the mountains for the artist, the freedom to imagine in this remote place, far from obligations and insistent patrons. But for the moment I was scared, in danger of losing my footing on a treacherous slope. Traces of the man-made sledge paths once used to lower Michelangelo's blocks still laced the mountainside, but here the path had been wiped out; looking down turned my legs to jelly. On safer ground a few minutes later, I couldn't help recalling that two of Michelangelo's workers had lost their lives in these mountains. He laconically noted their deaths, but particularly lamented the fall and shattering of a marble column which represented months of labor and thousands of dollars. Was Michelangelo so unfeeling? I have since learned that the life of a Renaissance quarryman was one that was constantly in jeopardy, and that Michelangelo did indeed care deeply about those who worked for him. He knew and paid them well, he was loyal and solicitous, and he sometimes looked after their personal affairs. Such are the seeming contradictions of probing into the past.

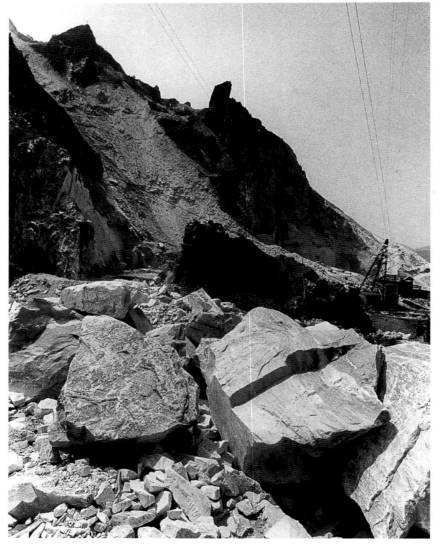

View of the marble quarry at Carrara

I am a historian. I became an art historian on my first trip to Italy, perhaps on that first night in Rome when, as an earnest undergraduate, I walked to St. Peter's basilica in the rain, drank a grappa, and tried to grasp the enormity of the building and its equally large role in history. Later, following in the footsteps of my romantic forbears, I visited the Colosseum by moonlight . . . and the memories could go on. My experience was much like other first-time visitors to Italy, for whom encounters with Michelangelo's art loom large: the *Pietà, Moses, David,* the Sistine Chapel ceiling. Soon one begins to wonder about the man who was capable of accomplishing so much in a lifetime.

Myth and legend envelop the artist; he sometimes seems more a caricature than human, more icon than real. Indeed, many people's dominant image of Michelangelo is probably that of Charleton Heston sassing Rex Harrison in the movie version of Irving Stone's *The Agony and the Ecstasy.* One often hears, for example, that Michelangelo accomplished all things alone (which is certainly not the case), that he and Pope Julius got into a shouting match over the Sistine ceiling (clearly not the proper manner to address a pope), and that he was a homosexual, which is probably true but does little to explain the man's complex and largely repressed sexual passions.

Conflicting viewpoints and confusion surround many aspects of Michelangelo's life and art—perhaps owing to the fascination that his singular genius never fails to excite. It is frequently claimed, for example, that the strange bulbous breasts of Michelangelo's *Night* in the Medici Chapel reflect a lack of knowledge of female anatomy. However,

this holds Michelangelo to a standard of "naturalism" that is not applied to the rest of his work, nor to most Renaissance art for that matter (one similarly could criticize Botticelli's *Birth of Venus)*. An assumed lack of sympathy for female beauty has blinded some viewers to the many tender representations of women such as those on the Sistine Chapel ceiling, the hauntingly beautiful *Pietà,* and the exquisite figure of *Leah* on the tomb of Julius II. In fact, Michelangelo took far greater liberties with the male nude. One need only examine the exaggerated musculature of *Day* or the impossible elongation and bizarre contortions of *Victory* to realize that the human body, whether male or female, was Michelangelo's principal arena of artistic expression. The figures he created—whether delicately or massively rendered—were ideas expressed in the eloquent and versatile language of the human body.

It is often said that Michelangelo was saddled with a remarkably unappreciative, even insensitive, family. A few choice quotations from volumes of extant correspondence in fact substantially support the opposite view. Michelangelo was very attached to his sometimes petty father and less successful brothers, and was immeasurably generous in providing lifelong financial support for his entire family. In letter after letter during Michelangelo's absence in the marble quarries in 1517, the family reveals itself eagerly awaiting his return to Florence: "Michelangelo still has not come, but they believe that it will be soon. It seems to me a thousand years." It had been less than six weeks! Even Michelangelo's supposedly obtuse father was greatly impressed by the commission awarded to his son to erect a façade for the Medici church of San Lorenzo, as was his favorite brother Buonarroto, who wrote: "I hear that Michelangelo is to make the façade of San Lorenzo; may God give him victory and to us all."

With remarkable frequency I find persons accidently confusing Michelangelo and Leonardo da Vinci—their works, their life stories, news of recent restorations of their work, even personal characteristics: which artist had a broken nose, and which was left-handed? At some point the stature of such titans is so far above mundane existence that we blur their lives and individuality, and unwittingly attach messy accretions to their legends. A prominent interviewer on National Public Radio once asked me how I could read Michelangelo's letters when he wrote backwards, "in mirror script"—it was actually Leonardo whose longhand was such a challenge to decipher. Today's advertising only compounds the confusion by indiscriminately exploiting the artists' imagery to sell, for example, wine, pasta, toothpaste, cars, cellular phones, movies, or trips to Italy or Las Vegas. I have found Michelangelo stamped on T-shirts and toilet paper, on the cover of the magazine *Competitive Edge Golf,* and as the cover illustration for a book on herpes diseases. The list is endless and grows daily. Michelangelo and Leonardo—not to mention Monet, Picasso, and a host of others—all enlisted to attest product excellence.

Thanks to the ubiquity of modern reproduction, many of the works in this book will be familiar. But no matter how familiar we are with Michelangelo's oeuvre, we are astonished anew when confronted by the full extent of his life and works. This volume presents all the artist's extant and securely attributed works of sculpture, painting, and architecture (and a few of his more than six hundred drawings), and attempts, through the highest quality of photographic reproduction, to suggest the full extent of his creativity. There are still many things to discover about this most familiar artist.

I have discovered much while writing this book, and I would like to thank Hugh Levin for the invitation to undertake the project. I am honored to follow in the footsteps of Michelangelo's first biographer, Giorgio Vasari, whose birthdate I am privileged to share. I doubt one could tell as good a story as he; rather, I have tried to sift fact from fiction and write a book that pays tribute to the past while appealing to the interests of a modern audience. In this task I have been helped by many: I am especially indebted to Ellin Silberblatt for her enthusiastic and patient assistance, to Debby Zindell for her careful editing, to Paul Barolsky for his sympathetic reading of the manuscript, to Ralph Lieberman for many of the photographs, and to Betha Whitlow for her research assistance. Special thanks are due to David Finn, who generously shared photographs from his longtime study of Michelangelo. This book is dedicated to Katie, who has seen more of Michelangelo in her seven years than many are privileged to see in a lifetime.

1475	March 6. Born in Caprese.	1496–1501	In Rome. Carves the *Bacchus* and the *Rome Pietà*.		to execute a bronze statue of Pope Julius II in Bologna (destroyed).

1475 March 6. Born in Caprese.

1481 Death of his mother, Francesca Neri di Miniato del Sera.

c. 1485 Attends the grammar school of the humanist Francesco da Urbino (to 1488?). Michelangelo's father remarries.

1487 Michelangelo documented in the workshop of Domenico Ghirlandaio.

c. 1490 In the Medici household (to 1492). Probable years of the *Madonna of the Stairs* and *Battle of the Centaurs*.

1492 Death of Lorenzo de' Medici.

1494 Expulsion of the Medici from Florence.

1494–1495 Michelangelo in Bologna. Carves figures for the tomb of St. Dominic.

1495 Returns to Florence, which is under the sway of the Dominican preacher Girolamo Savonarola. Carves *St. John the Baptist* and the *Sleeping Cupid*.

1496 First trip to Rome (arrives June 25).

1496–1501 In Rome. Carves the *Bacchus* and the *Rome Pietà*.

1501 Returns to Florence. Contracts to carve figures for the Piccolomini altar and receives the commission to carve the *David*.

1503 Commission for the twelve apostles, including *St. Matthew*, for the Florentine cathedral (Duomo).

c. 1503–1505 Completes the *Doni Tondo*, *Taddei Tondo*, *Pitti Tondo*, and *Bruges Madonna*.

1504 Completes the *David*. Receives commission to paint the *Battle of Cascina*.

1505 Summoned to Rome by Pope Julius II; commissioned to create the tomb for the pope. Spends eight months in the quarries of Carrara selecting marble for the tomb.

1505–1545 Michelangelo works on the tomb of Julius II on and off, in both Rome and Florence, carving *Moses*, the *Rebellious* and *Dying Slaves*, the *Accademia Slaves*, *Rachel*, and *Leah*.

1506 Returns to Florence (April). Michelangelo and Pope Julius II reconcile in Bologna (November). Commissioned to execute a bronze statue of Pope Julius II in Bologna (destroyed).

1507 In Bologna working on the bronze statue of *Julius II*.

1508 Returns to Florence (February). Summoned to Rome by Pope Julius II and asked to paint the ceiling of the Sistine Chapel (May).

1508–1512 In Rome painting the ceiling of the Sistine Chapel (finished October 1512).

1513 Death of Pope Julius II. Election of Giovanni de' Medici as Pope Leo X. Signs new contract for the tomb of Pope Julius II.

1514 Commission for the *Risen Christ*, and the Chapel of Pope Leo X in Castel Sant'Angelo, Rome.

1516 Returns to Florence (July). Commission to erect the façade of the Medici church of San Lorenzo in Florence. Signs third contract for the tomb of Pope Julius II.

1516–1519 Makes numerous trips to the marble quarries at Carrara and Pietrasanta for the San Lorenzo façade project.

c. 1517 Commission to design the "Kneeling Windows" for the Medici Palace.

1519 Commission to design the New Sacristy, or Medici Chapel, for San Lorenzo.

1520 Contract for the façade of San Lorenzo cancelled.

1521 Death of Pope Leo X. Begins work on the tombs for the Medici Chapel.

1523 Election of Giulio de' Medici as Pope Clement VII.

1524 Commission to design the Laurentian Library at San Lorenzo.

1527 Sack of Rome (May 6). Exile of the Medici from Florence (May 17).

1527–1530 The Last Republic in Florence. Commission to carve a *Hercules* (never executed). Michelangelo designs and builds fortifications.

1529–1530 Siege of Florence by the combined forces of Pope Clement VII and the Holy Roman Emperor Charles V.

c. 1530 Carves *Apollo/David*.

1532 Visits Rome, meets Tommaso de' Cavalieri. Presents Cavalieri with gifts of drawings and poems. Signs new contract for the tomb of Pope Julius II.

1533 Reliquary Tribune balcony in San Lorenzo completed.

1534 Death of Pope Clement VII. Election of Alessandro Farnese as Pope Paul III. Michelangelo departs Florence, never to return. *Medici Madonna* and *Victory* left incomplete in Florentine workshop. Spends remaining thirty years of his life in Rome.

1536 Begins painting the *Last Judgment* in the Sistine Chapel. Meets Vittoria Colonna.

1538 Begins work on the Capitoline Hill (Campidoglio).

c. 1540 Carves bust of *Brutus*.

1541 *Last Judgment* completed and unveiled.

1542 Contracts with Pope Julius' heirs for the final version of the pope's tomb (August). Begins work on the Pauline Chapel.

1545 Tomb of Julius II completed and installed in San Pietro in Vincoli, Rome. Still working on the Pauline Chapel frescos (to 1550).

1546 Death of Antonio da Sangallo; Michelangelo appointed chief architect of St. Peter's and the Farnese Palace.

1547 Death of Vittoria Colonna. Begins work on the *Florentine Pietà* for his own tomb (abandoned c. 1555).

1550 Publication of the first edition of Giorgio Vasari's *Lives of the Painters, Sculptors, and Architects*.

1553 Publication of Ascanio Condivi's *Life of Michelangelo*.

1555 Death of Urbino, Michelangelo's favorite servant/assistant. Begins work on the *Rondanini Pietà*.

1559–1560 Designs for San Giovanni dei Fiorentini, Rome.

c. 1560 Commission for the Sforza Chapel in Santa Maria Maggiore, Rome.

1561 Commissions for the Porta Pia and Santa Maria degli Angeli in Rome.

1564 February 18. Dies at home in Macel de' Corvi, Rome.

CHAPTER 1
ARTIST AND

BIOGRAPHY
ARISTOCRAT

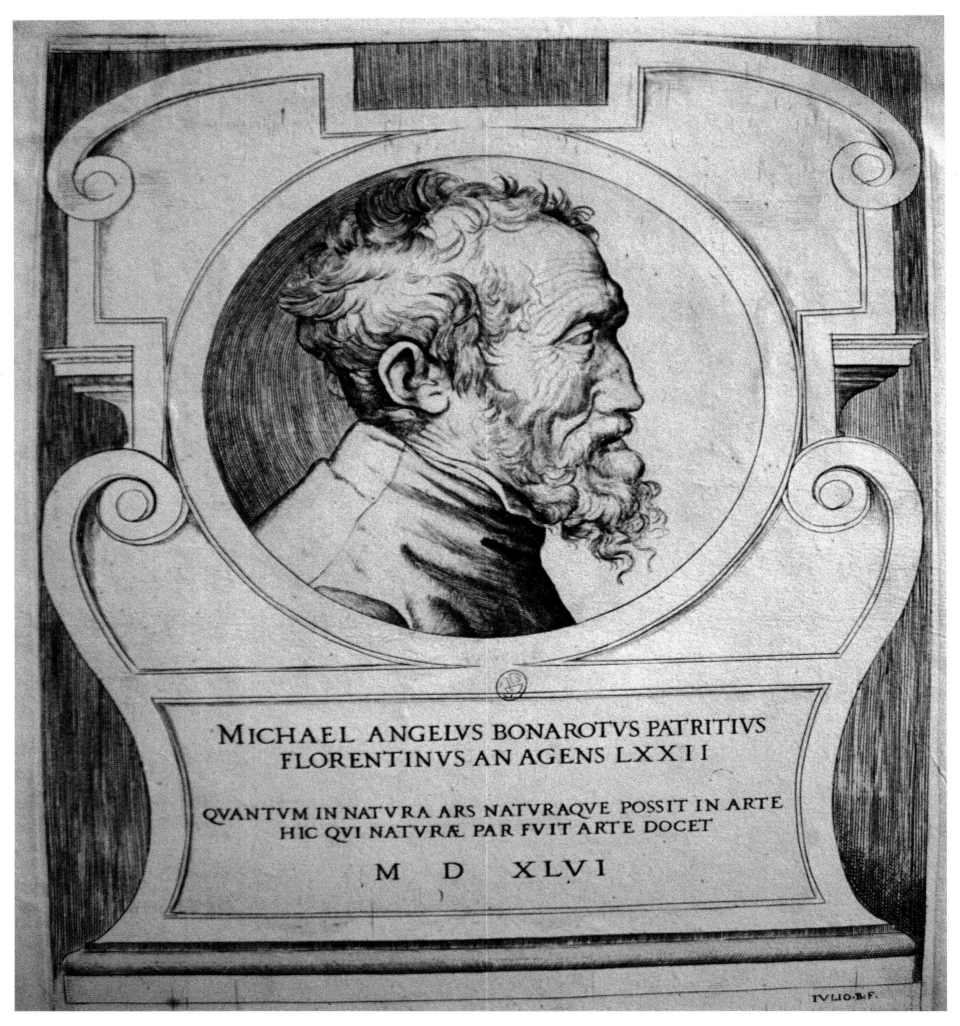

Giulio Bonasone. PORTRAIT OF MICHELANGELO. 1546. *Engraving.*

PRECEDING PAGES:
Detail of the ROME PIETÀ

Michelangelo was the greatest sculptor of the sixteenth century, as Donatello was in the century before him and Bernini in the century after him. We admire the products of his genius but we less frequently pause to consider the magnitude of the tasks he undertook, the problems he encountered, and the setbacks—even failures—he may have suffered. The *Rome Pietà* and the *David*, for example, are stunning accomplishments that obscure the more mundane facts of their creation. We tend to overlook that they were fashioned from raw and resistent stone, by hands that were strong and dexterous but also were occasionally tired or bruised. Before these sculptures became the sublime marvels we admire today, they were inert and spiritless material.

Carving marble is extremely difficult. Forget the frequently invoked image of the artist "peeling away" layers of the stone, or "liberating" a figure from the block. Michelangelo's contemporary and biographer, Giorgio Vasari, vividly but inaccurately described marble carving as a gradual issuing forth from the block, like a figure that is raised little by little from a tub of water. Michelangelo's rival Leonardo da Vinci was closer to the mark when he described the actual process of sculpture as a "most mechanical exercise." In his notebooks, Leonardo wrote:

> *The sculptor in creating his work does so by the strength of his arm by which he consumes the marble, or other obdurate material in which his subject is enclosed: and this is done by most mechanical exercise, often accompanied by great sweat which mixes with the marble dust and forms a kind of mud daubed all over his face. The marble dust flours him all over so that he looks like a baker; his back is covered with a snowstorm of chips, and his house is made filthy by the flakes and dust of stone.*

Leonardo preferred to paint, and considered it a more noble enterprise. Marble carving is hard work, loud and dirty. Every blow of hammer to chisel is a collision of metal against metal striking stone. Marble chips fly in all directions; the dust lies thick. Modern stone workers wear goggles; Michelangelo did not. He had to see the stone, to see each mark, to make tiny adjustments to the angle of his chisel and to the force of his blow. He could not afford to slip. One wrong stroke could break a finger, an arm, or worse. A figure comes alive only after thousands and thousands—tens of thousands—of perfectly directed hard and soft blows. Marble carving is difficult and unforgiving.

Michelangelo was one of the greatest marble sculptors of all time. Quite astonishingly, given the years required to master a craft, he was also one of the greatest painters, architects, and poets. Few artists have been as prolific; fewer still have succeeded in creating enduring masterpieces in so many different media. Had Michelangelo only carved the *David,* or painted the ceiling of the Sistine Chapel, or erected St. Peter's, he would have guaranteed his place in history. Rather, he made all three works, and each is a central achievement in the history of human endeavor. His was a creative genius unmatched in ancient or modern times.

Michelangelo Buonarroti was born on March 6, 1475, in the small town of Caprese, which is tucked into a fold of the Apennine mountains in rural Tuscany. His father, Ludovico Buonarroti, was a minor Florentine official and the local governor *(podestà)* of the small towns of Caprese and nearby Chiusi. After his six-month term of office, Ludovico moved the family back to Florence, where they owned a good-size farm in the little village of Settignano overlooking Florence. Here, and in the surrounding hills pock-marked with quarries, Michelangelo grew up and was first exposed to stone carving. Appropriately for a son whose family had noble pretensions, Michelangelo attended latin school. But as so often happens, the boy's aspirations were different from those of his father. Michelangelo was drawn to art rather than to the world of the Florentine banker and merchant.

His father naturally opposed his son's predilection, since art was considered a manual craft and a lowly occupation. After the inevitable struggle of wills, Ludovico finally, if reluctantly, acquiesced and had his son apprenticed to the most fashionable painter in Florence, Domenico Ghirlandaio. Ghirlandaio ran a large and extremely successful workshop *(bottega)* where Michelangelo learned drawing and painting, in both tempera and fresco. Although he

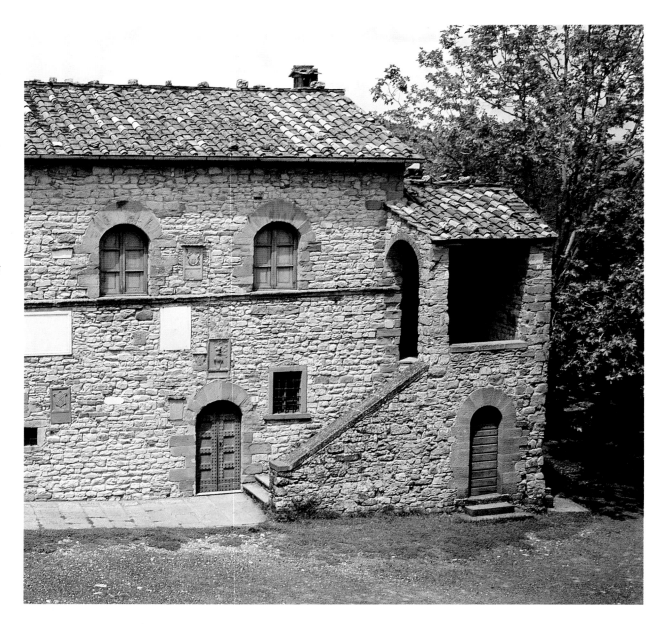

View of Caprese, Michelangelo's birthplace

Stefano Bonsignori. MAP OF FLORENCE. *Museo di Firenze Com'era, Florence*

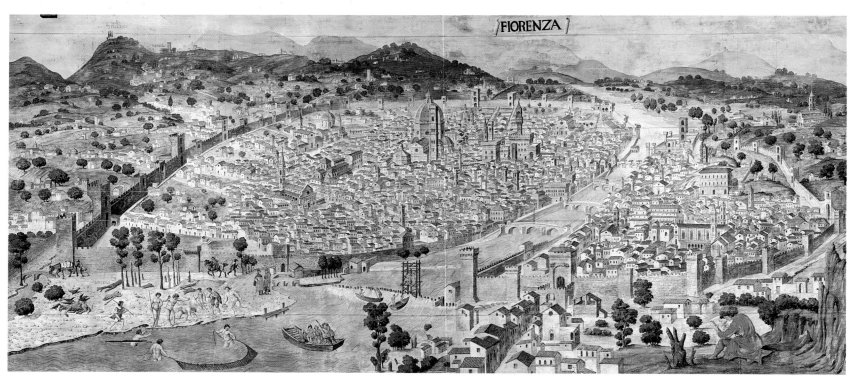

later denied learning much from his pedantic teacher, Michelangelo's early drawings and his first generally accepted efforts in painting (the *Doni Tondo* and the Sistine ceiling) offer abundant evidence that the young apprentice learned his lessons well. Michelangelo gained much from his apprenticeship with Ghirlandaio, but he was by no means "destined" to be an artist, especially when an even better opportunity presented itself.

Through Michelangelo's grandmother, the Buonarroti were distantly related to the Medici, the de facto rulers of

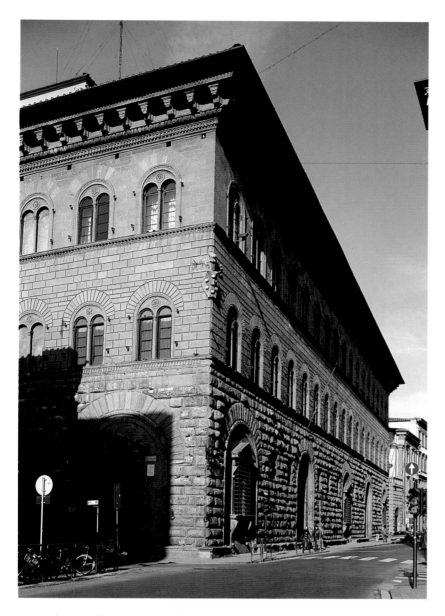

The Medici Palace, where Michelangelo lived c. 1490–1492

mostly read authors who wrote in Italian beginning with Dante, Petrarch, and Boccaccio. As was common, he imbibed much learning from conversation, especially since he had a "tenacious memory" which was, in fact, an important yardstick of learning. Michelangelo's skills as a letter writer and poet, and the subtlety of his thinking bespeak the formative influence of these years; never before or since has an artist received such a unique education.

Of course, most of what we know about Michelangelo's childhood and early years comes from the artist himself. It may be that one of Michelangelo's greatest creations was his collaboration with Ascanio Condivi and Giorgio Vasari in the fashioning of his autobiography, in which Michelangelo reflected and remembered events more than fifty years after the fact. Alongside his many artistic accomplishments, the written word offers us the master's most finished, long-lasting, and best-loved self-portrait.

His biographers tell a compelling tale of a genuine hero who, by the time they were writing, was the most famous artist in the world. They relate a fictionalized history about a precocious genius who had little or no formal training, whose artistic propensity was frustrated by his father but encouraged by Lorenzo de' Medici, and who succeeded against all odds to create masterworks without faults or any prior failures. The tale of heroic accomplishment is gripping, and probably mostly true, but it is not surprising that the phenomenally successful Michelangelo tidied up the story of his past and left out many of the everyday details. His was the pride of a well-born aristocrat.

The fifteenth-century humanists were fond of writing treatises on nobility. Continuing a debate from classical antiquity, a central concern of these writings was the question of whether nobility was a matter of birth or, rather, of one's virtue and personal attainments. On all counts, Michelangelo had a rightful and substantial claim to nobility. It is little wonder that he styled himself an aristocrat and tended to obscure his humble origins. But curiously, it is Michelangelo's claim to noble birth, about which he was most adamant, that is precisely the part of his biography that often has been eyed with skepticism, as myth or self-delusion. Instead, we willingly accept his biographers' tales of the child prodigy and his predestined rise to fame. Of course, we like to believe such romances for it reaffirms a satisfying, if sometimes unacknowledged, belief in genius.

Florence and the greatest art patrons of the Renaissance. Exploiting this distant family relationship, as was common practice in the Renaissance, Ludovico Buonarroti succeeded in placing his young son in the Medici entourage. The Medici were successful bankers and the most influential family in Florence; they provided for hundreds of family members, wives, cousins, distant relatives, illegitimate children, servants, and retainers, as well as writers, musicians, and artists. In the large Medici household, Michelangelo came in contact with the most learned men of the century, and the patron of them all, Lorenzo de' Medici, known as "the Magnificent." Inspired by this circle of intellectuals, Michelangelo may have created his first independent works of art, but what he gained above all in the Medici household was a humanist education. There he learned to speak and write well, and was exposed to a world of learning and culture for which the Renaissance, and the Medici in particular, are famous. He had access to the works of classical authors that were considered essential study for a good education: Plato, Aristotle, Ovid, and Virgil, as well as Seneca, Cicero, Juvenal, Plautus, and Horace. But since Michelangelo never mastered Latin, it is likely that he

Romantic biographers would like Michelangelo to have been attracted to Contessina de' Medici, the youngest daughter of Lorenzo de' Medici. He may well have been, for surely she was the most comely creature in the Medici household and approximately his same age. But relations beyond polite formalities would have been impossible.

They moved in different worlds; moreover, Contessina was marked from birth for a more socially advantageous match.

If Michelangelo sought relations with women, they came from a more humble station, where favors were dispensed more readily or were exchanged for money. A few poems suggest such experiences—and his ability to laugh at them: "When I look down upon each of your breasts they look like two watermelons in a bag."

Relations with men were more possible and probably more frequent. In the Medici household, Michelangelo was among a group of exceptionally learned and cultivated men with homosexual inclinations—both physically and philosophically: Angelo Poliziano, Marsilio Ficino, and Lorenzo de' Medici himself. Michelangelo was probably not the initiator of relations but rather the passive recipient of their attentions—a situation extremely common in Renaissance Florence. In turn, they offered a home that was intellectually stimulating, above moral scrutiny, and without economic or mundane obligations. Indeed, it was a privilege to be part of that select circle. It made an indelible impression on Michelangelo, and he naturally looked back on these years with nostalgia.

Michelangelo spent two of the happiest years of his life in the Medici household, surrounded by members of Lorenzo's humanist circle and alongside his future patrons, Giovanni and Giulio de' Medici (subsequently Popes Leo X and Clement VII). The death of Lorenzo in 1492 left Michelangelo without a patron or a regular income. Rather than try to make a living in the traditional manner of artists, by joining or opening a workshop, he bided his time and hoped for a new patron.

The Medici, now guided by the haughty and insufferable Piero de' Medici, abused their power and finally were exiled from the city in 1494. Michelangelo followed the family to nearby Bologna, where he remained for approximately a year. He lived in the household of the Bolognese nobleman, Gianfrancesco Aldovrandi, a position he could not have secured without his previous Medici connections. Appreciative of his Tuscan accent, Aldovrandi had Michelangelo read Dante and Petrarch out loud—a good indication of the young man's education. In turn the Bolognese gentleman secured a small commission for Michelangelo to carve some of the statuettes that were missing from the tomb of St. Dominic in the church of San Domenico in Bologna.

In a little more than a year, Michelangelo carved just three small figurines; they are skillful but hardly precocious given that Michelangelo was now twenty years old. Later in life, Michelangelo complained that the Bolognese artists were envious of his cozy circumstances. They had to run workshops, pay rent, purchase materials, and compete for commissions, while Michelangelo, unwilling to enter the profession by the traditional route, was given the commission, the marble, and a place to work, and all the time lived in the house of one of Bologna's leading citizens. Despite these comfortable conditions, opportunities were limited, so Michelangelo returned to Florence at the first opportune moment, in late 1495.

Florence was in the sway of the fiery preacher Girolamo Savonarola, who had managed to turn the city into a virtual theocracy. Preaching to overflow crowds in the Florentine cathedral, Savonarola condemned the prof-

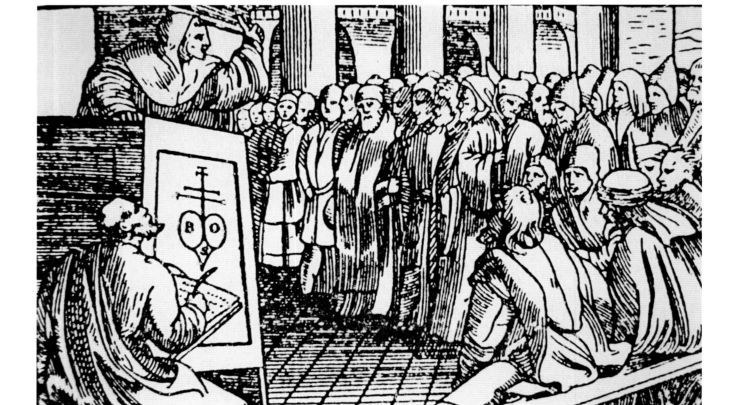

Girolamo Savonarola preaching. 1539. *Woodcut*

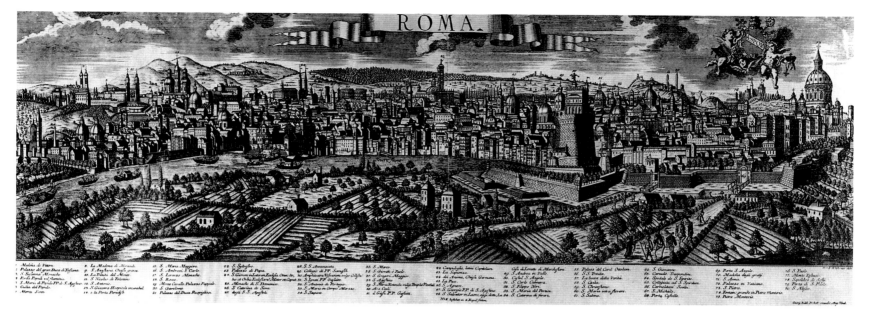

Friedrich Bernhard Werner. "ROMA." 1740. *Copperplate engraving*

ligate manners and morals of the Florentines. In a frenzy of reform, the city gave up its luxurious, self-indulgent lifestyle, even consigning books and works of art to a famous "bonfire of the vanities." Michelangelo told Condivi years later that he still retained the memory of the friar's living voice. Florence under Savonarola was not a conducive atmosphere for artists, especially those closely associated with the exiled Medici.

In need of a patron, Michelangelo curried the favor of Lorenzo di Pierfrancesco de' Medici, a member of the cadet branch of the family whose republican sympathies earned him respect as a "friend of the people." For Lorenzo, Michelangelo carved a youthful *St. John* and a *Sleeping Cupid,* both lost. The cupid so successfully imitated the antique that Lorenzo suggested passing it off as authentic, saying to Michelangelo: "If you can manage to make it look as if it had been buried under the earth I will forward it to Rome, it will be taken for an antique, and you will sell it much better." This "forgery" and Lorenzo's letters of introduction opened doors to circles of wealth and power in Rome otherwise unattainable for a young artist with only a handful of works to his name.

In 1496, the twenty-two-year-old artist arrived in Rome for the first time. Thanks to his letters of introduction, Michelangelo presented himself to Cardinal Raffaele Riario, the richest and most powerful man in Rome, second only to the pope. At the time of Michelangelo's arrival, the cardinal was completing a great new palace, today known as the Cancelleria. Given that Riario's household consisted of some 250 persons, it is actually not surprising that Michelangelo was given temporary lodging in the cardinal's considerable entourage.

Cardinal Riario owned a rapidly growing antiquities collection that offered Michelangelo his first extensive exposure to the art of the classical past. Michelangelo must

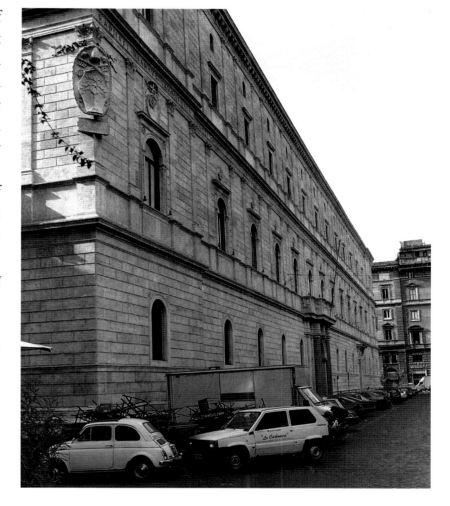

View of the Cancelleria, Rome

have been intoxicated. Given a block of marble, he was invited to "show what he could do." To this point Michelangelo's career had advanced largely because of his success within a tight-knit network of wealthy and influential patrons, aided by a small group of sculptures. Except for a lost marble *Hercules,* his oeuvre consisted of scarcely half a dozen mostly small works produced during the previous eight years. But challenged by Rome and high expectations, and given the opportunity to carve a larger than life-size marble, Michelangelo rose to the occasion

View of the marble quarries at Carrara

and created the *Bacchus.* The statue, in a sense, was a condensation of Michelangelo's unorthodox education to date: his immersion in the classics in the circle of Lorenzo de' Medici, his imitation and recreation of antique sculpture, and his first experience of the eternal city.

Despite our modern admiration of the *Bacchus,* Cardinal Riario apparently was unimpressed, an episode that caused Michelangelo to recall the man years later in unflattering terms. The rejected *Bacchus* came into the possession of the Roman banker Jacopo Galli. Through this connection with Galli, Michelangelo received the commission for a Pietà from a powerful French cardinal, Jean de Bilhères. Suddenly Michelangelo had the opportunity to create a monumental religious work for an important foreign patron and for a conspicuous public location in the ancient basilica of St. Peter's.

Michelangelo gave his best effort to his *Rome Pietà.* He began in an unusual manner, by purchasing a horse and going to the marble quarries of Carrara to select the block. Earlier artists occasionally visited the quarries, but unlike his predecessors and contemporaries, Michelangelo had neither a workshop nor assistants busy on other projects in his absence. Instead, Michelangelo invested enormous time and energy in the marble quarries, always insisting on the highest quality marble and oftentimes helping to supervise its quarrying and transport. He had a legendary ability to judge the quality of a block of marble; it was even said by some that he could see the figure imprisoned in it. More likely, his was knowledge gained from experience and frequent disappointments, which taught him to spot disfiguring veins and to judge the soundness of a block from only a few hammer blows.

For the *Pietà* his effort in selecting a block paid off since the marble is of exceptional quality. And so began Michelangelo's love affair with the quarries and his preferred manner of beginning every new commission. But such a procedure could backfire, as happened just a few years later when he spent more than eight months quarrying marble for the tomb of Julius II only to discover that during his long absence the attention of the impatient pope had turned elsewhere.

In 1501, again through the agency of Jacopo Galli, Michelangelo was commissioned by Cardinal Francesco Piccolomini to carve fifteen statuettes for the Piccolomini altar in Siena (left incomplete by the sculptor Andrea Bregno). Even though the commission was from an extremely important patron (a cardinal and the future Pope Pius III), it proved to be singularly unsuited to the artist's temperament. Reluctant to complete, like some journeyman, another artist's unfinished work, Michelangelo carved only four of the statuettes and then avoided fulfilling the remainder of his obligation, even to the point of legal difficulties. Michelangelo readily set the Piccolomini carvings aside when he received the unusual opportunity to carve a *David.*

Quarried and begun some forty years earlier by the Renaissance sculptor Agostino di Duccio, the giant marble block, commonly referred to as "the giant," stood abandoned in the workshop of the Florentine cathedral. It was generally believed to be a ruined marble. Thanks to the intervention of the Florentine head of government, Piero Soderini, Michelangelo was entrusted with the old and partially worked block. After five years in Rome, Michelangelo must have been particularly anxious to produce a spectacular work in his native Florence. The *David* testifies to Michelangelo's ambition, as well as his recent experience and successes in Rome.

With the twin achievements of the *Pietà* in Rome and the *David* in Florence, Michelangelo's reputation was now firmly established; he would never again lack for commissions. He was a creator of marvels and by far the greatest living sculptor; patrons, commissions, and opportunities proliferated. Between 1500 and 1508, Michelangelo sustained an astonishing level of productivity. Altogether in the eight years of this Florentine sojourn—a period we call the High Renaissance—Michelangelo accepted eighteen different commissions for works of varying importance, from a bronze dagger to the grandiose tomb he envisaged for Pope Julius II, from the Piccolomini commission to the Sistine Chapel ceiling. Condivi asserts that he even considered accepting an invitation from the Sultan of Turkey to construct a bridge across the Bosporus at Constantinople. In a bid for artistic preeminence, and contrary to his later practice, he appears to have refused no one. In fact, during this brief eight-year period Michelangelo carved nine marble sculptures, including the colossal *David,* the *Bruges Madonna,* the *St. Matthew,* two marble tondi, and four small figures for the Piccolomini altar; he completed three

works in bronze (all lost), including the dagger, a bronze *David* sent to France, and a monumental seated figure of Pope Julius for Bologna; he completed at least one painting—the *Doni Tondo*—and drew the cartoon for the *Battle of Cascina* fresco. A most prolific eight years.

The number, stature, and international character of Michelangelo's patrons during these years were equally impressive. They included two popes, the head of the Florentine government (the Gonfaloniere di Giustizia, Piero Soderini), four prominent Florentine families (Strozzi, Doni, Pitti, and Taddei), the Florentine cathedral, a company of rich Flemish merchants, a powerful French cardinal, and the French minister of finance. The first years of the sixteenth century were characterized by prodigious production for an extremely diverse, international clientele. Yet, Michelangelo's simultaneous commitment to an impossible number of commissions inevitably meant that many were destined to remain incomplete, and others were never begun. In hindsight, it seems irresponsible for Michelangelo to have accepted so many concurrent obligations, but there was little room for refusal, and every commission offered a new challenge. Besides, nothing must have seemed impossible for the sculptor of the *Pietà* and the *David*.

Paradoxically, for all his staggering outpouring of creative energy, Michelangelo may have had less of an impact on the High Renaissance in Florence than either Leonardo da Vinci or Fra Bartolomeo. The *David* was admired but little imitated. The most expensive, and arguably his most important commission during these years—the seated bronze statue of Pope Julius II—was created in Bologna and was destroyed in a burst of anti-papal sentiment in 1511, and two other significant sculptures—the bronze *David* and the *Bruges Madonna*—were shipped abroad shortly after they were completed. Michelangelo's work inspired awe but few imitations, that is, until he drew the *Battle of Cascina* cartoon and painted the ceiling of the Sistine Chapel. Nonetheless, the years leading up to the commission for the Sistine ceiling placed Michelangelo firmly on a world stage; he was in great demand, expectations ran high, and he made good use of the financial rewards of his success.

In 1506 Michelangelo purchased the first of many pieces of property that would help secure both his and his family's financial future. In the rolling hills south of Florence, he acquired a large farm from which he obtained most of his staples, including wood, grain, olives, and grapes. In 1507 he added a piece of property to the family homestead in Settignano, and the following year he bought the houses on Via Ghibellina that were refurbished into the Casa Buonarroti. Although Michelangelo never lived there, members of his family did, and most importantly, the purchase and renovation conferred honor on the Buonarroti, who now had an imposing house in the city. Thus, by 1508, Michelangelo had become a prosperous property owner and had established a pattern that repeated itself throughout his career: with each new commission, Michelangelo invested in additional properties in and around Florence. Buying, renting, and managing these farms occupied a significant segment of Michelangelo's time. Through astute investment and strict management of his finances, he provided for his entire family (his father and four brothers) and died a millionaire.

Michelangelo was quite sensitive about being considered an artisan. On several occasions he complained of being treated as if he ran a shop, and he once expressed his chagrin when his nephew sent him a mason's rule "as if I were a stone or woodworker." Michelangelo's father initially may have opposed his son's profession precisely because manual labor was contrary to the family's aristocratic pretensions. Taking up the paternal role some years later, Michelangelo gave his nephew Lionardo constant advice regarding a profession, a proper wife, and comportment befitting a member of their "noble" family.

Michelangelo claimed that the family had paid taxes and held government posts in Florence for three hundred years, thus placing them among the city's elite. The Buonarroti even traced a noble lineage. According to the genealogy of the day, Michelangelo was related to the counts of Canossa and was a descendent of the famous Queen Matilda of Canossa. It hardly matters that we now doubt the relationship; it was firmly believed by Michelangelo and his contemporaries. Michelangelo's pride of ancestry was evident in his dress and comportment, as well as in his frequent admonitions to members of his family to behave in a manner befitting their station. He once railed against his brother for being a peasant "who trudges after oxen," and he frequently expressed exasperation with his nephew, Lionardo, for his lamentable inability to write properly: "I do not know where you learnt to write. If you had to write to the biggest ass in the world, I believe you would write with more care."

Aspiring to high social station, he was pleased when his brother Buonarroto married Bartolommea della Casa, sister of the famous poet Giovanni della Casa. In addition, his nephew and niece also wedded Florentine aristocracy by marrying into the Ridolfi and Guicciardini families respectively. Thus was fulfilled Michelangelo's ardent wish to perpetuate the Buonarroti line, which survived to the nineteenth century.

Michelangelo's desire for wealth, landed security, and social status placed him squarely in a Florentine milieu, sharing the most fundamental values of his fellow citizens. At the

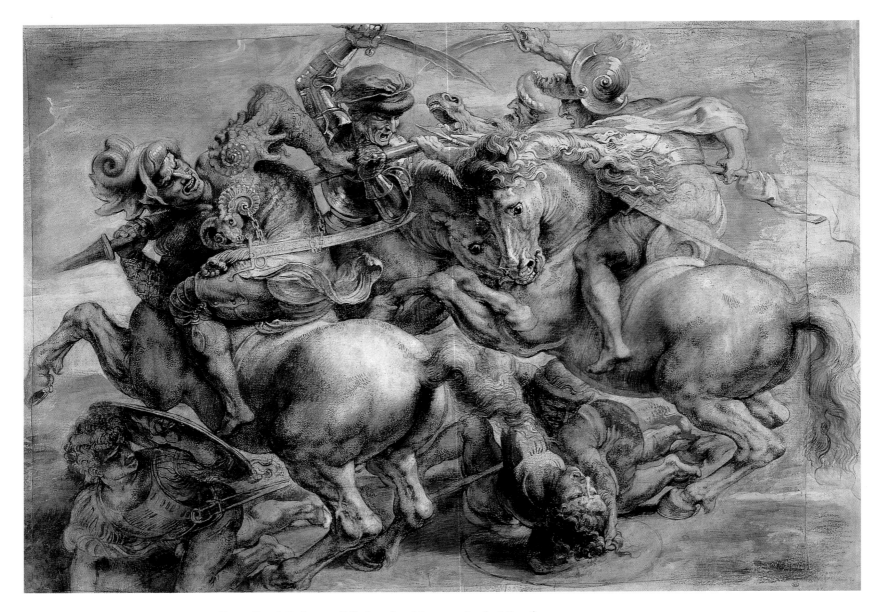

Peter Paul Rubens. Oil sketch of Leonardo da Vinci's BATTLE OF ANGHIARI

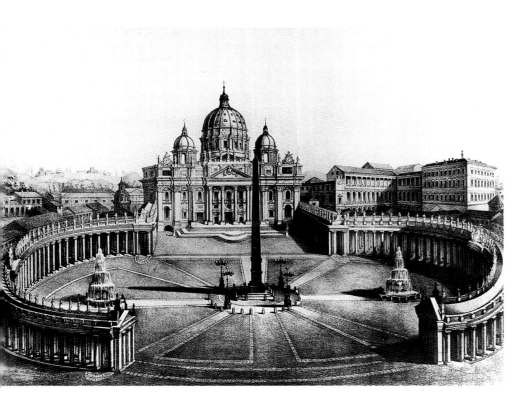

St. Peter's Basilica and Piazza. 1850. *Lithograph*

same time, these same concerns distinguished him from most of his fellow artists, few of whom could claim noble birth or were so preoccupied with family honor. Unusual among Renaissance artists, Michelangelo had a proper family name (many were merely named after their father, his profession, or the place of their birth, e.g., Pollaiuolo, Castagno, Botticelli). The Buonarroti traced a proud ancestry and, thanks to Michelangelo, secured undying fame.

Shortly after completing the *David* and in the midst of one of the busiest periods of his life, Michelangelo received the additional commission to paint a battle fresco opposite his rival Leonardo da Vinci in the Florentine hall of state (the Sala del Gran Consiglio in the Palazzo della Signoria). Here the two greatest artists of the Renaissance were pitted against one another—a confrontation intended to elicit each one's supreme effort. For differing reasons both artists failed to complete their commissions: Leonardo because of technical frustrations, and Michelangelo because he was summoned to Rome by Pope Julius II in 1505. The unrealized frescos remain one the greatest "what if" episodes in the history of art.

The recently elected Giuliano della Rovere (Pope Julius II, 1503–1513) was in the midst of a complete overhaul of Rome and the papacy. With unparalleled energy and ambition, the pope reinvigorated his office through bold military action and a sweeping program of artistic patronage. He employed the architects Giuliano da Sangallo and Donato Bramante to rebuild old St. Peter's, Raphael to decorate the Vatican apartments, and Michelangelo to carve his tomb—envisioned as the most grandiose funerary monument since ancient Rome. So began the longest and most convoluted chapter in Michelangelo's life—what his biographer Ascanio Condivi referred to as the "tragedy of the tomb"—but also one of his greatest endeavors.

Immediately upon receiving the charge to execute a monumental tomb for the pope, Michelangelo, in typical fashion, set out for the quarries to obtain marble. For almost eight months, Michelangelo was far from the center of intrigue and power, only to discover on returning to Rome that the tomb was no longer the pope's first priority; Julius had turned his attention to the rebuilding of the venerable but dilapidated basilica of St. Peter's. Piqued, Michelangelo is reported to have said, "From now on if he [the pope] wants me, he can seek me elsewhere." The artist returned to Florence where he once again took up his interrupted Florentine commissions and defiantly ignored the pope's repeated summons to return to Rome. Not until Julius was on campaign in nearby Bologna in 1506 was Michelangelo persuaded to appear before the pope and beg forgiveness.

In what surely must have seemed like penance to Michelangelo, he created a monumental seated bronze statue for Bologna at the pope's request. For the pontiff, such a statue of his own likeness was a vigorous assertion of papal authority over a subject city, but for the artist it was a colossal headache. Michelangelo spent an unhappy year in Bologna wrestling with the problems of bronze casting, recalcitrant assistants, and poor Bolognese wine. Just three years later, a mob destroyed the statue in an attack on papal authority, thereby erasing a significant chapter in Michelangelo's career and our best evidence for his success in the taxing medium of bronze.

Almost immediately after completing the statue in Bologna, Michelangelo was once again in Rome, and once again assigned a task ill-suited to a marble sculptor: the painting of the ceiling of the Sistine Chapel. Michelangelo's lament that "painting is not my art" proved a hollow objection since the pope's stubbornness was greater than his. But like all commissions that Michelangelo initially resisted, once he reconciled himself to the task, he threw himself into it with unrestrained energy. For four years, from 1508 to 1512, Michelangelo struggled with the manifold difficulties of painting nearly ten thousand square feet of a highly irregular, leaky vault. He spoke of his tribulations in an acerbic sonnet:

> *I've already grown a goiter from this toil*
> * as water swells the cats in Lombardy*
> * or any other country they might be,*
> * forcing my belly to hang under my chin.*
> *My beard to heaven, and my memory*
> * I feel above its coffer. My chest a harp.*
> * And ever above my face, the brush dripping,*
> * making a rich pavement out of me.*
> *My loins have been shoved into my guts,*
> * my arse serves to counterweigh my rump,*
> * Eyelessly I walk in the void.*
> *Ahead of me my skin lies outstretched,*
> * and to bend, I must knot my shoulders taut,*
> * holding myself like a Syrian bow.*

Sonnet written by Michelangelo about painting the ceiling of the Sistine Chapel

Following the sonnet Michelangelo noted, "I'm in no good place, nor am I a painter." The ceiling itself tells a different story, one of magnificent accomplishment and sublime beauty.

Following the completion of the ceiling in 1512, Michelangelo finally was able to turn again to sculpture and to the Julius tomb. Pope Julius died just a few months later. Michelangelo signed a new contract with the pope's heirs and soon returned to Florence. The new pontiff was Giovanni de' Medici (Leo X, 1513–1521), the first Florentine pope and Michelangelo's boyhood acquaintance from the Medici Palace. Although Leo's tastes ran to painting and to Raphael, he did ask Michelangelo to design a façade for the Medici family church of San Lorenzo in Florence. With this new obligation, the Julius project languished.

Once again, Michelangelo began in the marble quarries. Inspired by Roman antiquity, Michelangelo imagined an all-marble façade adorned with a dozen monolithic columns. With little previous training in architecture, he nonetheless set out to create the most magnificent and expensive building in Florence, "the mirror of architecture and sculpture of all Italy." He quarried marble blocks of a size and quantity unequalled in more than a thousand years, from Alpine quarries that even today are virtually inaccessible, with a transport system of sleds and oxen that had to be organized and staffed, with equipment that was made and borrowed and sometimes defective, in weather that was often uncooperative and roundly cursed, and with

men who were hand picked but required training. He selected and inspected all his materials, arranged for rope, tackle, and boats, haggled with carters about fees, and made drawings for even the tiniest, seemingly most insignificant detail before turning the paper over to make calculations, count bushels of grain, draft a letter, or compose poetry. Michelangelo was not only a creative genius but a savvy businessman, equally at home dealing with the mundane or creating the sublime.

A beautiful wooden model was constructed, and tons of marble were quarried and shipped to Florence. In the narrow brown-stone streets Michelangelo's marble façade would have been a spectacular, if strident, contrast to the medieval city. Michelangelo assured his patron, "With God's help, I will create the finest work in all Italy." Sadly, not a single marble was ever put in place; the raw façade is no more than irregular courses of masonry serving as convenient roosts for pigeons. Although never realized, the ambitious project prepared the way for Michelangelo's subsequent career as an architect.

It was one of the most bitter moments in Michelangelo's life when, primarily for financial reasons, the pope canceled the façade contract in 1520. A lengthy letter the artist wrote listing not only his monetary expenditures, but his physical and mental exertions as well, is one of the most famous and certainly most poignant documents of Michelangelo's life: "I am not charging to the pope's account the fact that I have been ruined over the said work at San Lorenzo; I am not

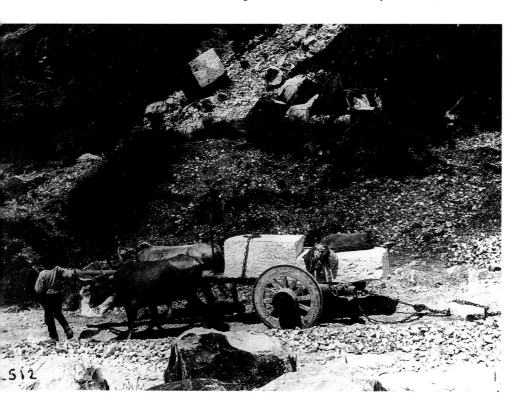

Nineteenth-century marble quarrying and transport, Carrara and Seravazza

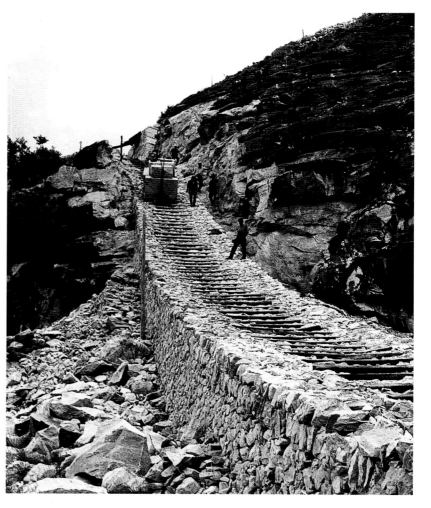

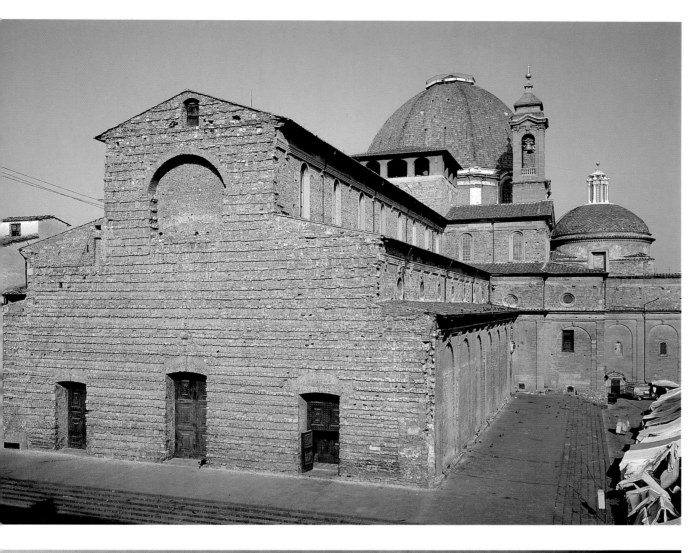

Exterior view of San Lorenzo showing Brunelleschi's unfaced west end and, to the right, the dome and cupola of Michelangelo's New Sacristy, Florence

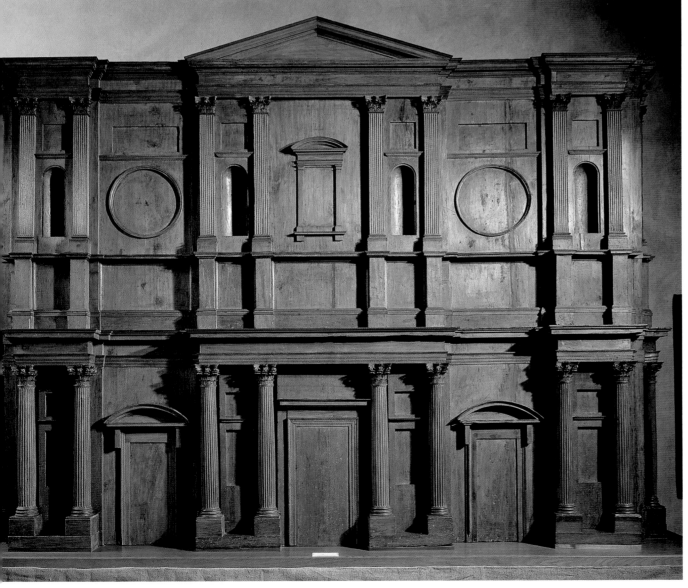

Michelangelo's wooden model of the San Lorenzo façade, which was to have been constructed in marble. Casa Buonarroti, Florence

charging to his account the enormous insult of having been brought here to execute the said work and then having it taken away from me . . . I am not charging to his account." And so it continues. This, the second longest letter Michelangelo ever wrote, elicits wonder and encourages our sympathy, and amply confirms the worst that is often said about Michelangelo's fickle patrons. Michelangelo had made a herculean effort to no avail; nonetheless, the façade helped make the next two projects possible—the Medici Chapel and the Laurentian Library.

The immediate impetus to build a Medici mausoleum at San Lorenzo was the untimely deaths of two young scions of the family, Giuliano and Lorenzo de' Medici, whose tombs now grace the lavish interior. In the midst of this project, Giulio de' Medici was elected Pope Clement VII (1523–1534). Yet another of Michelangelo's boyhood friends, Pope Clement proved one of the greatest and most sensitive of the artist's many patrons. Together—as artist and patron, creator and financier—they collaborated to realize some of the artist's most acclaimed works. In addition to the chapel, Clement wished Michelangelo to design and build a library to house the valuable collection of Medici books and manuscripts.

From 1516 to 1534, Michelangelo devoted himself to the Medici commissions at San Lorenzo. More than three hundred persons assisted him on these large, simultaneous projects. Thus Michelangelo immersed himself in architecture and proved that he was an effective business manager and something of an entrepreneur. He personally selected his workforce of friends, associates, and trained professionals, and knew them all by name, most by colorful nicknames: the Stick, the Basket, the Little Liar, the Dolt, Oddball, Fats, Thorny, Lefty, Stumpy, and Gloomy. There were assistants nicknamed the Fly, the Chicken, the Goose, the She-Cat, the Porcupine, and the Woodpecker, as well as Nero, the Priest, the Friar, the Godfather, the Thief, the

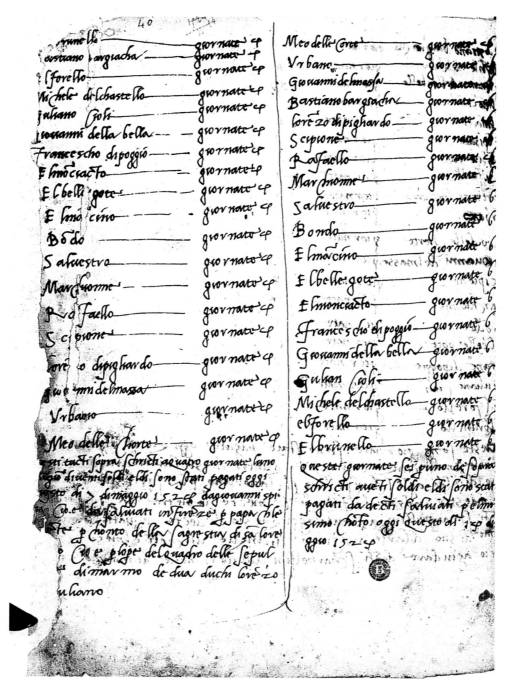

List of Michelangelo's workers written in his own hand

Turk, and the likely butt of many jokes, the Anti-Christ. Having grown up in the stone-working town of Settignano, Michelangelo was well acquainted with most of his assistants; he was familiar with their talents and foibles, and often knew and employed their fathers, cousins, and neighbors. Such familiarity was a form of quality control and helped ensure labor stability. It also helped Michelangelo identify and recruit skilled workers, a potentially large problem for an artist without a *bottega* or a conventional artistic practice.

Inevitably there were frictions, such as when his long-time assistant Bernardino Basso cheated Michelangelo's father of some grain and stole six florins, a jewel, and a ring worth twenty florins (a third of a year's wages). Michelangelo once warned his nephew: "Don't trust Bernardino: pretend to have faith in him but don't believe a word he says because he is a great felon." Another time, Michelangelo told his brother that Bernardino "is a proper scoundrel; shun him like the devil, and don't let him enter the house under any pretext whatsoever": the reprobate assistant was obviously close enough to Michelangelo's family that they needed to be alert to his shenanigans. But despite these occasional angry outbursts, the artist remained close to Bernardino for more than sixty years, and they worked together for more than twenty.

Although it is a cherished myth, Michelangelo, in fact, hardly ever worked alone. He himself claimed to speak to no one, to "have no friends, and don't want any." His biographers emphasized his love of solitude, and Michelangelo contributed to this image by frequent and sometimes bitter complaints against his family, friends, and closest associates: Michele was unreliable and deceitful, Sandro di Poggio was a swindler and a philanderer, Donato Benti was a rascal, and Rubecchio was a "contemptible wretch." His oft-quoted outbursts lend substance to the image of Michelangelo's *terribilità* (terribleness), yet these few instances present a misleading picture for in nearly every case, Michelangelo maintained close and mutually beneficial relations with these same persons long after they inspired his momentary rage. Many ordinary human emotions lie beneath the surface of myth.

Michelangelo's workers sometimes disappointed him but he never fired them. "One must have patience," he wrote. He paid them well, provided them housing, and was genuinely fond of them, as they were of him. He employed many for ten, twenty, thirty, or more years, which was remarkable, given the generally unreliable nature of labor. But Michelangelo's generosity was not without limits. When Francesco da Sangallo turned out shoddy carving, for example, Michelangelo docked his weekly pay "because he did not abide by what he promised." In short,

Michelangelo micromanaged, keeping tabs on all facets of his multiple operations. So many obligations, he wrote, "require a hundred eyes." Like many entrepreneurs, there were flaws in his managerial style and personal relations, but he was enormously successful in eliciting the best, from himself and from his many assistants. The results of his efforts speak for themselves.

On May 6, 1527, the disgruntled troops of the Holy Roman Emperor Charles V sacked Rome. With the city in turmoil, the pope and his immediate entourage barely escaped to the comparative safety of nearby Orvieto. Florence threw off the shackles of Medici rule and declared the city once again a free and independent republic. Pope Clement felt betrayed by his native city. During the next three years one of the major objectives of Clement's diplomacy was to reinstate his family and ensure their future security in Florence. By 1529, Clement and Charles were reconciled, and according to the Treaty of Barcelona signed in June of that year, the two major powers agreed to a joint military campaign to reinstate the Medici.

Michelangelo, a lifelong republican, but also now a Medici employee, found himself in an extremely awkward situation. Despite the pope's effort to dissuade him, Michelangelo elected to side with his native city, and he devoted the next three years of his life to the heroic but ultimately doomed republican cause. Largely for lack of funds, the workshop at San Lorenzo was closed down. Michelangelo turned his attention instead to a commission to carve a marble *Hercules* and subsequently to the defense of the city.

In the fall of 1528, Michelangelo offered his services to Florence, and in April 1529 he was appointed Governor and Procurator General of the Florentine fortifications. In his capacity as a military engineer, Michelangelo was dispatched to inspect the defenses of Pisa, Livorno, and Ferrara, then considered to have the most advanced fortifications in all Italy.

Michelangelo designed, coordinated, and directed the enormous Florentine defense effort, probably the largest construction project since the erection of the medieval circuit of walls. The city was invested in October 1529, and withstood a grueling ten-month siege. Florence finally capitulated on August 12, 1530, and then sustained a protracted witch-hunt of retribution. It is something of a miracle that Michelangelo was able to survive these chaotic times. Fortunately, he had friends in high places and a pope who genuinely liked and admired him. Clement magnanimously forgave Michelangelo his defection and set him to work once again on the Medici projects at San Lorenzo. But Michelangelo's heart lay elsewhere.

It is evident that after the extended interlude of the Republic and the dangerous period following its collapse, Michelangelo no longer felt the same commitment to the Medici projects. Increasingly disaffected with Florence, where the last vestige of republican liberty was erased when the tyrant Alessandro de' Medici was proclaimed duke in 1532, Michelangelo spent more and more time in Rome. There he found a large community of Florentine expatriates and a new friend, Tommaso de' Cavalieri, who renewed his artistic and poetic inspiration. In 1534, Michelangelo left Florence and never returned. He spent the remaining thirty years of his life in Rome, and, like his beloved Dante, in exile.

Rome was a vibrant city in the 1530s, especially following the election in 1534 of the energetic, reform-minded Alessandro Farnese as Pope Paul III (1534–1549). Paul was probably the greatest and most discerning of Michelangelo's numerous patrons. There appears to have been trust and mutual respect between the two men, based in no small measure on the fact that they were contemporaries. Paul lost no time in the employment of Michelangelo's talents, first commissioning him to paint the altar wall of the Sistine Chapel. When Michelangelo protested that he was still under obligation to complete the tomb of Julius II, the pope is said to have burst out:

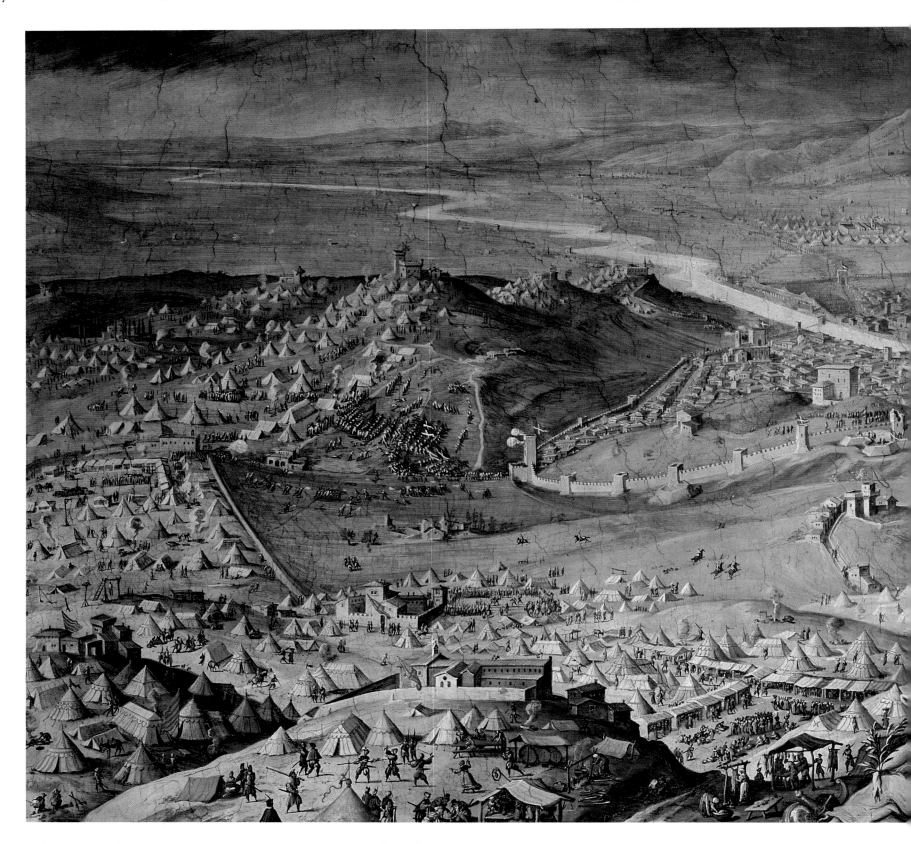

Giorgio Vasari. SIEGE OF FLORENCE. *Fresco. Palazzo Vecchio, Florence*

"I have nursed this ambition for thirty years, and now that I'm pope am I not to have it satisfied? I shall tear the contract up. I'm determined to have you in my service, no matter what." And he succeeded; Paul kept Michelangelo busy throughout much of his fifteen-year reign. During these same years, Michelangelo also found time to complete a reduced version of the tomb of Pope Julius II.

In addition to the *Last Judgment* for Pope Paul, Michelangelo painted two large frescos in the so-called Pauline Chapel. And most importantly, Paul patronized Michelangelo as an architect, appointing him in 1546 to direct the construction of St. Peter's and the Farnese Palace. St. Peter's was Michelangelo's torment and his triumph, the largest and most spectacular building in Western Christendom, but also a continuous series of headaches, from construction debacles to management intrigue. He once lamented that mistakes were made when he, being old and sometimes incapacitated, was unable to appear at the worksite every day. Nonetheless, Michelangelo remained devoted to the project even when his great admirer, Duke Cosimo de' Medici, tried repeatedly to persuade him to return to Florence. Michelangelo donated his waning energy, and the last twenty years of his life, to completing

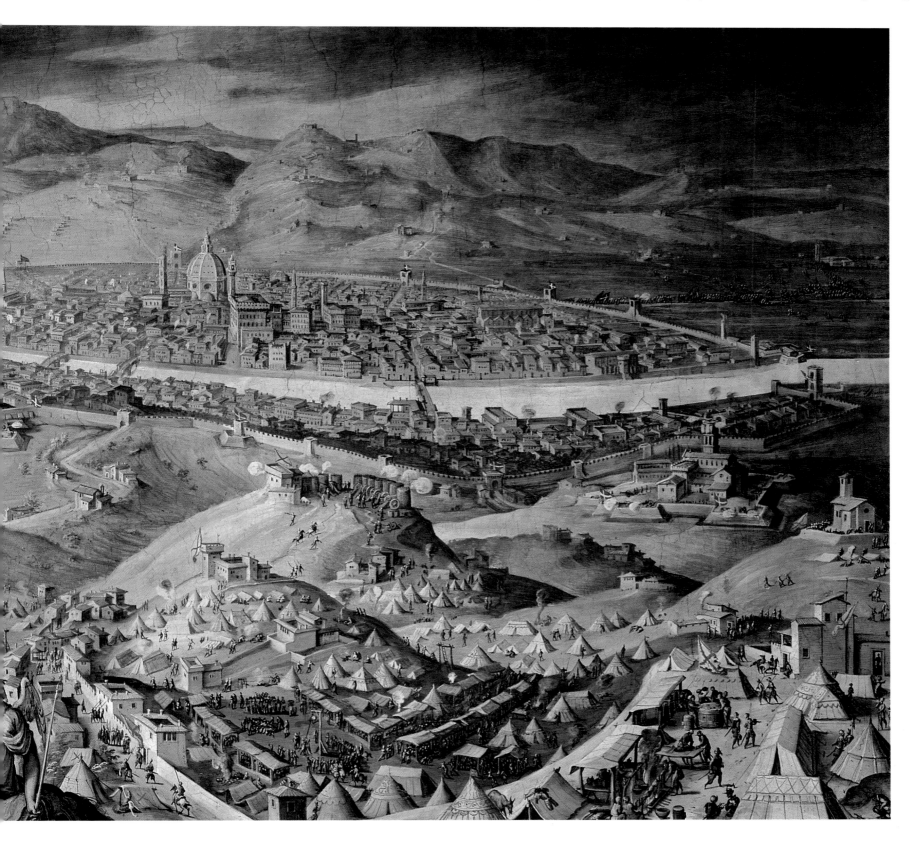

St. Peter's. It was, I think, his best hope for a remission from sins in the afterlife.

In Rome, Michelangelo had a large and remarkable circle of friends and acquaintances. Acutely conscious of his claim to nobility, the artist was particularly attracted to persons of high social station, and vice versa. His friendship with the young Roman nobleman Tommaso de' Cavalieri continued to the artist's death, even if somewhat diminished from its initial passionate intensity. Another close friend, Luigi del Riccio, encouraged Michelangelo to publish some of his poetry. Despite a burst of creative and editorial activity, the project was suspended with the sad and untimely death of del Riccio in 1546. Michelangelo found sustained nourishment from a long friendship with Vittoria Colonna, the scion of a noble Roman family and an accomplished poetess whom he met while he was working on the *Last Judgment*. Stimulated by the passions aroused especially by Cavalieri and Colonna, Michelangelo was inspired to become one of the most important poets of the Renaissance.

Vittoria Colonna served as something of a spiritual guide and a refuge during the tumultuous Counter-Reformation, the Catholic response to the threat of Protestantism. Through Colonna, Michelangelo was exposed to the leading reform thinkers of the day, including Juan Valdès, Bernardino Ochino, and the English Cardinal Reginald Pole. As his drawings and letters testify, Michelangelo was sympathetic with the reformers' belief in justification by faith, a position that ran afoul of Catholic orthodoxy and caused the artist frequent consternation. Michelangelo was devastated by Vittoria Colonna's death in 1547; it was one of many poignant separations from those the artist loved best.

With each successive pope, Michelangelo was confirmed in his position as architect of St. Peter's, all the while taking on additional responsibilities from the popes or select patrons. During the reign of Pius IV (1559–1565), for example, Michelangelo designed the Porta Pia, transformed the Baths of Diocletian into the Christian church of Santa Maria degli Angeli, and designed the Sforza Chapel in Santa Maria Maggiore.

While working as an architect in the public sphere, he continued to plumb the depths of his personal faith in the more private world of poetry, drawings, and even sculpture. Quite remarkably for an artist who proudly signed himself "Michelangelo scultore," in the last thirty years of his life he completed just three sculptures: the *Rachel* and *Leah* for the tomb of Julius II, and the bust of *Brutus*. The *Florentine Pietà* was destined for his own grave but was given away, and the *Rondanini Pietà* was begun for no ostensible reason, except perhaps to keep himself busy and spiritually nourished. Architecture was his final and perhaps most influential legacy.

In 1555 the artist became an octogenarian, almost unheard of in the Renaissance, when the average age was approximately half that. Yet, his creative powers scarcely flagged. We have a remarkable contemporary description of the speed and energy of Michelangelo's carving, even at the age of seventy:

> *I have seen Michelangelo, although more than sixty years old and no longer among the most robust, knock off more chips of a very hard marble in a quarter of an hour than three young stone carvers could have done in three or four, an almost incredible thing to one who has not seen it; and I thought the whole work would fall to pieces because he moved with such impetuosity and fury, knocking to the floor large chunks three and four fingers thick with a single blow so precisely aimed that if he had gone even minimally further than necessary, he risked losing it all.*

And Michelangelo himself reflected in a sonnet:

> *If my crude hammer shapes the hard stones*
> *into one human appearance or another,*
> *deriving its motion from the master who*
> *guides it . . .*

Michelangelo evidently thought about poetry in the midst of carving, since poems have been found that were scribbled on sheets in the workshop. Michelangelo moved easily between the two media. The rhythmic strokes of the hammer suggested verse; his verse retained elements of its lapidary origins. There was an exalted vision that drove the sculptor's arm, and a spiritual meaning lay beyond the sweat.

Despite the worsening pain caused by kidney stones, Michelangelo continued in his multifarious duties as architect and urban planner. He took great interest in the business affairs and marital plans of his nephew, and kept up an impressive correspondence with family, friends, admirers, and hopeful patrons. Just a few days before his death he was still carving the *Rondanini Pietà*. In a poetic fragment, Michelangelo mused,

> *No one has full mastery*
> *before reaching the end*
> *of his art and his life.*

And he lamented the inevitable end of both his art and his life when he wrote, "Art and death do not go well together."

Michelangelo lived through the reigns of thirteen popes, and worked for nine of them. For most of his long life, he lived with one or two assistants, a male servant/secretary, and a female cook and housemaid. Michelangelo never married, but this was not uncommon among Renaissance artists. Instead he formed lasting attachments with a few friends and was loyally committed to his immediate and extended family. Sadly, he outlived most of his friends and family. He faced the death of his brother in 1555 with composure: "I had the news of the death of Gismondo, my brother, but without great sorrow. We must be resigned; and since he died fully conscious and with all the sacraments ordained by the church, we must thank God for it." He was completely devastated, however, by the death of Urbino, his faithful servant and companion of twenty-five years. Revealing the depth of his emotions, Michelangelo wrote to his nephew of "his intense grief, leaving me so stricken and troubled that it would have been easier to have died with him." Instead, Michelangelo lived for another nine years, more alone but never neglected or forgotten. It is characteristic that he provided for Urbino's widow and also took an active interest in her fatherless child.

The world watched as Michelangelo approached death. Fully conscious of his hero's place in history, Giorgio Vasari wrote to Duke Cosimo de' Medici in 1560:

> *He now goes about very little, and has become so old that he gets little rest, and has declined so much that I believe he will only be with us for a short while, if he is not kept alive by God's goodness for the sake of the works at St. Peter's which certainly need him. He made me astonished that the ancients are surpassed by the beauty and grace of what his divine genius has been able to achieve.*

Michelangelo, the equal of the ancients: in the Renaissance there could be no higher praise.

At Michelangelo's side during his final illness were his friend Tommaso de' Cavalieri and his pupil, Daniele da Volterra. The artist died on February 18, 1564, just two weeks shy of his eighty-ninth birthday. Informing Duke Cosimo in Florence, Michelangelo's doctor wrote: "This afternoon that most excellent and true miracle of nature, Messer Michelangelo Buonarroti passed from this to a better life." That same year Galileo and William Shakespeare were born.

CHAPTER II
THE ARTIST'S

SCULPTURE
INITIAL TRIUMPH

MADONNA OF THE STAIRS

♦ ♦ ♦

C. 1491 ♦ MARBLE RELIEF ♦ 22 X 15¾ INCHES ♦ CASA BUONARROTI, FLORENCE

This relief is a surprise beginning to an artist's career. If this carving is by a fifteen-year-old boy then it is evidence of a truly precocious talent, a Bernini or a Mozart. But is this the first work of a largely untutored sculptor? Was it executed sometime later than is usually thought, or was it reworked many years later by an artist conscious of fashioning his biography and artistic origins?

Differing views aside, the truth is that Michelangelo probably had more training in sculpture by the time the *Madonna* was carved than either he or his biographers admitted. Many an artist's early works ended as duds or disasters, or were never completed, or were recarved because a young artist was unable to afford the luxury of wasting expensive marble. The *Madonna,* therefore, along with the *Battle of the Centaurs* relief, must represent Michelangelo's juvenalia, even though there should be reservations about calling these Michelangelo's "first" works.

The *Madonna of the Stairs* is a curious combination of sophistication and technical awkwardness. It has a grandeur well beyond its modest dimensions; it is smaller than we sometimes imagine it from reproduction. The Madonna entirely fills the field, extending from the top to the bottom edges of the marble. This is the sort of maximum extension of figures within the confining boundaries of blocks that is a hallmark of Michelangelo's sculpture.

The Madonna is seated on a square plinth, less a throne than a beautifully dressed hunk of quarried stone. Her idealized, classic profile is framed by the circle of her halo and accentuated by the drapery fold that extends the line of her nose. Free of the face, the drapery cascades in soft, abundant folds, over the shoulder, around the arms and legs, and over the raised lip of the carved frame.

Despite her physical proximity to the other figures in the relief, the Virgin is immensely remote, far removed

PRECEDING PAGES:
Detail of the BRUGES MADONNA

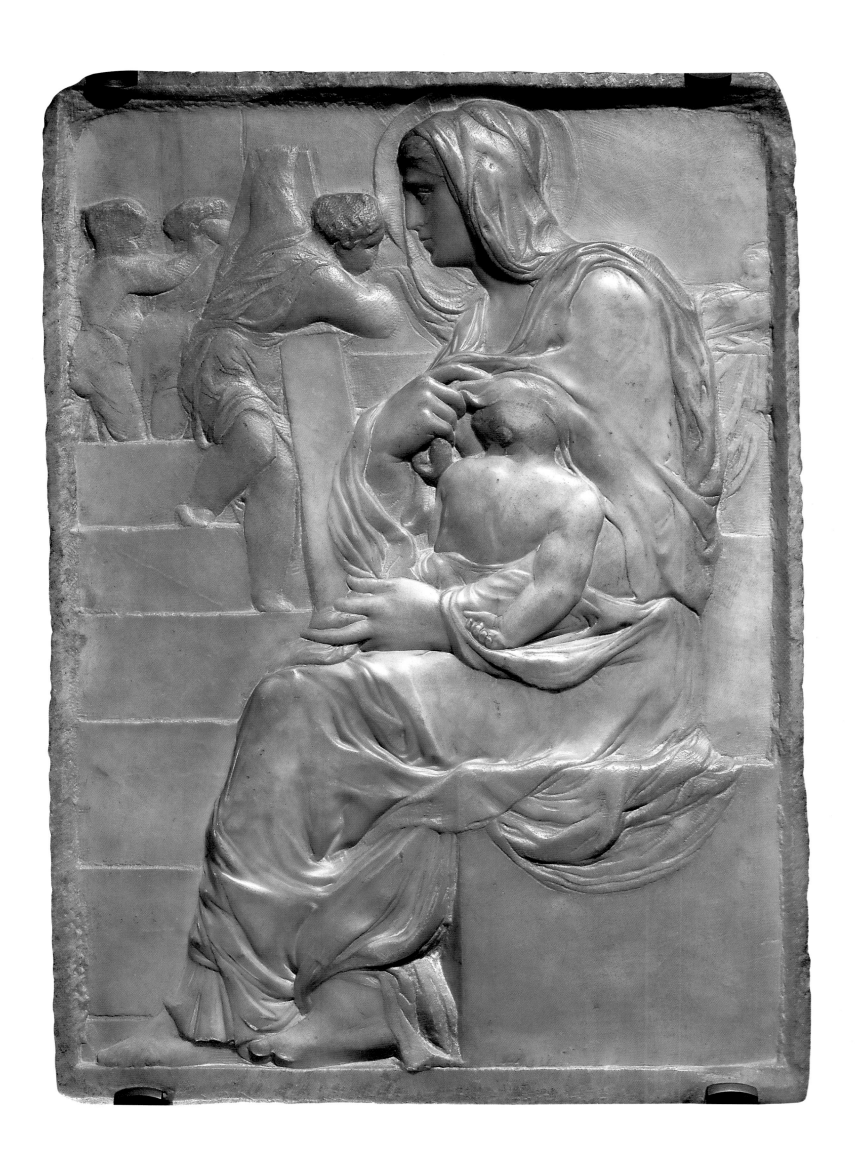

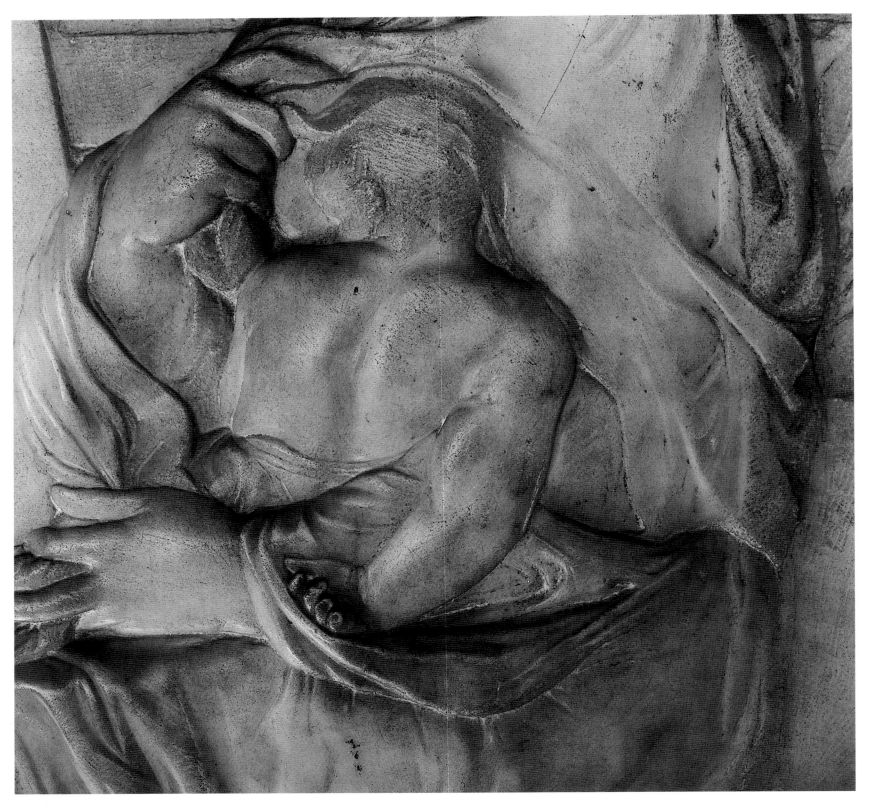

. . . The child's head is discernible even
under a loose fold of drapery. . . .

from us, and from her child. The physical and psychological distance from her offspring is remarkable, especially for a nursing mother. But, in fact, the child is no longer nursing: still at his mother's breast, the child slumps into sleep, the head falling to his chest, the muscular pronated arm caught in a large drapery fold.

And what a child! It is a body of some years, not an infant recently issued from the womb. A little Hercules. The heavy folds of drapery create a womb-like space filled by his compact, muscular body. As is often the case in Renaissance art, the sleeping Christ child suggests Christ's

eventual death. The drapery that protects the infant will become the linen tomb shroud; the peacefully sleeping child soon will confront the longer oblivion of death. Perhaps this helps explain the mother's distracted look. She alone foresees her child's history from swaddling clothes to winding sheet.

Michelangelo's skillful rendering of depth, volume, and physicality makes the *Madonna* a tour de force of illusionistic carving. The child's head is discernible even under a loose fold of drapery. Similarly we perceive the pristine geometry of the Madonna's seat despite the drapery

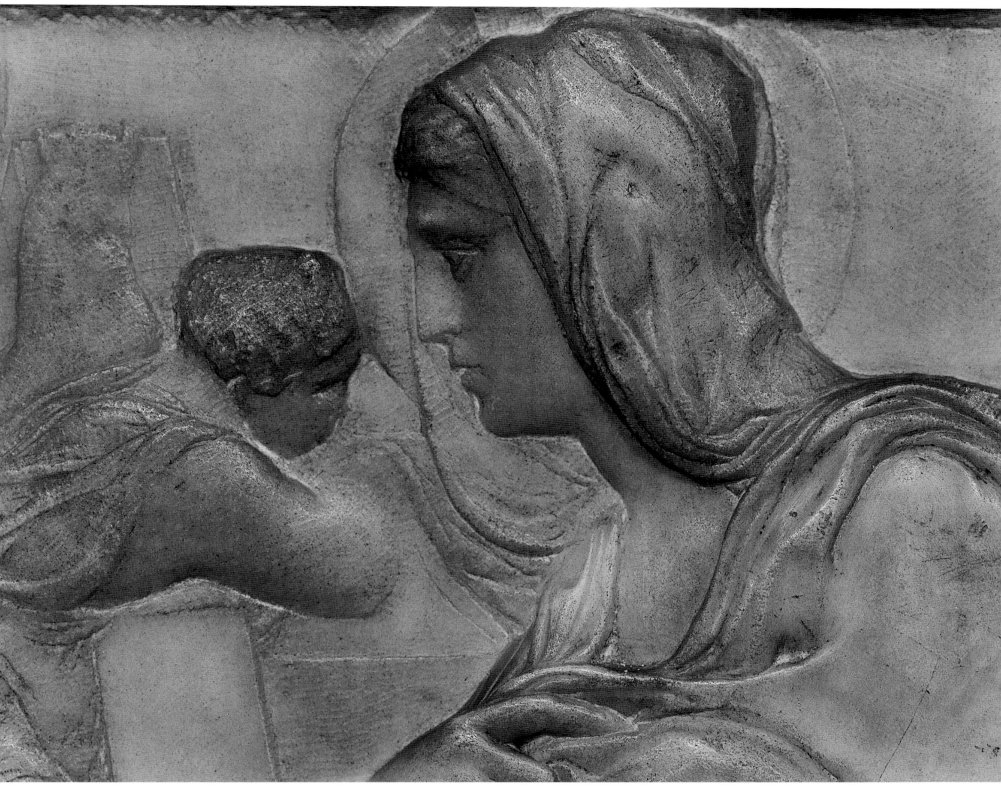

. . . The physical and psychological distance from her offspring is
remarkable, especially for a nursing mother. . . .

obscuring its top edge. The Virgin's foreshortened right foot is crossed underneath the left, and athletic cherubs ascend the staircase. Such passages, although occasionally awkward, reveal a remarkable command of a difficult medium.

The *Madonna of the Stairs* is a demonstration of low relief carving in the tradition of Michelangelo's great predecessor, Donatello. But did he make it for himself, or for someone else? What possible purpose could it serve? It is too small to function as a devotional object and too large to

be a plaquette-like, collectible art object. Even at its relatively modest size it cannot be handled or easily moved. Therefore, it is unlikely that it was made in the Medici household, as is often supposed. It is difficult to imagine Michelangelo tucking it under his arm when he left that haven. It probably was a demonstration or practice piece made under the tutelage of the unknown Florentine stone carver from whom Michelangelo learned his craft. The same may also be true of his other presumably early relief sculpture.

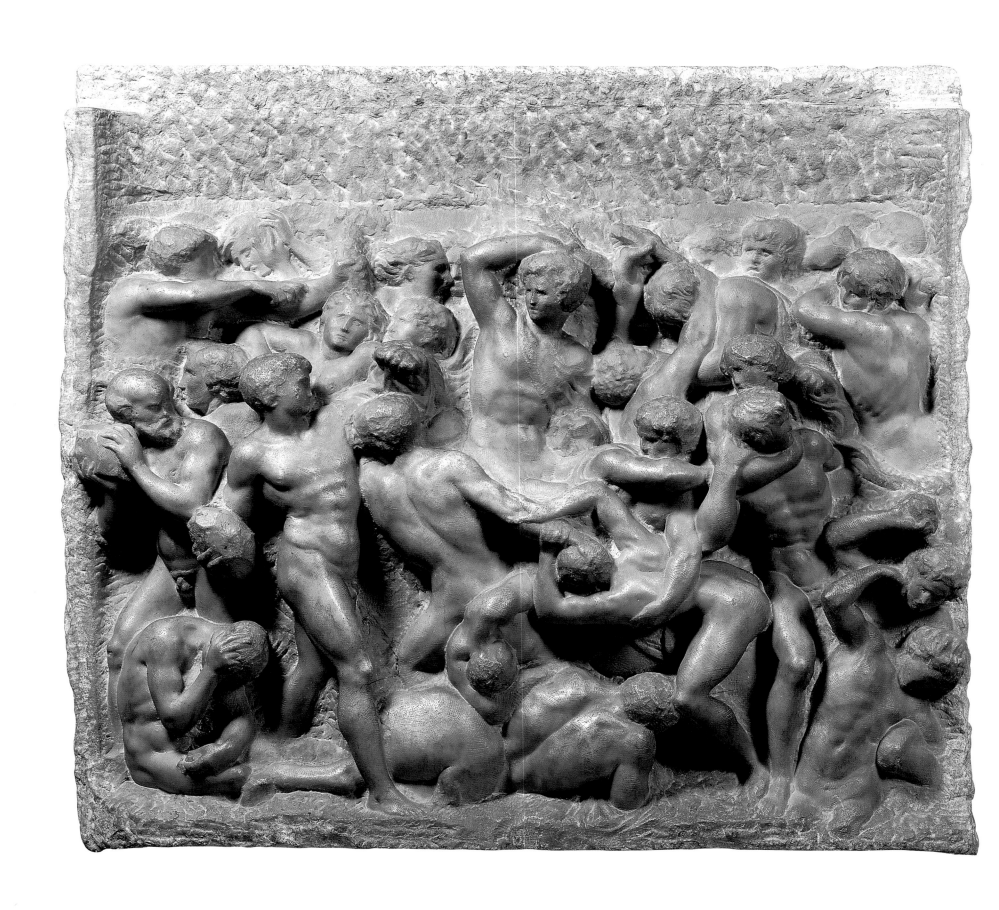

BATTLE OF THE CENTAURS

◆ ◆ ◆

C. 1492 ◆ MARBLE RELIEF ◆ 33¼ X 35⅝ INCHES ◆ CASA BUONARROTI, FLORENCE

It is often said, and rightly so, that in this relief Michelangelo anticipated ideas that he explored in painting and sculpture for the next forty years. It certainly reveals one of the dominant themes of his art, the male nude in action.

This jumble of writhing, struggling figures tumbles from the block and into our space. With its rough-sketched, unfinished, and unevenly polished surfaces, we are never far from the raw stone out of which these figures were extracted. In all the extant fifteenth-century sculpture, there is nothing like its insistent three-dimensionality, and its unfinished, rough-hewn quality.

Where did Michelangelo obtain the thick, squarish block? Marble was expensive and not easy to come by, unless it was a remnant obtained from the cathedral or an artist's workshop. Perhaps Condivi and Vasari are correct in relating that the famous humanist and tutor who was in the Medici household, Angelo Poliziano (Politian), provided Michelangelo with the subject, but that is not necessarily reason to think that he carved it in the Medici sculpture garden. Even heavier than the *Madonna of the Stairs* relief, this is not an easy object to transport.

And what an interesting slab of marble! It is larger and thicker than many relief sculptures by Donatello or Desiderio da Settignano. Michelangelo has exploited the full thickness of the block, layering the figures in different spatial planes. Although there is almost no free space in this compact mass of struggling figures, spatial depth is created by the overlapping of human forms. Michelangelo has worked to the extreme edges of the block, except at the top, where he has left a wide band of rough-chiseled stone. Like the *Madonna of the Stairs,* it is unlike anything carved by Michelangelo's predecessors or contemporaries. It is

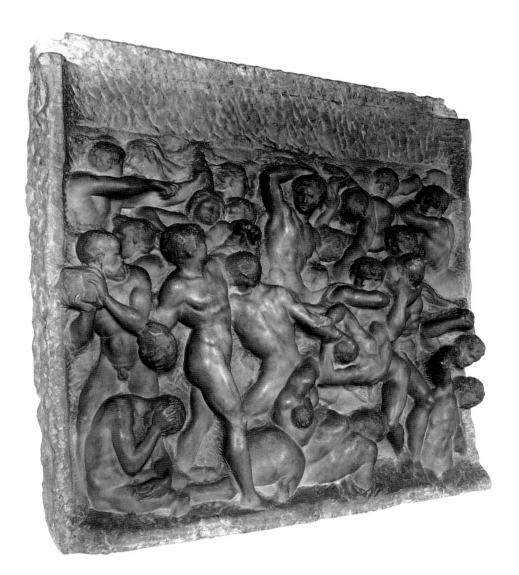 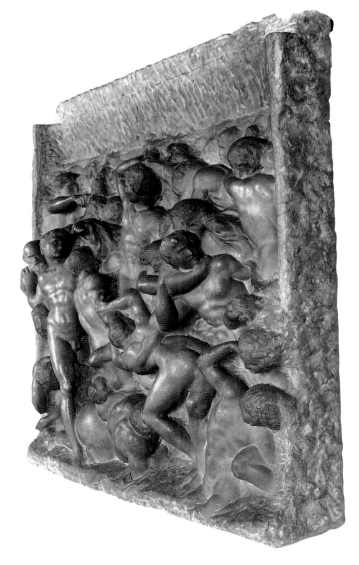

. . . there is almost no free space in this compact mass of struggling figures,
spatial depth is created by the overlapping of human forms. . . .

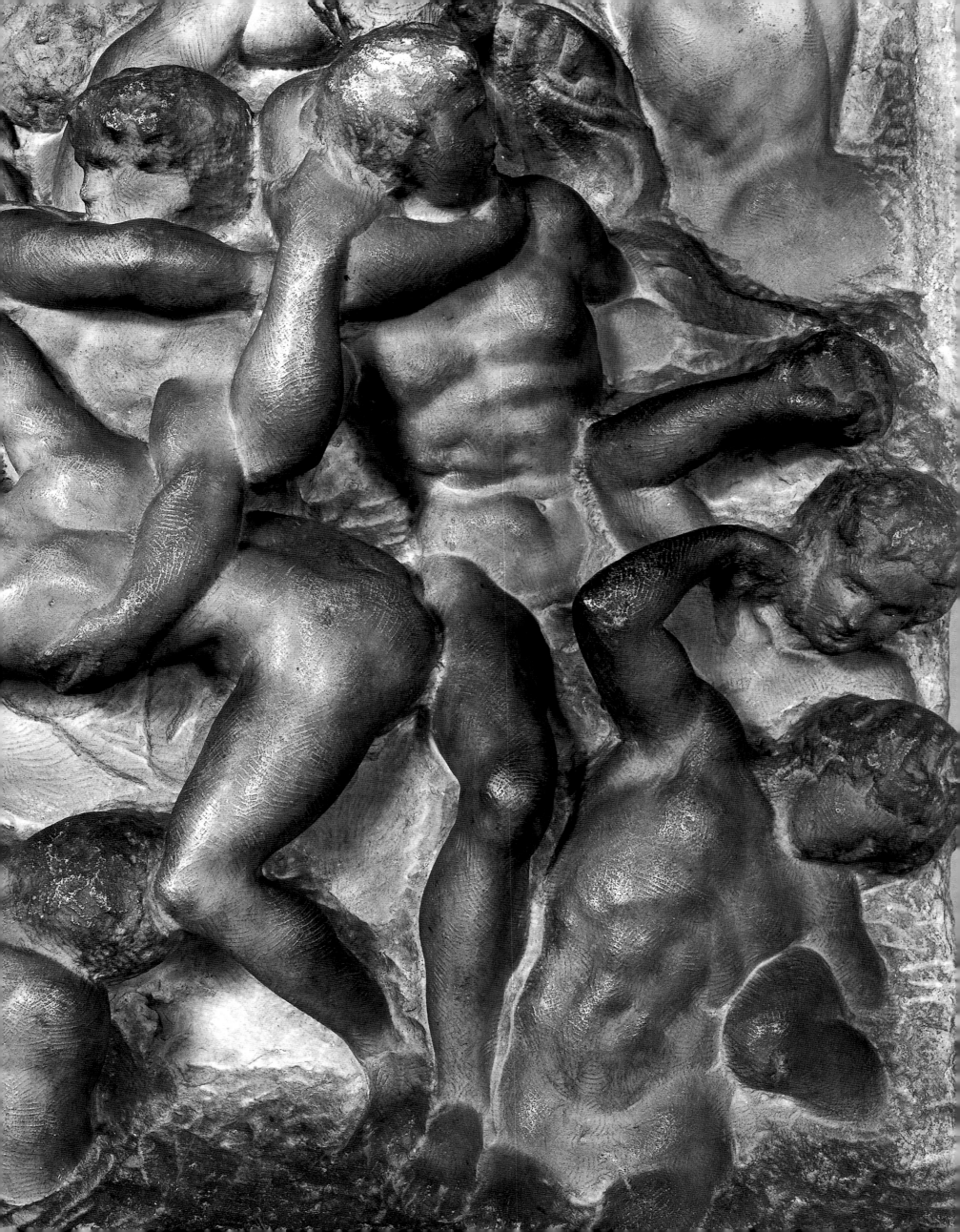

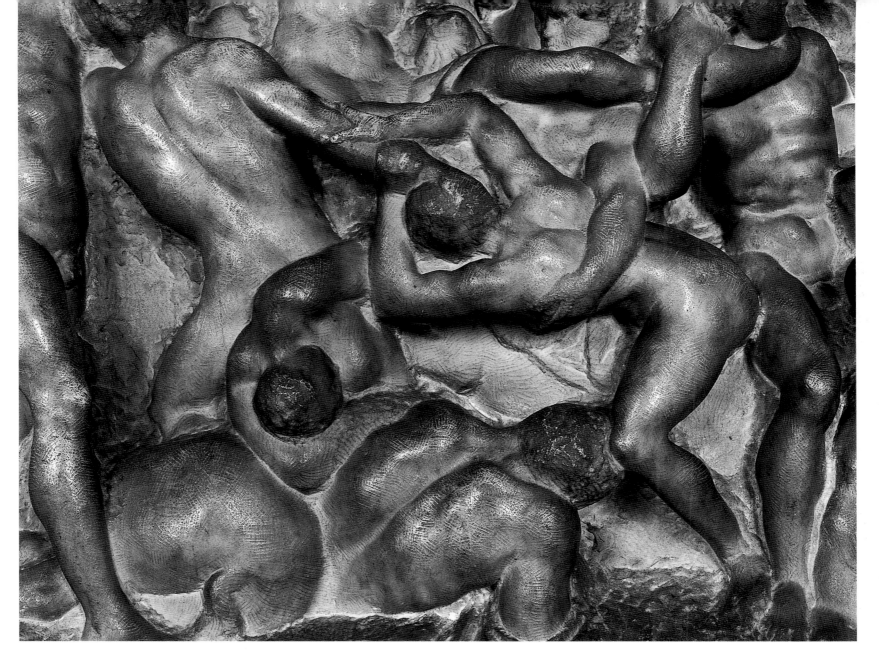

possible that he thought of removing it (note how he has scored the stone horizontally just above the heads of the background figures), in which case the relief would more closely resemble ancient sarcophagi which Michelangelo undoubtedly knew and studied, especially in nearby Pisa. On the other hand, the roughened band of stone also suggests an architectonic element, albeit unfinished, such as those that enframe the pulpit reliefs carved by his famous fourteenth-century forbears, Niccolò and Giovanni Pisano. Whatever the explanation for this anomaly, it certainly insists on the unfinished nature of the work and forcefully reminds us that, like the *Madonna* relief, there is no obvious destination for such a work. It cannot stand up by itself, it is difficult to affix to a wall, and it certainly was not meant to be seen lying down. Most likely, it is a practice and demonstration piece, but one that Michelangelo in his old age considered one of his best works.

And what about the subject? There is some disagreement on this point. Even Michelangelo's own biographers seem to have been confused. Condivi reported that this was a Rape of Dejanira (which it is not), while Vasari identified it as Hercules and the Centaurs (also probably incorrect). Most call it a Battle of the Centaurs, although few such creatures are identifiable as such. Whatever the iconography, the relief is a congested swirl of struggling, entwined humanity in which bodies emerge and disappear in a flotsam of petrified flesh. The complicated interlockings of bodies and the contrapuntal echoing of limbs create some semblance of order within the apparent chaos. The suggestion that these are complete figures, even though only partial bodies are discernible, is masterful. The repertoire of gestures and movement were to continue to serve the artist for years to come.

On the left side two figures are about to toss stones into the melee; the one projectile is faceted, the other is crude and appears strikingly similar to a number of the roughly shaped heads. Perhaps Michelangelo is playing on the nature of artifice, reminding us that an artist fashions new realities from raw materials. We are witness to the artistic process, the sculptor creating a miracle of living flesh from inert rock, yet simultaneously we are reminded of the miracle's humble, lapidary origins.

THE BOLOGNA STATUETTES

◆ ◆ ◆

1494–1495 ◆ MARBLE ◆ SAN DOMENICO, BOLOGNA
ANGEL WITH CANDLESTICK ◆ 20¼ INCHES HIGH
ST. PROCULUS ◆ 22 INCHES HIGH
ST. PETRONIUS ◆ 25 INCHES HIGH

When the Medici fled Florence in 1494, Michelangelo followed his patron/protectors northward. It would have made more sense for an aspiring sculptor to go to Rome, like his great forbear Donatello. Yet Michelangelo chose to maintain the ties of patronage he had developed, no matter how threatened by the present circumstances.

Probably thanks to the artist's Medici connections, Michelangelo was received in Bologna and taken into the household of Gianfrancesco Aldovrandi, one of the city's most prominent citizens. In addition, Aldovrandi secured some work for the nineteen-year-old youth. The tomb of Saint Dominic was, and still is, one of the city's most important pilgrimage sites and artistic monuments. Begun by Niccolò Pisano in the fourteenth century and left incomplete at the death of Niccolò dell'Arca in 1492, the giant tomb ensemble was still missing some of its statuettes and one of the altar candelabra.

With the model of Niccolò dell'Arca directly before his eyes, Michelangelo carved an angel candelabrum, one of the sweetest of all his works. Indeed, he may even have been purposely imitating the gracile style of his predecessor. The youthful angel kneels on what appears to be a truncated bit of entablature. On his upraised right knee the angel supports the heavy, classicizing candleholder. Unlike Niccolò's more androgynous angel, Michelangelo's is clearly male and robust despite its diminutive size. Michelangelo displays his nascent skills as a marble carver in the lively expression of the open mouth, the thick head of hair, the layered feathers of the stout wings, and the pliant folds of drapery. One particularly beautiful passage is the drapery that loops over the left shoulder and falls to the waist where the angel's belt cinches the excess material before it once again spreads in billowing folds below. Some of this excess is gathered in the angel's left hand, which holds the base of the candlestick in a fashion that recalls an Adoration of the Kings, in which the Magus touches Christ, but only through a cloth or veil.

The two other statuettes are both standing figures and represent local saints of Bologna: St. Petronius and St. Proculus. Just as Michelangelo looked to Niccolò dell'Arca for the model of his candelabrum, so he looked to the prominent Sienese sculptor Jacopo della Quercia for inspiration for his figure of the bishop saint, St. Petronius (and again later for some of his figures in the Sistine Chapel).

As patron saint of Bologna, *St. Petronius* holds a model of the city. It is a wonderfully cubistic composition, but is also a recognizable shorthand of the city's most prominent landmarks, including the city walls with coats of arms and the famous leaning towers noted in Dante's *Inferno*. The rugged face of the saint is offset by the swirl of folds that fall to feet barely visible under the animated hem of his garment. Learning to carve the exaggerated activity of drapery, one garment over another over a *contrapposto* (weight-shift) body, would serve Michelangelo well; in just two years he would be carving the *Rome Pietà*.

The pugnacious visage of *St. Proculus*, anticipating similar facial expressions on the *David, Moses,* and *Brutus,* endows his figure with individual personality and character appropriate to a youthful soldier saint. The bold animation of the figure is further suggested by the right hand held in readiness, the long cloak slung over the left shoulder, and the multiple twists of the body and head. The movement is then emphasized by the swish of the short, belted tunic that responds to the advanced left leg and opposing retracted right shoulder. Although small, the lively expression and *contrapposto* movement of both figures suggest the more ambitious sculptures of the coming years, the *Bacchus, St. Matthew,* and *David.*

OPPOSITE:

TOMB OF ST. DOMINIC. *San Domenico, Bologna. Tomb sculptures by Niccolò Pisano, Niccolò dell'Arca, and Michelangelo (right candelabrum, second from left standing figure, and figure on rear, not visible)*

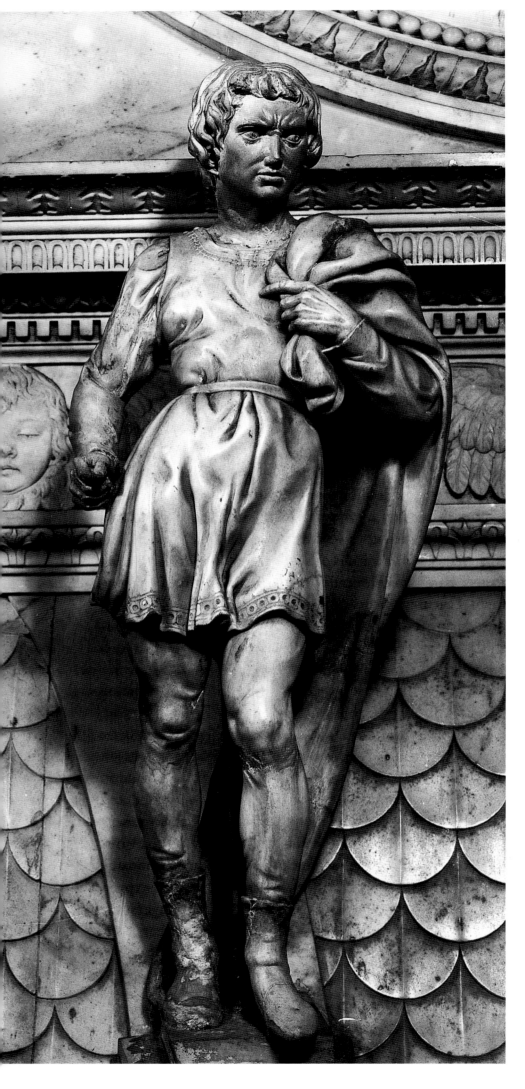

ST. PROCULUS

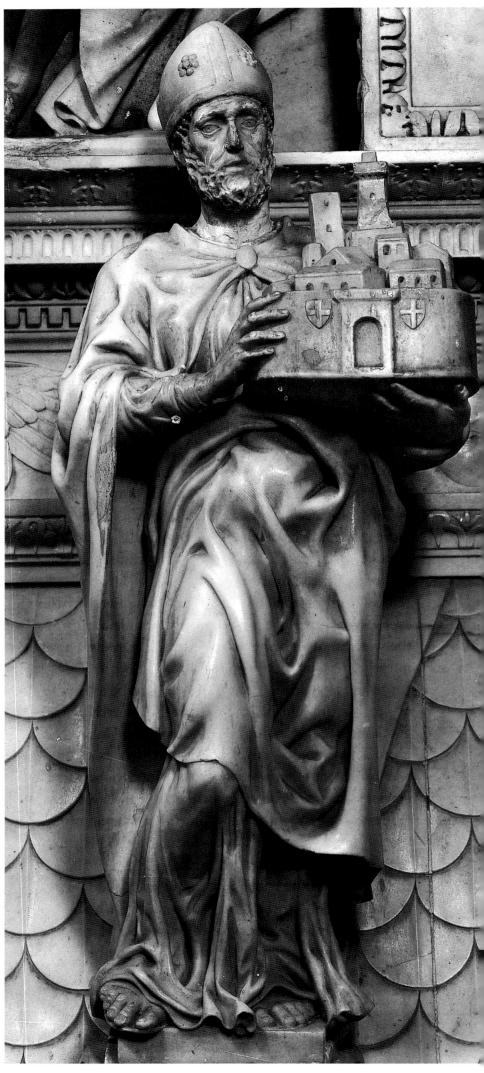

ST. PETRONIUS

MICHELANGELO

42

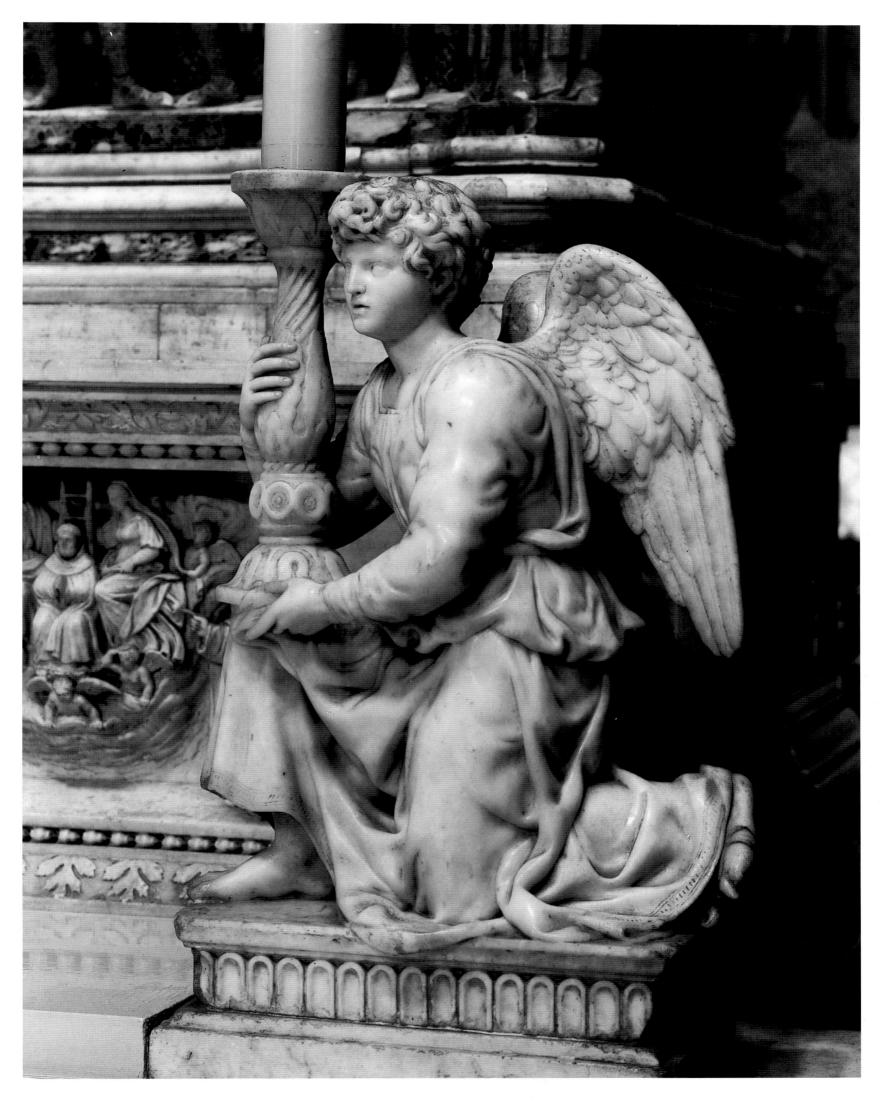

ANGEL WITH CANDLESTICK

BACCHUS

◆ ◆ ◆

C. 1496–1497 ◆ MARBLE ◆ 80 INCHES HIGH ◆ BARGELLO MUSEUM, FLORENCE

Despite the experience gleaned in the first half dozen years of his young career, there is little of Michelangelo's preserved work that prepares us for the stunning accomplishment of the *Bacchus*. Whether or not the sculpture actually appeals to us—and there are qualities that simultaneously attract and repel—we must acknowledge that this carving of a larger than life-size double-figure marble sculpture in the round is a virtuoso performance. With this work, the twenty-two-year-old artist made a spectacular bid for public recognition as a talented marble carver—and he succeeded.

To many viewers, a first encounter with Michelangelo's *Bacchus* is disconcerting; it has few of the heroic and idealizing qualities we normally associate either with his sculptures or with antiquity, his newest inspiration. Prominent examples of classical sculpture were available for the artist's inspection in the collections of Cardinal Riario, Giuliano della Rovere (the future Pope Julius II), and Jacopo Galli, another early patron. But did the antique provide a model for Michelangelo? Attempts by scholars to link the *Bacchus* to classical prototypes are not terribly convincing, and none of those generally cited were known in 1496. Michelangelo certainly was a student of antiquity and found inspiration there, but just as certainly did not copy it. In the best sense of artistic imitation *(imitatio)* Michelangelo has recreated the antique, perhaps more successfully than any known work of the classical past. His

Bacchus could well be a Hellenistic sculpture, standing comfortably alongside the most famous work of antiquity, the Apollo Belvedere, with which it shares many stylistic features even while divergent in spirit.

Bacchus, the ancient god of wine, lurches toward us as though too much enamored with the divine elixir that was his gift to mankind. His soft, pliant body moves unsteadily, even awkwardly; it is a serious undermining of the classical conventions of *contrapposto* movement. His unsteady stance and lolling head further underscore the figure's potentially radical imbalance. Even the wine cup—an intelligent bit of archeological invention—tilts unnervingly, so that we can easily imagine wine being poured onto the hallowed earth as in some Bacchic ritual, or, less respectfully, a sloshing of the divine liquor upon the spectator should we approach too near. To avoid the god's unsteady movement, we move to the side, and then around the figure. There we discover Bacchus's semi-human companion, the satyr who mischievously smiles at us while impishly imitating Bacchus's pose and stealing the god's fruit. But a few missing grapes will hardly matter, for they are in abundance; we see them even draped over the head of the god. They are so artfully integrated with Bacchus's hair that we easily mistake one for the other.

We continue around the figure, since every angle presents new surprises. Michelangelo has successfully

Marteen van Heemskerck. Drawing of BACCHUS *in the Galli Garden*

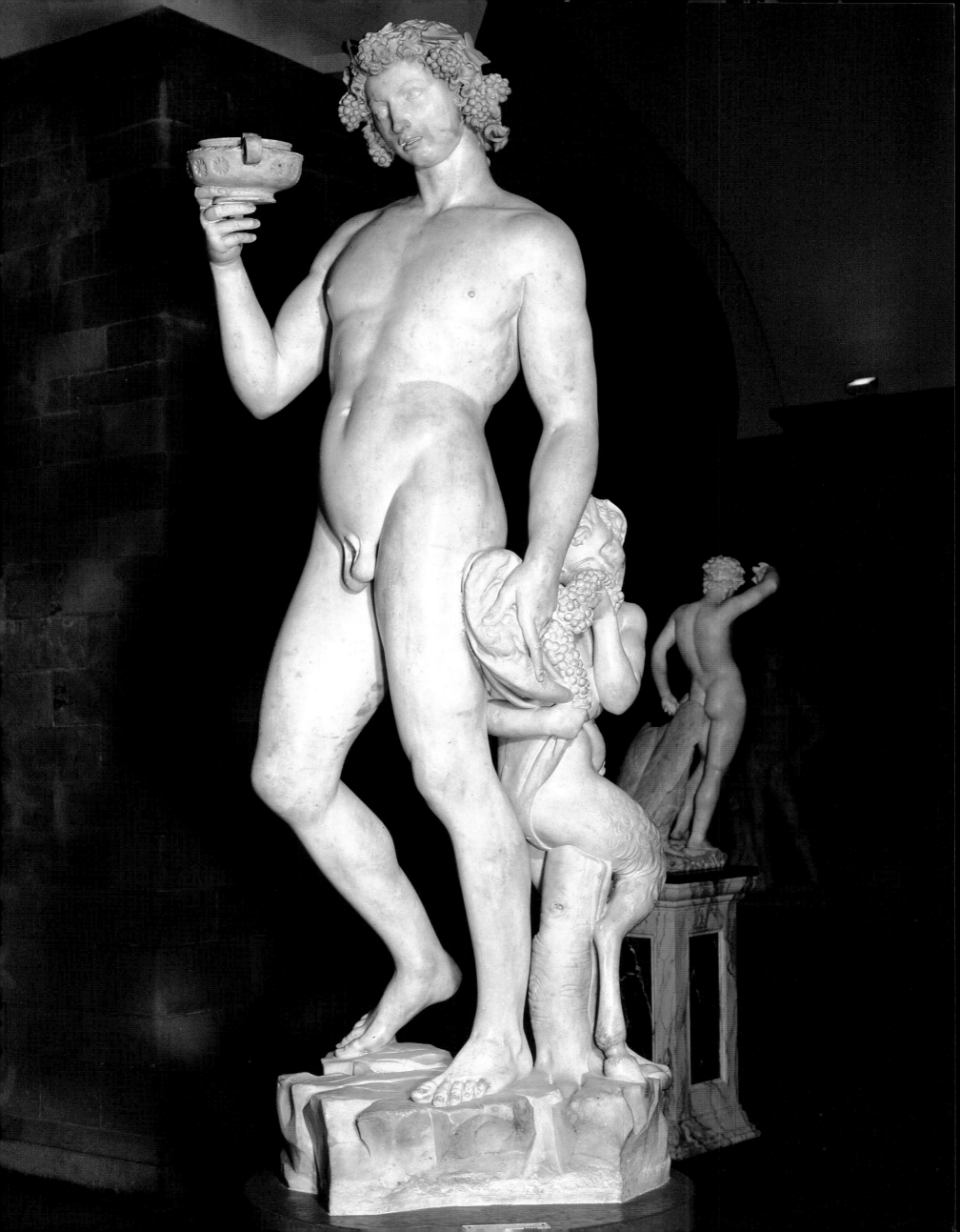

created a multiplicity of views, and no one is obviously dominant. This is actually a highly successful artistic ploy, since, as we circle the figure, we become dizzy until eventually our state begins to approximate that represented by the inebriated god. Through the antics of our moving and looking, we are encouraged to imitate art, until ultimately we discover ourselves peering through the eye of the wine cup, acting and perhaps feeling every bit as intoxicated as the god himself. By means of a smile and a slightly swirling head, we are afforded a glimpse of the divine.

Michelangelo carved a rocky base for his figure; thus it appears perfectly natural standing on the ground among other ancient sculptures in Jacopo Galli's garden. With broken hand and broken penis (or was it purposely cut?), the figure readily fits among marbles more than a thousand years older than itself. Further, the use of the satyr to help support the tall, sinuous figure recalls a common device employed by ancient marble sculptors.

It is in the *Bacchus* that Michelangelo first made extensive use of the drill, a tool especially favored by the Romans. Evidence of this device is found in the carving of the grapes, the lion pelt, and along the edges of limbs such as the satyr's left leg. Like the Romans before him and Bernini after him, Michelangelo employed the drill to create illusionistic effects that were not possible with his favored tools, the claw, toothed, and flat chisels.

More ambitious and in many ways more successful than any antique sculpture, Michelangelo has successfully captured the deliciously ambiguous state of divine inebriation. For us it is a brilliant essay by a budding genius, but it is not impossible to imagine the presumed patron, Raffaele Riario, a high-ranking cardinal of the Curia, finding it distasteful and perhaps inappropriate.

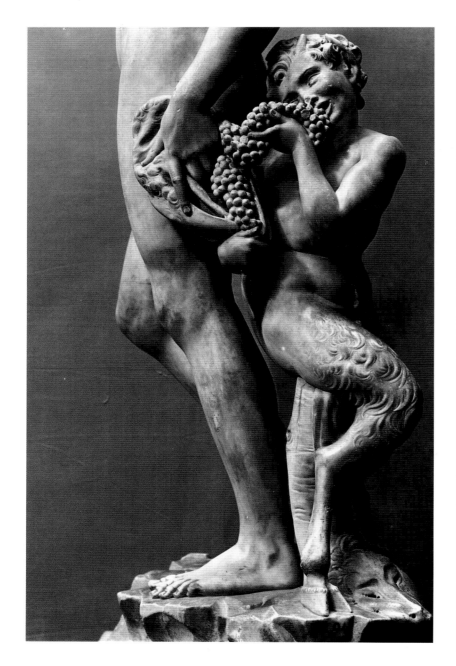

. . . Like the Romans before him and Bernini after him, Michelangelo employed the drill to create illusionistic effects that were not possible with his favored tools, the claw, toothed, and flat chisels. . . .

THE ROME PIETÀ

◆ ◆ ◆

1498–1499 ◆ MARBLE ◆ 69 INCHES HIGH ◆ ST. PETER'S, ROME

The *Rome Pietà* is surely the most universally loved work of Michelangelo. With good reason, we admire the miraculous transformation of a giant piece of marble into a larger than life-size two-figure sculpture group. But more than a work of art, the *Pietà* is a moving and deeply affecting portrayal of the Virgin and Christ, of a mother mourning the loss of her son.

The sculpture is currently exhibited in St. Peter's on a high pedestal and at a great distance, behind bullet-proof glass. The remote object appears precious, jewel-like, and diminutive, quite different from Michelangelo's intention and its original installation. The group was commissioned as a grave marker for the powerful French cardinal, Jean de Bilhères. Originally, the large sculpture most likely sat on a low plinth, with the cardinal's tomb slab in the floor directly before it. Shortly after completing the work, the rebuilding of Old St. Peter's resulted in the removal of the *Pietà*, and its subsequent placement in various locations within the new church.

The Virgin is seated on a low rocky outcrop which sprouts a small tree with grasping roots, at once a naturalistic detail, a support for the left foot of Christ, and also a symbolic suggestion of life after death. According to Michelangelo, true sculpture was a reductive process and precluded the addition of extra pieces of stone or the combination of different materials. He conceived of sculpture as ideally created from a single block of stone, suggesting that he treated the base as an integral part of his work rather

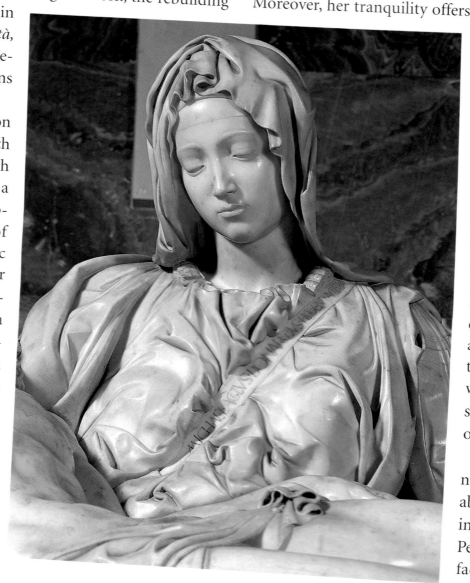

than as a separate appendage. In the *Pietà,* as in the immediately preceding sculpture of *Bacchus,* Michelangelo devoted considerable attention to the base of his figure, in both cases providing visual and iconographic justification for placing his sculptures low to the ground. The pedestal mentality of modern museums is a much later development. In the Renaissance, art and especially the three-dimensional medium of sculpture was intended to be accessible to the faithful, even to touch. The present inaccessibility of the work is in marked contrast to the manner it was probably treated upon completion.

We tend to focus on the Virgin, whose lovely visage is alternatively sad, serene, loving, longing. Her expression of outward calm suggests her inward serenity, for she knows, perhaps better than we, that this is the son of God. Moreover, her tranquility offers some assurance of Christ's eventual triumph over death.

But is it proper to intrude upon the sorrow of a grieving mother, to be curious about the expression of the mother of God? In fact, Mary's head is tilted noticeably downward; she avoids our look and internalizes her sorrow. Her quiet dignity and resignation are beautifully conveyed through her averted gaze and the gesture of her left hand which indicates that her son is the proper object of our contemplation.

If the *Pietà* is lit natural light falling from above, as it was in its original installation in Old Peter's, then the Virgin's face is cast in sh

. . . Her expression of outward calm suggests her inward serenity, for she knows, perhaps better than we, that this is the son of God. . . .

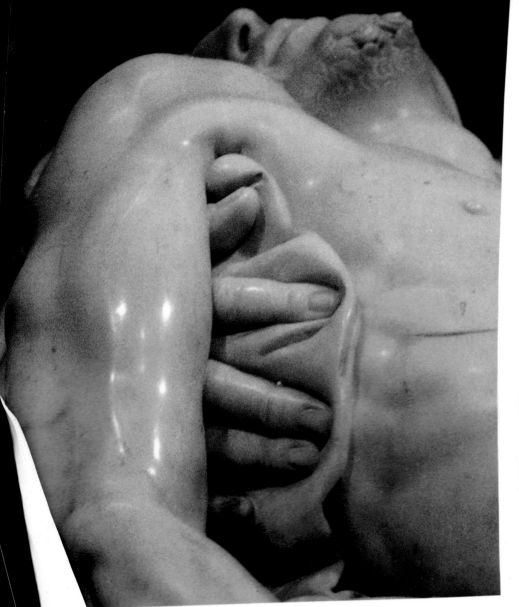
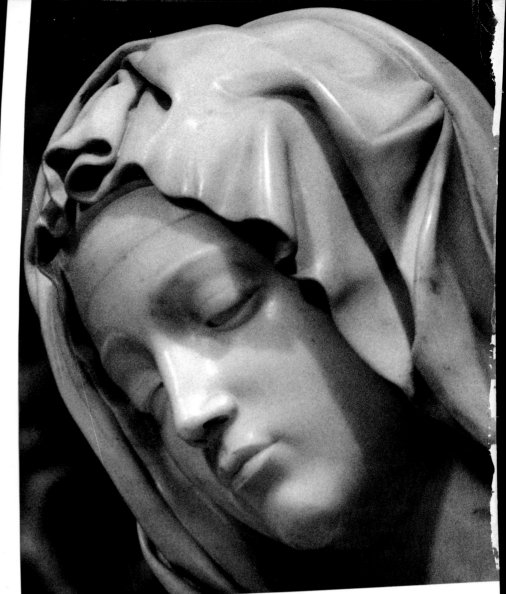

. . . Mary's head is tilted noticeably downward; she avoids our look and internalizes her sorrow. Her quiet dignity and resignation are beautifully conveyed through her averted gaze and the gesture of her left hand, which indicates that her son is the proper object of our contemplation. . . .

the body of her son is fully illuminated. The light
s the only remaining warmth in the dying flesh.
sents the body—our hope for salvation and our
e of eternal life. At the same time she encourages
ct on our own mortality, since her gaze and
gesture direct our attention first to Christ and
mortal remains buried before her. In such
Pietà would have been physically accessible
distant—human and divine. It is both
d decorous funerary monument and an
al image, a private memorial as well as a
.

ngelo has incised a fine line into the marble of
head. Seen from a distance and under the
or which Michelangelo carved the
ural light falling from above—this
s a faint line of shadow. By this aston-
device, Michelangelo has created the
transparent veil without actually carv-
ichelangelo decorously cover the head

of the Virgin, accomplishing in marble what is comparatively easy for a painter.

Michelangelo's biographers tell a delightful tale of how the artist signed his masterpiece on the diagonal sash across the Virgin's chest. The artist supposedly overheard two persons who, admiring the sculpture but uncertain of its author, attributed it to a certain Gobbo of Milan. Incensed, Michelangelo returned later that night and prominently carved (in translation): "Michelangelo Buonarroti Florentine made this." A closer inspection of how the band articulates the body underneath and affects the surrounding drapery forces us to recognize that the signature was not an afterthought but was conceived as an integral part of the sculpture from the beginning. It is likely that Michelangelo always intended to sign or decorate the sash in some manner. The story, nonetheless, is one that universally delights in the retelling, and however fictional, it also captures an important truth about this unique work: this was Michelangelo's boldest quest for fame and his graduation piece to public acclaim. Never again would Michelangelo sign a work.

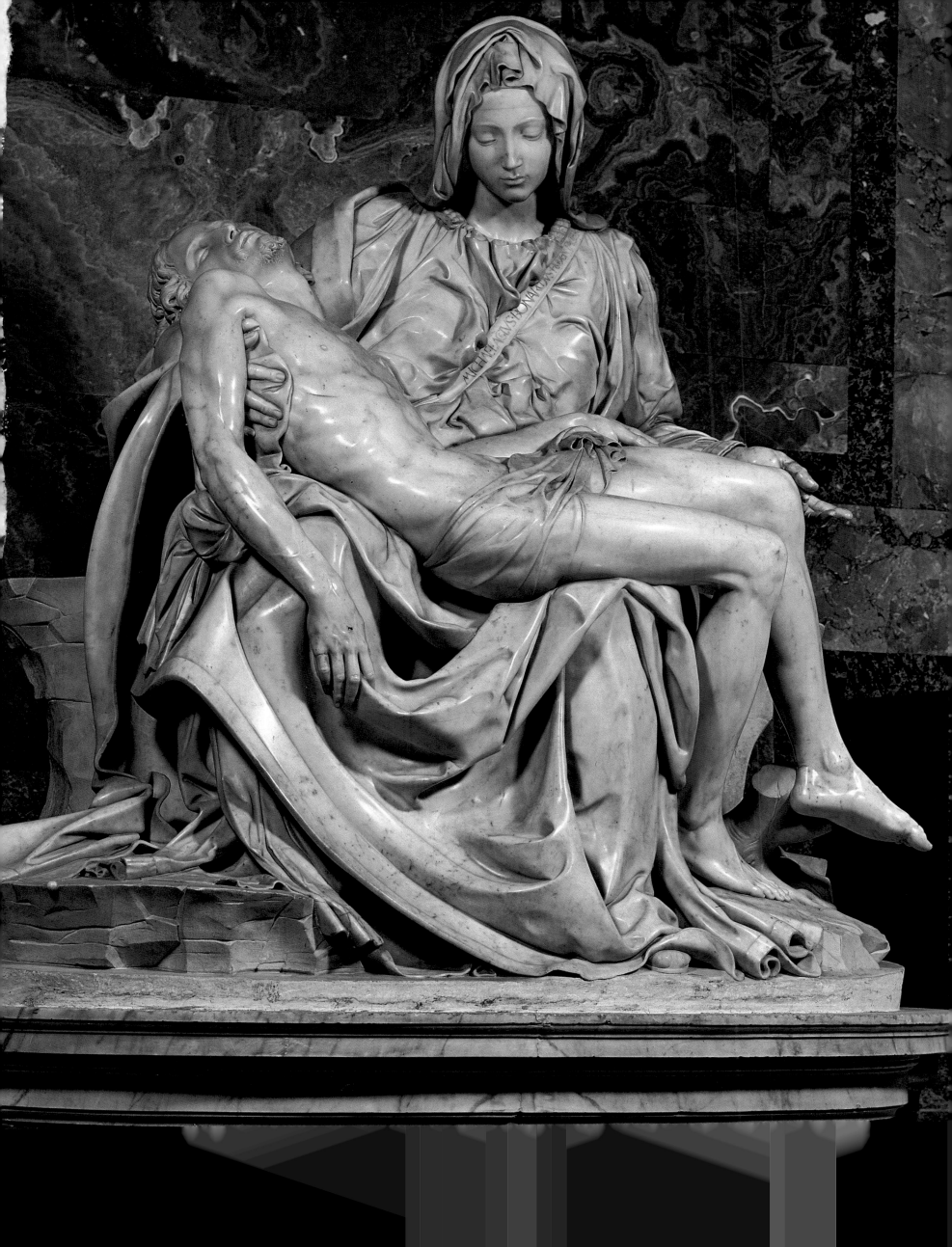

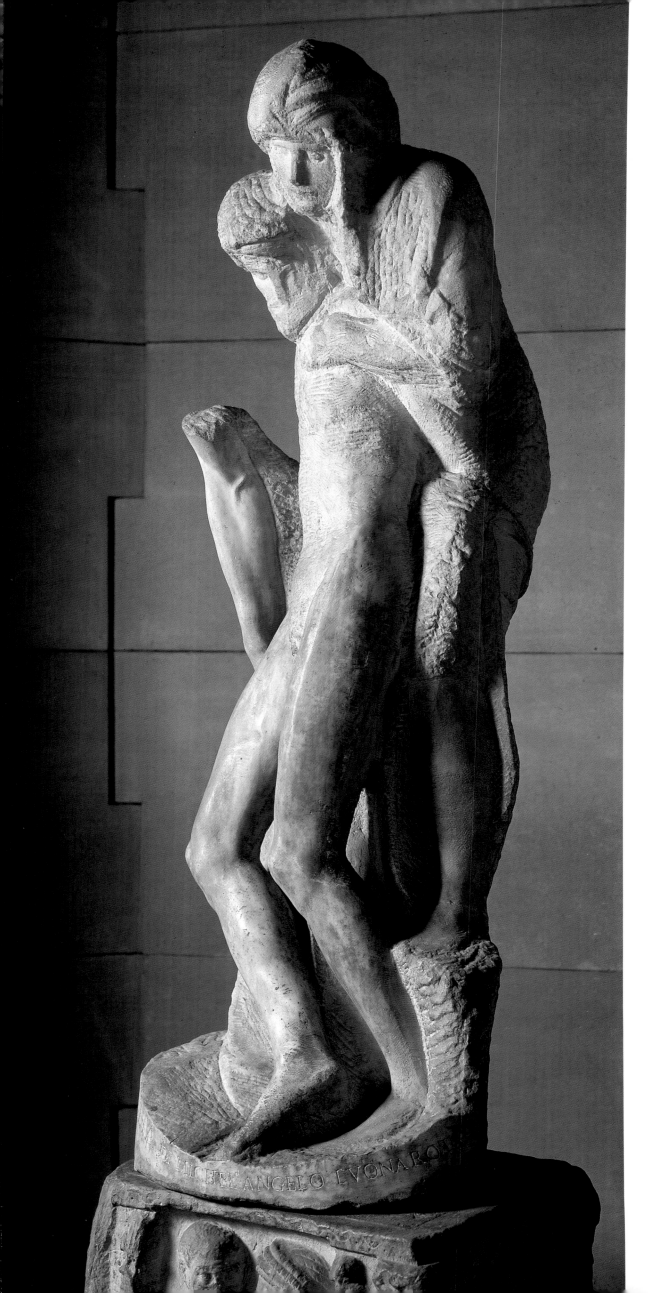

LEFT:
THE RONDANINI PIETÀ

FOLDOUT (FROM LEFT TO RIGHT):
THE PITTI TONDO
THE BRUGES MADONNA
MADONNA OF THE STAIRS
THE TADDEI TONDO

OPPOSITE:
THE FLORENTINE PIETÀ

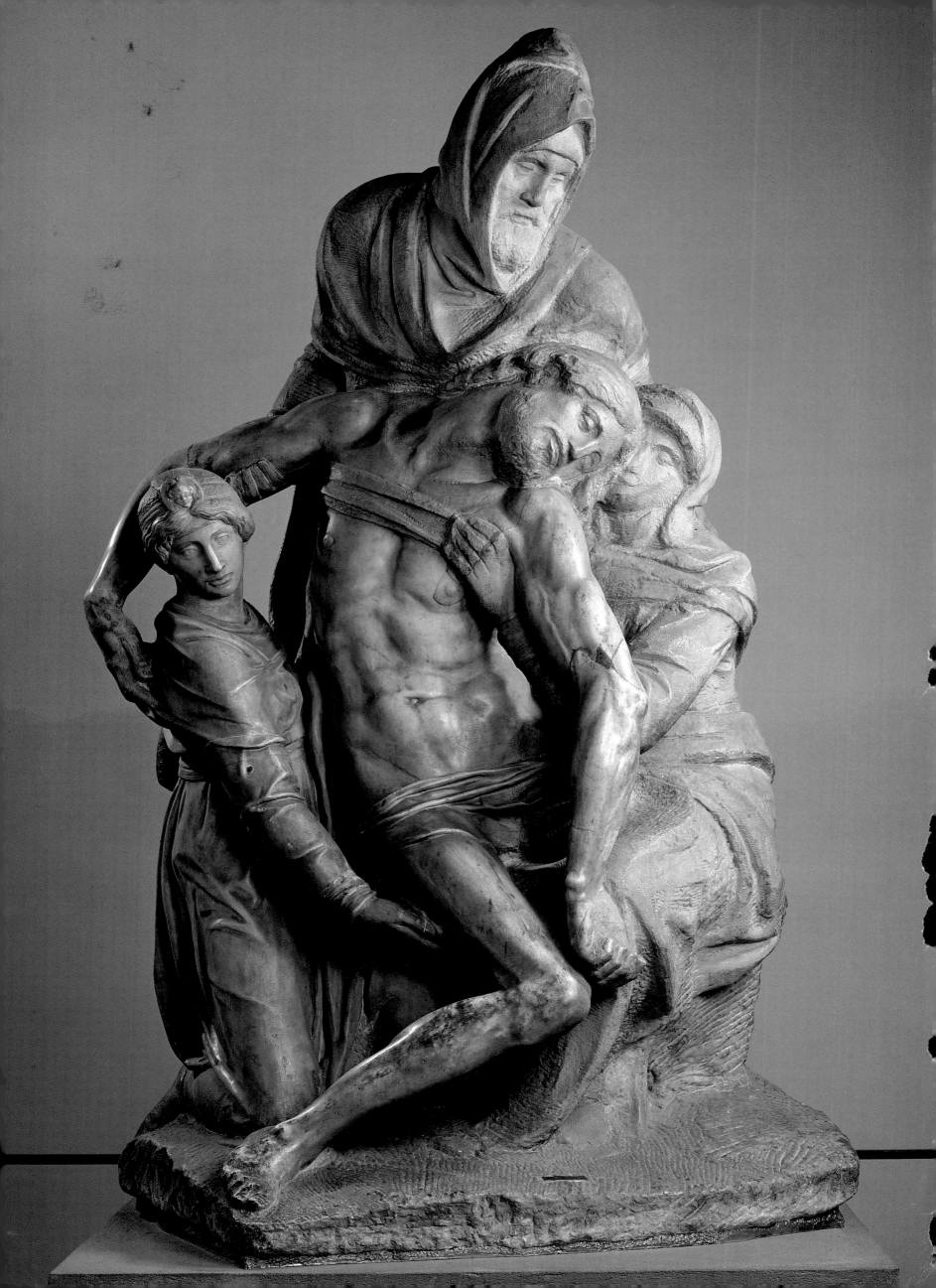

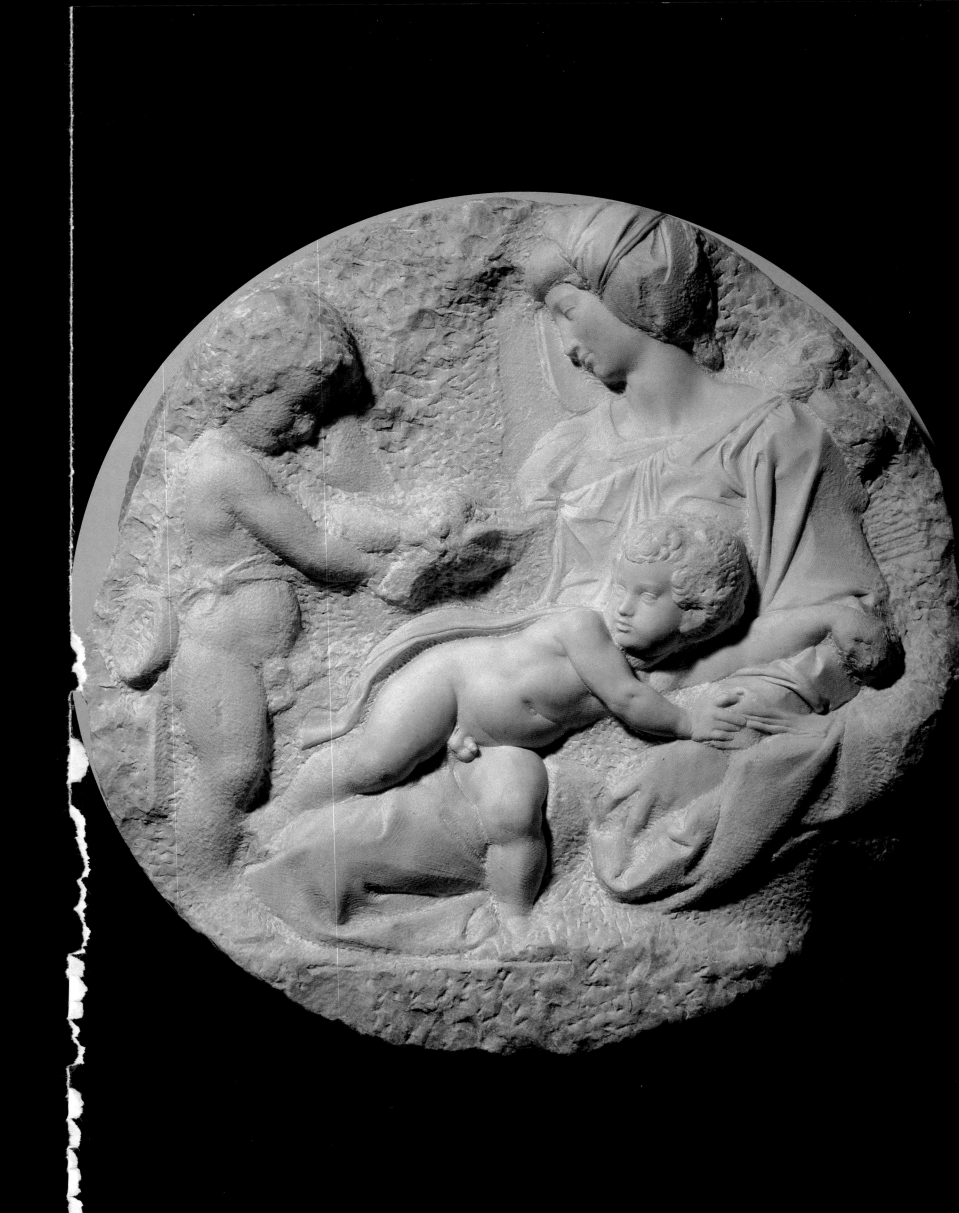

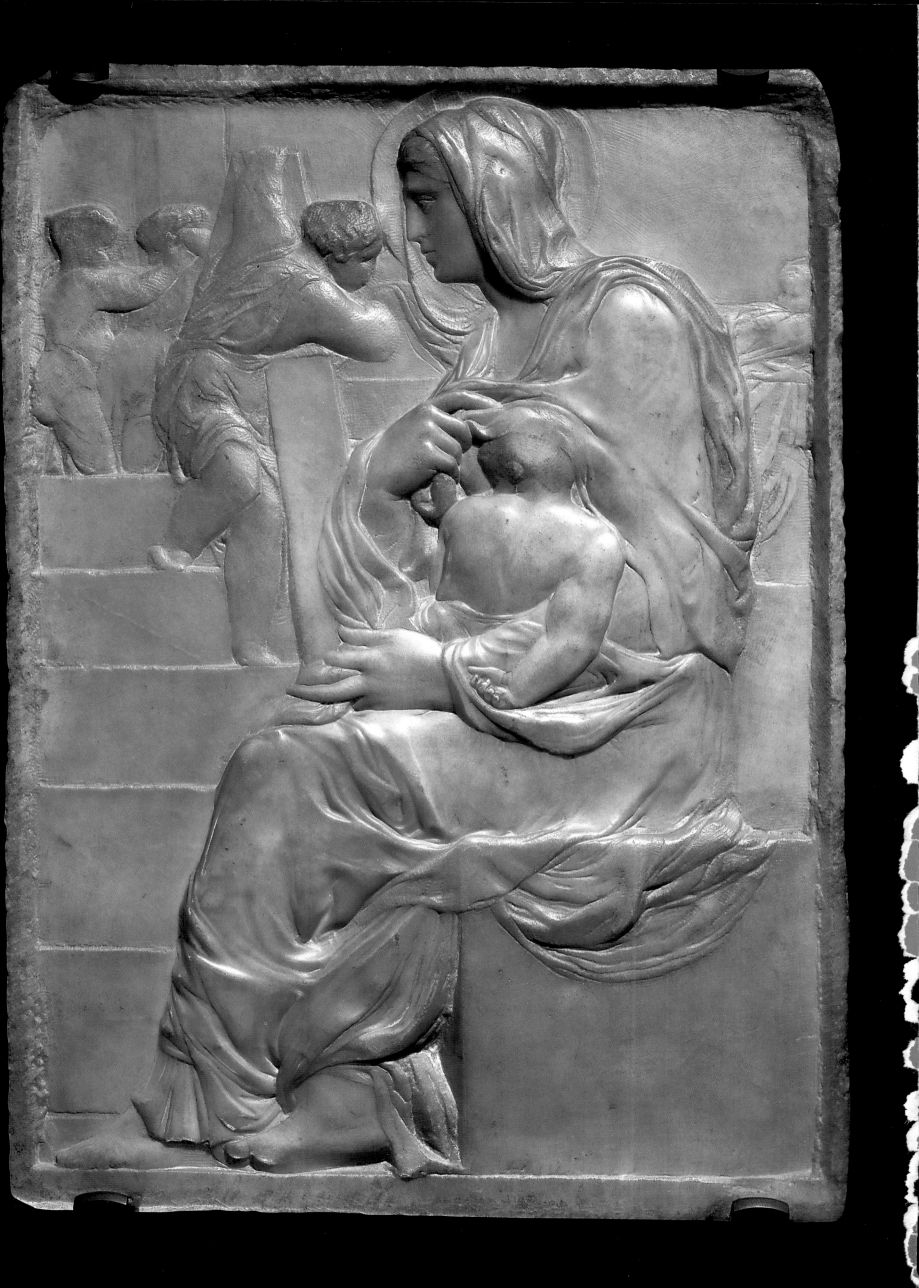

PICCOLOMINI ALTAR STATUES

◆ ◆ ◆

1501–1504 ◆ MARBLE ◆ EACH FIGURE: ABOUT 50 INCHES HIGH ◆ SIENA CATHEDRAL

The celebrity Michelangelo earned as a result of the *Pietà* did not, however, immediately result in further commissions. Given that the artist was without work and claimed to be living near poverty following its completion, Michelangelo must have welcomed a commission from Cardinal Francesco Piccolomini in 1501. Michelangelo was to carve fifteen statues to complete the Piccolomini altar in Siena Cathedral begun but left incomplete by Andrea Bregno. While the commission guaranteed employment for the next three years, Michelangelo was probably not wildly enthusiastic about the task. The commission was not unlike the work he had done in Bologna for the tomb of St. Dominic, that is, completing a large decorative ensemble envisioned and largely carried out by others.

The *Bacchus* and *Pietà* had established Michelangelo as an exceptionally talented marble figure carver. True enough, but few persons in Rome wanted or could afford a Hellenistic imitation or an expensive tomb memorial. Many Renaissance artists lived hand to mouth, accepting any commission available, no matter how humble.

Even though the Piccolomini commission was from an extremely important person (a cardinal and the future Pope Pius III), it proved singularly unsuited to Michelangelo's current temperament. He fulfilled barely a quarter of his contract, the first of many tasks that Michelangelo left incomplete.

Saints Peter and *Paul* are the most interesting figures carved by Michelangelo for the altar. As the two most important early Christian apostle-martyrs, Peter and Paul are often represented paired, and it seems likely that Michelangelo conceived them as such. *Paul* is animated and extroverted, *Peter* more introverted. Their postures mirror each other, the former standing with locked right leg looking right, the other disposed in just the opposite manner. They are both heavily draped and bearded. The thick swirl of locks is Michelangelo's signature hair style, seen again in the similarly expressive hair of *David* and *Moses*.

Both figures hold volumes in their left hands while their right arms hang at their sides, active rather than limp. The animation of limbs—even if unconscious and

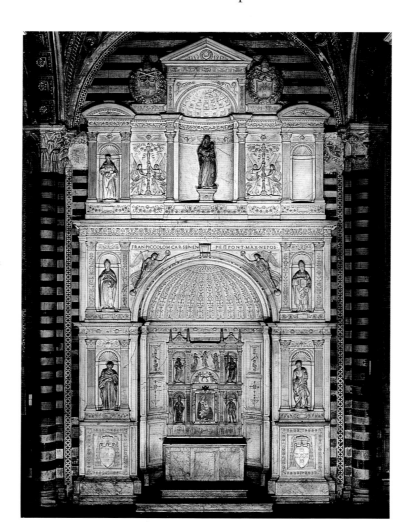

THE PICCOLOMINI ALTAR,
Siena Cathedral

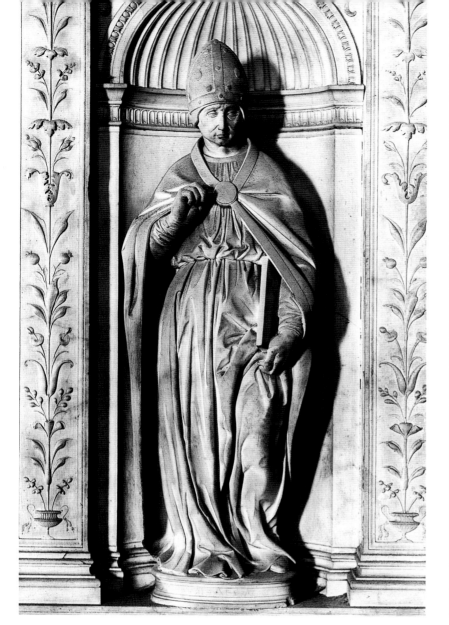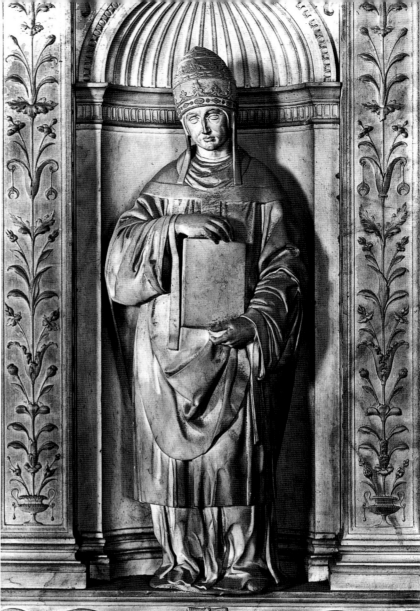

. . . SAINT GREGORY THE GREAT (LEFT) *and* SAINT PIUS (RIGHT) *are*
technically competent, especially in the carving of the lavish drapery . . .

unspecific —is another Michelangelo stylistic signature; we see it especially in the bunching of drapery folds in *Peter's* right hand.

The large volumes are presumably the saints' sacred writings. While perhaps appropriate to suggest the scholarly Paul, a book is less apt for the fisherman, Peter. These are not the saints' standard attributes: Paul usually wields a sword, and Peter normally holds the keys to heaven conferred upon him by Christ. Repeatedly, we will discover this characteristic in the art of Michelangelo: the artist was forever experimenting and pushing the boundaries of sacred meaning and conventional iconography. Michelangelo was no iconoclast; indeed, just the opposite. He pondered his faith so deeply that he was inevitably led to reinvent and reexpress the deepest meanings of faith, often in unconventional ways. The substitution of a standard symbolic attribute for another is merely the tiniest glimpse of this constant invention. It is also an indication that significance resides not primarily in attributes or symbols but in a totality of meaning discovered in context and most eloquently expressed through bodily expression and gesture. In this, the artist shared the ideas of his great rival,

Leonardo da Vinci, who stated that "the soul is revealed through gesture." The substitution of the saints' expected attributes, and the endowing of his figures with unconscious gestures, expressive hair, facial features, and animated drapery are examples of some of the artistic devices that Michelangelo would continue to employ to give his figures life and meaning.

Having said that, it comes as something of a disappointment to regard the wooden figures of *Saints Pius* and *Gregory the Great*. They are technically competent, especially in the carving of the lavish drapery—one of the first of those expressive devices that Michelangelo totally mastered. We even see, for example, *St. Pius's* left hand unconsciously gripping and bunching the drapery beneath the book that he presses against his left side. These are interesting details, but the overall effect of these figures is far from inspired. We are reminded that carving sculpture is more work than inspiration, and that there is no reason to believe that Michelangelo took special interest in everything he made. We permit second-rate quality, even failure, in every artist except Michelangelo. Here, we are confronted by an artist fulfilling an obligation, and not much more.

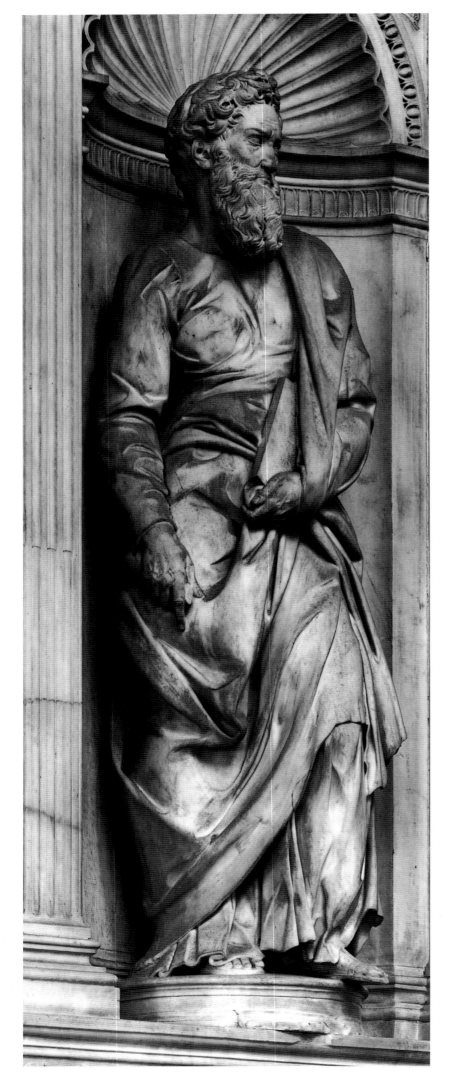

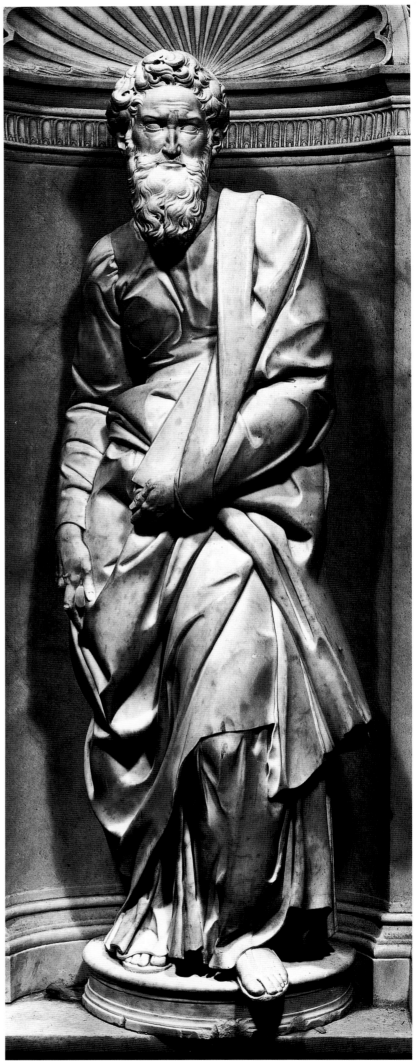

. . . Peter (OPPOSITE) and Paul (ABOVE) are often represented paired,
and it seems likely that Michelangelo conceived them as such.

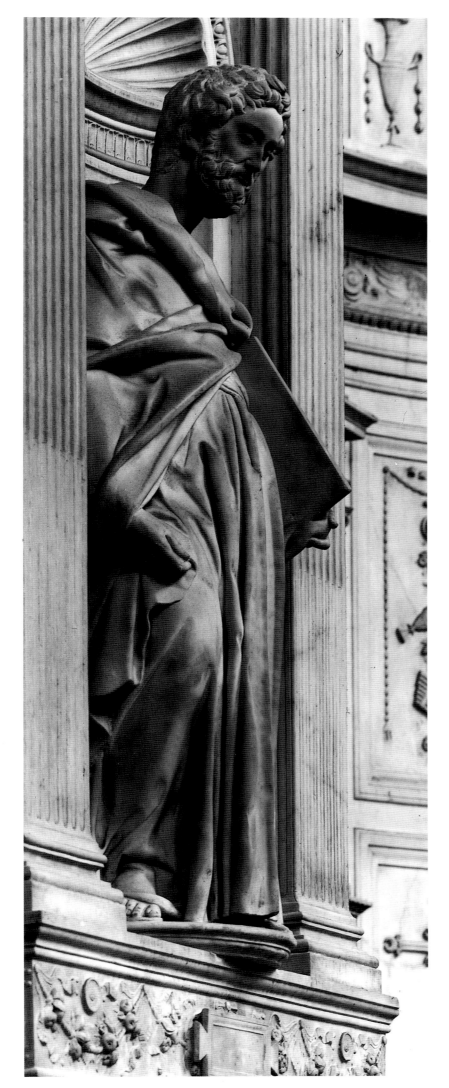
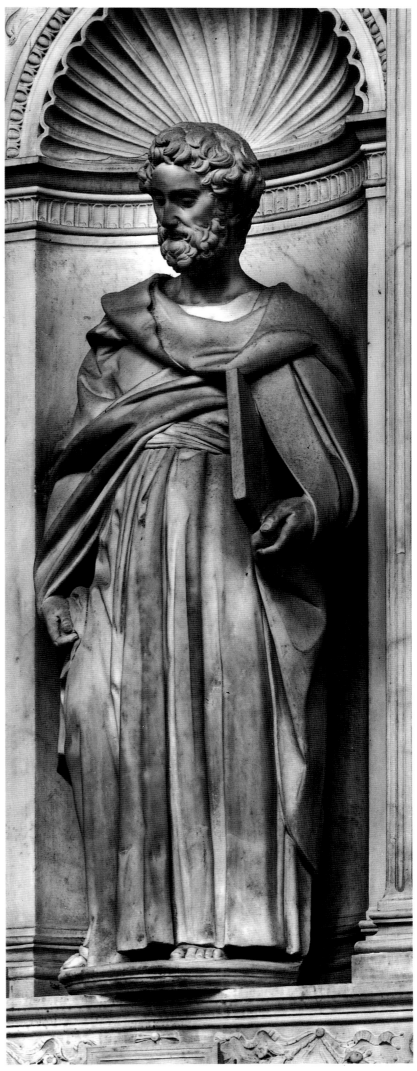

. . . PAUL *is animated and extroverted,* PETER *more*
introverted. Their postures mirror each other. . . .

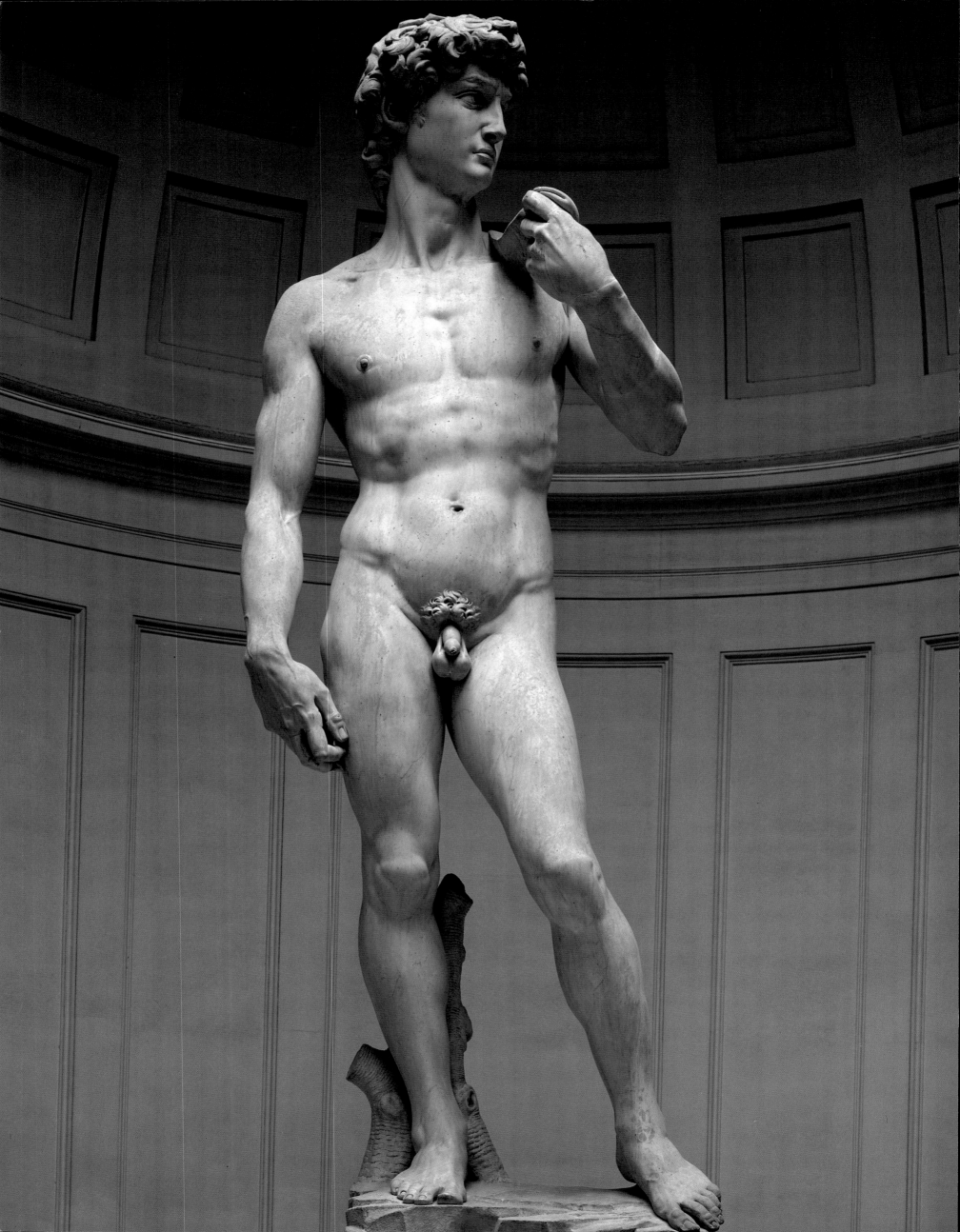

DAVID

◆ ◆ ◆

1501–1504 ◆ MARBLE ◆ 16 FEET 10½ INCHES HIGH ◆ ACCADEMIA MUSEUM, FLORENCE

"What a piece of work is man," declared Shakespeare. It seems he could have been speaking of Michelangelo's *David.* Here, the heroic is both imagined and realized before our eyes. Here, Michelangelo has mastered the ancient ideal of male nudity in action or immanent action, physical and psychological. Here, Michelangelo has employed colossal size, reserved in classical times for the representation of the gods but here bestowed upon a young shepherd boy from the Bible. Here, Michelangelo has achieved the nearest modern equivalent to the Parthenon sculptures of Phideas. When we speak of the Renaissance as the "rebirth" of classical antiquity, no work demonstrates that better than Michelangelo's *David.*

Fresh from a five-year sojourn in Rome, Michelangelo was evidently fired by the example of classical antiquity. Yet nothing in Rome or in his earlier experience fully prepared him to invent the *David.* Like the *Bacchus* and the *Rome Pietà,* it is a unique achievement in the history of art, no matter how many sources and influences we may cite.

Once again, Michelangelo carved a spectacular sculpture demonstrating to the utmost his skill and imagination. He thereby achieved in Florence what the *Bacchus* and *Pietà* had done for him in Rome, giving him everlasting fame as a marble sculptor. And unlike those earlier works, the *David* virtually guaranteed that he would never again be without work. Patrons flocked to Michelangelo, and in these early years he scarcely refused or disappointed any of them. For more than a decade following the *David,* Michelangelo remained enormously busy, and his output was truly prodigious.

The *David* is variously described as between fourteen and more than sixteen feet tall, reminding us of the difficulty of actually measuring a colossal statue, but also indicating that at some point, such measurements are not the proper yardstick of what we are trying to describe. *David* stands with his weight shifted to his right leg, which supports the upper body. The advanced and bent left leg and slightly depressed left foot suggest the immanence of movement. The massive torso bends away from the direction of this suggested action and *David's* piercing glance. Photographs, but not real-life experience, permit us to look directly into the youth's fierce and exaggerated features. The unruly mop of hair, furrowed brow, deeply set eyes,

long, straight nose, and prominent lips are all features that lend intensity to the face.

The head is disproportionately large, for expressive effect and to correct for the natural diminution when seeing the figure from a distance. The thick neck and prominently bulging muscles of neck, torso, and arms increase the sense of taught preparedness, of a figure coiled and ready to unleash unimaginable energy. It is the same achievement, but more subtly accomplished, as seen in Myron's famous *Discus Thrower (Discobolus)* from classical antiquity. These are figures whose potentiality for action belies the fact that they are forever unmoving. To animate inert stone with such a vibrant expectancy is truly a remarkable achievement.

David's left arm is raised and grasps one end of the unfolded sling strap. The disproportionately large right hand cups a stone and the other end of the sling. Art historians talk about "closed" and "open" profiles, front and dominant views, but like the *Bacchus,* this figure forces us to circle it. The front view is immensely satisfying especially since it is artfully framed in its current setting in the Accademia Museum in Florence. But equally impressive are views from the sides and along various diagonals. From such angles, instead of an artfully composed body, the sense of immanent motion is greatly enhanced. And only from the rear do we see the sling strap and realize how distant temporally we are from the confrontation with Goliath.

Rather illogically for the young boy who was too small to wear Saul's armor, Michelangelo has carved *David* as a giant. Equally surprising might be his stark nudity, although this establishes the figure's ancestry in classical art and suggests David's rejection of Saul's armor. The sculpture is true not to the narrow parameters of historical narrative but to the spirit of David, who was a giant-slayer, a future king, and whose faith and courage were of such gigantic proportions. For Florentines, David was an exemplar of strength and courage in the face of adversity and a hero with whom they closely identified. Immediately upon its completion, Michelangelo's colossus became a centerpiece of civic pride and was given a place of honor on the main piazza guarding the entrance to the government palace.

Like only a few great monuments, the *David* is a symbol of a culture; it paradoxically stands for the achievements of

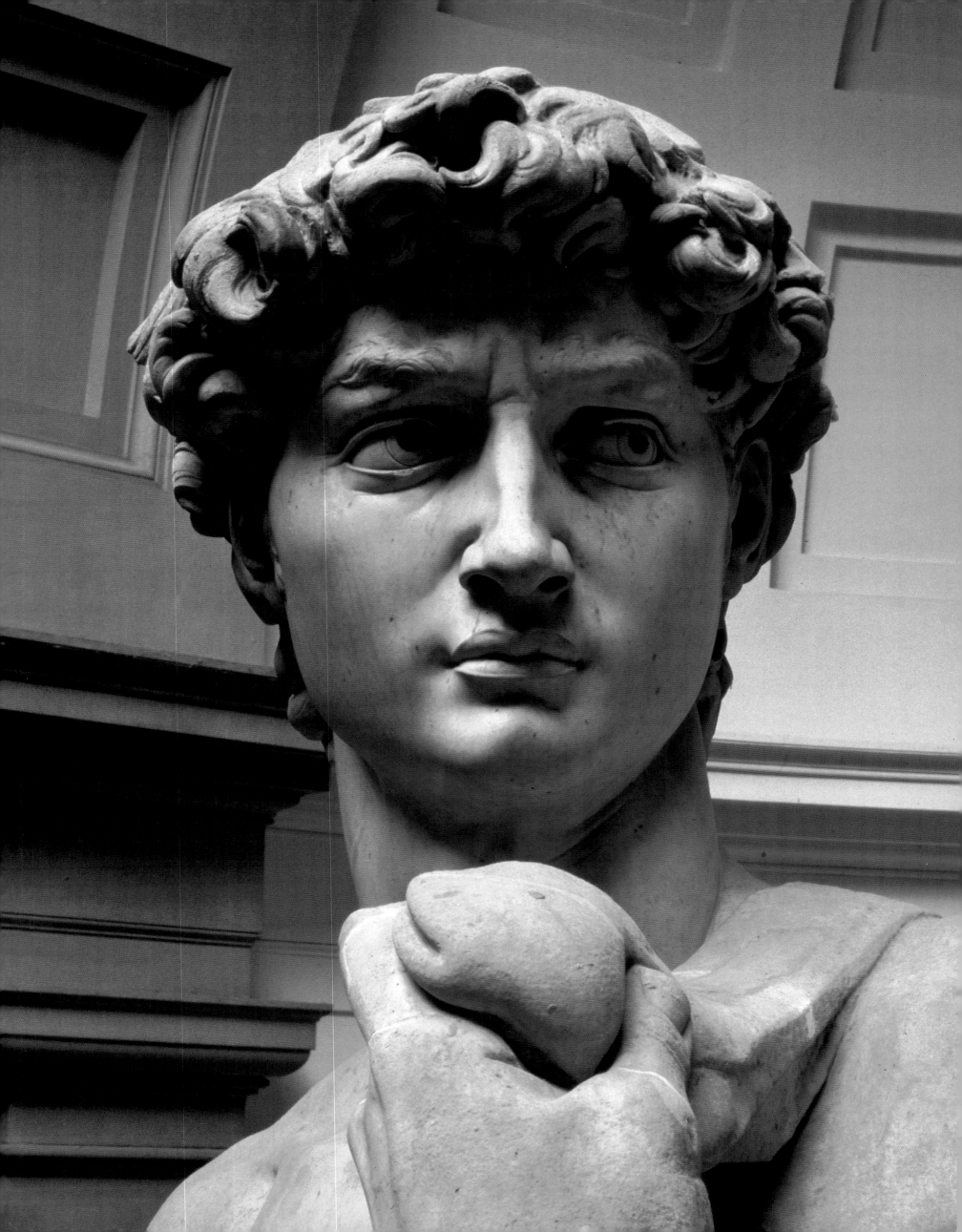

an entire era even as we recognize that it is a unique creation of one remarkable individual. Giorgio Vasari, attempting to capture in words the monumental grandeur of the *David*, wrote: "Without any doubt this figure has put in the shade every other statue, ancient or modern, Greek or Roman . . . To be sure, anyone who has seen Michelangelo's *David* has no need to see anything else by any other sculptor, living or dead."

OPPOSITE:

. . . *The unruly mop of hair, furrowed brow, deeply set eyes, long straight nose, and prominent lips are all features that lend intensity to the face . . .*

RIGHT:

. . . DAVID *stands with his weight shifted to his right leg. The advanced and bent left leg and slightly depressed left foot suggest the immanence of movement. . . .*

PAGE 64:

. . . DAVID*'s left arm is raised and grasps one end of the unfolded sling strap. . . .*

PAGE 65:

. . . *The massive torso bends away from the direction of this suggested action and* DAVID*'s piercing glance. . . .*

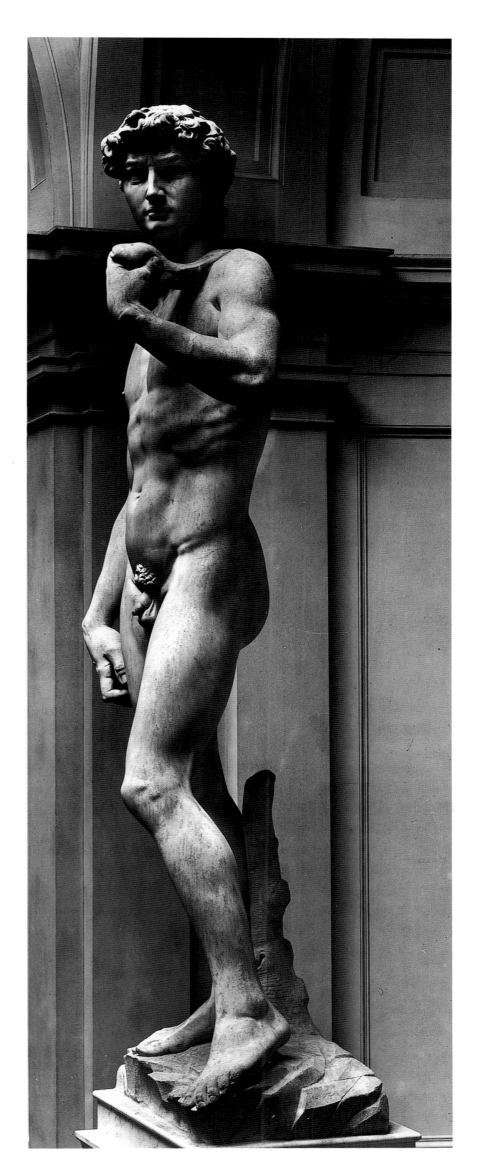

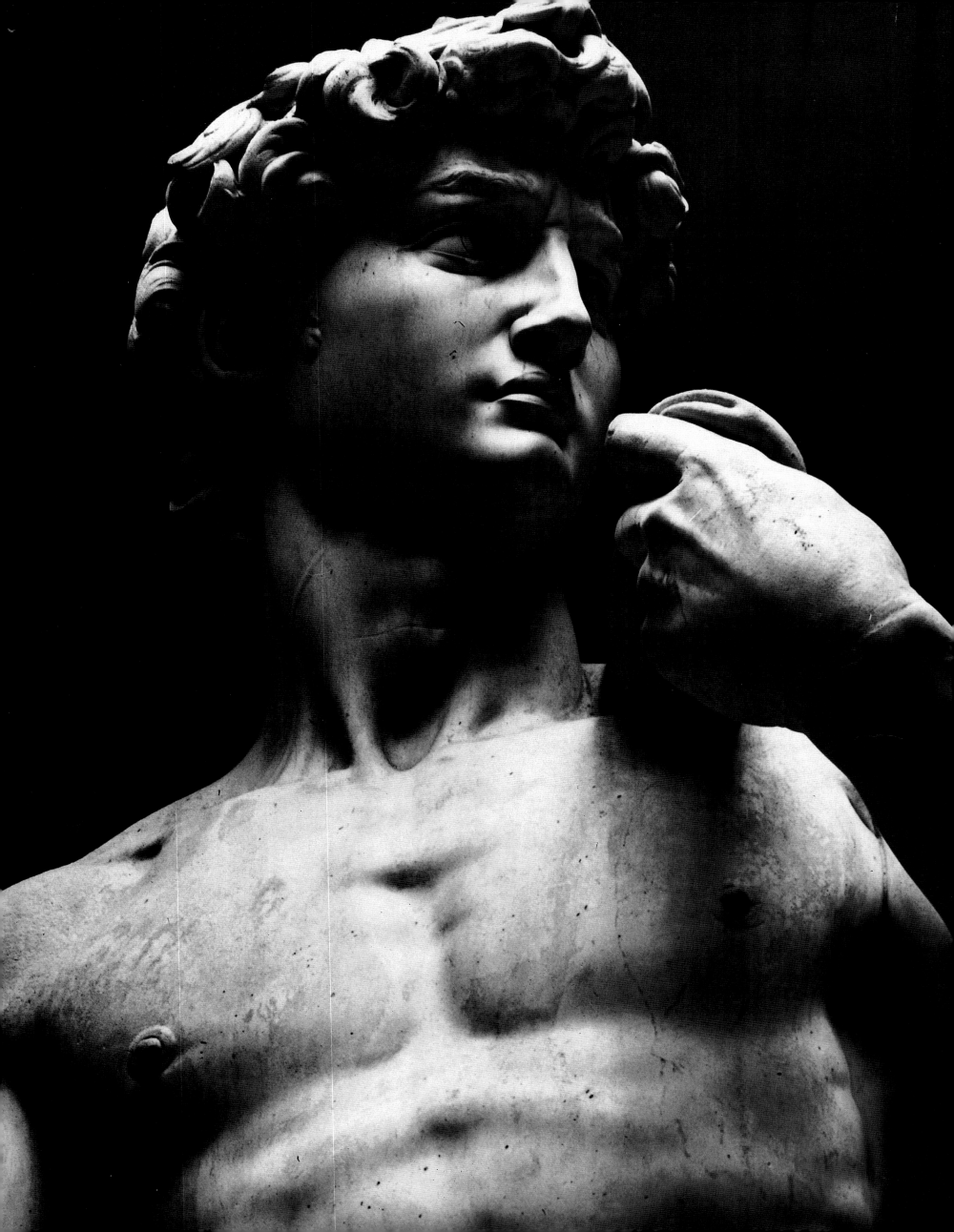

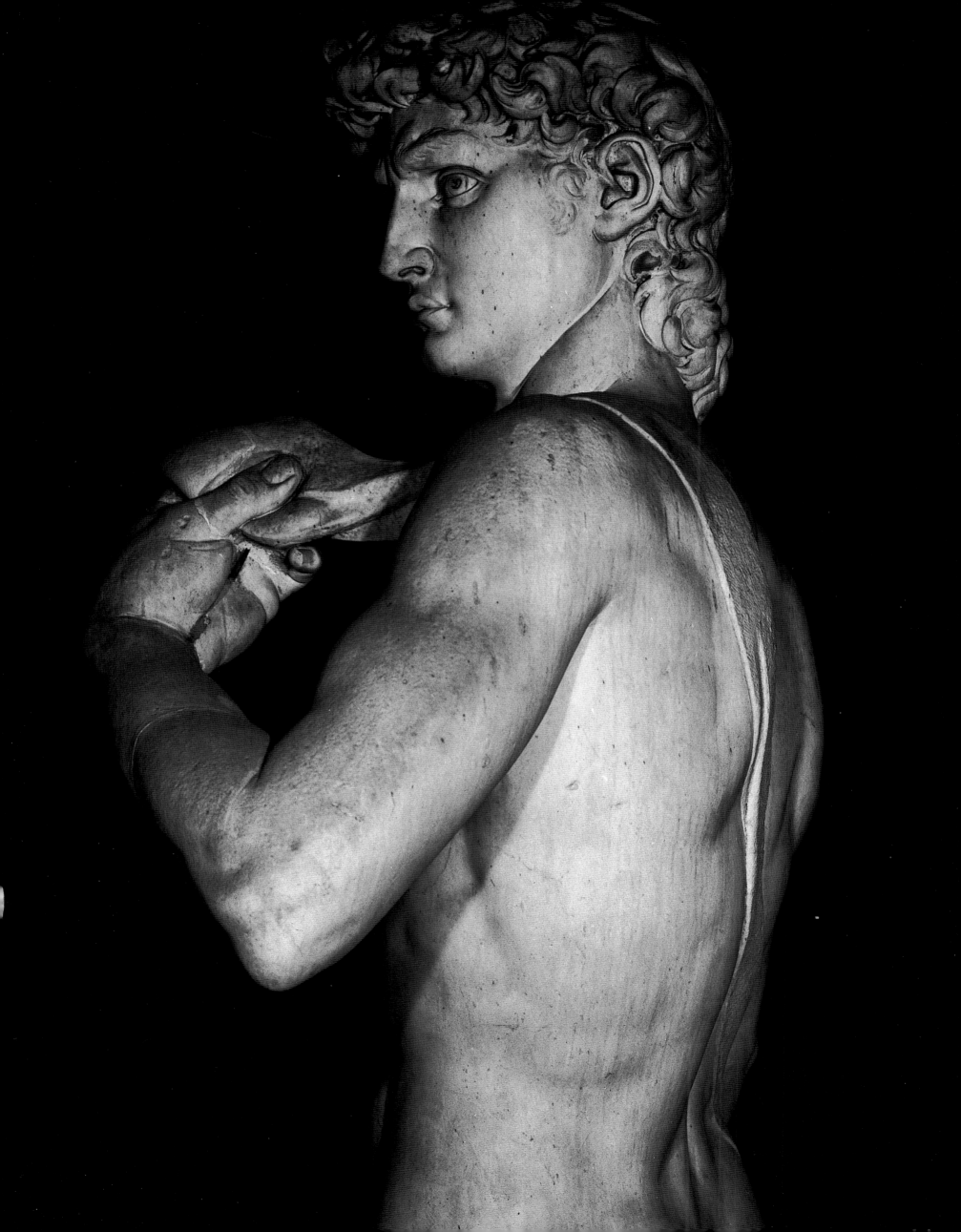

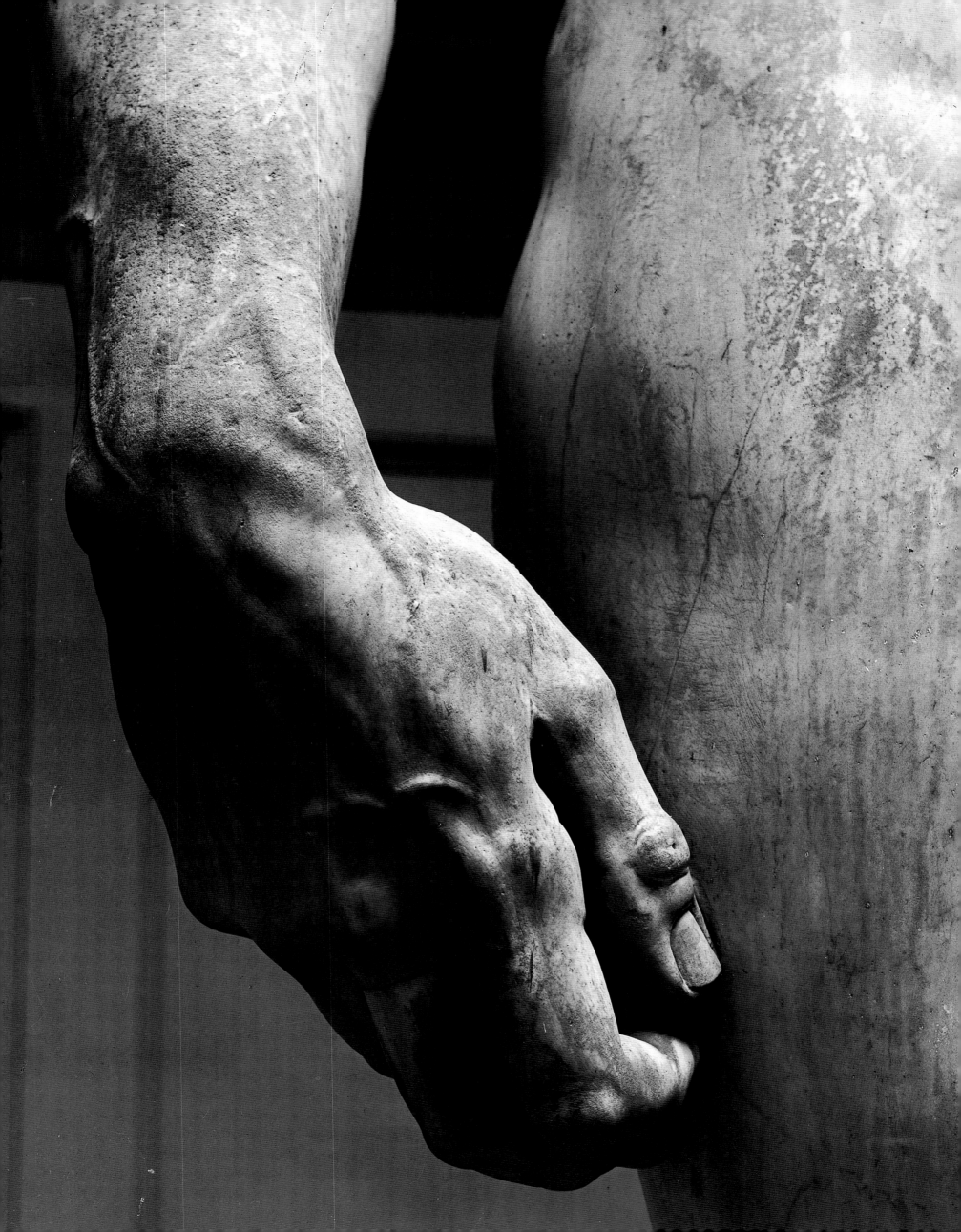

OPPOSITE:

. . . The disproportionately large right hand cups a stone and the other end of the sling. . . .

RIGHT:

. . . only from the rear, do we see the sling strap and realize how distant temporally we are from the confrontation with Goliath. . . .

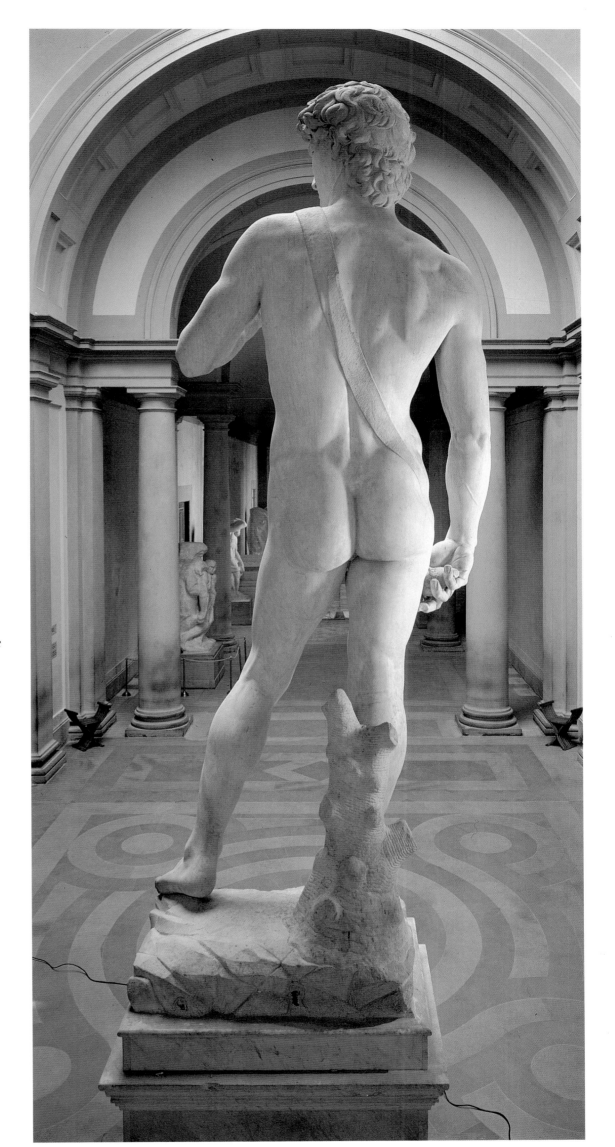

THE BRUGES MADONNA

◆ ◆ ◆

C. 1504 ◆ MARBLE ◆ 50¼ INCHES HIGH ◆ NOTRE-DAME, BRUGES

Such tenderness and sympathy here towards mother and child by an artist who never married and scarcely knew his mother. Psychoanalysts might tell us that the artist's interest in the subject of mother and child is an act of recovery, a means of perpetuating a mother's love that was lost too young. It is, however, more than an act of yearning or healing, for the sculpture is a stunningly beautiful work of art with a universal message.

The *Bruges Madonna,* so named because it was commissioned by a group of merchants from that northern city, is one of the lesser known works of Michelangelo. Being completely unfamiliar with the sculpture, Michelangelo's biographer, Ascanio Condivi, declared that it was made of bronze, a mistake repeated by Giorgio Vasari.

The marble is as pure and translucent as that miraculous material from which Michelangelo carved the *Rome Pietà.* Once again, the artist has entirely transformed a resistent material into malleable flesh and large, supple folds of drapery. The naked Christ child, prescient beyond his indeterminate age, partly stands, partly sits between the legs of his mother. He is enfolded in her statuesque form, as though still one with her flesh. She is as stable as the rock on which she sits, offering an immobile counterpart to the tentative movements of her child. The child's left arm is draped across the raised left leg of his mother, and his right hand is entwined with hers in a complicated gesture unexpected in sculpture and perhaps without precedent. This is one of those invented, unconscious gestures that so often characterize Michelangelo's figures and help to illuminate an inner state of being. In the slippage of those tiny fingers we discover the simultaneous reluctance yet need for the child to relinquish his mother's protection. The activity of those entwined fingers contrasts with

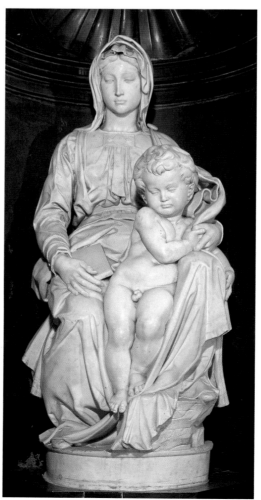

the Madonna's right hand, which inattentively secures a volume from falling. The book domesticizes the scene—the Virgin's reading has been interrupted by her child; at the same time, that volume suggests the holy scripture wherein is foreshadowed the painful history that begins to unfold before us.

The child has already begun his first step, yet his upper body reveals his reluctance to depart the maternal embrace. His left leg barely supports his weight, and in nearly slipping from its precarious support it pulls at the folds of the Madonna's robes. Thus is created a long sweeping arc of drapery that rises from the lower left all the way to the bunched folds by the child's head. That inexplicable drapery flourish, in contrasting blacks and whites, solids and voids, punctuates the tremulous emotions expressed in faces and gestures.

Christ's right leg is suspended in space; its implied destination is the altar just below. In that one step is the passage from childhood to manhood, from man to God, from gift to sacrifice. The child looks towards his destiny, and his eyelids begin to slide close.

The broad, chubby features of the child contrast with the thin, drawn face of his mother, with eyes, nostrils, and lips given the sweeping, sinuous lines of Chinese calligraphy. The cloth draped over her head accentuates the attenuated proportions of her face, and the bunched folds at the top form a sort of diadem. Once again, Michelangelo has incised a fine line across her forehead, implying rather than actually carving a transparent veil.

As in the *Rome Pietà,* Michelangelo seduces us with the sheer beauty of his creation, and yet our immersion in aesthetic pleasure makes all the more poignant the gradual realization of the work's profoundly moving spiritual implications.

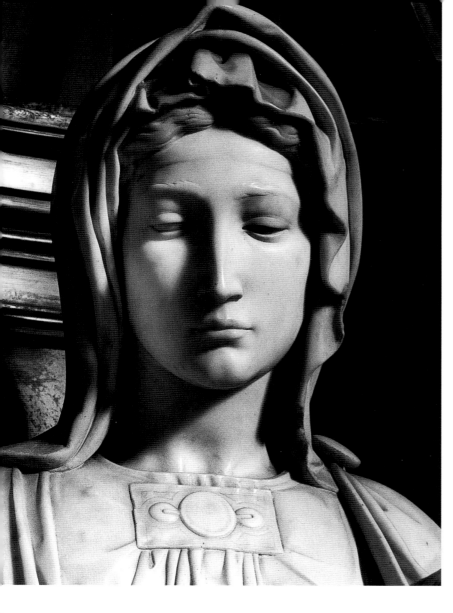

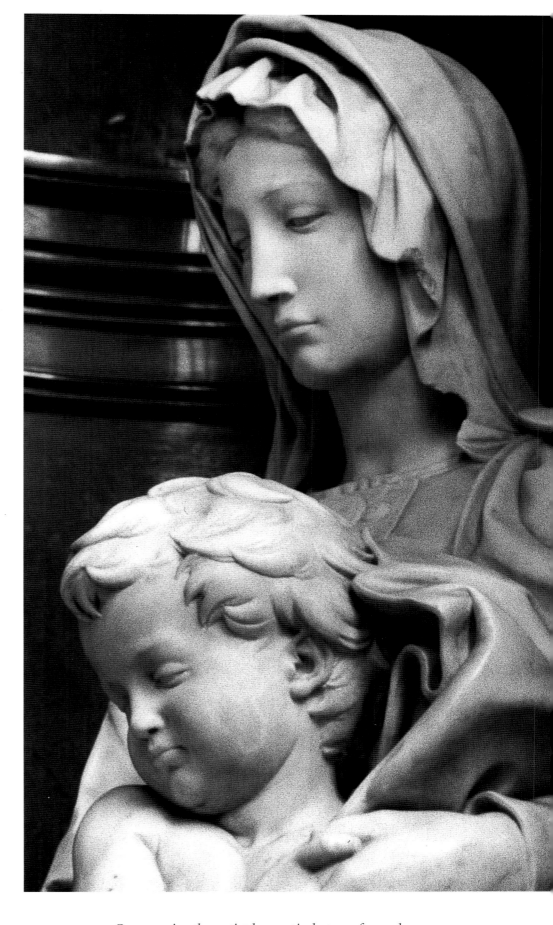

. . . Once again, the artist has entirely transformed a
resistent material into malleable flesh and large, supple
folds of drapery. . . .

THE TADDEI TONDO

◆ ◆ ◆

C. 1504 ◆ MARBLE ◆ DIAMETER: 46¼ INCHES ◆ ROYAL ACADEMY, LONDON

How does one display a marble tondo? How is a round composition such as this fastened to the wall? The relief that appears diminutive in photographs is actually a heavy and unwieldy work of art—awkward to move and difficult to display. Like many of Michelangelo's early works, such fundamental questions remain unanswered, and frequently unasked.

In the *Taddei Tondo,* so named for the Florentine family that commissioned it from Michelangelo, the artist has returned to the medium with which he began, relief carving. Merely to carve a circular composition from a marble block is a challenging task: note the irregular outline, the flattening of the Virgin's turban, and the incision in the lower right, perhaps where a marble flaw was removed. Within the difficult circular shape, Michelangelo has created a complex three-figure composition. The infant Christ appears startled by the object held by the child Saint John at the left. Conventional iconography would lead us to identify the object presented as a goldfinch, a bird that supposedly fed on thorns and thus served to symbolically prefigure the Passion of Christ. The pose of the Christ child is actually more artful than probable, and it has been suggested,

with good reason, that this is an example of Michelangelo influenced by his rival and contemporary, Leonardo da Vinci. It is just like Michelangelo to take the idea of the older master and translate it into the three-dimensional medium of sculpture.

Also similar to Leonardo is Michelangelo's willingness to explore the boundary between suggestion and definition, finish and unfinish (*non-finito* in Italian). Many passages reveal the marks of the sculptor's chisels, as though proud of his handiwork and unwilling to polish them away. Thus, the infant John is still part of the rough stone and the Virgin incompletely emerges from a hazy background. The stretched pose of the infant Christ is accentuated and extended by a flutter of the Virgin's robe—a lyrical line that flows across the entire composition. But is the work finished? Would a Florentine businessman, who was also a patron of an exquisitely wrought painting by Raphael, be satisfied with this object? Evidently so. To the best of our knowledge, the relief was delivered and admired, first by Raphael, who made a spirited drawing from it. Thus the relief is testament of Michelangelo's rapidly growing stature and perhaps evidence of a growing taste for the *non-finito.*

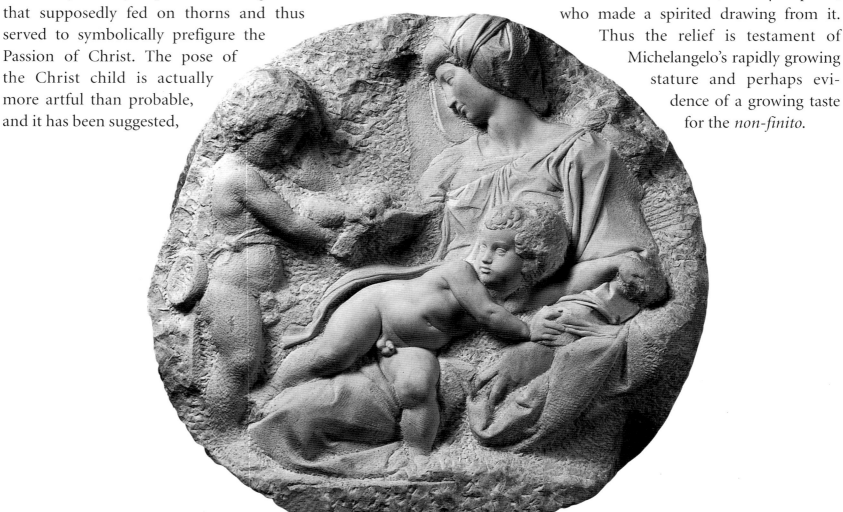

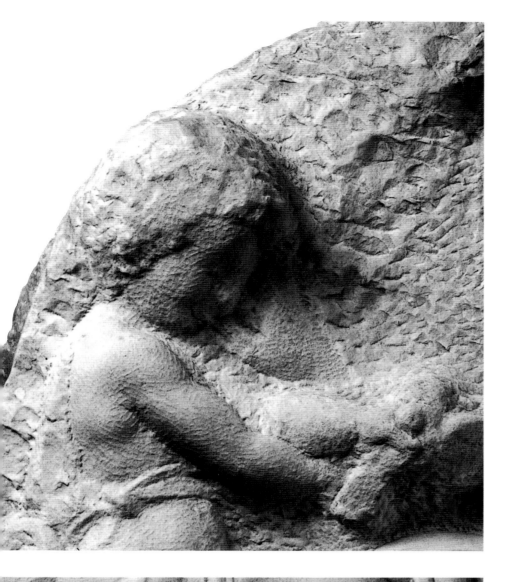

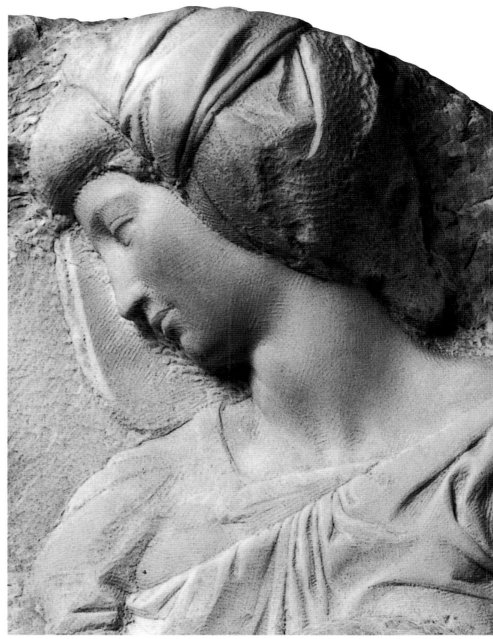

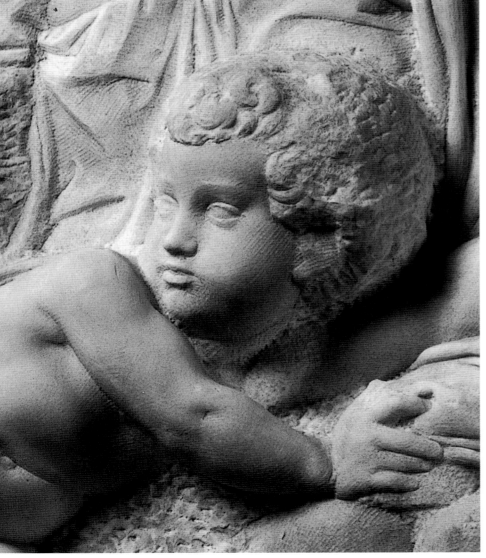

ABOVE:

. . . the Virgin incompletely emerges
from a hazy background. . . .

TOP LEFT:

. . . the infant John is still part of
the rough stone . . .

LEFT:

. . . The infant Christ appears
startled by the object held by the
child Saint John . . .

OPPOSITE:

. . . The stretched pose of the infant
Christ is accentuated and extended by
a flutter of the Virgin's robe . . .

SCULPTURE

THE PITTI TONDO

C. 1504 ◆ MARBLE ◆ DIAMETER: 46¼ INCHES ◆ BARGELLO MUSEUM, FLORENCE

The exploration of the aesthetic effects of the unfinished is carried to an even more sophisticated level in the *Pitti Tondo*, again named after the family that commissioned it. Unlike the *Taddei Tondo*, however, the *Pitti* appears to be a finished work in which Michelangelo quite consciously employed the *non-finito* as an expressive device.

Although everywhere revealing the hand of the artist still at work, it is difficult to imagine what more needs to be done to "complete" this relief. Michelangelo offers us a catalog of sculptor's marks, from the slightly polished face of the Virgin to the rough grooves of the pointed chisel suggesting an atmospheric background. Even the obviously "unfinished" passages—such as those parallel grooves at the left, or the various textures of the block on which the Madonna is seated—appear self-conscious. Seeking a means to create three-dimensionality in low relief sculpture, Michelangelo employed a variety of marks and textures to suggest a spatial ambiance far greater than the physical limits of the marble tondo. At the same time, there is little effort to disguise the medium and the means. Thus the sculptor's marks are at once illusionistic and self-referential.

When asked by the humanist scholar Benedetto Varchi about the relative merits of painting versus sculpture, Michelangelo responded: "In my opinion painting should be considered excellent in proportion as it approaches the effect of relief, while relief should be considered bad in proportion as it approaches the effect of painting." Michelangelo's *non-finito* ensures that we will never mistake this for the slick surface and illusionistic tricks of painting.

Precisely the same compositional elements are present in the *Pitti* as in the *Taddei Tondo*: the seated Virgin and Christ child, and the infant Saint John. The Madonna more substantially dominates the space, so much so that John, just glimpsed over her right shoulder, is left little room at the composition's margin. The Madonna is literally the intermediary between the two infants: she embraces her own child, and her over-the-shoulder glance suggests cognizance of John's presence.

The classical features of the Madonna are now familiar, similar to that of the *Rome Pietà* and the *Bruges Madonna*. High in the center of the composition, the Virgin's lovely face, framed by her hair, a cloth veil, and a seraphic diadem, is the first and the final focus of the tondo. Despite the obvious fact that Michelangelo has taken pains to carve a raised lip that serves to enframe the whole composition, the head of this blessed being rises above and beyond the physical confines of the frame.

As though unwilling to find fault in

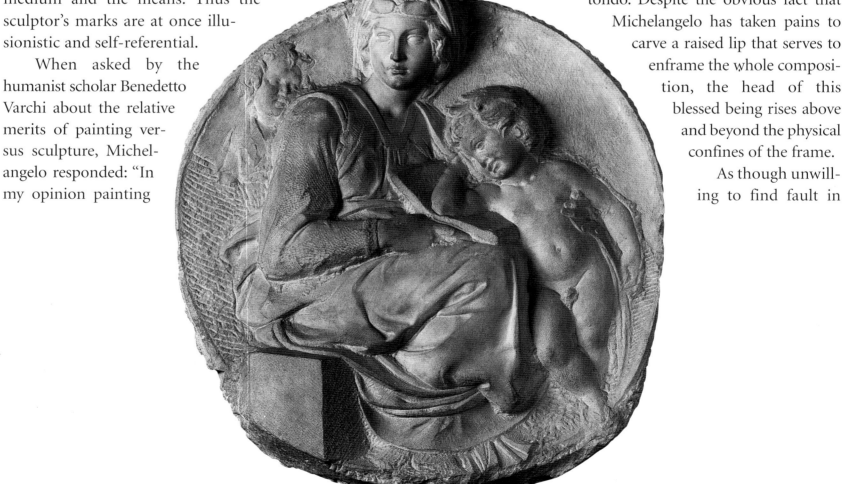

. . . Christ looks meditatively down towards us. . . .

Michelangelo, few observers note the squat and awkward proportions of the Madonna. Did Michelangelo merely run out of room, solving the problem in two unsatisfactory ways, by bursting forth at the top and stunting the Virgin's growth at the bottom? I think Michelangelo, taking a lesson from Donatello, recognized that the tondo would be placed high on a wall, at least above the dado level, and he adjusted his forms for these specific circumstances. Seen *di sotto in su,* that is, foreshortened from below, the Madonna's proportions do not seem at all strange, but rather quite natural, like the queen of heaven enthroned on a perfect cube. Moreover, from this vantage, the Virgin is inscribed in the field of the tondo, which stands in for the absent halo of the Holy Mother.

Christ looks meditatively down towards us. The fleeting smile and the almost casual, unthinking elbow resting on the open book beguile us into accepting this domesticized version of a religious subject. Yet these are sacred figures with a destiny, and that book is holy scripture. We are temporarily relieved of the obligation to meditate on the future, but that delay makes a return to contemplation all the more poignant.

ABOVE:

*. . . John, just glimpsed over her right shoulder, is left
little room . . .*

OPPOSITE:

*. . . The Madonna is literally the intermediary between
the two infants: she embraces her own child, and
her over-the-shoulder glance suggests cognizance of
John's presence. . . .*

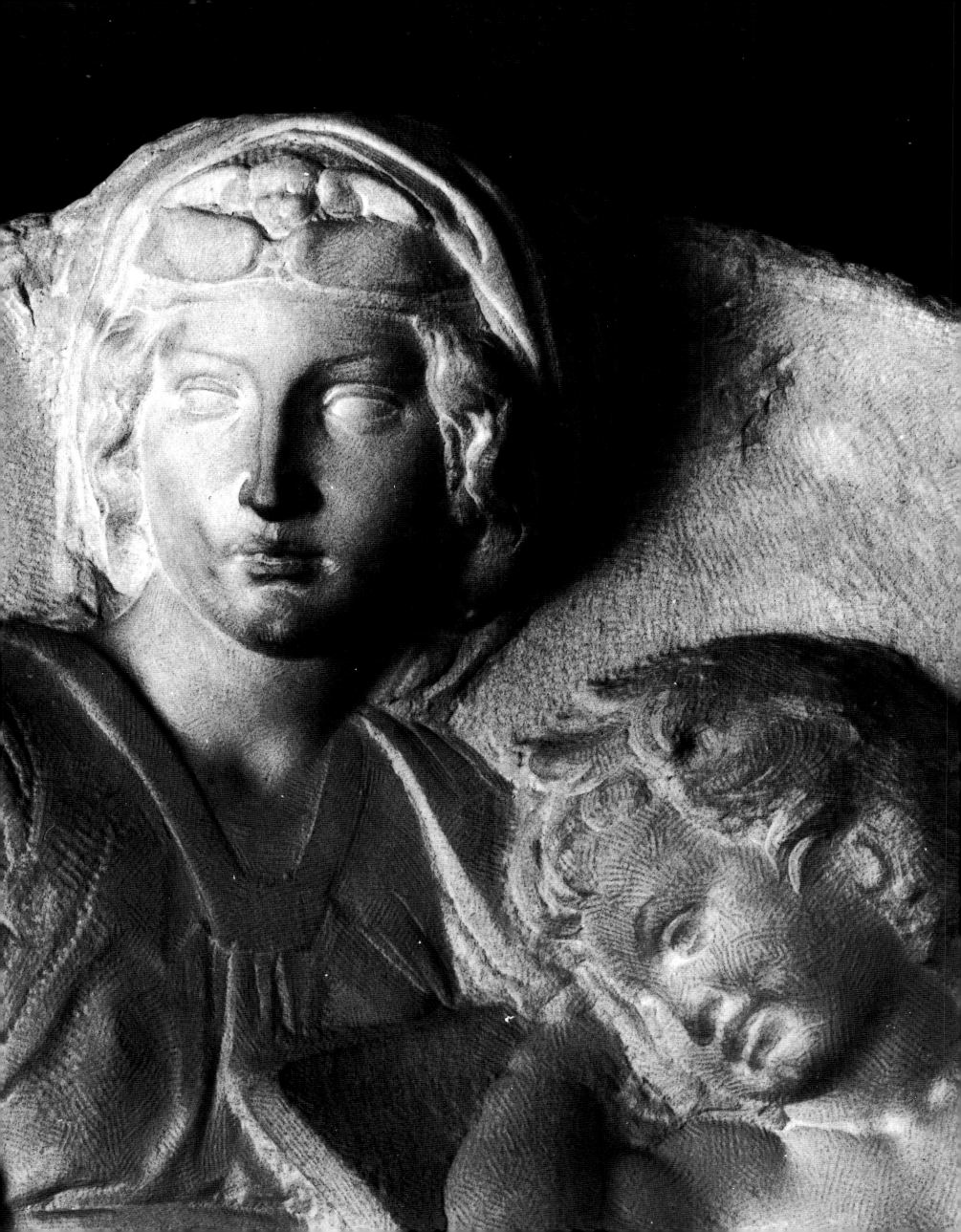

ST. MATTHEW

◆ ◆ ◆

C. 1505–1506 ◆ MARBLE ◆ 8 FEET 11 INCHES HIGH ◆ ACCADEMIA MUSEUM, FLORENCE

The commission from the Florence cathedral to carve twelve larger than life-size marble apostles was an opportunity to transform entirely the course of modern sculpture—to single-handedly create a High Renaissance. This commission would test Michelangelo's powers of invention to the extreme: how to express through gesture, body language, and a minimum of attributes, the spiritual strength and individual characters of Christ's twelve apostles. Michelangelo made a trip to the marble quarries of Carrara, selected his blocks, and had at least five shipped to Florence. Only the *St. Matthew* was ever begun.

The upper torso of *St. Matthew* faces forward but the head and left leg are turned sharply to the saint's right. The head, although it is only roughly sketched in stone, reveals Michelangelo experimenting with a gesture that we have already seen in a milder form in the *Pitti Tondo,* and will see again in some of the Prophets and Sibyls on the ceiling of the Sistine Chapel. The turned head and glance cast over the right shoulder suggest that the saint directs his attention to something that is beyond what is represented in the work itself.

From Carolingian times, the unlettered St. Matthew, who was aided in writing his gospel by an angel, was often shown with the divine messenger whispering in his ear and guiding his hand in writing. In the turn of the saint's head, and the unusual torsion of the body, Michelangelo has discovered a bodily language that eloquently describes a state of divine inspiration, as though he were in the midst of receiving the word of God. Matthew is not, as in so many paintings, represented actually writing his gospel, but rather he holds his book (or tablet) high in his left hand. Along the same diagonal as the saint's glance to the upper left, the volume is a *tabula rasa,* a blank slate, held up to receive the word of God. Being illiterate, Matthew's right hand hangs limply at his side. One can imagine the unfinished hand holding a quill, the useless instrument emphasizing that Matthew's gospel was inscribed not by human agency but through divine intervention. Even in its unfinished state, Michelangelo's invented language of bodily gesture permits us to glimpse the ineffable, to see the unseeable. This is how, in the medium of stone, Michelangelo is able to describe matters of faith.

*. . . The head, although only roughly sketched in stone,
reveals Michelangelo experimenting with a gesture . . .*

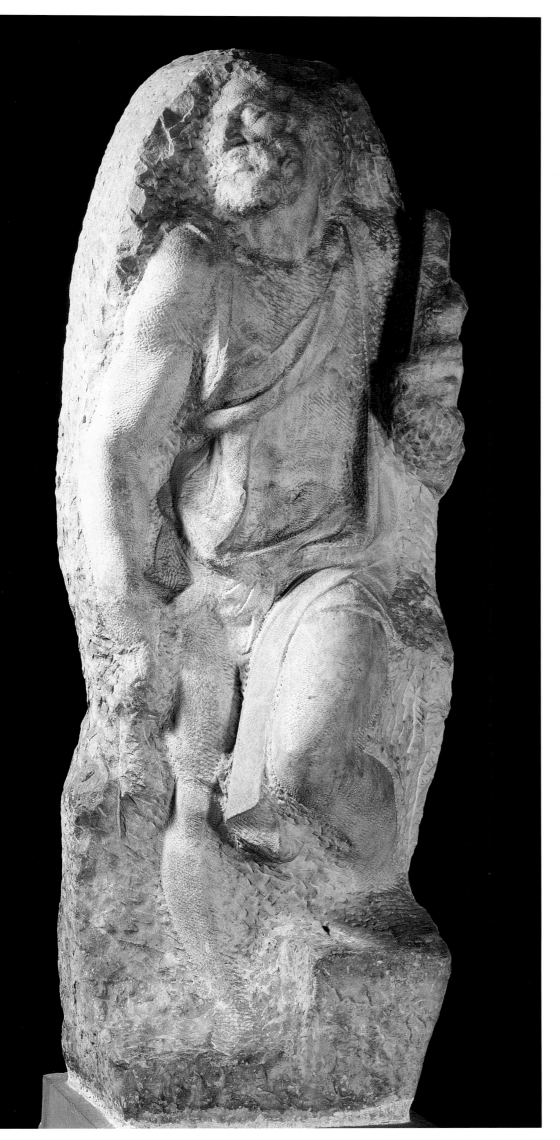

. . . he holds his book (or tablet)
 high in his left hand. . . .

THE TOMB OF POPE JULIUS II

◆ ◆ ◆

1505–1545 ◆ SAN PIETRO IN VINCOLI, ROME

The commission that proved to be Michelangelo's albatross is equally so for the artist's biographer. It all began auspiciously in 1505, when Julius promised to pay Michelangelo the astronomical sum of 10,000 ducats (enough to build a small church) to carve a huge, 23 x 36-foot tomb decorated with some forty marble statues. Forty years later, the tomb, much reduced but still grand, was finally installed in San Pietro in Vincoli, the titular church of Pope Julius. During this drawn-out history, Michelangelo designed at least six different monuments, signed at least four contracts, and changed his mind many more times. This is a classic example of a Renaissance work of art whose meaning and iconography evolved with the slow realization of the project. But despite the many changes in design and program the tomb still accomplishes its original purpose: to celebrate the deceased by means of a monumental architectural ensemble decorated with marble figures.

In the course of forty years, Michelangelo carved many sculptures for the tomb, although in the end only three figures by the artist—the *Moses, Rachel,* and *Leah*—adorn the tomb we see today. The *Rebellious* and *Dying Slaves* were given to Michelangelo's friend, Roberto Strozzi, and sent to France (now in the Louvre Museum in Paris), and the unfinished *Accademia Slaves* are displayed in the museum of that name in Florence.

In relating the tortuous history of the Julius tomb, Condivi aptly termed it a "tragedy." Surely he was reflecting some of Michelangelo's frustrations, and he was lamenting, as most persons have since, that the tomb is only a torso of its original conception. But to imagine what the tomb might have been is to blind ourselves to what it is. Michelangelo devoted enormous energy to create one of the grandest and most noble funerary ensembles of the Renaissance, and perhaps of all time.

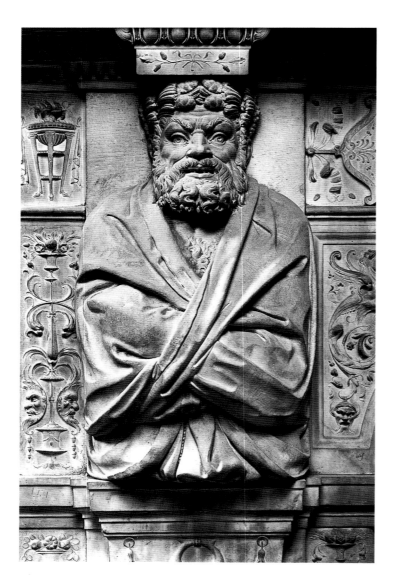

LEFT:
Relief figure to the right of MOSES

OPPOSITE:

UPPER TIER:

LEFT:	CENTER:	RIGHT:
	MADONNA AND CHILD	
	Domenico Fancelli	
SIBYL	EFFIGY OF POPE JULIUS II	PROPHET
Raffaello da Montelupo	*Tomaso Boscoli*	*Raffaello da Montelupo*

MIDDLE TIER:
Four relief figures

BOTTOM:

LEFT:	CENTER:	RIGHT:
RACHEL	MOSES	LEAH

(All three bottom figures by Michelangelo)

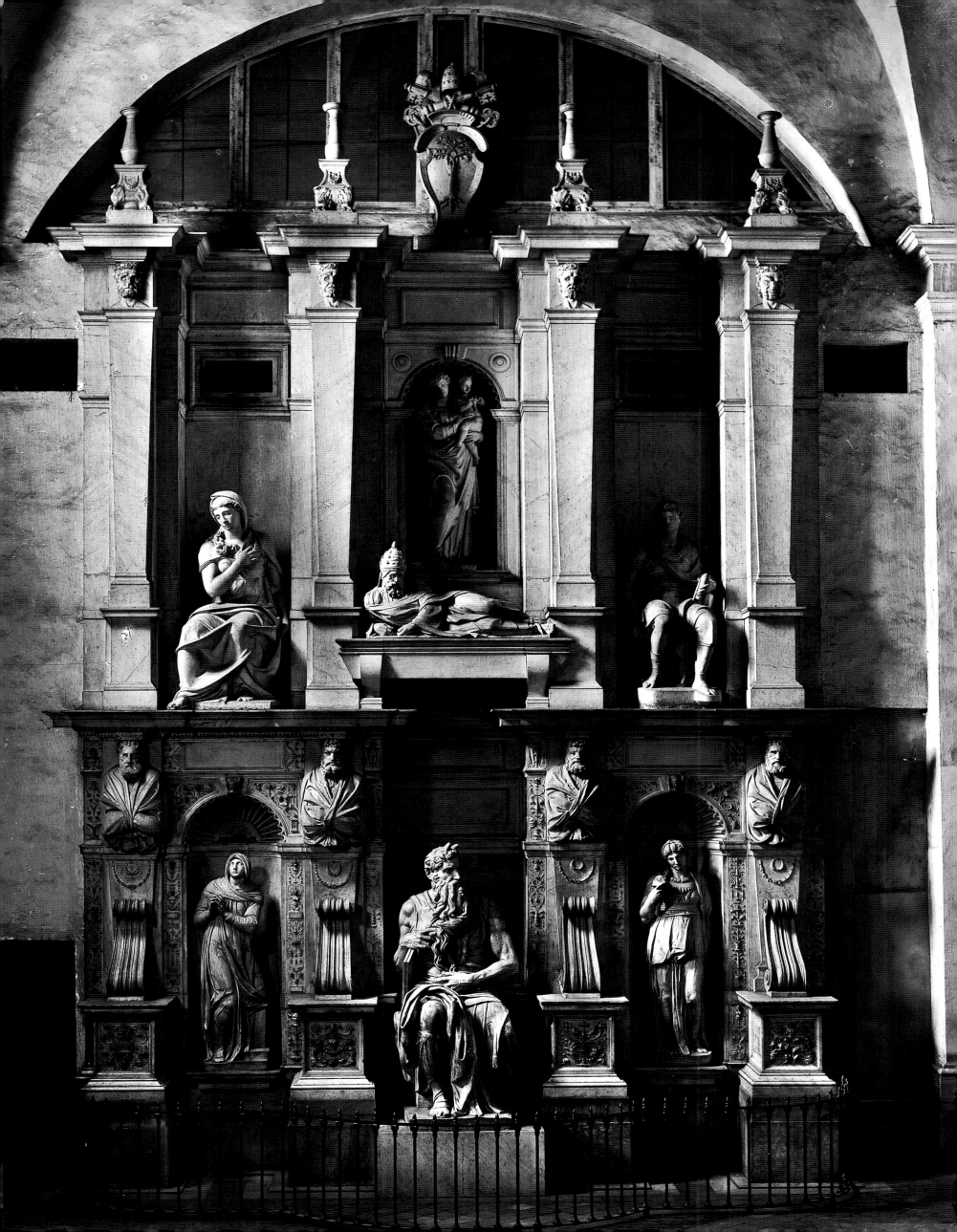

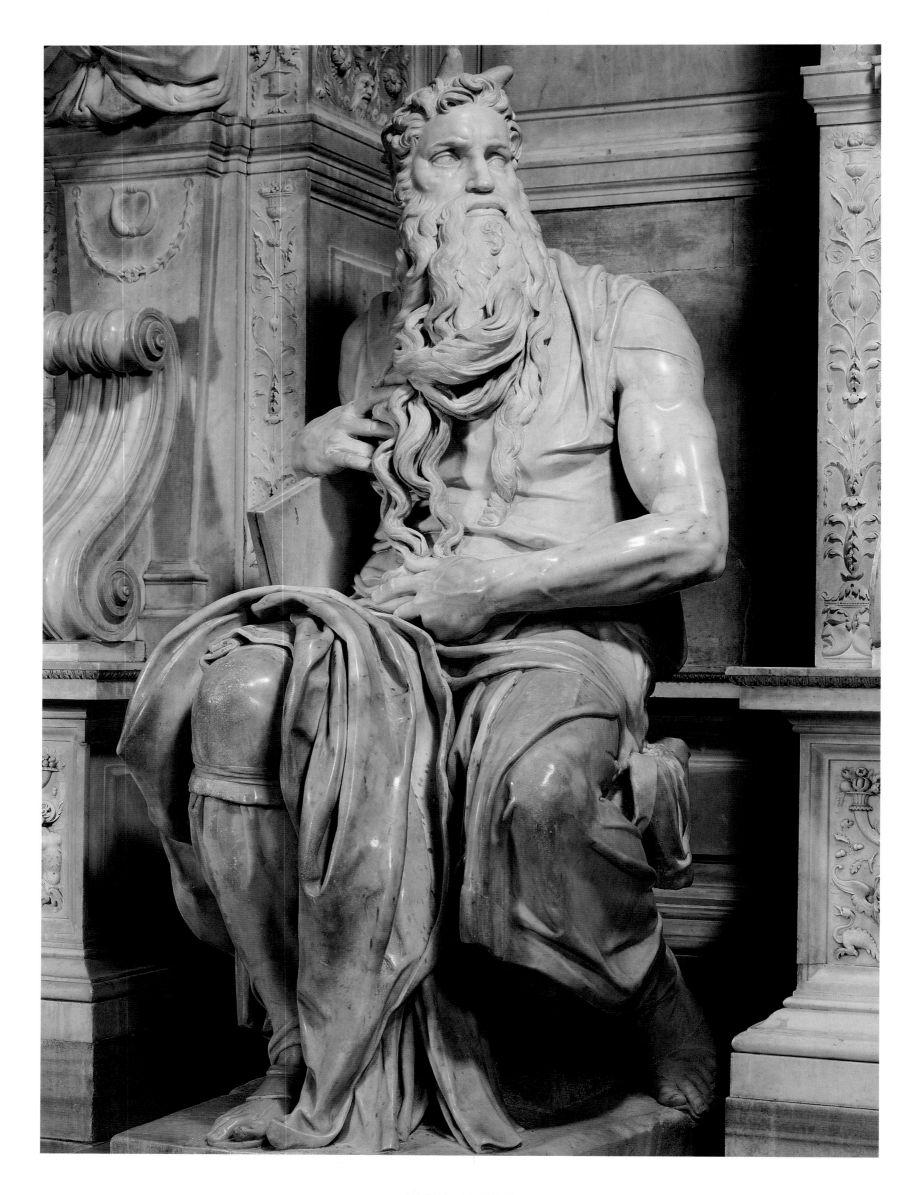

MOSES

◆ ◆ ◆

1513–1516 ◆ MARBLE ◆ 100 INCHES HIGH ◆ TOMB OF JULIUS II, SAN PIETRO IN VINCOLI, ROME

In a famous essay on Michelangelo's *Moses,* Sigmund Freud imagined the prophet, angry at the faithless Israelites, restraining himself from rising and hurling the tablets of the Ten Commandments to the ground. Indeed, the heavy stone slabs are even now in the act of slipping from the prophet's grasp.

Whether or not we perceive the same implied narrative as Freud, the famous psychoanalyst did attempt to describe what is true of many of Michelangelo's marble sculptures: they have an air of expectancy, a sense of immanence, that endows them with life and movement. The figures often seem to burst the bounds of the squarish blocks from which they were carved. On all sides *Moses* is circumscribed within an imaginary rectangle suggested by the squarish base, except on the right side where *Moses'* left elbow and knee press beyond that invisible boundary. Similarly, the retracted left foot actually slips off the edge of the sculpture's base.

Viewing the *Moses,* few people are concerned that the prophet may leap to his feet; on the other hand, every observer tacitly acknowledges that there is a vitality and a spiritual intensity that radiates from this figure. Perhaps the word used by contemporaries to describe Michelangelo, *terribilità* (terribleness), is an apt description of *Moses.* Michelangelo has successfully evoked the awesome aspect of the most fearsome prophet of the Old Testament.

Even seated, *Moses* is taller than a standing person; if he stood he would be over ten feet tall. His immensity is both implied and real. His powerful gaze is directed slightly upwards as though towards the Lord. Unlike other Michelangelo sculptures such as the *Rome Pietà,* the *David,* or the *Risen Christ,* photographers respect the force of that look and rarely attempt to photograph the face straight on. Rather incredibly, Michelangelo has imagined a face that, having beheld divinity, is more than human and thus not for mere mortals to gaze upon. The horns (standing in for the beams of light that emanated from Moses when he came down from Mt. Sinai), his tempestuous hair, and rippling facial muscles further emphasize the transfiguring power of *Moses'* expression.

Just as one might hesitate to look directly into *Moses'* face, so too it seems inappropriate to question the manner in which he is dressed. A loose sleeveless shirt is a tour de force of marble carving that permits Michelangelo to reveal, decorously, the figure's muscular build. Meanwhile, an inexplicable excess of drapery cascades over the knees, exposing the peculiar, loose-fitting leggings and sandals.

The thick ropes of the weighty beard are pulled to one side by the exaggeratedly long fingers of the right hand. This is the most animated of those unconscious hand gestures that characterize many of Michelangelo's sculptures. The gesture successfully runs a gamut of emotions, from tension to thoughtfulness.

Michelangelo conceived *Moses* as one of four seated prophets that were intended to adorn the corners of the second story of the great tomb complex of Pope Julius II. Taking into account this elevated location, Michelangelo carved *Moses* with an elongated torso, the disproportionate length of which is only evident from angle views. Even so, most visitors scarcely note the anatomical distortion since it is disguised by the enormously powerful arms and the extravagant, cascading beard. In the final version of the tomb, *Moses* was situated prominently at the lower center, the manner in which we see him today. Indeed, so important is he to the overall effect of the present tomb that I think many visitors pay little heed to other interesting elements of the ensemble, including the reclining effigy of the pope (seen at approximately the height originally intended for Moses), the tapered piston-like piers, the efflorescence of grotesque decoration, and the curiously anthropomorphic coat of arms.

Vasari tells us that every Sabbath the Jews of Rome went to see the *Moses,* like flocks of starlings. As tourists in Rome, we still flock to San Pietro in Vincoli, surely not to see Pope Julius II, but to stand in awe before the Old Testament prophet. Rarely has the countermanding of the Second Commandment resulted in such a forceful image of faith.

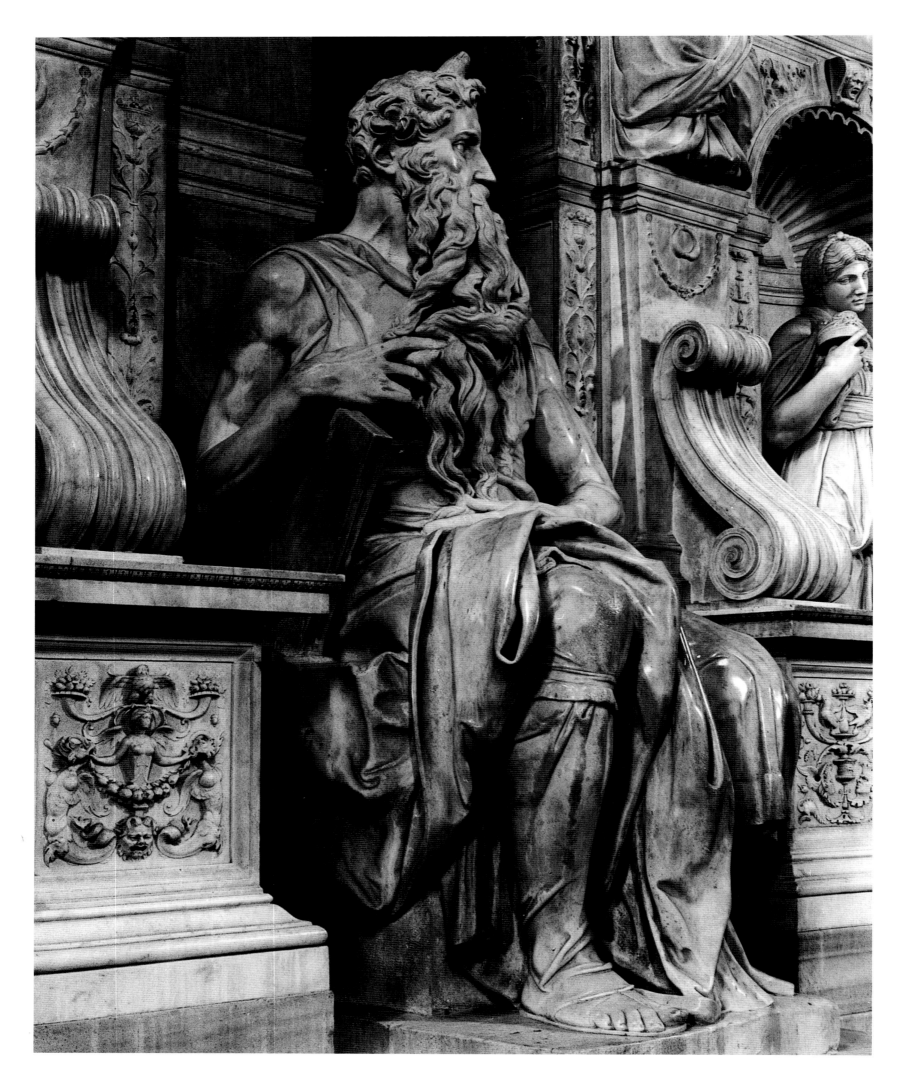

. . . Michelangelo carved MOSES with an elongated torso,
the disproportionate length of which is only evident
from angle views. . . .

MICHELANGELO

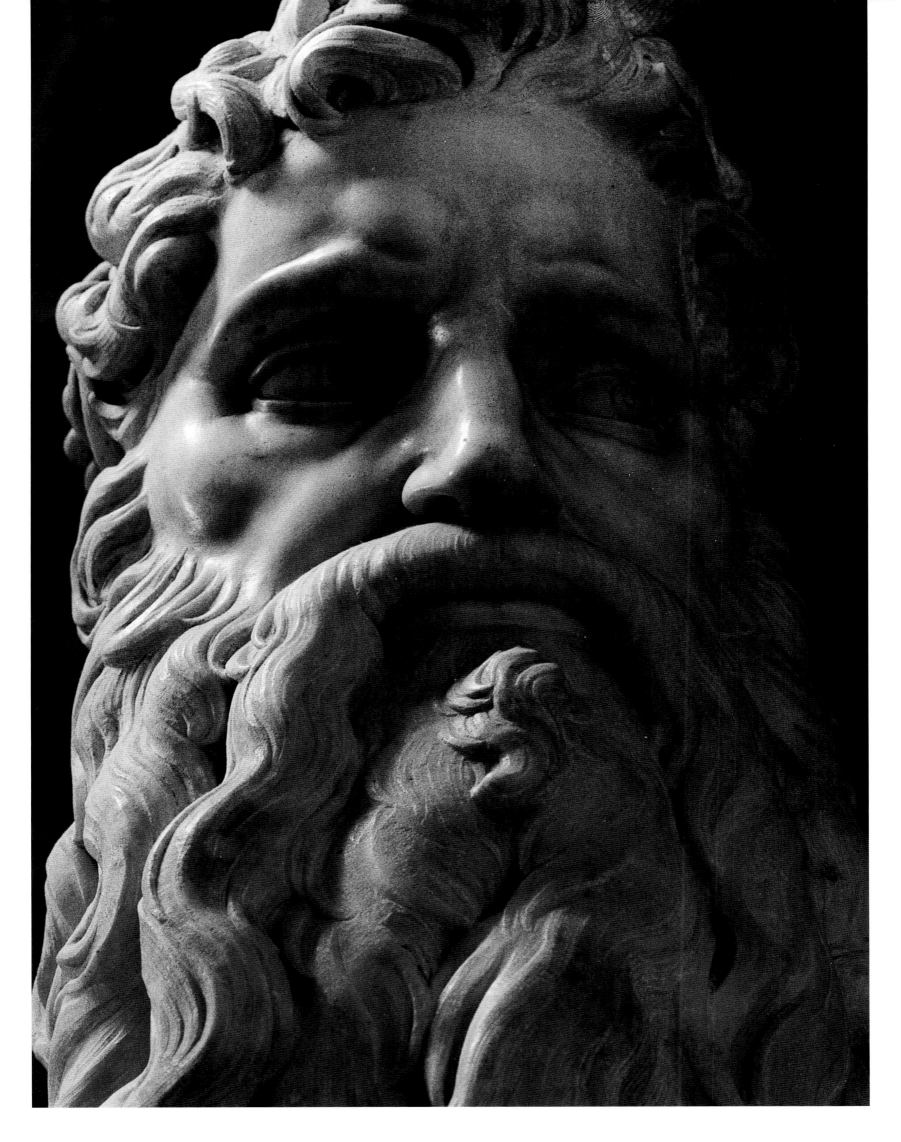

*. . . Even so, most visitors scarcely note the anatomical
distortion since it is disguised by the enormously powerful
arms and the extravagant, cascading beard. . . .*

SCULPTURE

83

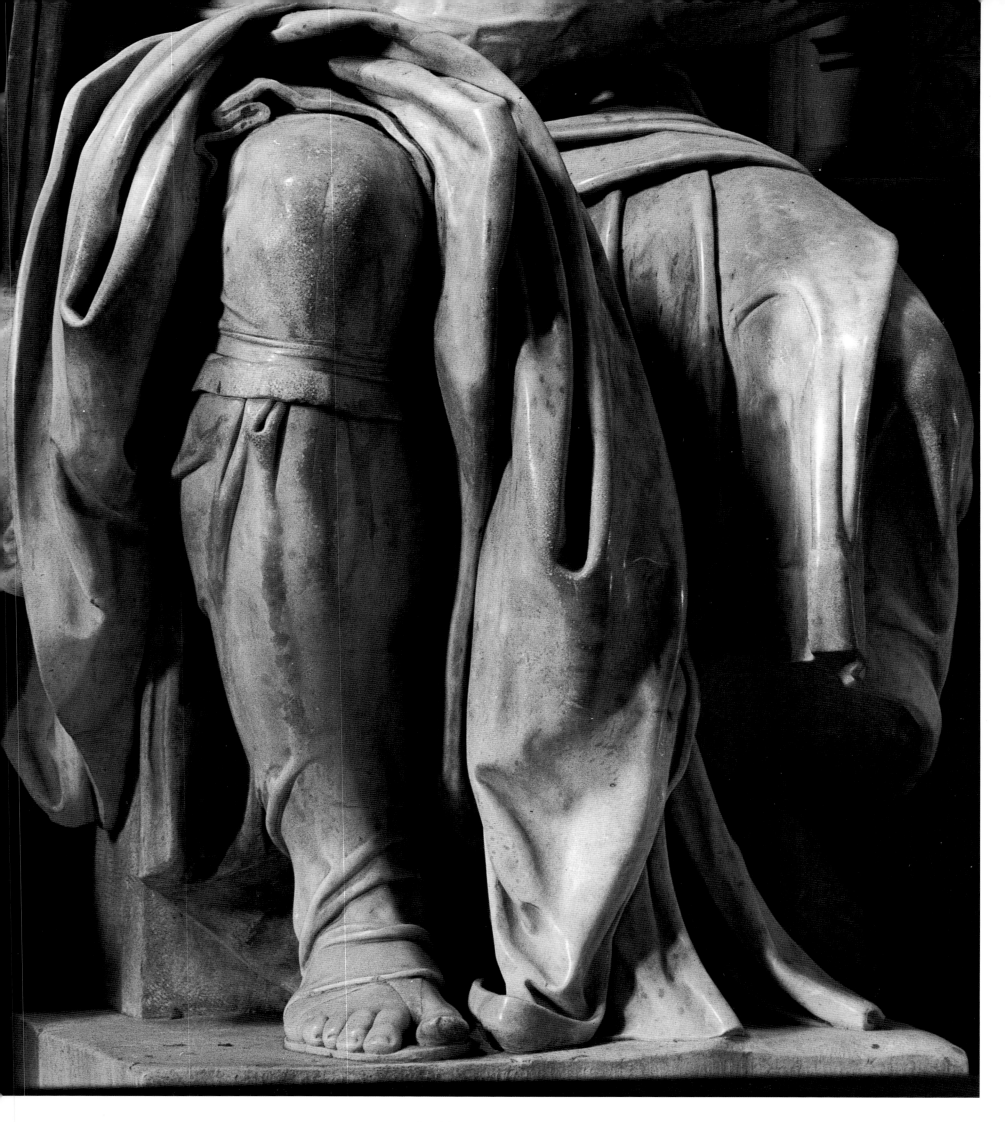

*. . . an inexplicable excess of drapery cascades over the
knees, exposing the peculiar, loose-fitting leggings
and sandals. . . .*

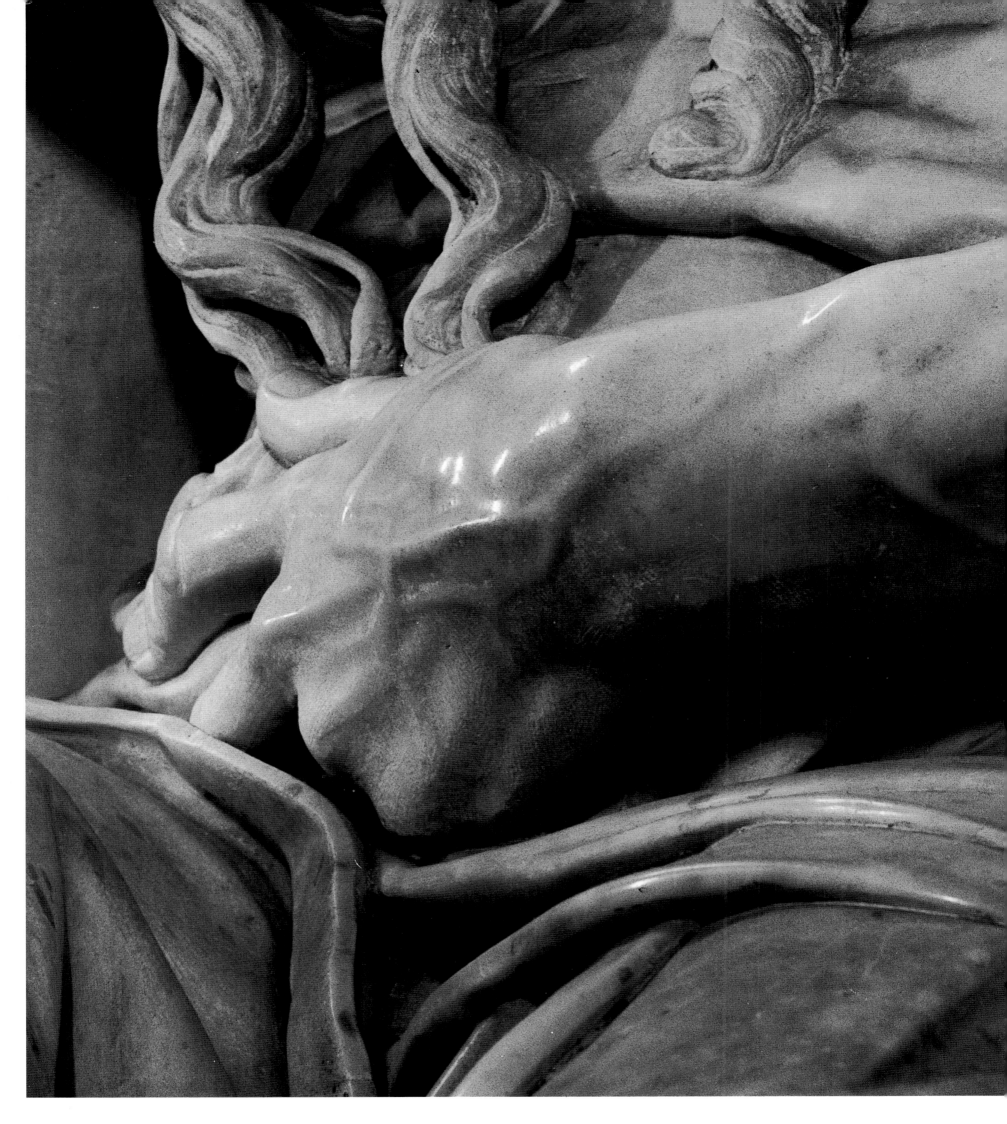

. . . The thick ropes of the weighty beard are pulled to one side by the exaggeratedly long fingers of the right hand. This is the most animated of those unconscious hand gestures that characterize many of Michelangelo's sculptures. . . .

SCULPTURE

THE REBELLIOUS AND DYING SLAVES

◆ ◆ ◆

1513–1516 ◆ MARBLE ◆ LOUVRE MUSEUM, PARIS
THE REBELLIOUS SLAVE ◆ 7 FEET 1 INCH HIGH
THE DYING SLAVE ◆ 7 FEET 6½ INCHES HIGH

As part of the original conception for the tomb of Julius II, Michelangelo was to carve forty larger-than-life sculptures in marble. It is characteristic of the artist to begin with some of the less important figures, as though he wished to work his way slowly to the more important and difficult tasks. It is also characteristic that he would create masterpieces of "minor" figures, while never completing the ensemble as originally planned. This is essentially the story of the two marble figures presently in the Louvre Museum, the so-called *Rebellious* and *Dying Slaves* or *Captives (prigioni)*. No matter what we may think of them now, they were intended to be only a part, and a lesser part for that matter, of a decorative scheme that was never completed. The sculptures are orphans, but in the absence of a family they became independent masterpieces.

Michelangelo's intention for including "slaves" or "prisoners" is uncertain: Vasari writes that they are "captives meant to represent all the provinces subjugated by the Pope and made obedient to the Apostolic Church." Condivi, with greater subtlety, and probably more closely reflecting Michelangelo's views, states they represent the liberal arts that, like Julius, were now prisoners of death. The two slaves were probably carved simultaneously. It is possible that Michelangelo even imagined them as a contrasting pair, although their removal from their original context, and the modern names we have attached to them, heighten the sense of their duality.

The *Rebellious Slave* reveals a similar torsion, but more forceful and in the opposite direction, to the *St. Matthew*. Unlike the earlier figure, where the animated *contrapposto* helped express a state of religious inspiration, here the body is subject to physical restraint. Yet, only one cloth strap crosses the chest and tightly binds the left arm causing the muscles to bulge. The suggested discomfort is not revealed in the figure's face, which is turned upwards as if making its appeal heavenward. The thick neck and rippling muscles of the torso and shoulders would suggest volcanic energy, but there is little actual movement; Michelangelo has created a paradoxical state of struggle and stasis.

The *Dying Slave* is significantly misnamed; if only dying were such a combination of semi-sleep and relaxed sensuality! The weight of the figure supposedly rests on its right leg, but without its marble support—a strangely amorphous shape, part animal, part vegetable—the figure would not stand: most of the weight is, or appears to be, well to the right of the block's center line. Michelangelo has created the semblance of a reclining figure in a vertical position. The figure is replete with such paradoxes: the amount of limb movement in contrast to the state of semi-oblivion; the muscular male in a sensual body; and the creation, pygmalion-like, of an erotic human from stone. The indeterminacies extend even to its sex; there is an almost hermaphroditic quality to the figure. We are forever noting Michelangelo's masculinization of females, but here is an instance of the reverse.

Particularly beautiful is the contrast of raised left and lowered right arms creating a tilted lozenge shape bisected by the diagonal of the head. The separated index finger of the nearly limp right hand gently inserts itself in a loose fold of the inexplicable cloth band that confuses the state of being nude or naked, bound or unbound. In contrast to earlier figures, the individual curls of hair are not as sharply differentiated; rather, the rough carved mass tends to accentuate, by contrast, the smooth skin and incised features of the face.

As one circles the figure, the composition rotates in a slow-motion spiral. One is made forcefully aware of Michelangelo's remarkable ability to create a complicated artistic composition from a single figure. In the end, thoughts of rational corporeal behavior and historical "context" or interpretation are subordinated to the admiration of the brilliance and beauty of Michelangelo's carving. Here the master has mastered the art of artifice.

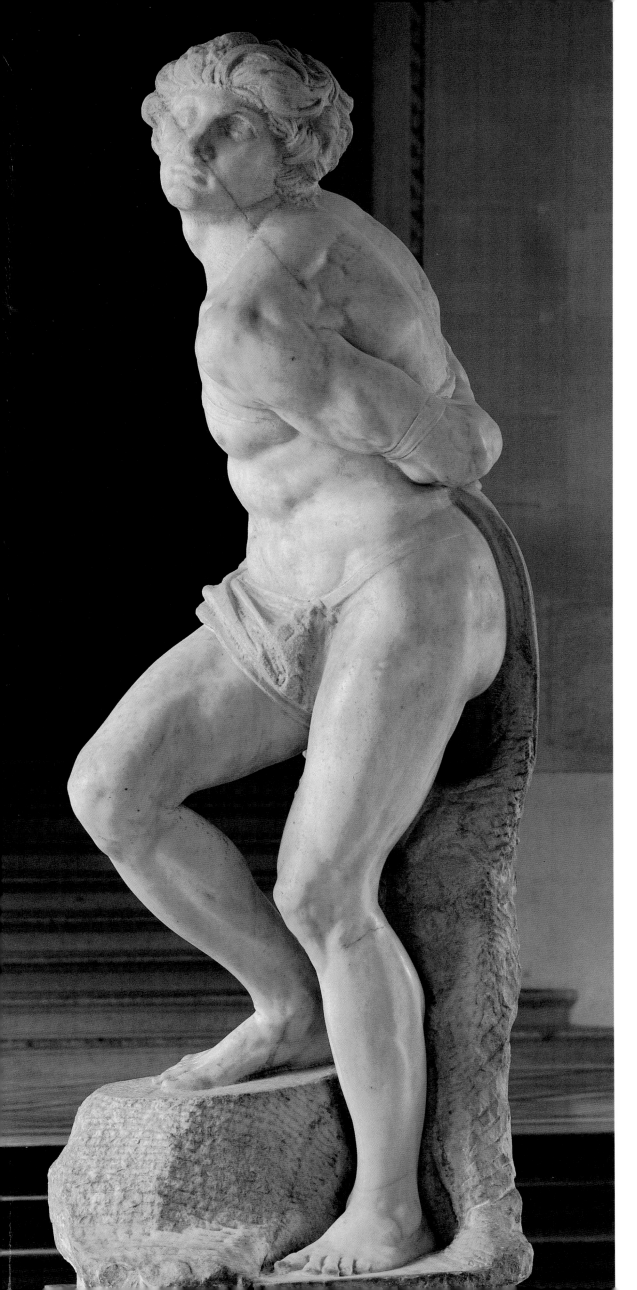

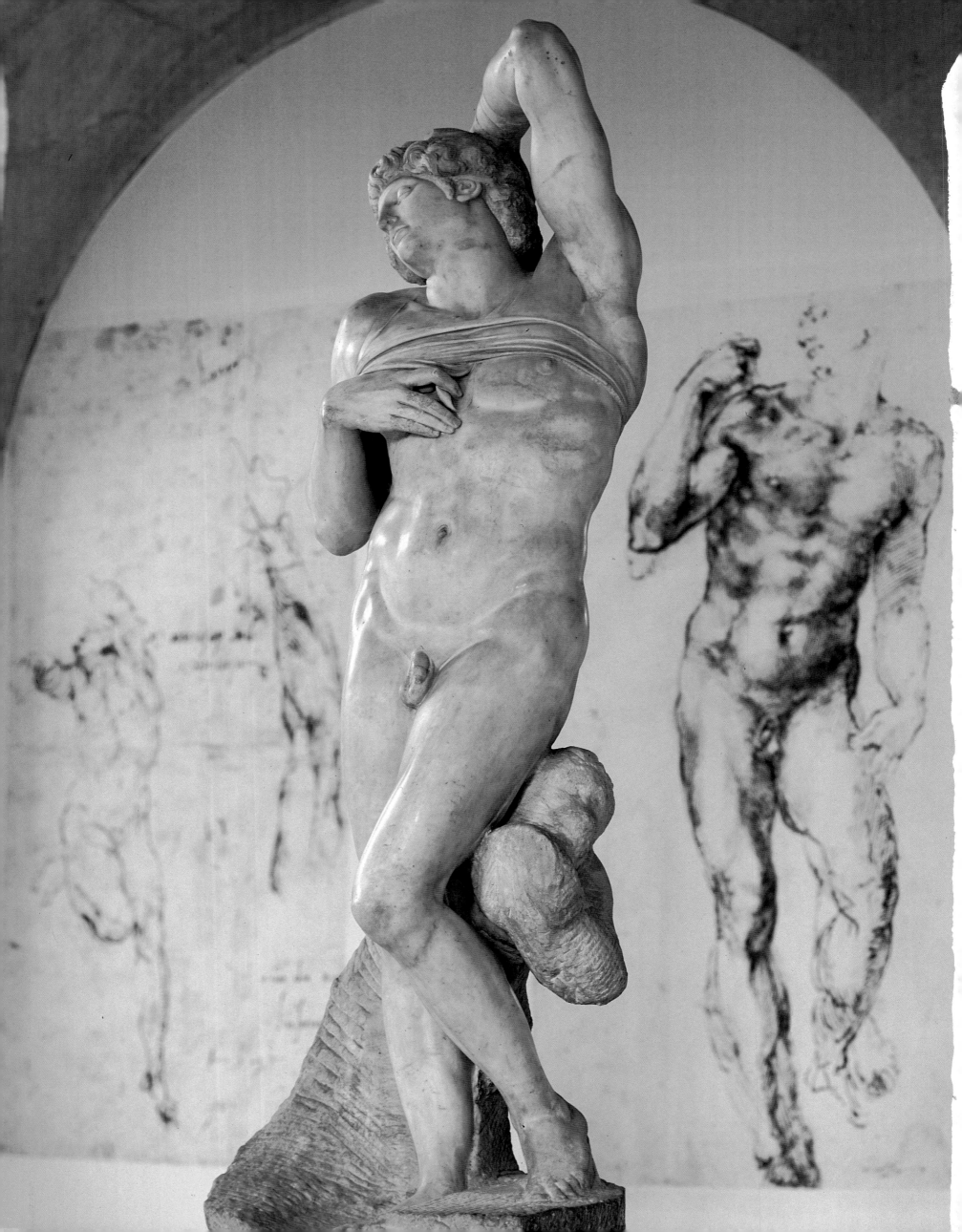

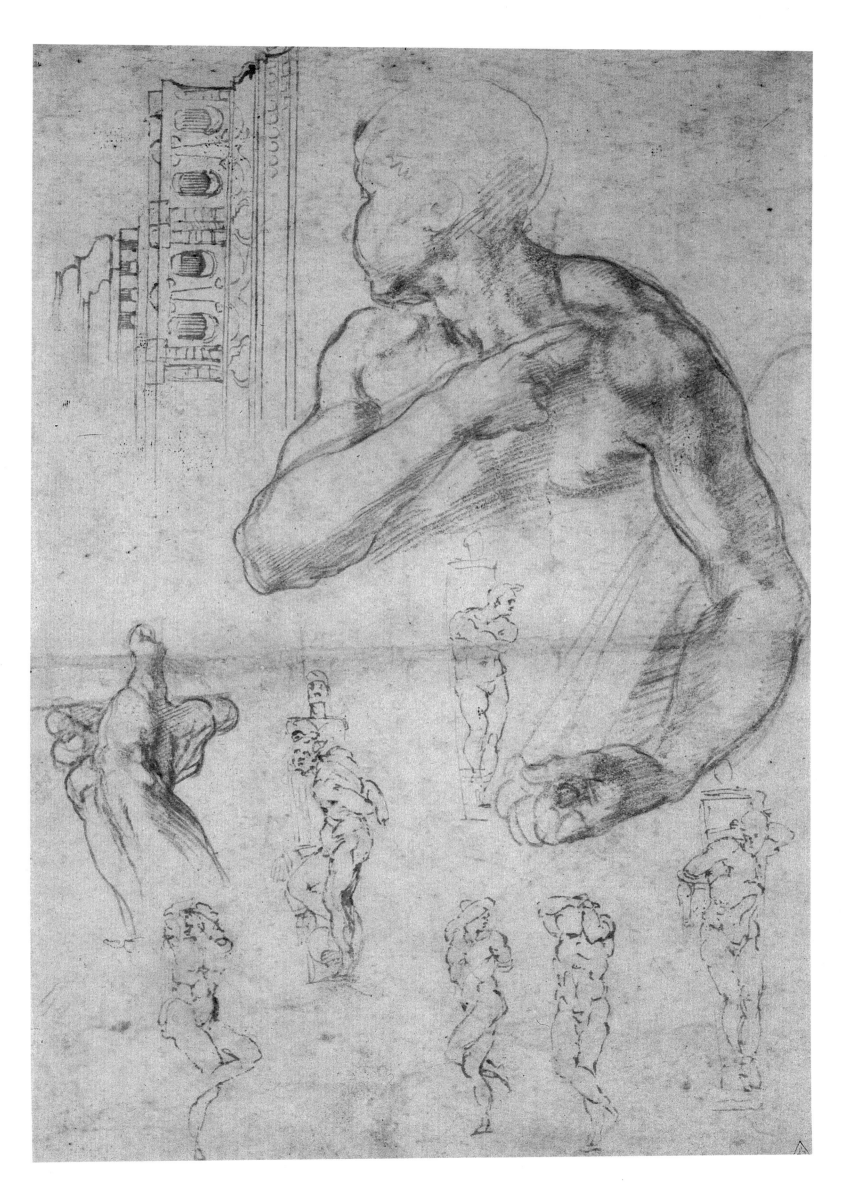

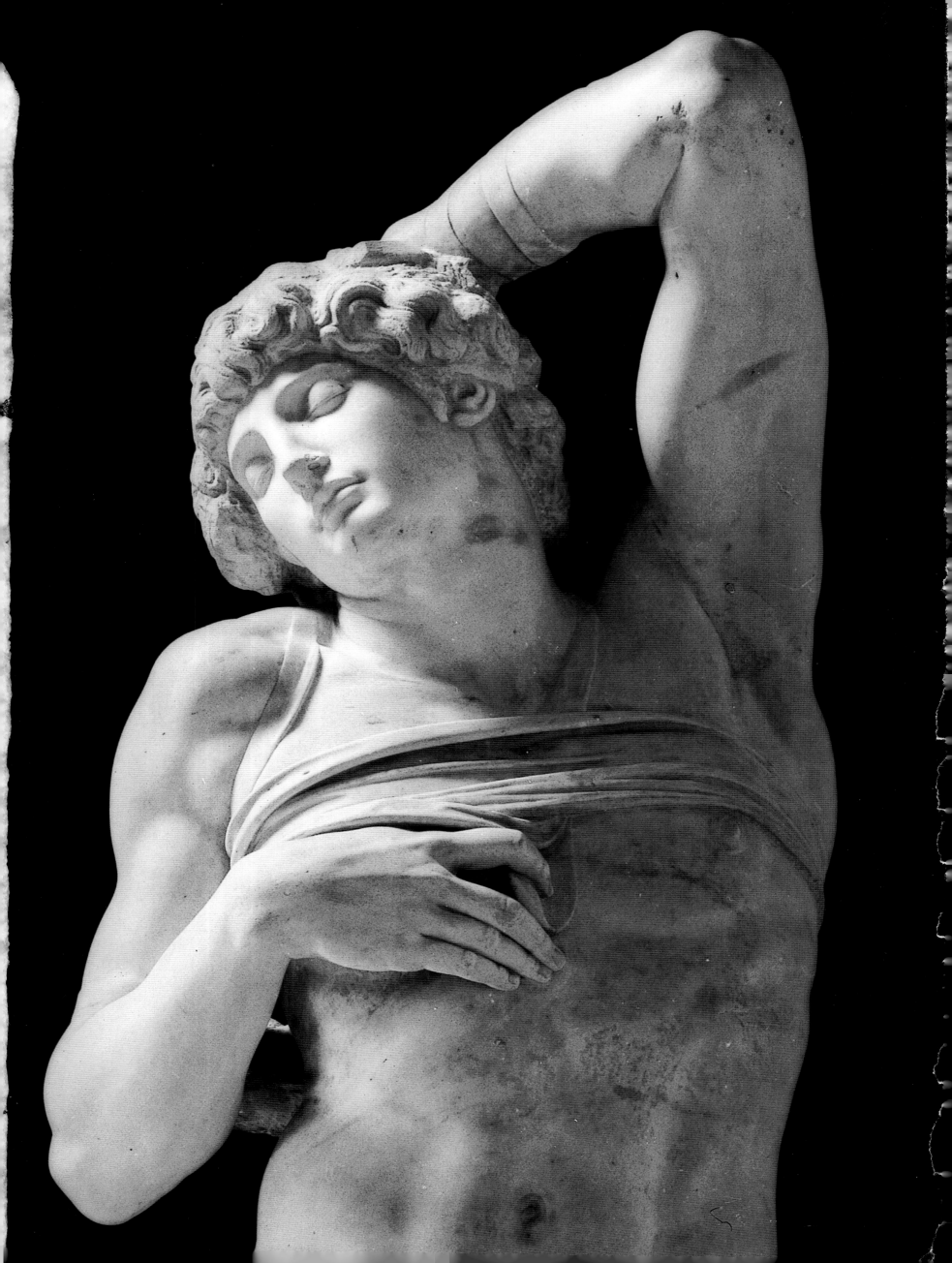

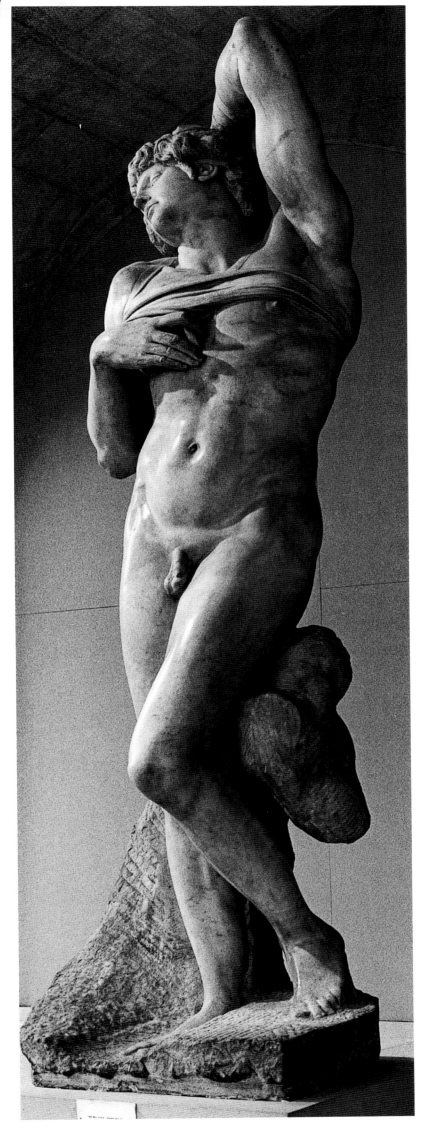
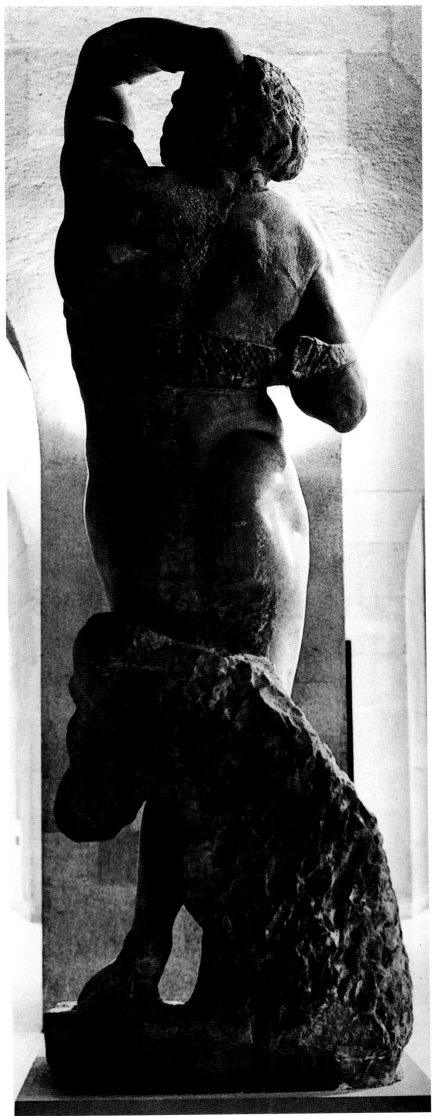

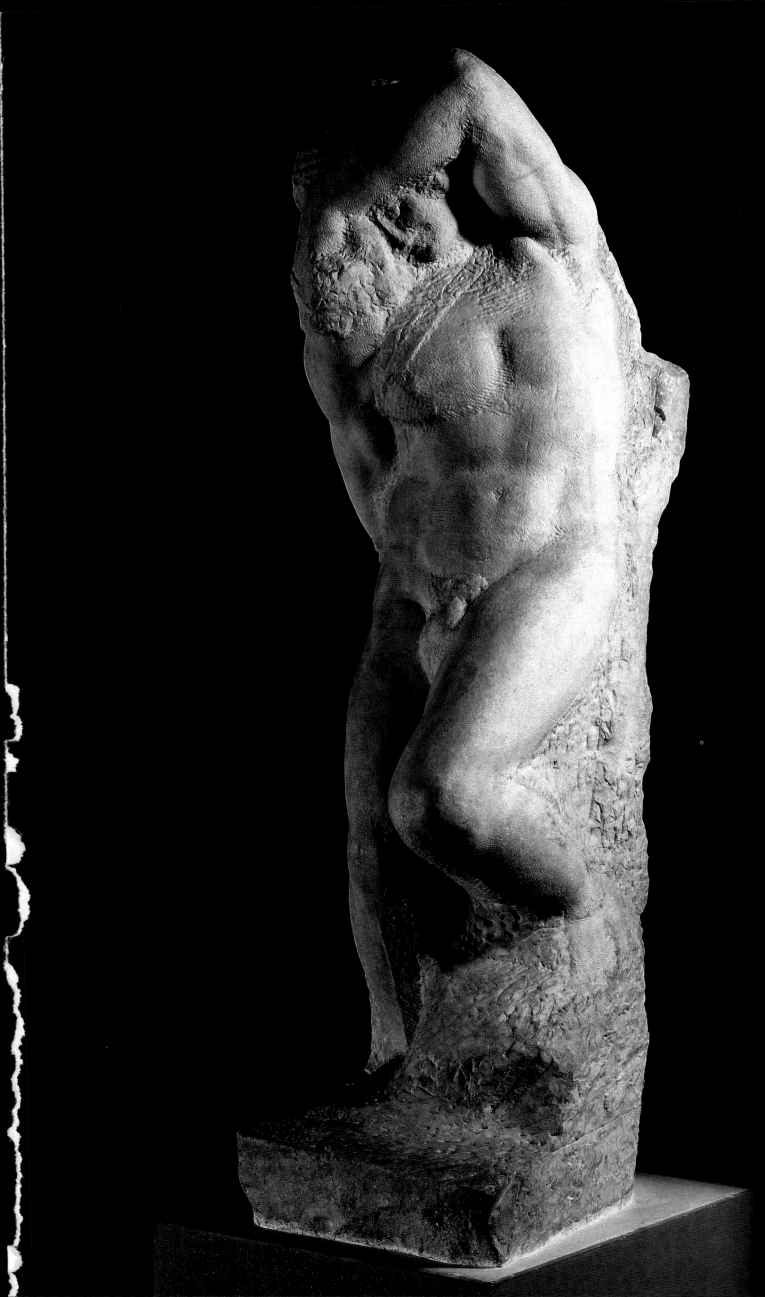

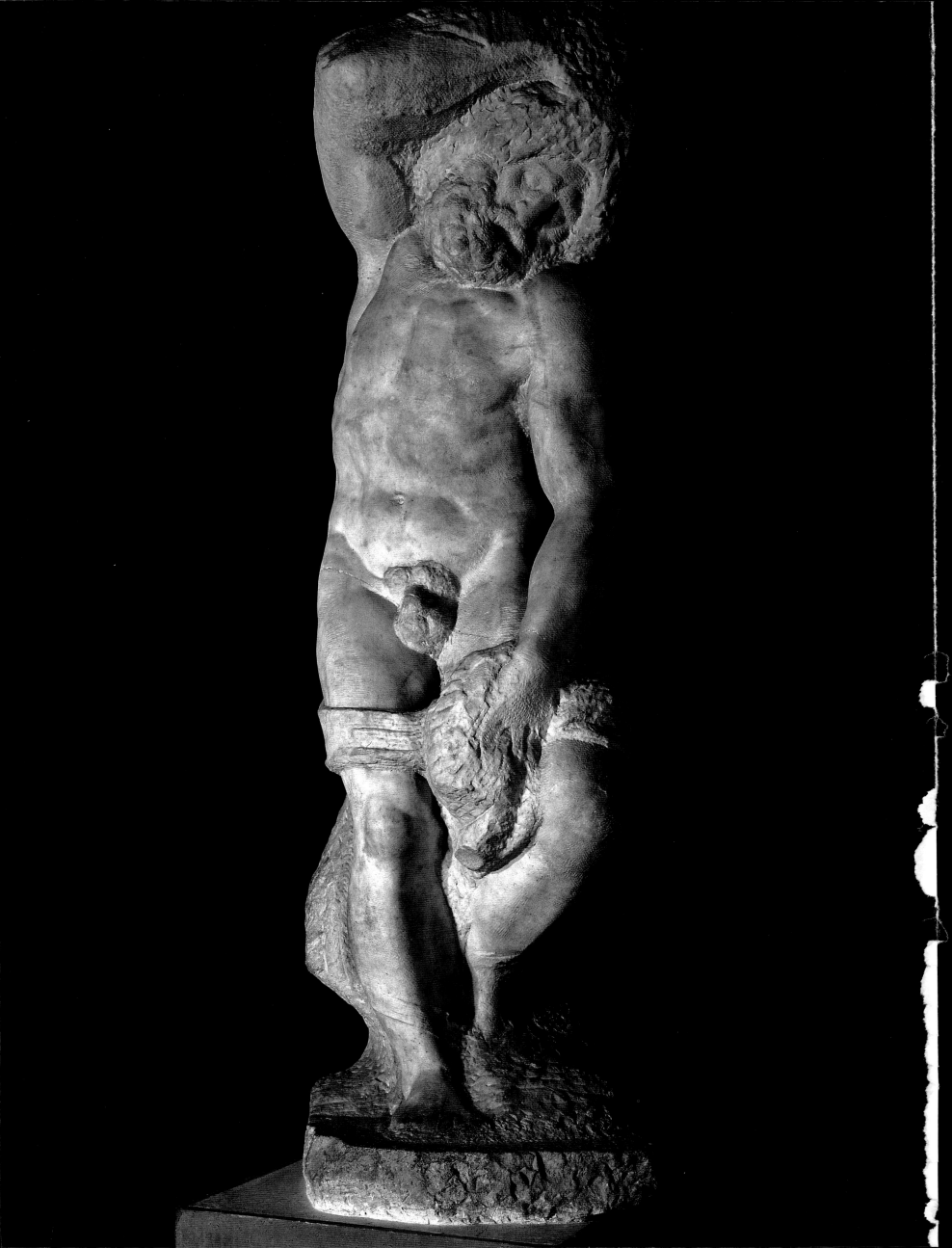

THE ACCADEMIA SLAVES

◆ ◆ ◆

C. 1520–1530 ◆ MARBLE ◆ ACCADEMIA MUSEUM, FLORENCE
YOUNG SLAVE: 8 FEET 6¾ INCHES HIGH ◆ BLOCK-HEAD SLAVE: 9 FEET 1½ INCHES HIGH
BEARDED SLAVE: 8 FEET 8¼ INCHES HIGH ◆ AWAKENING SLAVE: 9 FEET HIGH

Many of the themes adumbrated in the *Rebellious* and *Dying Slaves* reemerge in the four unfinished figures today lodged in the Accademia Museum in Florence. However, Michelangelo learned an important lesson in the intervening years. For the earlier figures, Michelangelo quarried marble blocks only as large as the figures he desired to carve from them. Yet, because there was no extra stone, Michelangelo sometimes found himself with little or no room to maneuver, especially if he encountered impurities in the marble, as was the case with the *Rebellious Slave*. Running through the face and neck of that figure is a disfiguring crack. In trying to avoid it, Michelangelo sculpted the head as if it were tossed back; nonetheless, the thin block did not allow him to escape the marble blemish. Similarly, it seems that he ran out of stone while carving the right arm of the same figure, which is why that side appears so flat, and why most photographs of the figure favor views taken from the opposite angle.

Michelangelo tried to avoid this problem in these later figures. He now ordered marble blocks substantially thicker than he needed; thus, he was virtually guaranteed enough stone should he encounter a flaw. For example, towards the back edge of the so-called *Block-head Slave,* just where the figure's rear end would be, one can see a small triangular excavation, which is probably where Michelangelo cut away flawed or discolored marble.

Michelangelo's precautionary measures also ensured that these would be among his best-loved works. With the excess envelope of marble sheathing each of the unfinished statues, we see the figures "emerging" from the blocks, the figures in a titanic struggle to free themselves from the raw material, Michelangelo's agony and ecstasy in bringing the forms to life. By a sort of poetic extension inspired by Michelangelo's own poetry, we imagine the soul yearning to free itself from its earthly prison. Such descriptions are compelling, and infinitely more suggestive than the banal explanation that Michelangelo may never have finished the figures and left them abandoned in his studio when he departed Florence in 1534.

On the other hand, certain details give us pause and reason to consider whether Michelangelo too responded in a positive fashion to their unfinished state. For example, in the *Block-head Slave* Michelangelo has left intact a large slab of unfinished stone—the uncarved epidermis of the block—projecting behind the figure. In fact, he has excavated a very deep crevice between the figure and this "retaining" wall, even adorning the V-like channel with a line of drill holes and neatly parallel chisel marks. But why? If he intended to carve the figure fully in the round, then it would be logical, and much easier, to have removed this excess stone.

And what about the so-called *Awakening Slave?* The right leg is raised and crosses over the left, the weight of the figure supposedly supported on the left leg, and yet the head and upper torso are bent sharply backwards creating a significant imbalance. Was it even possible to finish a figure so tenuously posed, and if he did what would it look like? Could it stand without some sort of artificial support? Why did Michelangelo bother to articulate the torso fully, even begin to smooth away the chisel marks, while leaving so much of the stone untouched or only roughly worked? Did Michelangelo—like most visitors today—appreciate the contrasting surfaces and the metamorphosis that takes place before our eyes.

Even the two most "finished" figures—the *Young Slave* and the *Bearded Slave*—are largely unfinished, at least according to prevailing Renaissance taste. But it is possible that Michelangelo purposely exploited the expressive possibilities of the *non-finito* (unfinished). It is sometimes possible to say more through less, through suggestion rather than definition.

The *Young Slave* and the *Bearded Slave* are close relatives to the figures in the Medici Chapel, which may have been carved at approximately the same time. While working on the Medici Chapel figures, Michelangelo constantly had before his eyes these essays in body allegory. He liked to surround himself with a quantity of marble and to work simultaneously on more than a half-dozen blocks. In the 1520s, Michelangelo quarried an immense amount of marble to be used on three overlapping projects: the façade for the church of San Lorenzo, the tomb of Julius II, and the Medici Chapel. It would have been impossible to keep the commissions entirely separate, especially in the confines of his workshop, where many different blocks were being worked simultaneously. Blocks were mixed, shuffled, and reused. A final decision about the destination of a particularly fine specimen of statuary marble was made only after Michelangelo had chiseled into its surface, tested its hardness, texture, and purity—felt its quality.

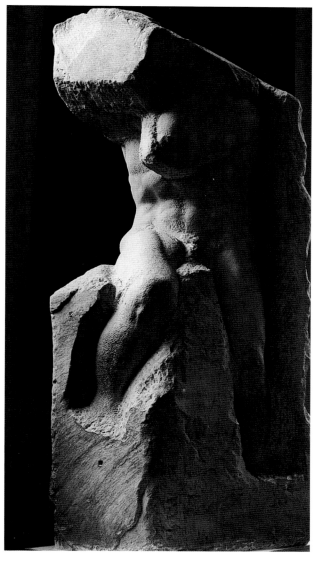

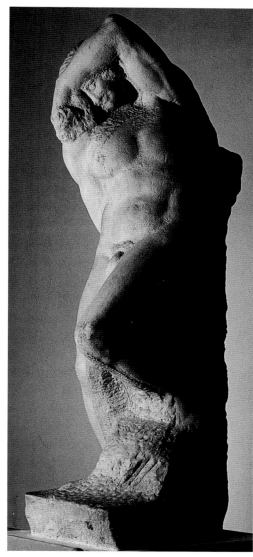

CLOCKWISE FROM TOP LEFT:
THE BLOCK-HEAD SLAVE
THE YOUNG SLAVE
THE BEARDED SLAVE
THE AWAKENING SLAVE

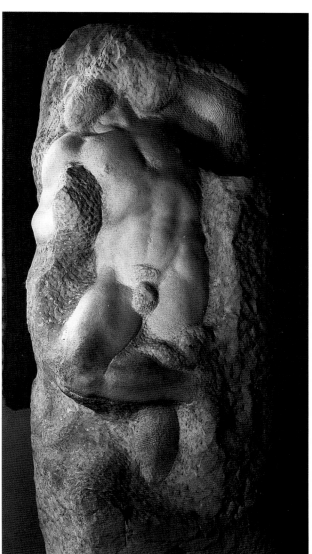

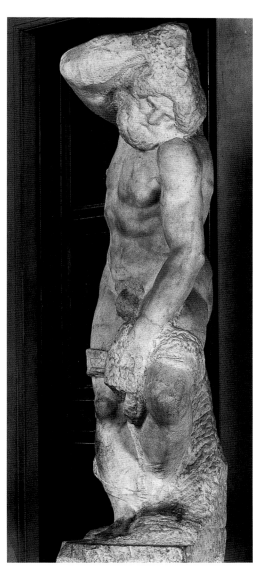

RACHEL

◆ ◆ ◆

1542–1555 ◆ MARBLE ◆ 6 FEET 7½ INCHES HIGH
TOMB OF JULIUS II, SAN PIETRO IN VINCOLI, ROME

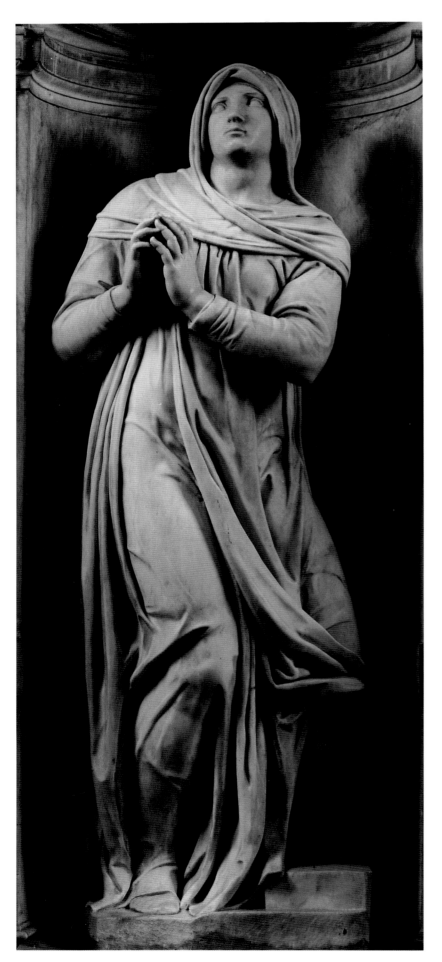

A very different aesthetic informs the sculptures of *Rachel* and *Leah*, two allegorical figures that Michelangelo carved for the final version of the Julius tomb (contract of 1542). Precisely because our modern sensibilities are drawn to the expressive power of Michelangelo's unfinished slaves, these two statues have often been treated as though they were tossed off by an artist of slackening will and energy. It is difficult to appreciate fully the quiet dignity of these two female figures, in stark contrast to the sublime *Moses* and amidst the dense ornamental jungle of the tomb's lower story. We too easily forget that Michelangelo approached the feminine form with as much respect and reverence as he did the male nude. These are supreme examples of his mature powers as a marble sculptor and as a creator of moods in marble.

The *Rachel* and *Leah* were clearly conceived as a pair, in form and expression, to flank but not compete with the prophet *Moses*. Michelangelo purposely created demure, even diminutive females that represent Faith and Good Works, or, as they were commonly allegorized, the active and the contemplative life. In substituting these two female figures for the earlier slaves, Michelangelo turned from a language of exaggerated physicality to one of spiritual yearning, from pagan to Christian allegory expressed in the comely forms of draped femininity. The modesty of their size and expression, well confined by the niches that enclose them, is remarkable given that we tend to think of Michelangelo's titanic forms as bursting bonds and the boundaries of their blocks. These two figures quietly encourage us to reflect upon the nature and passage of life, both here and hereafter.

. . . RACHEL clasps her hands and submits her appeal to heaven. The drapery modestly clads yet reveals the subtle and multiple turns of the elongated, asymmetrically disposed body. . . .

LEAH

◆ ◆ ◆

1542–1555 ◆ MARBLE ◆ 6 FEET 10 INCHES HIGH
TOMB OF JULIUS II, SAN PIETRO IN VINCOLI, ROME

In robes that suggest a nun's habit, *Rachel* clasps her hands and submits her appeal to heaven. The drapery modestly clads yet reveals the subtle and multiple turns of the elongated, asymmetrically disposed body. Her form rises ethereal and flame-like, in direct contrast to the solid, matronly aspect of *Leah.*

Leah's voluminous drapery and *contrapposto* stance give her the appearance of a classical goddess, and indeed, it is likely that Michelangelo was inspired by a famous antiquity, the *Cesi Juno.* Yet, comparisons with the so-called model reveal the modernity of Michelangelo's conception. The youthful maiden glances wistfully and unspecifically towards the mirror (adorned with a grotesque mask) she holds in her right hand—the Bible informs us that "Leah's eyes were weak"—while her limp left arm holds a garland. Her symmetrically parted and braided hair is bound up to create a sort of natural diadem, the effect of which is heightened by the shell niche that enframes and accentuates, radiant-like, the beautiful head. One thick tress falls over her right shoulder and trails to her waist, there to be confused with the tress-like behavior of her drapery.

Leah's long flowing garment sports an unusual ornamented bodice and collar, a tightly wrapped horizontal band that accentuates smallish breasts, and loose folds that loop down below her waist. A knot of drapery just in front of her womb evokes her fertility and the six sons she bore Jacob. According to the Bible, Leah was not as comely as her sister, but she was favored by God. As though to express the beauty of her inner spirit, Michelangelo has created one of the most majestic and supremely lovely creatures of his entire oeuvre.

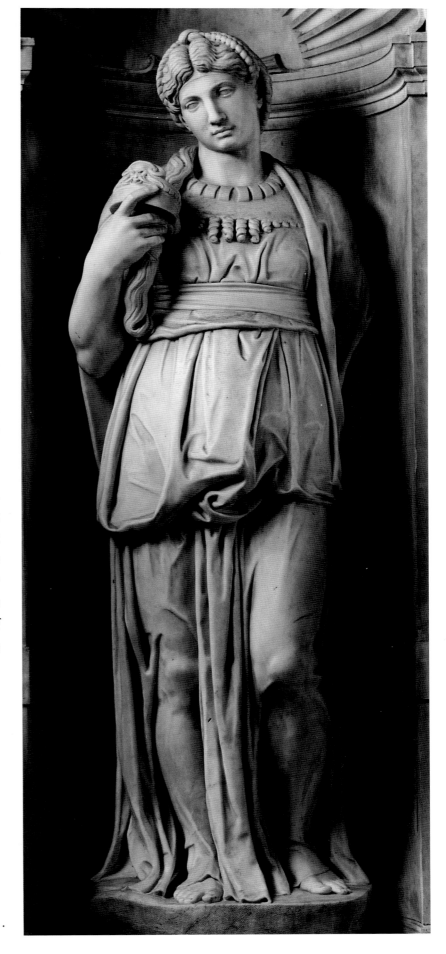

. . . LEAH's *voluminous drapery and* contrapposto *stance give her the appearance of a classical goddess, and indeed, it is likely that Michelangelo was inspired by a famous antiquity, the* Cesi Juno*. . .*

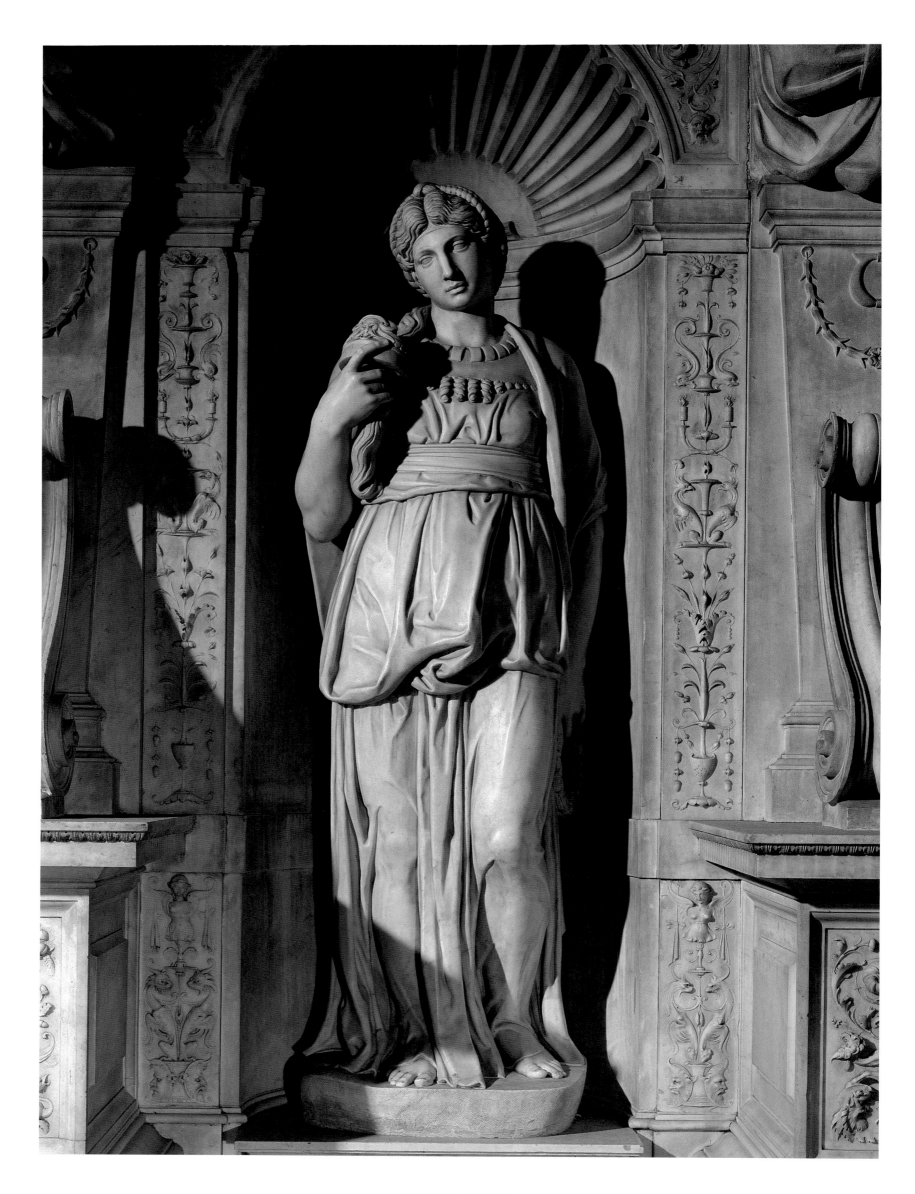

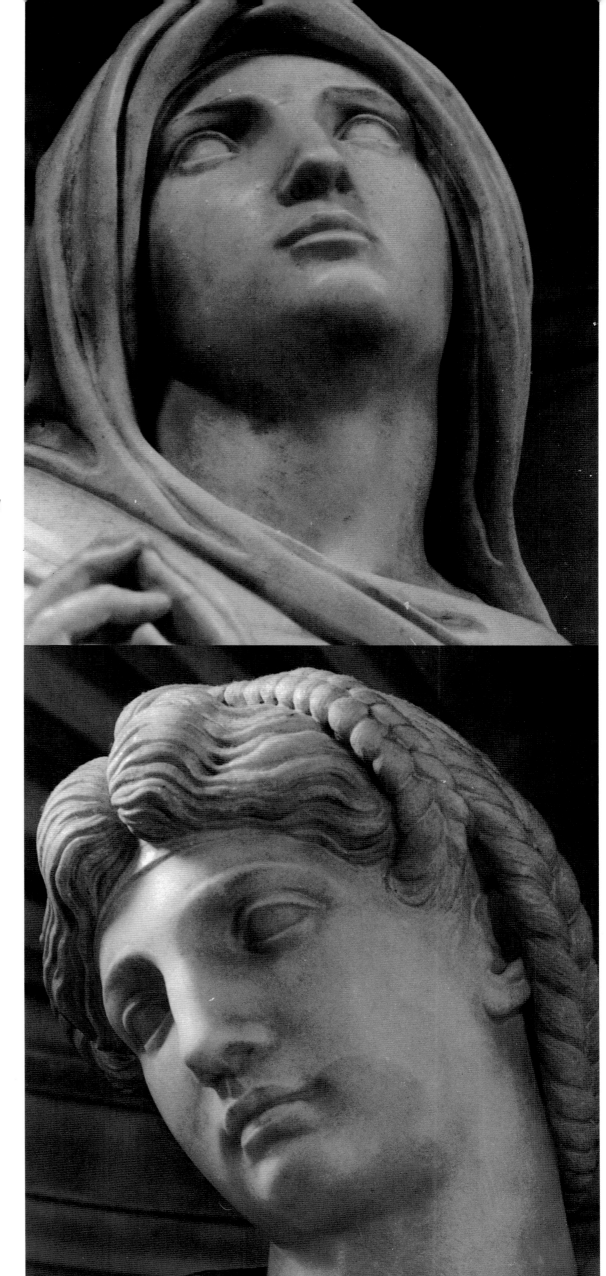

RIGHT:

... [RACHEL'S] *form rises ethereal and flame-like, in direct contrast to the solid, matronly aspect of* LEAH. ...

OPPOSITE AND RIGHT:

..."*Leah's eyes were weak*"...

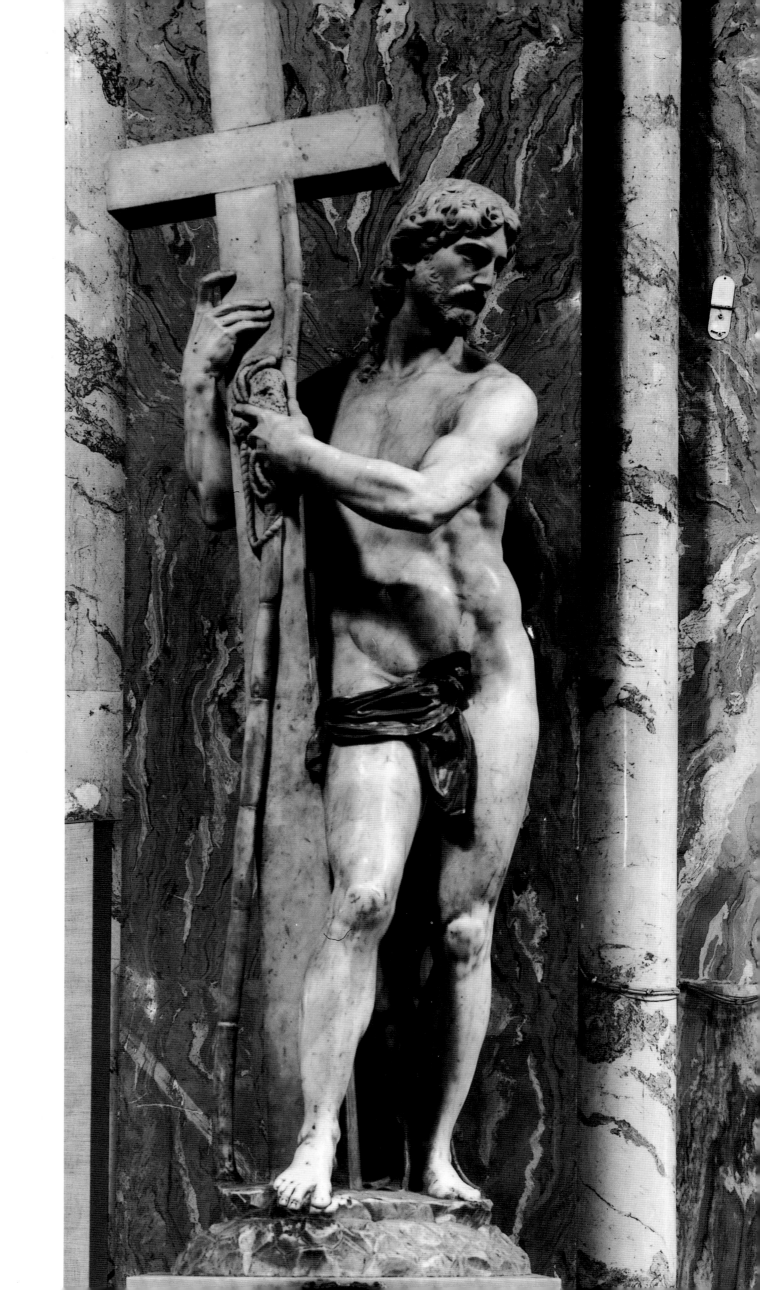

THE RISEN CHRIST

◆ ◆ ◆

1519–1520 ◆ MARBLE ◆ 6 FEET 10 INCHES HIGH ◆ SANTA MARIA SOPRA MINERVA, ROME

For many admirers of Michelangelo's art, the *Risen Christ* in Santa Maria sopra Minerva in Rome is their least favorite work by the sculptor. The modern distaste for the statue is in sharp contrast to the contemporary admiration it received and Michelangelo's own devotion to the commission. This is actually the second version of the sculpture; Michelangelo abandoned the first when he discovered a flaw in the marble block. Given that the artist always had a sackful of excuses when he wished to avoid an obligation, it is revealing that he carved this figure twice. He evidently greatly desired to make this work and went to great pains to please its Roman patrons.

The commission offered Michelangelo the opportunity to represent the Christian divinity in the language of classical antiquity: God as an ideal, fully nude male. Many ambivalent feelings about the *Risen Christ* arise from the figure's stark, frontal nudity. The audacious nudity—all the more striking given that this is a life-size, three-dimensional figure—may seem more appropriate to a pagan than a Christian statue. In fact, through most of its history the figure has been covered by a variety of raiments, ranging from a dainty wisp of drapery to a flamboyantly Baroque loincloth.

Many critics of the *Risen Christ* direct attention to the alarming proportions of the figure: a weighty torso and excessively broad hips rise above a pair of peculiarly tapered and spindly legs. Particularly displeasing is a side or rear view of the figure that show Christ's buttocks. But such a view is not only indecorous; it was unintended and originally unavailable. In contrast to many of the sculptures discussed so far, the *Risen Christ* was conceived and carved to be seen in a niche, which necessarily limited its viewing. It seems that Michelangelo, fully aware of the intended setting, sacrificed the back view in order to render convincingly the slender proportions and refined, dance-like pose of the frontal views.

It is a self-evident point, but one rarely made, that the appearance of the sculpture subtly but significantly changes depending on one's viewing angle. If we view the sculpture from the front left, perhaps its best side, then Christ is no longer an unpleasantly thickset figure with monumental buttocks. Rather, his proportions are more pleasing, and his body merges with the cross in a graceful and harmonious composition.

The turn of Christ's body and his averted face suggest something like the shunning of physical contact that is central to another post-Resurrection subject, the *Noli me Tangere* ("Touch Me Not"). The turned head is an eloquent and poignant means of rendering Christ inaccessible even as his corporeal reality is made manifest. We are encouraged to regard not Christ's face but, instead, the instruments of his Passion. Our attention is directed to the cross by the extreme but effortless cross-body gesture of the left arm and the entwining movement of the right leg. With his powerful but graceful hands, Christ cradles the cross, and the separated index fingers direct us first to the cross and then heavenward. Christ presents us with the symbols of his Passion—the tangible recollection of his earthly life and suffering. In placing them before us, we are encouraged to reflect on his sacrifice and on the means of our redemption.

. . . excessively broad hips rise above a pair of peculiarly tapered and spindly legs. . . .

Behind Christ and barely visible between his legs we see the cloth in which Christ was wrapped when he was laid in the tomb. He has just shed the earthly shroud; it is in the midst of slipping to earth. In this suspended instant just prior to his ascension, Christ is completely and properly nude. If we look with the eyes of the faithful, it is possible to see marble transformed into flesh, a statue into action, the resurrected Christ ascending. This is how Michelangelo carved an apparition from marble.

We must imagine how the figure must have appeared in its original setting, within the darkened confines of an elevated niche. Christ steps forth, as though from the tomb and the shadow of death. Foremost are the symbols of the Passion, the relics that Christ will leave behind when he ascends to heaven. For centuries, the faithful have stroked and kissed the advanced foot of Christ, for like Mary Magdalene and the Doubting Thomas, they impulsively wish to verify the apparition before it disappears.

To carve a life-size marble statue of a naked Christ certainly was audacious, but it is also theologically appropriate. Michelangelo's contemporaries recognized, more readily than do we, that the *Risen Christ* was a moving and profoundly beautiful sculpture that was truthful to nature and to sacred history.

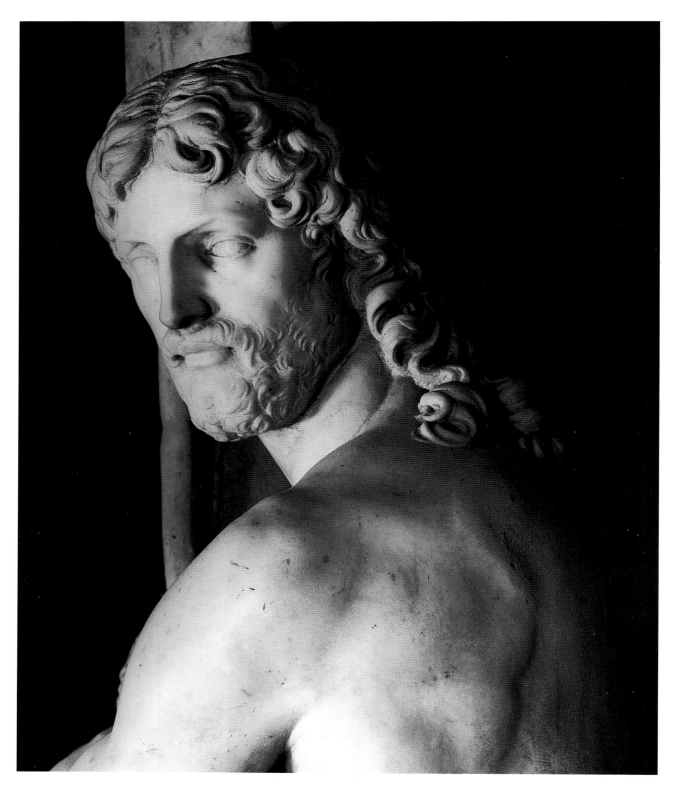

. . .The turned head is an eloquent and poignant means of rendering Christ inaccessible even as his corporeal reality is made manifest. . . .

THE MEDICI CHAPEL STATUES

◆ ◆ ◆

1520–1534 ◆ MARBLE ◆ SAN LORENZO, FLORENCE

TOMB OF GIULIANO, DUKE OF NEMOURS
GIULIANO: 5 FEET 8 INCHES HIGH
DAY: 6 FEET 8 ¾ INCHES ◆ NIGHT: 6 FEET 4¾ INCHES

TOMB OF LORENZO, DUKE OF URBINO
LORENZO: 5 FEET 10 INCHES HIGH
DAWN: 6 FEET 8 INCHES ◆ DUSK: 6 FEET 4¾ INCHES

Michelangelo carved eight marble sculptures for the Medici Chapel, and they must be considered together, as part of a single ensemble. The Medici Chapel was the first realization of Michelangelo's longstanding ambition to combine architecture, painting, and sculpture. The painting campaign was aborted, and the sculpture is only a fraction of what Michelangelo initially intended; nonetheless, the ensemble is a satisfying tomb complex and one of the artist's greatest masterpieces.

Michelangelo fashioned a lavish environment in which marble tombs project from the walls, and figures adorning those tombs appear to slip from their supports. There is no longer a clear barrier between art and spectator; the architecture is beladen with marble figures turned into luminous flesh spilling into available space. In photographs the larger-than-life sculptures appear to be situated approximately at eye level, but the actual experience of them is quite different; they are over our heads, and we are dwarfed, hushed, in their presence.

The two Medici dukes are seated in shallow niches above the sarcophagi that contain their remains. When Michelangelo was criticized for not creating more recognizable likenesses, the artist is supposed to have responded that no one would recall their appearance in a thousand years. Indeed, less than half that time has elapsed, yet the deeds of these minor Medici dukes have faded from memory, to be replaced by their powerful allegorical representations. Michelangelo has endowed them with greater fame in death than they ever enjoyed while living. It is common to see them not in terms of individual historical personalities but as allegories, a Miltonian pair: "l'Allegro" and "il Penseroso."

With a head of short, thick, disordered curls, an impossibly long neck, and directed gaze, *Giuliano* looks towards the *Madonna*, placed diagonally across the room, but also towards the chapel entrance. He is dressed in armor and a short, fringed skirt with leather boots turned down at mid-calf. His cuirass is decorated with a large feathered mask, ornamental strap-work, and leather-like epaulets. Michelangelo has invented a type of fantastic, skin-tight armor that simultaneously clothes and reveals the muscular torso. The invention had an amazingly long life, especially in mannerist painting and sculpture.

Lorenzo is majestic in his reflective calm. The legs are lightly crossed at the ankles, the pronated right arm rests against his thigh. The left elbow rests on a cashbox decorated with yet another animal face, and the left hand rests against his chin. From behind an extravagantly bent index finger and a hand lightly holding a bunched cloth, the blank eyes are directed towards the *Madonna* and into eternity.

Four nude allegorical figures recline on the curved sarcophagi lids. Traditionally, these represent *Day* and *Night*, *Dawn* and *Dusk*—a sort of figural meditation on time. Michelangelo has relied little on attributes (which identify only the *Night),* rather more on body language and different degrees of finish and polish to suggest their "characters."

The strangely muscular, masculinized body of *Night* is bent in impossible contortions; nonetheless, she maintains an air of perfect serenity. Poised ambiguously between sleep and wakefulness, she is more divine than human, more flesh than marble. Laborious polishing has given *Night* a subtlety of surface that is alluring, and seemingly alive. Michelangelo's contemporary, Giovanni di Carlo Strozzi, wrote a poem suggesting that one could touch and wake her, to which the artist replied rather more curtly:

Dear to me is sleep and better to be stone,
So long as shame and sorrow is our portion.
Not to see, not to feel is my great fortune;
Hence, do not wake me; hush, leave me alone.

The polished sheen of her skin evokes the mysterious radiance of moonlight. She is surrounded by symbols that suggest darkness, sleep, and death—a lunar diadem, a large bunch of poppies, an owl, and a mask, which is really a mask within a mask, sockets within hollow sockets, all strangely animated.

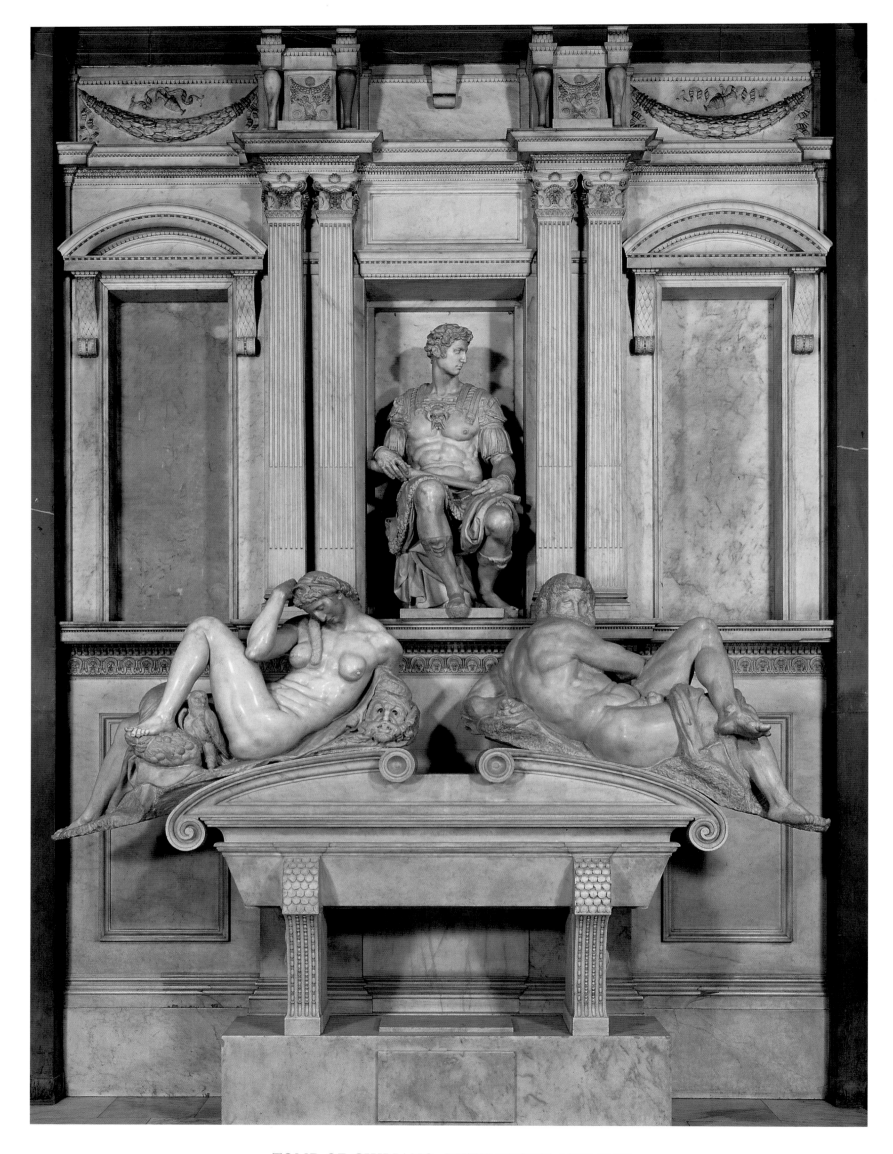

TOMB OF GIULIANO, WITH NIGHT AND DAY

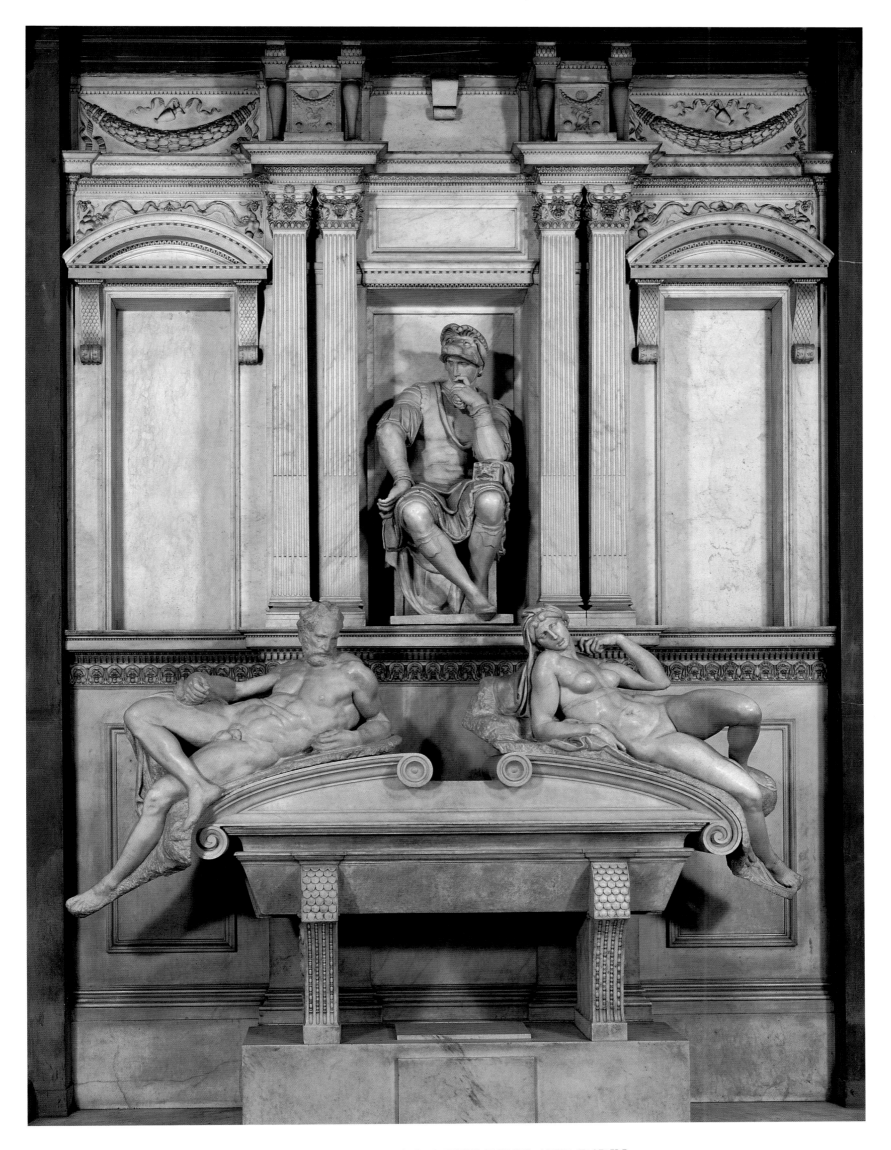

TOMB OF LORENZO, WITH DUSK AND DAWN

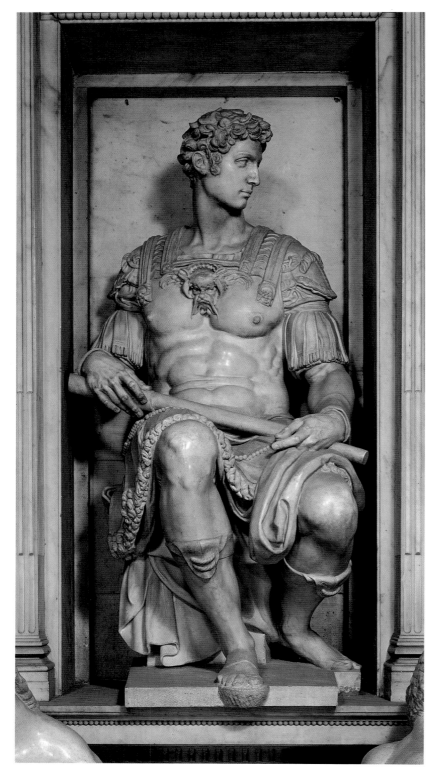

Day is the most muscular and impossibly contorted of the four sarcophagus figures. As with the figure of *Night*, Michelangelo has invented a pose of contrapuntal limbs not replicable in real life. The extreme convolutions result in a flexing of all muscles and even the distension of veins in the twisted left forearm. Like the sun rising behind a promontory, the haunting visage of *Day* looks out from behind a massive right shoulder. The unfinished head is a means to suggest in stone the indeterminacies of light, the ambiguity of time.

A similar use of the expressive potency of the unfinished (*non-finito*) is exploited in the head of *Dusk*. The rough-cut facial features contrast with the polished surfaces of the body. The eyes staring from under hooded brows and the taut line of the mouth give the face an expression unattainable in a more "finished" work. Note too how the hands and feet are less polished than other surfaces, and appear ready to sink back into the unworked marble block. In details such as these, every stroke is reconstructible; we can feel, even hear, the chisel biting the stone.

In contrast, the smooth limbs of *Dawn* slide glacier-like down the curved surface of the sarcophagus lid. It seems impossible that she should maintain her precarious perch or that the lower portions of the block do not break and fall away. Although carved without obvious attributes, the lifting of the cloth veil from her head and shoulders suggests inchoate light emerging from under the cloak of darkness. One of those inexplicable bands, like those that bind but do not restrain the Louvre slaves, crosses her thick, masculinized chest. The vacant eyes under architectonic brows and the open but equally vacant mouth leave us suspended between emotions, somewhere between silence and speech, like dawn, between dark and light.

ABOVE:

. . . With a head of short, thick, disordered curls, an impossibly long neck, and directed gaze, GIULIANO *looks towards the* MADONNA *but also towards the chapel entrance. . . .*

RIGHT AND OPPOSITE:

. . . an owl, and a mask, which is really a mask within a mask, sockets within hollow sockets, all strangely animated. . . .

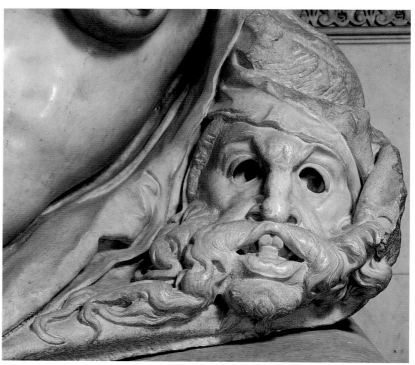

Michelangelo carved the marbles on heavy wooden tables which gave him access to all parts of the irregular blocks. Nonetheless, he had to keep in mind the figures' high placement, visualizing how they would be seen from below and in the context of a multi-figure funerary complex. Michelangelo generally worked with a wide-headed wood mallet and three chisels: a point for the rough and rapid working of the raw block, a coarse claw chisel for the majority of figural carving, and a multi-tooth claw chisel *(gradina)* for the penultimate layer before polishing. Polishing was a punishing chore, carried out with pumice and grit, infinite patience, and lots of sweat. It could take weeks, and most of it had to be done by Michelangelo himself. Only he could achieve the subtle variations in the surfaces of flesh, hair, and drapery. He knew best how to exploit the unfinished surfaces to suggest a finished figure.

Once again, as in the Julius tomb, Michelangelo has created masterpieces of "minor" sculptures. As any visitor to the chapel can easily confirm, the four tomb allegories dominate our attention; they are the essence of the Medici Chapel and are close to our notion of the genius of Michelangelo. It is a testament to the unerring power of Michelangelo's conception that we sense a complete and satisfying work of art even from such fragments of the artist's initial conception.

Despite its so-called unfinished state, the Medici Chapel both honors the dead and speaks eloquently of the political ambition and dynastic claims of the powerful Medici family. Michelangelo's transcendent art ensured their immortality. At the same time, the chapel moves us to more universal reflection on the transience of earthly life and fame.

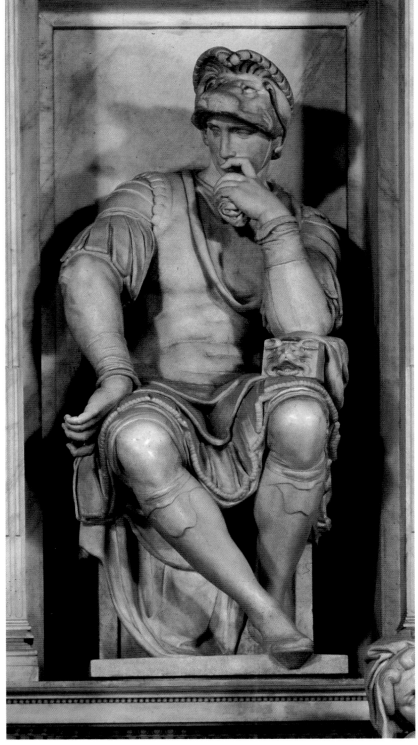

ABOVE:

. . . LORENZO *is majestic in his reflective calm. . . .
From behind an extravagantly bent index finger
and a hand lightly holding a bunched cloth,
the blank eyes are directed towards
the* MADONNA *and into eternity. . . .*

OPPOSITE:

. . . *The strangely muscular,*
masculinized body of NIGHT
is bent in impossible contortions;
nonetheless, she maintains
an air of perfect serenity.
Poised ambiguously between
sleep and wakefulness,
she is more divine than human,
more flesh than marble.
Laborious polishing has given
NIGHT *a subtlety of surface*
that is alluring, and seemingly
alive. . . .

RIGHT:

. . .*The extreme convolutions result*
in a flexing of all muscles and
even the distension of veins in the
twisted left forearm. Like the sun
rising behind a promontory, the
haunting visage of DAY *looks out*
from behind a massive right
shoulder. . . .

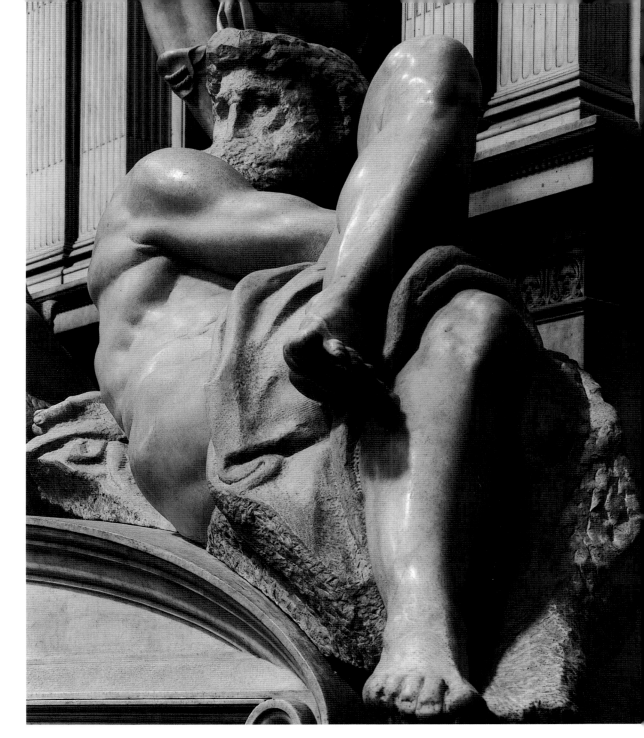

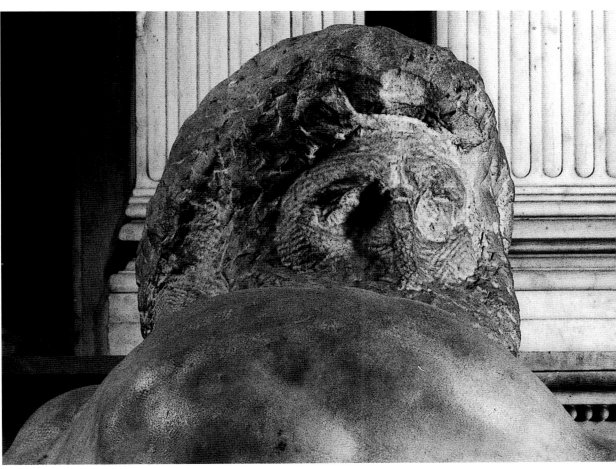

SCULPTURE

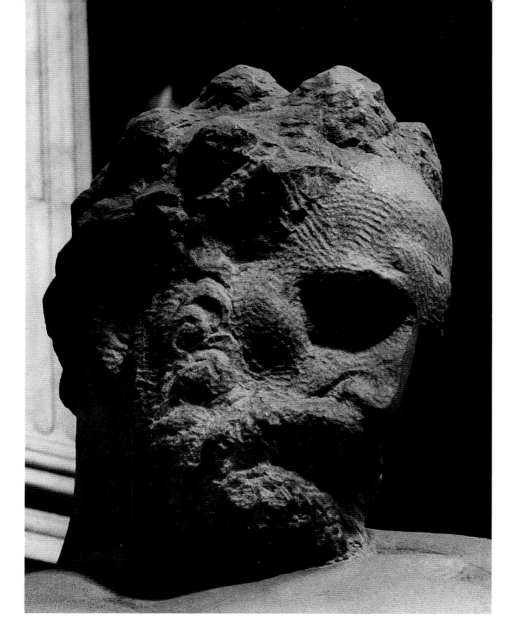

LEFT AND BELOW:

. . . non-finito is exploited in the head of DUSK. *The rough-cut facial features contrast with the polished surfaces of the body. The eyes staring from under hooded brows and the taut line of the mouth give the face an expression unattainable in a more "finished" work. . . .*

OPPOSITE PAGE:

. . . the smooth limbs of DAWN *slide glacier-like down the curved surface of the sarcophagus lid. It seems quite impossible that she should maintain her precarious perch or that the lower portions of the block do not just break and fall away. Although carved without obvious attributes, the lifting of the cloth veil from her head and shoulders suggests inchoate light emerging from under the cloak of darkness. . . .*

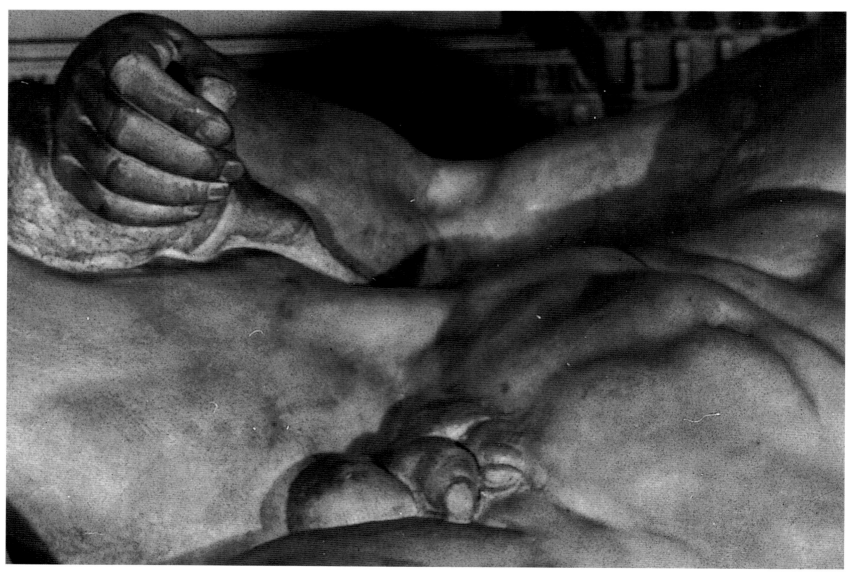

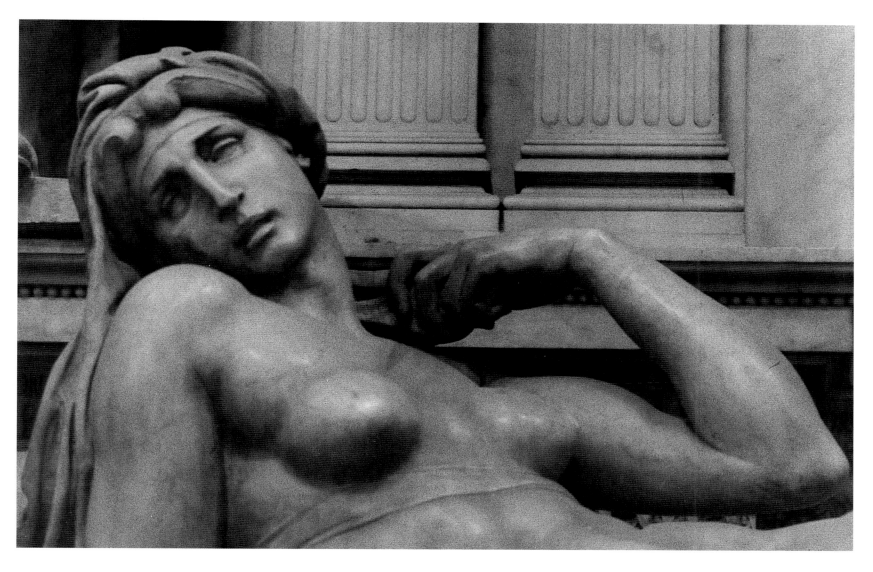

THE CROUCHING BOY

◆ ◆ ◆

C. 1530 ◆ MARBLE ◆ 22 INCHES HIGH ◆ HERMITAGE MUSEUM, ST. PETERSBURG

Another figure that probably belongs to the Medici Chapel but was never installed, is the so-called *Crouching Boy* now in the Hermitage Museum in St. Petersburg. The marble was probably intended to crown the entablature of one of the tombs, thereby contributing to the figural density of the ensembles. But as with many other good ideas—like the rivergods (never carved) or the marble trophies (now in the entrance hall to the Medici Chapel)—the *Crouching Boy* is sculptural residue from Michelangelo's fecund marble imagination. The compact figure inevitably reminds one of Rodin, perhaps the greatest student of Michelangelo's unfinished ideas.

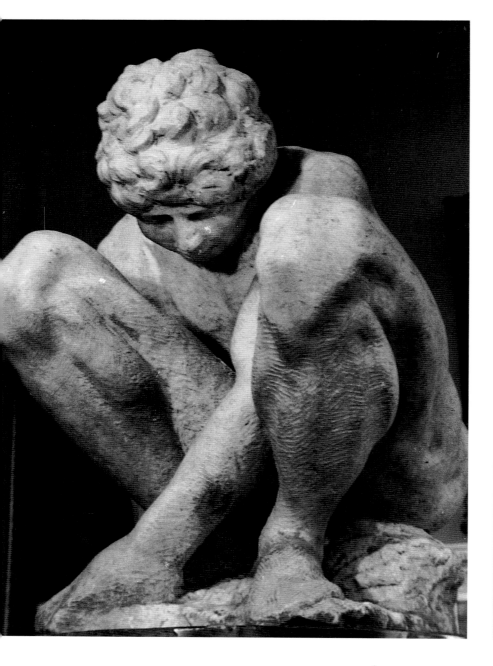 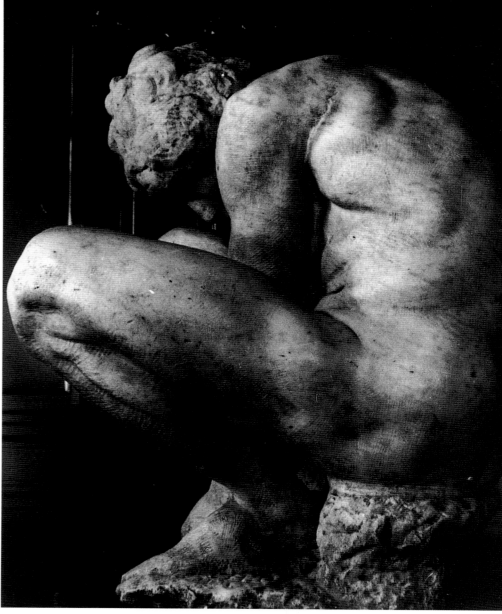

. . . the CROUCHING BOY *is sculptural residue from
Michelangelo's fecund marble imagination. The
compact figure inevitably reminds one of Rodin . . .*

MADONNA AND CHILD

❖ ❖ ❖

1524–1534 ◆ MARBLE ◆ 7 FEET 5¼ INCHES ◆ MEDICI CHAPEL, SAN LORENZO, FLORENCE

Michelangelo left this marble group of a Madonna and her child unfinished in his Florentine studio when he departed for Rome in 1534. Although it was not installed until years later, the marble was probably intended for the Medici Chapel, as the centerpiece for the never executed tomb of the Medici princes.

The Virgin is seated with her left leg crossed over her right. Straddling the raised leg is the large, muscular child who turns away from us, seeking his mother's breast. Michelangelo has depicted an unusual moment, for the child is neither suckling nor is he comfortably situated on his mother's leg; instead he is shown in mid-action, uncomfortable and unfulfilled. While the child's torsion suggests a sort of restless movement, it contrasts markedly with the distant, immobile mother.

The two figures engage in a lovely gestural counterpoint, each with a hand on the other's shoulder. The counterclockwise turn of the child is matched by a less violent opposing clockwise motion of the mother. Her left shoulder is forward and hunched down, as if she were offering herself to her child, and her right arm rests on the rear of her seat,

as if counterbalancing his weight.

Similar to the Christ of the early *Madonna of the Stairs*, the child is enfolded in the protective embrace of his mother, yet, at the same time, their contact is more physical than emotional. As if prescient of the destiny of her child, the mother gazes vacantly into space, classically beautiful but infinitely remote. Her indistinct, slightly out of focus mood is accentuated by the web of chisel marks on her unpolished face. Literally and figuratively we see as through a gauzy veil.

Michelangelo studies a portion of this composition in a large drawing in the Casa Buonarroti. We naturally but not always correctly assume that a drawing is a preliminary step in the carving of a sculpture. In this case, the drawing may well have been made *while* Michelangelo was carving his figure. The artist generally worked by excavating the front face of a block. The projecting knee of the Madonna, the child's legs, and his muscular right shoulder therefore would have been the first elements to emerge from the raw stone. At this point, Michelangelo was viewing his composition blindly, so to speak, with the back of the child visible but the important faces and hands still deep within the unfinished marble. The placement of the hands in the drawing seems to have served as eyes for his chisel, an attempt to visualize his way into the stone.

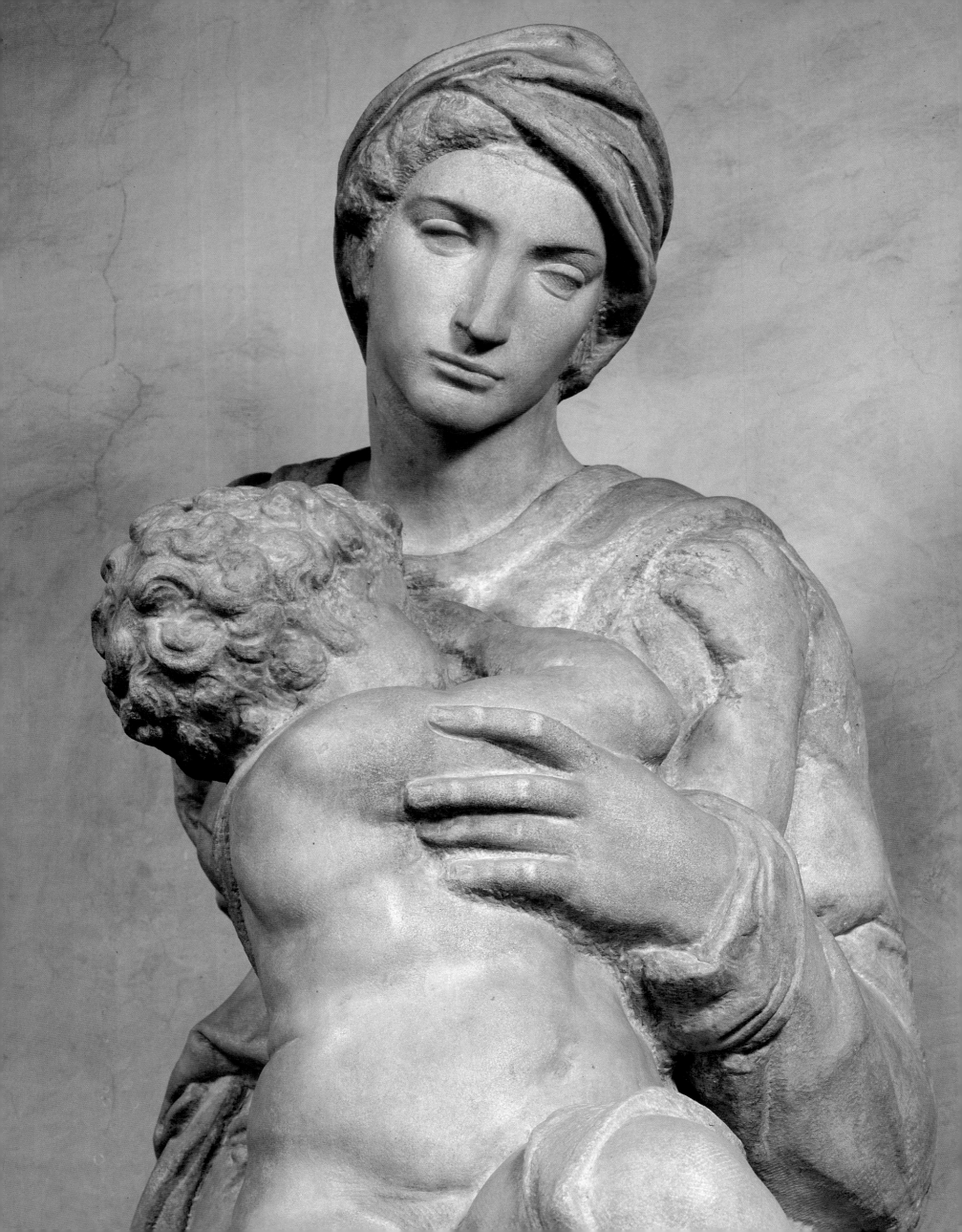

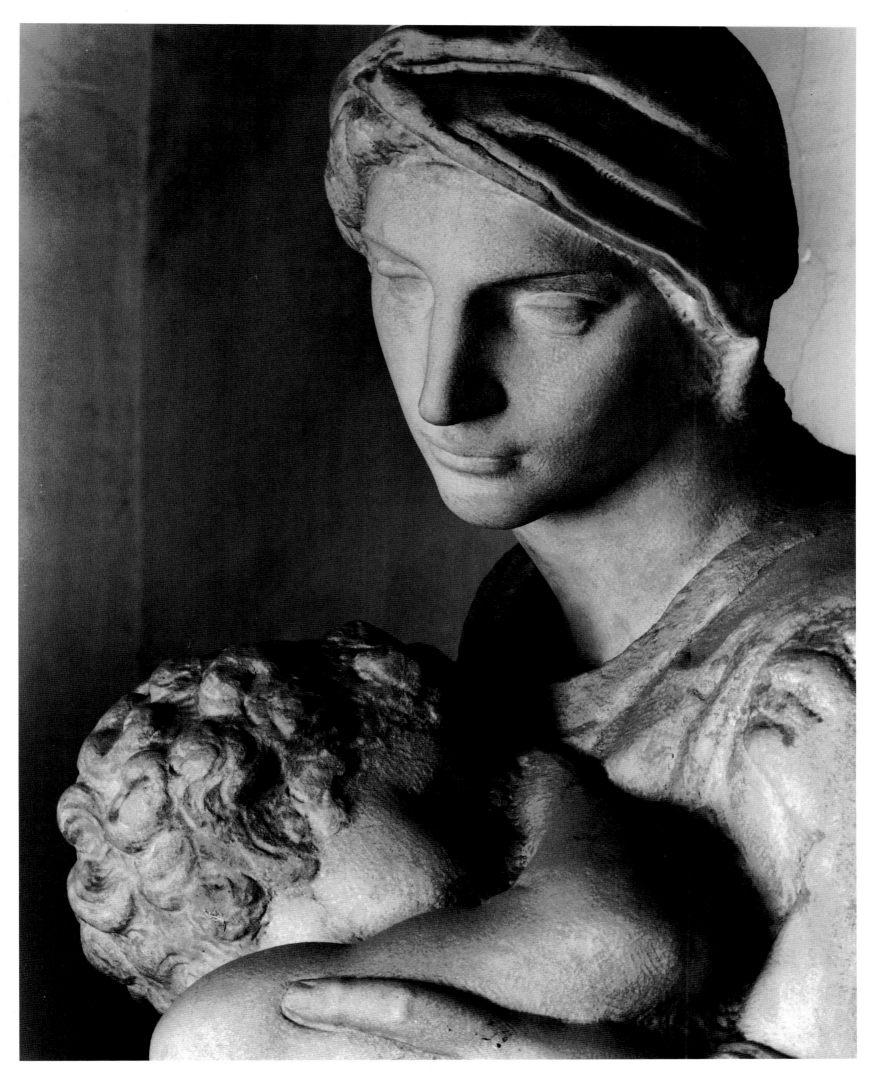

. . . The projecting knee of the Madonna, the child's legs, and his muscular right shoulder, therefore, would have been the first elements to emerge from the raw stone. . . .

SCULPTURE

HERCULES AND CACUS

♦ ♦ ♦

C. 1525–1528 ♦ CLAY MODEL ♦ 16½ INCHES HIGH ♦ CASA BUONARROTI, FLORENCE

While Michelangelo occasionally reverted to drawing to help him resolve problems of design, he normally used small three-dimensional models in wax and clay for his "sketching." A rare and fascinating survivor of this common practice is found in the Casa Buonarroti. The model was made in response to a commission that Michelangelo received during the Last Republic to carve a marble *Hercules* as a pendant sculpture for his *David* in the Piazza della Signoria. Now, some twenty years after that early triumph, Michelangelo's ambition was to create a complicated, two-figure composition of struggling forms. The twisted and entwined figures of the Casa Buonarroti model suggest satisfying views from all angles. It must have been one of the greatest disappointments of his life when the commission was taken from Michelangelo and given to his rival, Baccio Bandinelli. From the beautiful block of marble, Bandinelli carved his *Hercules and Cacus*—a bloated pomposity that still stands opposite the copy of Michelangelo's *David* on the Florentine piazza.

. . . Michelangelo's ambition was to create a complicated, two-figure composition of struggling forms. The twisted and entwined figures of the Casa Buonarroti model suggest satisfying views from all angles. . . .

THE VICTORY

◆ ◆ ◆

C. 1525–1530 ◆ MARBLE ◆ 8 FEET 7½ INCHES HIGH ◆ PALAZZO VECCHIO, FLORENCE

Although Michelangelo never carved his sculpture for the Piazza della Signoria, some of the ideas expressed in the Casa Buonarroti clay model were realized in the *Victory*. An immensely tall youth dominates an older man whose bent and folded form is crouched uncomfortably below the youth's left knee. While only roughly finished, it is evident that the bearded man is dressed in the short leather skirt and leggings of a soldier. The specificity of this figure contrasts with the idealized, allegorical character of the youth; a brutish captive conquered by a modern Nike.

The extravagant twists of the youth's elongated body are well beyond the realm of possibility; no person is capable of imitating this pose. The proportions of the youth, especially the small head atop the elongated body, are made even stranger by our *di sotto in su* viewing of the sculpture. As was often the case in the Medici Chapel figures or the *ignudi* on the Sistine ceiling, Michelangelo prompts us to accept as "natural" an utterly unlikely anatomy and completely impossible contortions of the human body. We see, for example, the front and back of the youth's torso simultaneously. With an easy grace that belies the extreme torsion of the body, the victor glances over his shoulder and lightly fingers a strap that crosses the shoulder and supports an immense billow of improbable drapery behind.

Given the multiple satisfying views, it is impossible to determine what is the "front" of the sculpture. Like the *Bacchus, David,* or the Louvre slaves, the *Victory* encourages us to circle the group, but unlike those earlier sculptures, there is no place where the statue "composes" itself, no relaxation to the continuously restless movement.

We don't know the purpose of the sculpture, how it was to be displayed or viewed, or what it means. While such uncertainties do not completely surprise us about Michelangelo, these are not normally the case with most Renaissance sculptures. Although it is likely that there was an ostensible destination—most scholars assume it was made for the tomb of Pope Julius II —the *Victory* never left Michelangelo's studio. Here again, as throughout his life, Michelangelo carved a unique sculpture, with few precedents and few concessions to convention, unfinished and ultimately not entirely explicable. It is simultaneously strange and beautiful, allusive and elusive.

. . . An immensely tall youth dominates an older man whose bent and folded form is crouched uncomfortably below the youth's left knee. . . .

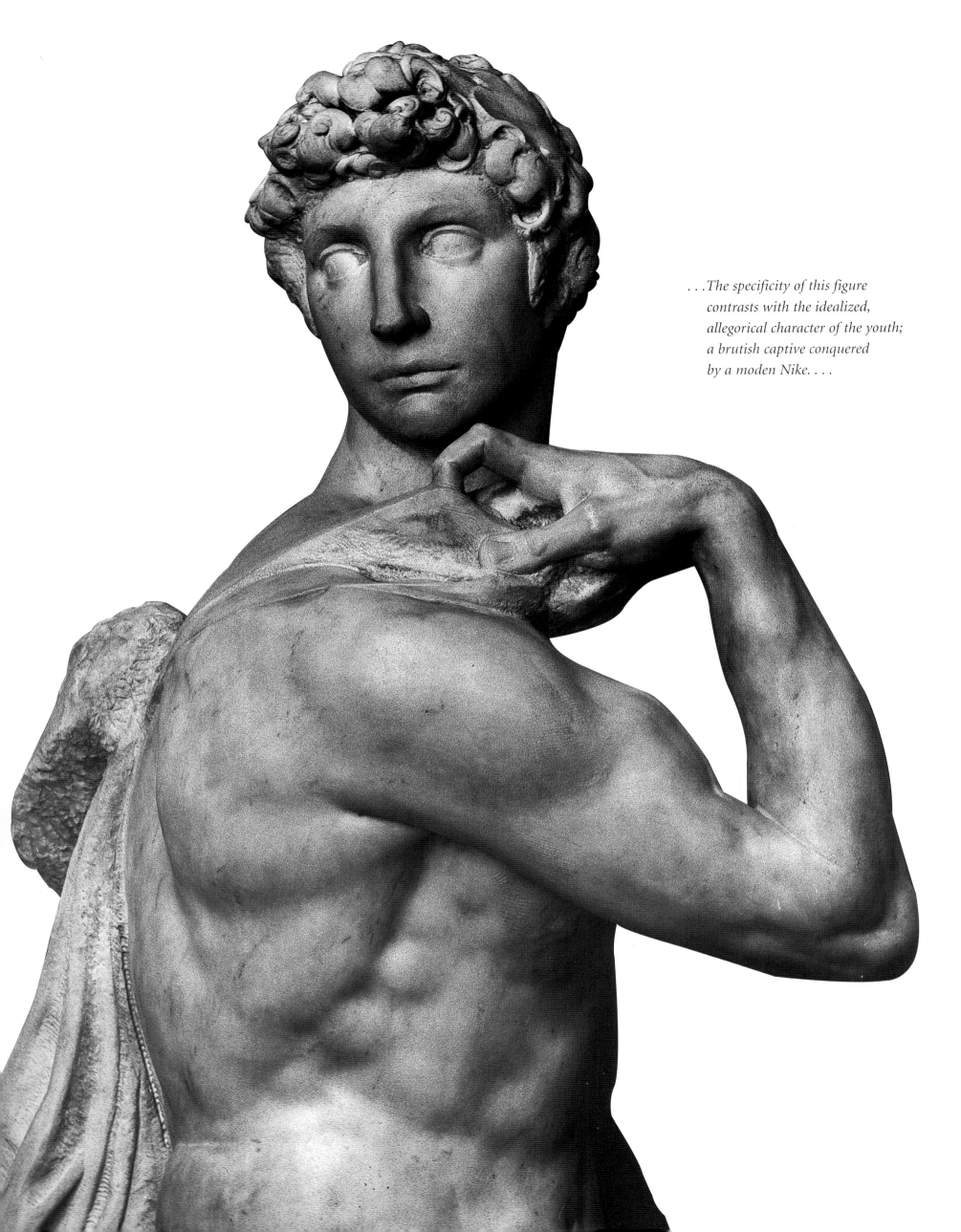

...*The specificity of this figure contrasts with the idealized, allegorical character of the youth; a brutish captive conquered by a moden Nike....*

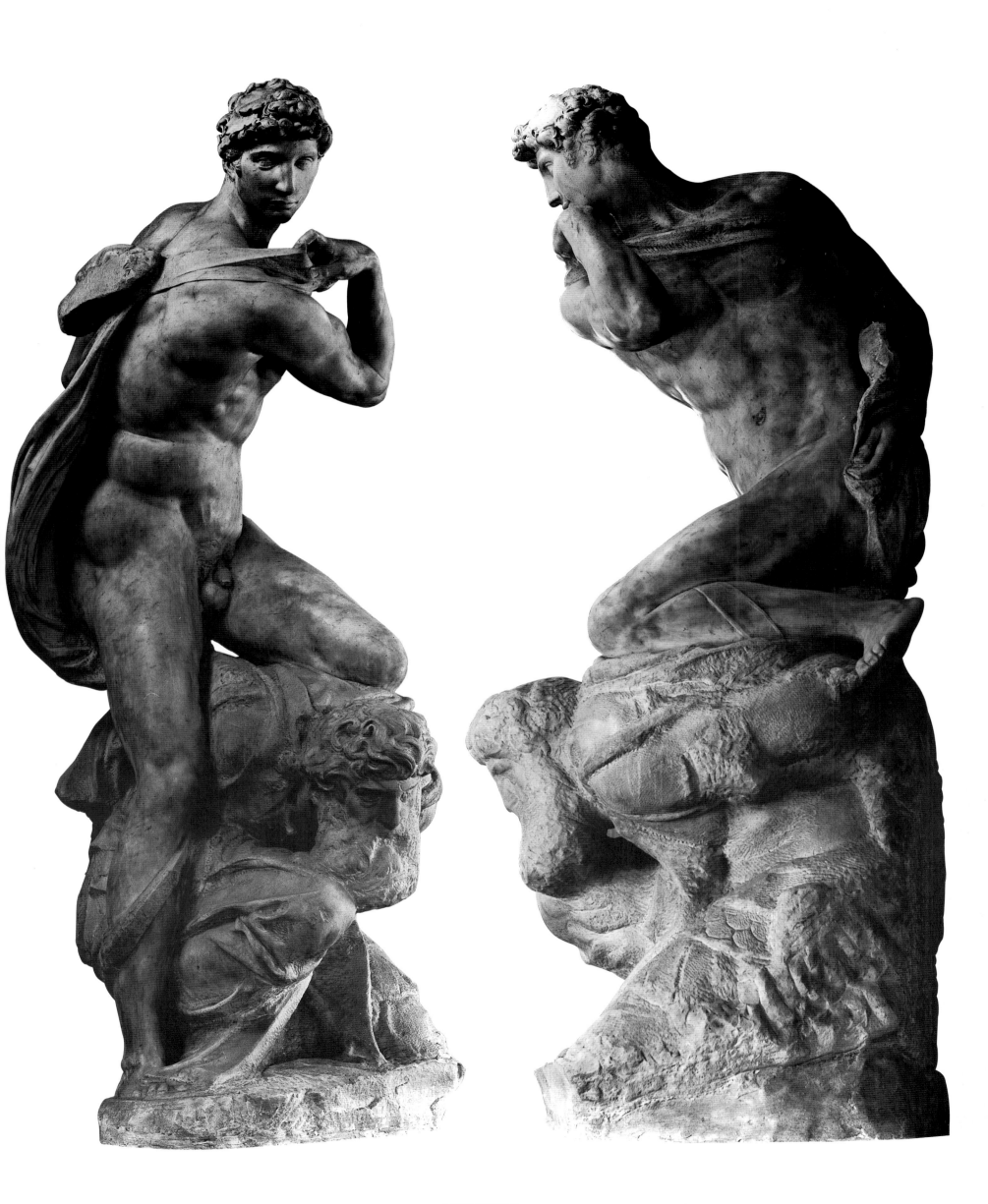

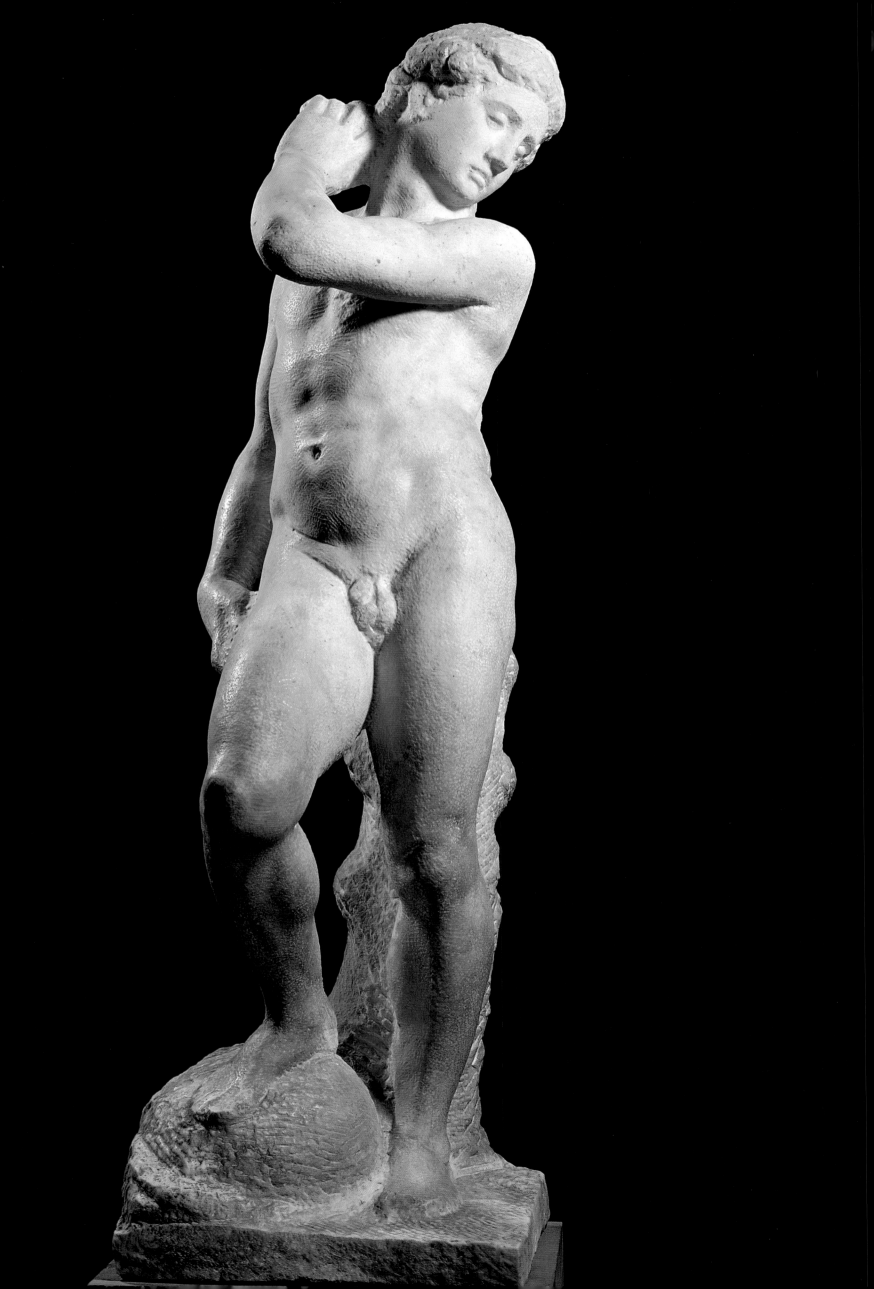

APOLLO/DAVID

◆ ◆ ◆

C. 1530 ◆ MARBLE ◆ 4 FEET 10½ INCHES HIGH ◆ BARGELLO MUSEUM, FLORENCE

Following the collapse of the Last Florentine Republic in 1530, Michelangelo was suddenly in great demand and obliged to satisfy requests from a number of insistent patrons. For the much feared temporary governor of Florence, Baccio Valori, Michelangelo began this small marble, but, as with so many other works, it was never completed and never delivered.

The *Apollo/David* is a less extravagant essay in *contrapposto* than the *Victory,* but in some ways no less ambiguous. As with the *Victory,* it is not possible to definitively resolve the iconography of the statue, although the range of interpretative possibilities is narrower. The figure is either a David or an Apollo, depending on how one reads the unfinished lumps of stone on the figure's shoulder and under his right foot: a quiver would argue in favor of Apollo; a head underfoot would render it David. That the sculpture can be either a pagan god or a biblical hero with the merest alteration of an attribute is testament to Michelangelo's reconciliation, or rather fusion, of classical antiquity and Christianity. The primary element of the sculpture—the standing nude youth— is precisely the same in either case.

Recalling the earlier experiments of the *St. Matthew,* one leg and one arm are raised; the other hangs at the right side and appears to grasp something. The extreme cross-body gesture of the left arm and the turned head recall the movement of the *Risen Christ,* but without the heroic proportions and smooth finish of that earlier work. Moreover, a gossamer web of chisel marks reminds us of the figure's unfinished status, in the penultimate stage of definition.

Neither David nor Apollo adequately accounts for the direction and reflective quality of the figure's demeanor. The downward tilt of the head, the sinuous movements of the body, and the complete nudity give the sculpture an ambiguous air: modest, serene, and sensual—a contrast with the potentially violent subject matter. In its highly refined pose, the figure is more a work of art than the subject of a story.

. . . The APOLLO/DAVID *is a less extravagant essay in* contrapposto *than the* VICTORY, *but in some ways no less ambiguous. . . .*

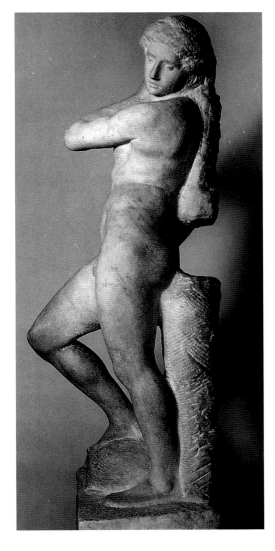

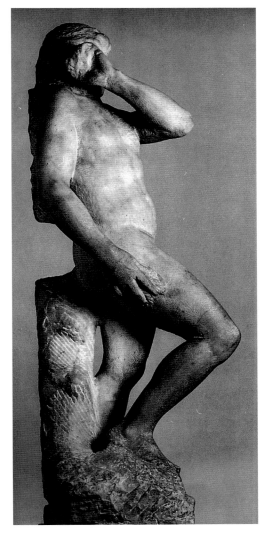

. . . one leg and one arm are raised; the other hangs at the right side and appears to grasp something. . . .

BUST OF BRUTUS

◆ ◆ ◆

C. 1542 ◆ MARBLE ◆ 29½ INCHES HIGH ◆ BARGELLO MUSEUM, FLORENCE

The bust of *Brutus* is Michelangelo's only true essay in portraiture, that is, if we accept that a portrait can represent someone who has been dead for fifteen hundred years. The tyrannicide is dressed in a toga-like cloak that is fastened by a large, figurated brooch on the right shoulder. The head is turned sharply to the left revealing the taut muscles of the thick neck. The powerful, frowning countenance and the directed gaze are enhanced by the rippling eyebrows, deep-set eyes, and firmly pressed lips. The mat of close-cropped hair contrasts with the comparative smoothness of the face and drapery. Each is textured by the working of the stone to differing degrees of finish, from the lumpy rawness of the hair to the exquisite net of parallel chisel marks that help to describe the woven fabric of the cloth. There is clearly nothing unfinished about these passages; the hard stone is carved to illusionistic ends; at the same time the material is never denied.

Clearly Michelangelo has utilized the unfinished, or rough-finish, as a technique of representation. The reality and immediacy of the powerful figure, somewhere between life-size and colossal, is enhanced by the roughened surfaces. One might even read them as an analogue to Brutus himself; a man of principles and action, fashioned in the rough-hewn era of Republican Rome. Michelangelo has invented his own version of a "Republican" style, different from the slick finish and soft sensuality of Greek Hellenism or Roman imperialism.

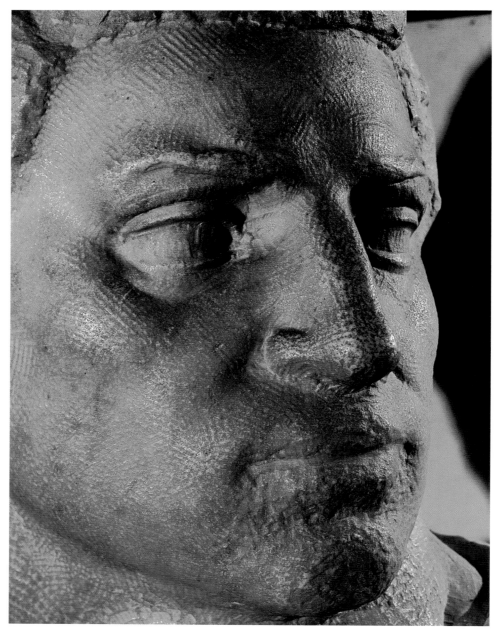

Curiously, the bust was inspired by an imperial portrait of the emperor Caracalla; this is yet one more instance of how Michelangelo fashioned originality from the inherited past.

As with so many of Michelangelo's works, antiquity is a catalyst for his art, an articulate language that he forges ahead according to his own will. While the *Brutus* is the epitome of the republican hero, he would never be mistaken for an ancient sculpture: it is more classical than much of ancient art.

. . . The powerful, frowning countenance and directed gaze are enhanced by the rippling eyebrows, deep-set eyes, and firmly pressed lips. The mat of close-cropped hair contrasts with the comparative smoothness of the face . . .

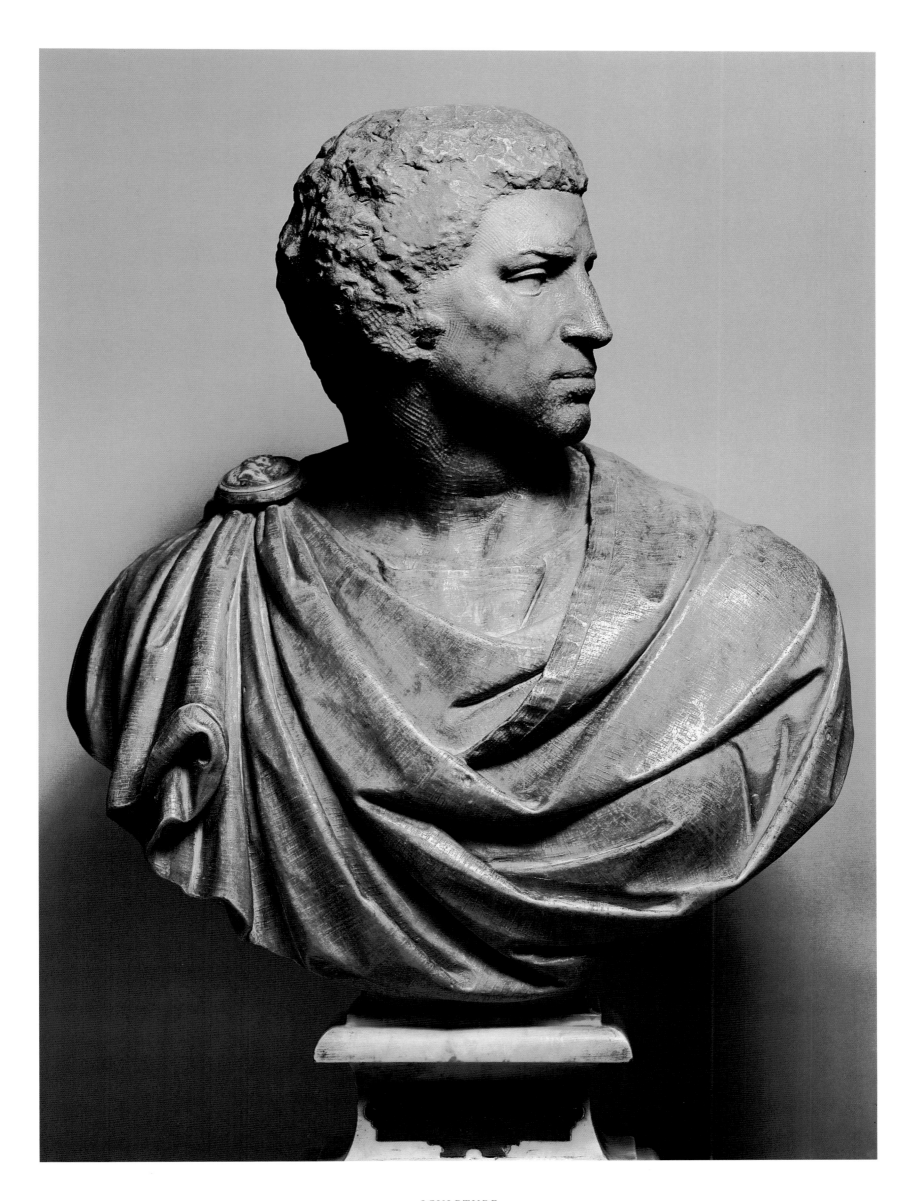

THE FLORENTINE PIETÀ

◆ ◆ ◆

C. 1547–1555 ◆ MARBLE ◆ 7 FEET 8 INCHES ◆ MUSEO DELL OPERA DEL DUOMO, FLORENCE

Michelangelo carved the *Florentine Pietà* to be his own funerary marker. Vasari, who evidently did not understand why Michelangelo never completed the sculpture, fabricated a tale of how the artist, frustrated with the quality of the stone and irritated by the persistent nagging of his servant, took a hammer to the work. Scholars too have speculated at length on the reasons why Michelangelo damaged and then abandoned a work of such obvious personal importance. Perhaps that is the very issue; to carve one's own tomb memorial is to confront, in inescapable fashion, one's mortality. To finish the sculpture was to bring the marble to life, but also to leave its creator without further purpose.

Returning to the theme of the *Rome Pietà* and to the challenge of carving more than one figure from a single block, Michelangelo has created a four-figure group. It is the most ambitious and complicated of his sculptures, and herein may lie the seeds of his eventual dissatisfaction. How was it possible to realize from the limited stone four figures in proper relation and proportion to one another, and all composed in a manner that would be artistic and meaningful?

We know that Michelangelo tended to change his mind in the course of carving. He had even learned to quarry extra large blocks so that he would have sufficient material to change the form and disposition of figures as he carved. But where is the excess stone of the *Florentine Pietà*? The Virgin is already too small in comparison to the Christ and the standing figure of Nicodemus. In fact, there really is not enough stone left to finish her face without compromising the more realized head of her dead son. Similarly, Michelangelo has not

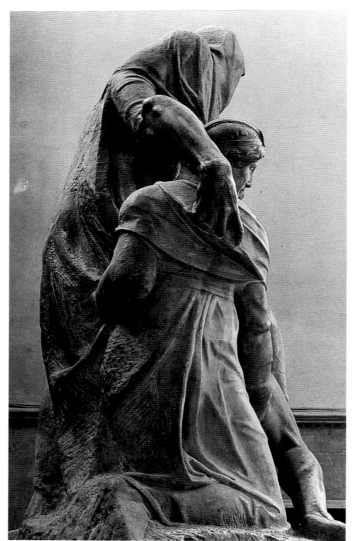

left sufficient stone to finish carving the Virgin's hand which helps to support Christ. To complete it is to disfigure the already finished and polished torso on which it rests. And then Michelangelo encountered an even more intractable problem in carving Christ's left leg. Whether the marble broke or was purposefully removed, the leg has been trimmed in order to receive an attachment. Such an expediency was contrary to Michelangelo's notion that true sculpture is created by a process of removal from a single block. These are the sorts of problems whose accumulative effects may have resulted in his abandoning the sculpture. We perhaps are reluctant to imagine the mature master meeting potentially irreconcilable problems, but it seems we are witness to a combination of personal and technical impediments that plagued this sculpture.

What is most remarkable is that most visitors fail to notice that Christ is missing a limb. Even when the absent leg is noted, few people are disturbed by Christ's dismembered state; the sculpture is still moving and acceptably complete. Although Michelangelo could not have been happy with the group's imperfect condition, it is to us still a masterpiece.

There is nearly unanimous agreement that the hooded figure behind Christ is a self-portrait of the aging artist, probably in the guise of Nicodemus. Nicodemus was himself a sculptor, and was a secret follower of Christ. Michelangelo's hooded figure, and the unpolished features of the face, suggest the veil of night under which Nicodemus revealed his faith. Once again, Michelangelo has employed the *non-finito* for expressive ends. In these features, Michelangelo has carved his autobiography. Like Nicodemus who revealed himself

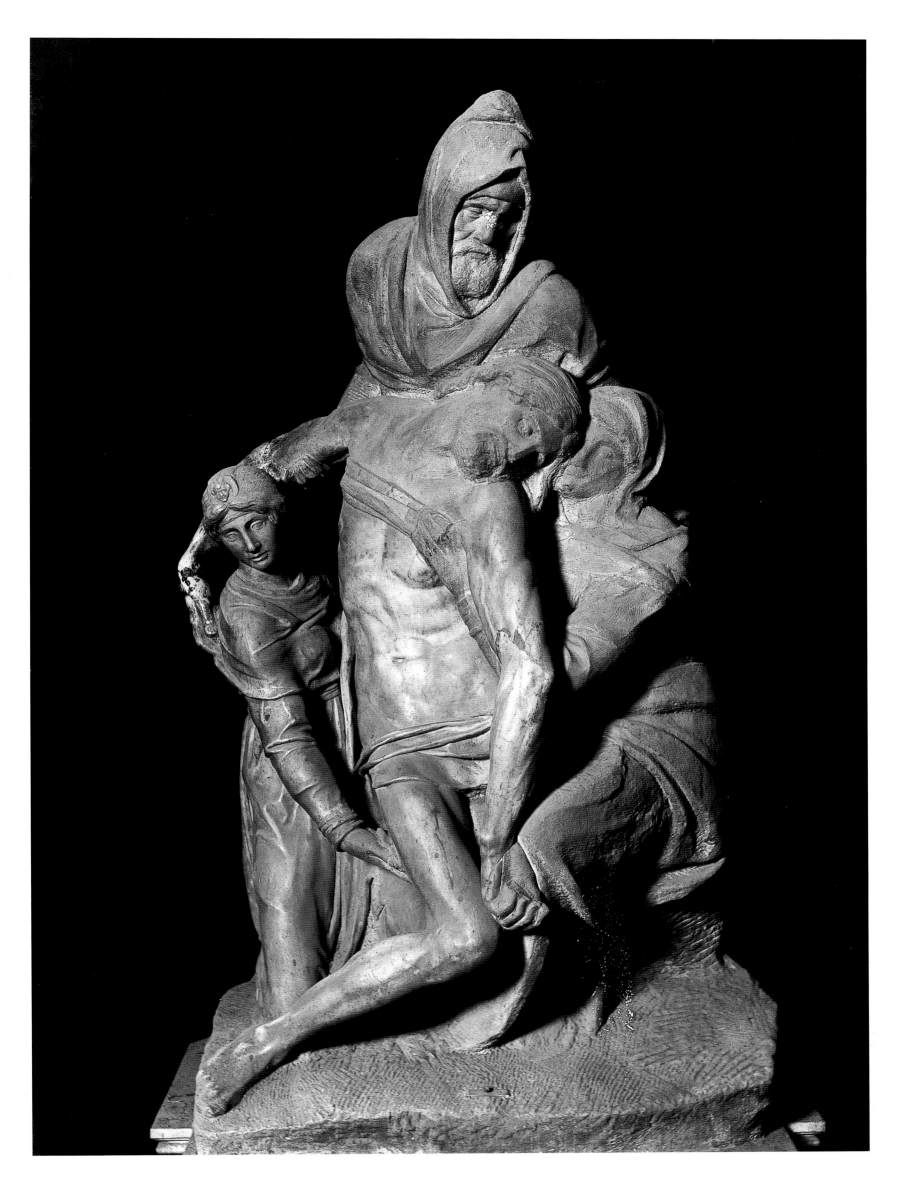

in the hour of Christ's need, Michelangelo here declares himself devoted to his savior, yet cloaked and in someone else's guise.

In these years, Michelangelo composed a deeply autobiographical poem that, like the sculpture, passed through many drafts and had to be coaxed into being. The sculpture and the poem, in marble and words, reveal Michelangelo's acute consciousness of the transitoriness of life and the futility of finishing one more work of art:

> Arrived at last is the course of my life
> Through stormy seas, as in a fragile barque I toss
> To the common port which all must cross
> To render up accounts of good and evil.

> Whence now I know how fraught with error still
> Was the fond imagination which made of art
> My idol and my monarch, and how vain that
> Which every man despite himself desires.
> Those amorous thoughts, once joyous, those frivolous fires,
> What now? If toward a double death I draw?
> One certain, I know, the other menacing me?

> Painting nor sculpturing no more will allay
> The soul turned toward that divine love at last
> Which opened to us its arms upon the cross.

Michelangelo was either unable or reluctant to finish his own tomb marker, but in so doing perhaps sculpted his own epitaph.

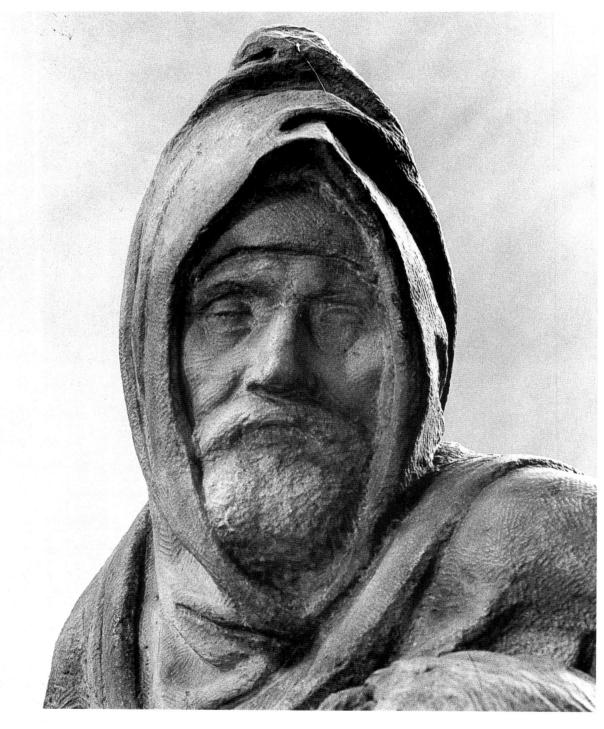

. . . There is nearly unanimous agreement that the hooded figure behind Christ is a self-portrait of the aging artist, probably in the guise of Nicodemus. . . .

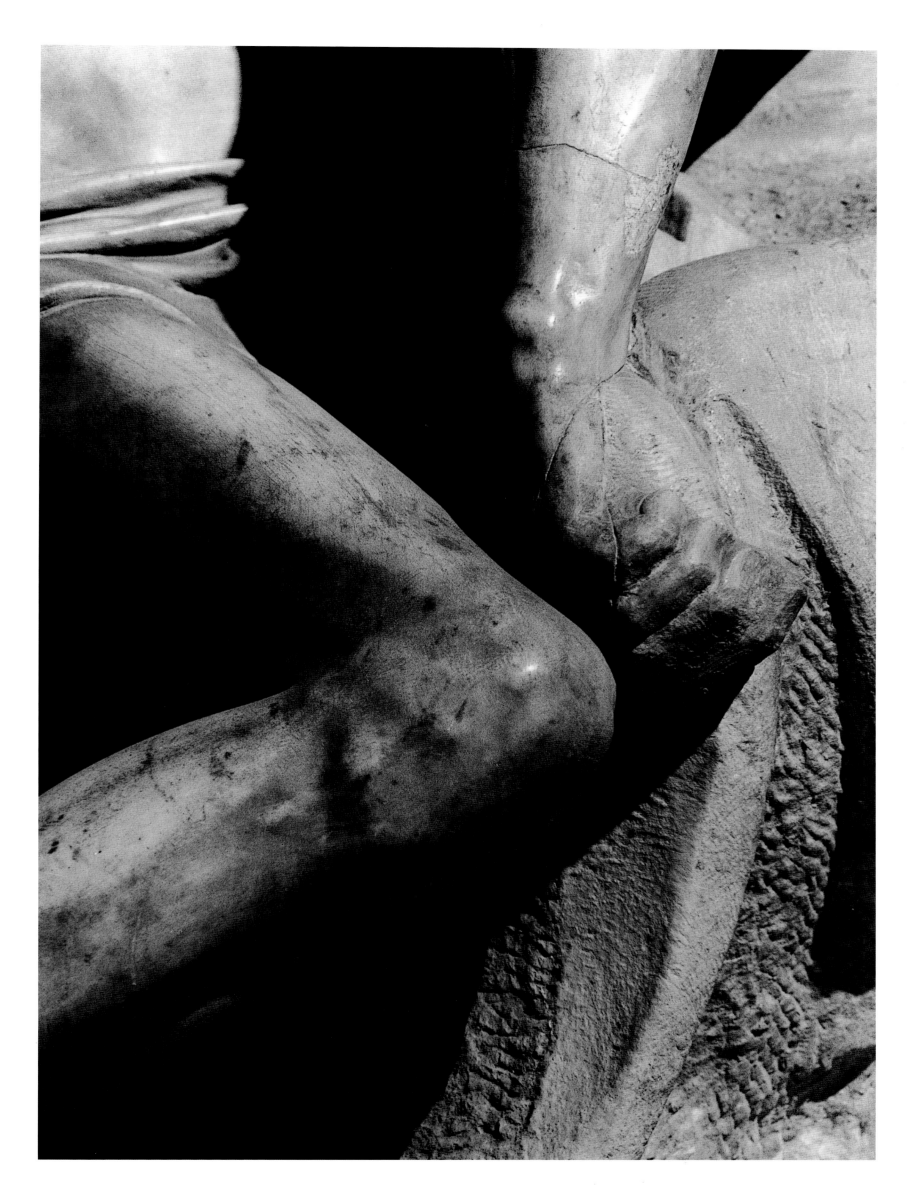

THE RONDANINI PIETÀ

◆ ◆ ◆

C. 1556–1564 ◆ MARBLE ◆ 6 FEET 3⅝ INCHES HIGH ◆ CASTELLO SFORZESCO, MILAN

In the last days before his death, just shy of eighty-nine years of age, Michelangelo was carving this marble group, known as the *Rondanini Pietà,* named for the Roman palace where it long stood. There is no indication that the sculpture was intended for anyone but the artist himself. It is, indeed, the equivalent of Michelangelo's intensely personal and deeply religious late poetry, most of which he wrote as a form of private devotion and consolation. So too, it seems that carving was a form of prayer, a way of physically bringing Michelangelo closer to God, and closer to salvation through creation.

It is difficult to describe the subject of the sculpture: we call it a *Pietà* but it is radically different from the other two versions of the same subject carved by Michelangelo, and unlike anything else ever made. The mother stands on a rock and embraces but scarcely supports the dead weight of her child. Defying logic and gravity, Michelangelo's figures are suspended in an impossible composition and a timeless moment. The semi-standing pose and unfinished character of Christ lend him greater animation than might be expected of a dead, slumping body. Christ's head turns, and at least one eye appears to gaze towards his mother's hand resting on his shoulder. Their bodies fuse into one; they who once were of one flesh, become so again.

If one looks at the sculpture less poetically and less forgivingly, then one sees an artist with too little stone remaining to give each figure full definition. Michelangelo has carved and recarved, removing one idea after another until the image is almost entirely rubbed away. The evidence of the multiple changes is most obviously visible in the detached stalk of Christ's right arm. This haunting fragment attests a one-time larger, more muscular body. It is the ghostly remnant of an earlier composition. Curiously, as though it was now invisible to the artist, Michelangelo never bothered to remove it. It recalls some prehistoric cave painter who sees only the image currently being painted; all previous representations were no longer living, no longer relevant, no longer seen. Without the evidence of that truncated arm, we would scarcely imagine that Michelangelo had made so many radical changes while carving. It is eloquent testimony of the artist's restless, creative urges and relentless assault on the block. Rather than an anomaly, perhaps we should accept this as incontrovertible evidence of Michelangelo's usual working procedure.

A side view of the sculpture reveals the extent of Michelangelo's excavation of the block. The abstracted forms suggest a Brancusi bird or a curling tongue of flame (and in such living, rising forms reside the slimmest hope of resurrection). We are attuned and appreciative of such radical abstraction, but the artist surely saw the son of man,

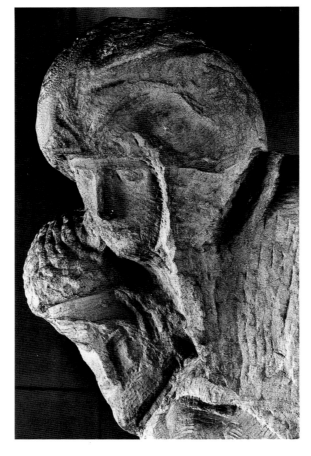

imagined his love for his Lord, and the loss to the mother of God. In rendering such a body, each chisel blow contributes to Christ's torment. The lacerated surface is a painful reminder of the mortification of his flesh. In the *Rondanini Pietà,* Michelangelo has carved a miracle, transforming stone first into flesh and then into spirit. Sculpture, the most physical of the arts, is made to express the ineffable. Through Michelangelo's art, we gain access to the central mystery of Christ's sacrifice.

. . . The lacerated surface is a painful reminder of the mortification of his flesh. . . .

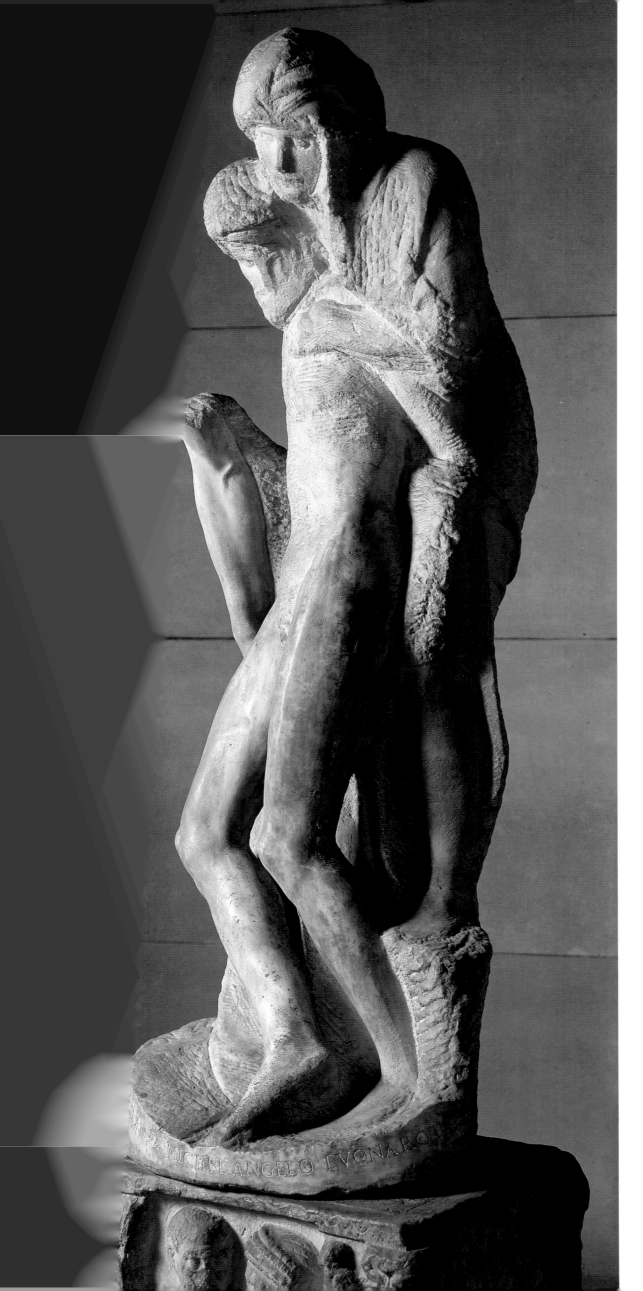

. . . *we call it a* PIETÀ *but it is radically different from the other two versions of the same subject carved by Michelangelo, and unlike anything else ever made. The mother stands on a rock and embraces but scarcely supports the dead weight of her child. . . .*

. . . The abstracted forms suggest a Brancusi bird or a curling tongue of flame (and in such living, rising forms reside the slimmest hope of resurrection). . . .

. . . the artist surely saw the son of man, imagined his love for his Lord, and the loss to the mother of God. In rendering such a body, each chisel blow contributes to Christ's torment. . . .

CHAPTER III
MASTERPIECES OF

PAINTING
A RELUCTANT MASTER

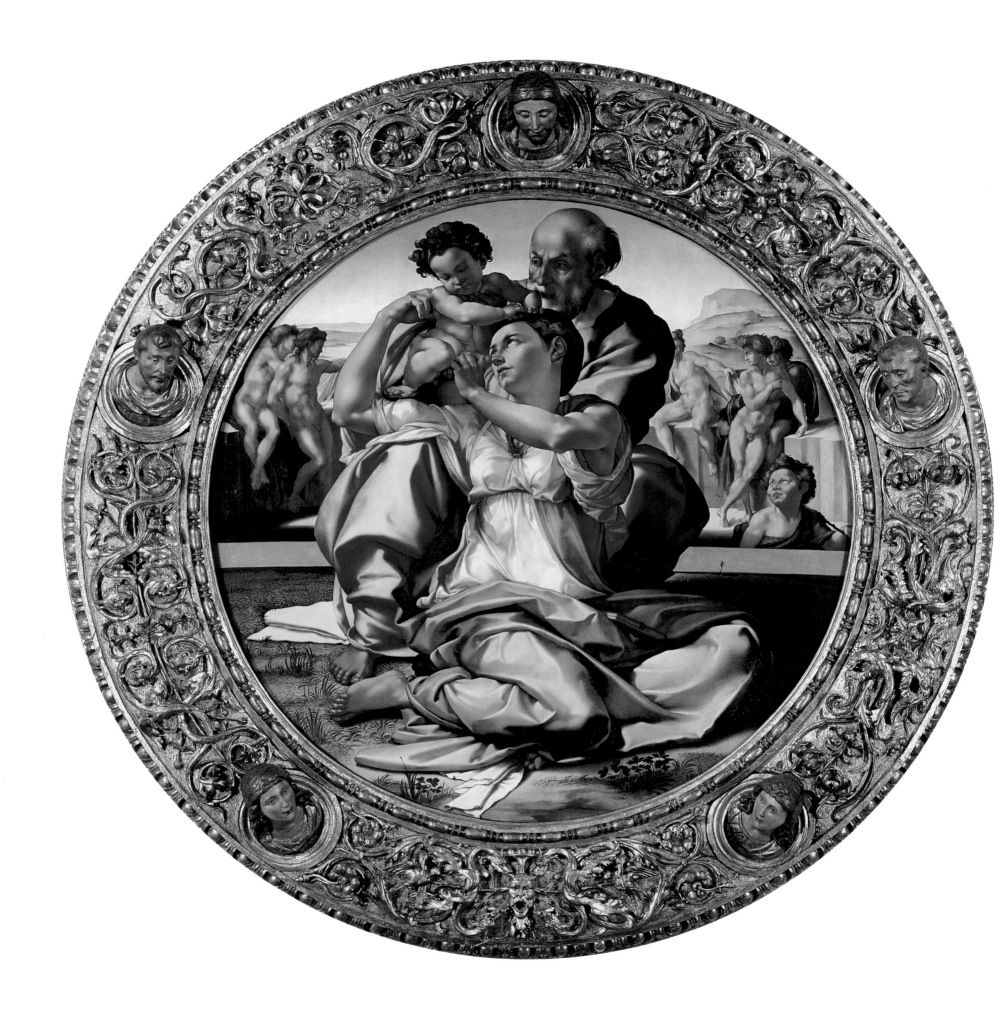

PRECEDING PAGES:
Detail of the LIBYAN SIBYL

THE DONI TONDO

◆ ◆ ◆

C. 1504 ◆ TEMPERA ON WOOD ◆ DIAMETER: 47¼ INCHES ◆ UFFIZI GALLERY, FLORENCE

There is little in Michelangelo's oeuvre to prepare us for the innovative features of the *Doni Tondo*. As in Michelangelo's sculptures, all the sources and influences cited by scholars do not add up to an adequate explanation for the beauty, invention, and subtle intelligence of this picture. One of the many unanswered questions about the painting is why the Florentine businessman Agnolo Doni commissioned a renowned sculptor to paint a picture . . . and why Michelangelo agreed to do so. With only limited experience in tempera painting, Michelangelo stepped into mastery.

The Madonna is seated on the ground with a closed book on her lap. She turns towards her athletic child while Joseph kneels, actually squats, behind her. It is uncertain whether Joseph takes the child or passes him to his mother. The purposeful ambiguity of the action permits us to read it either way and in so doing, we invest the composition with continuous movement.

The three heads form an inverted triangle enframed and stabilized by a parallelogram of arms. But more than formal geometry unites the Holy Family. They are linked by the intensity and intimacy of their looks. Joseph gazes upon the child, who looks at his mother from under lidded eyes. The rapt adoration and glowing face of Mary is an especially eloquent expression of profound love. The spectator is made privileged witness of this intimate, ineffable moment.

The gesture of the prescient child recalls that of a priest/healer laying on hands. The mother's left hand conceals but also calls attention to the child's genitals, an assertion of Christ's humanity and a reminder of his dual nature, as both man and god, flesh and spirit. In this small area at the upper left of the picture there is a dense congregation of expressive hands and faces; it is one of the tenderest and most intimate grouping of figures in Michelangelo's art.

The fullness of emotions finds its counterpart in the bright, tempera colors. The Madonna's traditional red dress and blue mantle are framed by a strip of deep green and the glowing, iridescent orange-gold of Joseph's mantle. The metallic blue folds that fill the foreground are echoed in the deeper blue of Joseph's tunic and in the lighter hues of the sky and distant landscape. Thus are foreground and background joined through the repetition and modulation of color.

In the middle ground, just beyond the smooth ledge of cut stone, is the young St. John the Baptist. His ecstatic look—with upward tilted head, raised eyes, and prominent white orbs—reflects that of the Madonna, and for a similar purpose since John and Mary were the first to recognize Christ's divinity and to accept his earthly mission. Beyond John is a group of nude youths who lounge in various attitudes of repose and more intimate erotic embrace. Theirs is a carnal love that serves as foil to the spiritual love of the foreground group. We can read the painting as a sort of chronology from background to foreground, from pagan antiquity to the Christian present with John as the intermediary between old and new dispensations.

The nude youths occupy a semicircular cavity reminiscent of the excavated face of a stone quarry. Once again a temporal dimension is suggested: the worked stone is intermediary between the raw nature of the background and the carefully dressed stone ledge fashioned by man. The semicircular faceted stone wall behind the Holy Family also evokes the partly constructed apse of a Christian church, as though we were witnesses both to the new dispensation and to its architectural enshrinement. Appropriately then, the Holy Family occupies the place of the altar.

The picture is surrounded by a richly carved and gilt wood frame, designed but not carved by Michelangelo. It magnifies and adorns the holy image and serves as intermediary between painted icon and the world of the spectator. Entwined in the tendrils of the verdant growth are Strozzi crescent moons, a celebration of the marriage of Agnolo Doni to Maddalena Strozzi in 1504. From five small tondi emerge carved and painted heads, probably Christ at the top and four prophets who foretold the coming of the Messiah and who now witness the moment when their prophecies are fulfilled.

Michelangelo has frequently been accused of demonstrating little interest in landscape. Although landscape was not his principle vehicle for pictorial expression, it was also not incidental. The landscape elements in the *Doni Tondo* are attractive in their own right, offer a visual foil to Michelangelo's more fluent figurative language, and underscore the sacred history that is the main subject. In this stunningly beautiful and highly crafted object, Michelangelo presents an image of the Christian church, as history, physical space, and visible doctrine.

BATTLE OF CASCINA

◆ ◆ ◆

1504 ◆ PREPARATORY CARTOON ON PAPER ◆ LOST

In the Florentine hall of state (Palazzo della Signoria) and in direct competition with Leonardo da Vinci, Michelangelo had the opportunity to prove himself in painting as he had done in sculpture by carving the *David*. The *Battle of Cascina* fresco never proceeded beyond the cartoon stage; nonetheless, as a monumental drawing it exercised a profound influence on subsequent generations who copied and imitated it.

The composition of the bathers, the central portion of Michelangelo's fresco, is preserved in a handful of extant drawings and the grisaille panel painted in 1542 by Michelangelo's friend and former assistant, Aristotile da Sangallo. Michelangelo chose to represent a peculiar and utterly minor episode in Florence's protracted struggle against its rival, Pisa. Because of the heat, the Florentine soldiers went to the Arno river to bathe, but afraid they might be caught off-guard by the enemy, the Florentine captain raised a false alarm. Thus we witness a chaotic scene in which the soldiers scramble to dress and arm themselves. It is a curiously unheroic "battle" picture, especially given its prominent public location and presumably propagandistic intent. Rather than celebrating a victory, hero, or some divine intervention—as such state commissions tended to do—Michelangelo's fresco served as a clarion call for civic and military preparedness. It was especially suited to the circumstances, however, since at the time of the commission

(1504) Florence still had not subjugated Pisa. In addition, Michelangelo's peculiar emphasis gave him unprecedented scope to exercise his artistic specialty: the male nude in action. The latter was of particular importance given that Leonardo was similarly displaying his special talent in painting an equestrian battle scene as the focus of his contemporaneous *Battle of Anghiari*.

One of the most impressive of Michelangelo's preparatory drawings for the Cascina fresco is a study, now in the British Museum, of a seated nude whose head and upper torso are turned sharply away from the spectator. The strongly reinforced outlines and densely modeled forms give the figure a three-dimensionality that recalls sculpture. In the difficult pose and richly articulated modeling we find the seeds for the *ignudi* and other figures painted on the Sistine ceiling.

The *Battle of Cascina* fresco was Michelangelo's most important commission to date, and promised to be one of the greatest paintings of the Renaissance. Like so many commissions in the artist's career, the project languished and remained incomplete. But even the scale and ambition, as well as some of the specific figural poses, had a decided impact on the history of art. We cannot usually say the same about the unfulfilled dreams of other artists. Rarely has so much attention been given to a work of art that never existed.

Aristotile da Sangallo. Painted grisaille copy of Michelangelo's BATTLE OF CASCINA *cartoon.* C. 1542. *Holkham Hall, Norfolk, England*

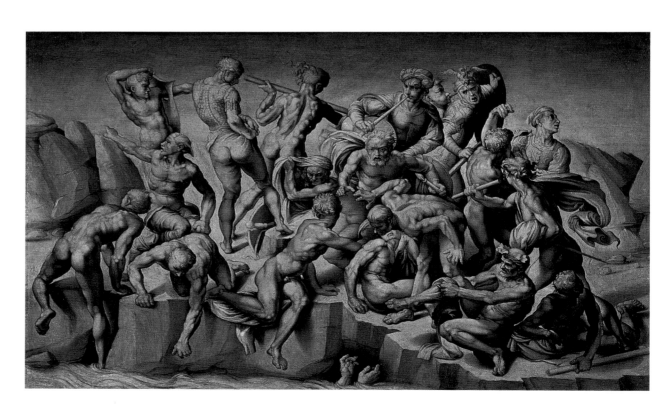

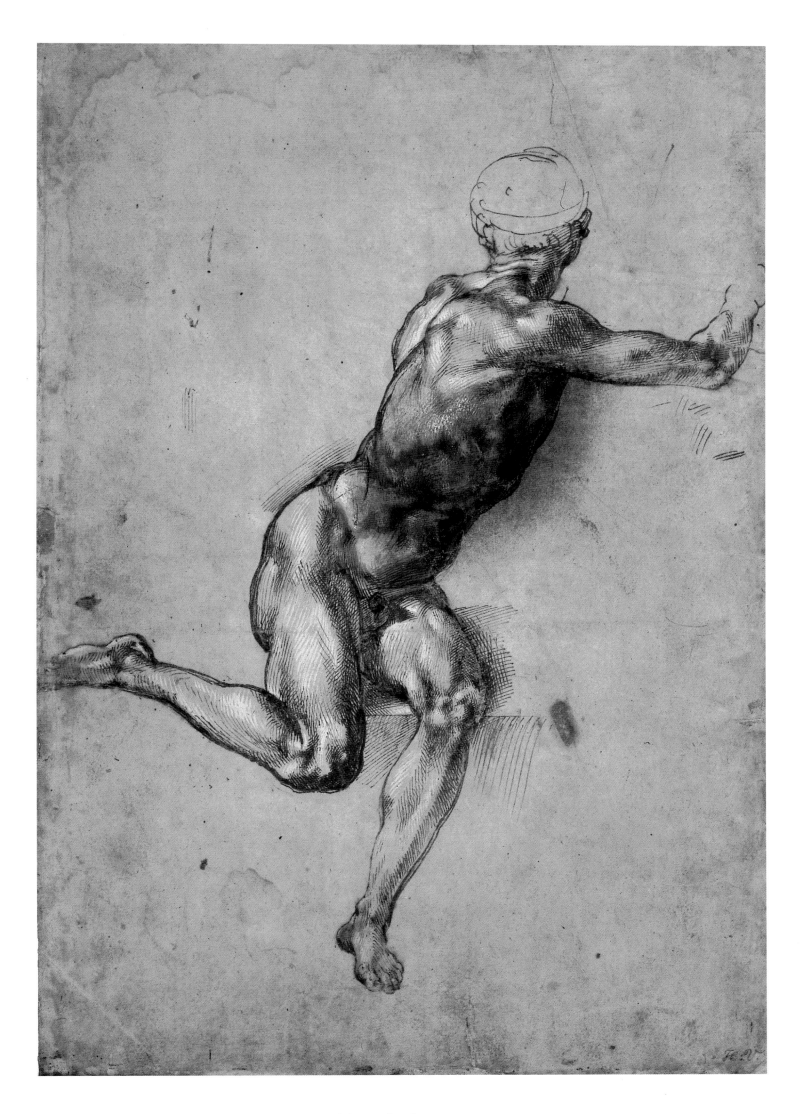

Study for seated figure for the BATTLE OF CASCINA.
Drawing in pen and chalk. British Museum, London

THE SISTINE CHAPEL CEILING

◆ ◆ ◆

1508–1512 ◆ FRESCO ◆ 45 X 128 FEET ◆ VATICAN, VATICAN CITY

The words of Genesis, the first book of the Bible, march with stately dignity through the mind as one looks upon one of the greatest works of art ever created. Like a handful of still extant monuments of the ancient and modern world—the pyramids, the Taj Mahal, and the great wall of China among them—the Sistine Chapel never fails to instill wonder. Even in a fast-paced world of technological marvels, the ceiling causes us to pause awestruck at the creative imagination and accomplishment of one human being. No one quite forgets the experience of stepping through the small doorway into the vast expanse of the Sistine Chapel and having one's eyes drawn inexorably to the heavens.

As was the case with some of his large sculptural projects, such as the tomb of Pope Julius II and the Medici Chapel, Michelangelo proceeded backwards in painting the vast, irregular barrel vault. He began with what he knew best, the sinful state of man, and proceeded to the creation scenes where he would be forced to imagine and portray the face of God. This is also the manner in which we were meant to experience the frescos (although tourists now enter the chapel at the opposite end, under the *Last Judgment*). We are supposed to enter the chapel under the scene of the *Drunkenness of Noah* and proceed in reverse chronological order towards Creation, by analogy from our present sinful state to a renewal of faith at the altar.

In a total of nine scenes—four large and five smaller rectangular fields—Michelangelo related the book of Genesis. This was certainly not the first time the subject had been depicted, yet, like Leonardo's *Last Supper* it has become virtually the canonical representation; we visualize the first book of the Bible according to Michelangelo.

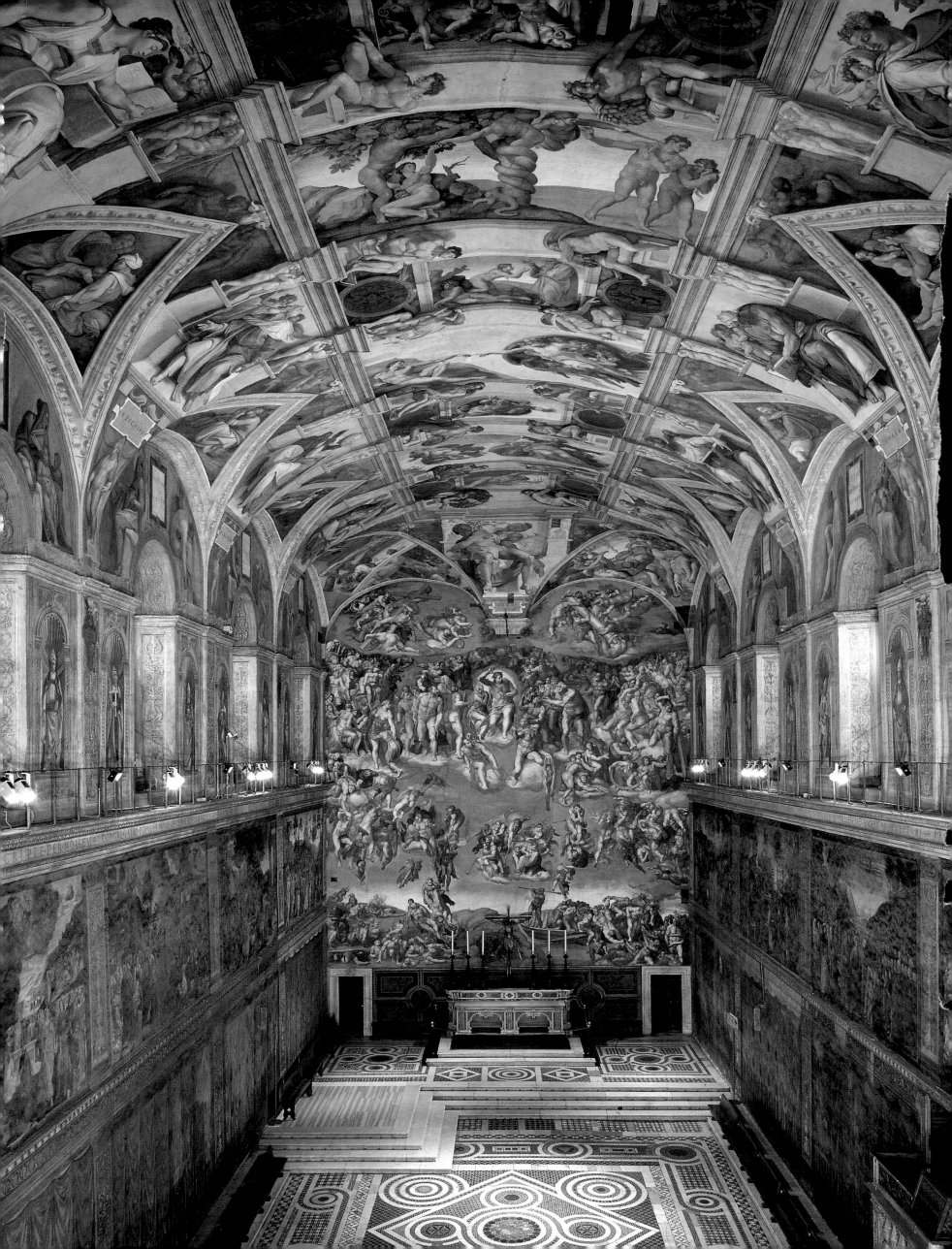

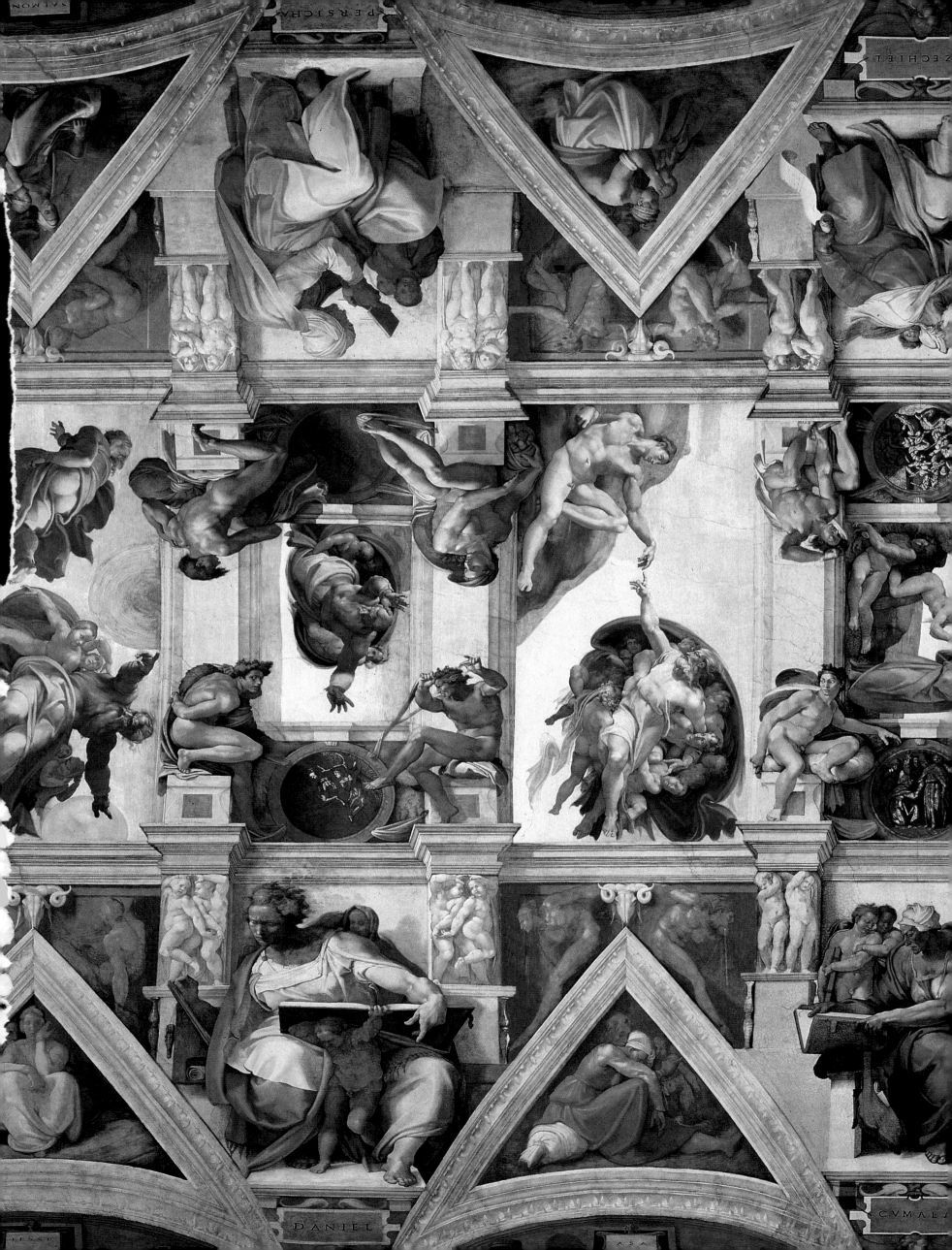

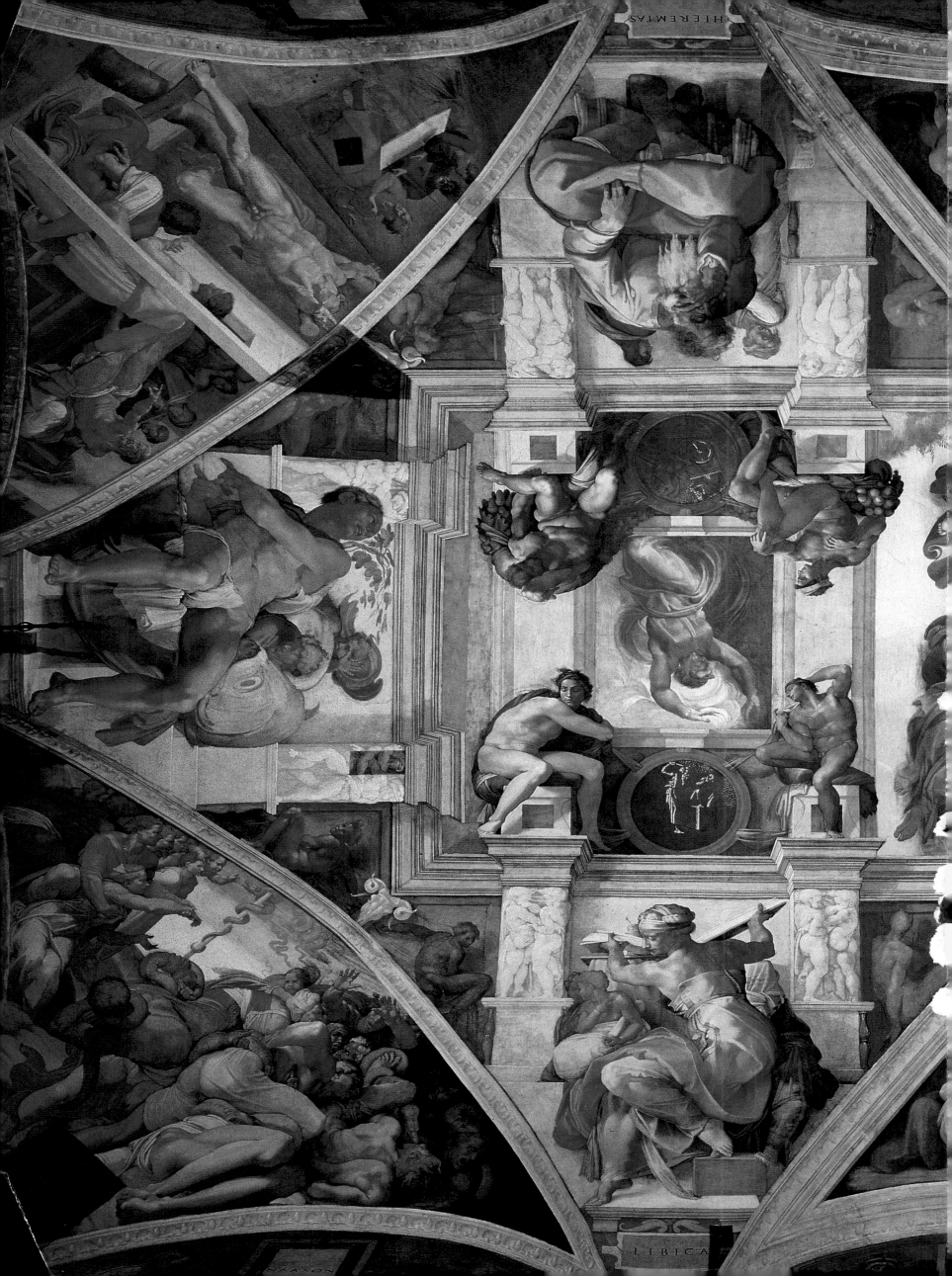

LISTED BELOW ARE THE NAMES OF THE WORKS

PENDENTIVES AND LUNETTES
FROM LEFT TO RIGHT:

TOP:		BOTTOM:	
PENDENTIVES:	LUNETTES:	PENDENTIVES:	LUNETTES:

CORNER: THE PUNISHMENT OF HAMAN	JACOB ◆ ABRAHAM ◆ JUDAH ◆ ISAAC	CORNER: THE BRAZEN SERPENT	HEZRON ◆ PEREZ ◆ RAM
SALMON	AMMINADAB	JESSE	NAHSHON
REHOBOAM	BOAZ ◆ OBED	ASA	DAVID ◆ SOLOMON
UZZIAH	ABIJAH	HEZEKIAH	JEHOSHAPHAT ◆ JORAM
ZERUBBABEL	JOTHAM ◆ AHAZ	JOSIAH	MANASSEH ◆ AMON
CORNER: DAVID ◆ GOLIATH	ABIUD ◆ ELIAKIM	CORNER: JUDITH ◆ HOLOFERNES	JECHONIAH ◆ SHEALTIEL
	ACHIM ◆ ELIUD		AZOR ◆ ZADOK
	JACOB ◆ JOSEPH		ELEAZAR ◆ MATTHAN

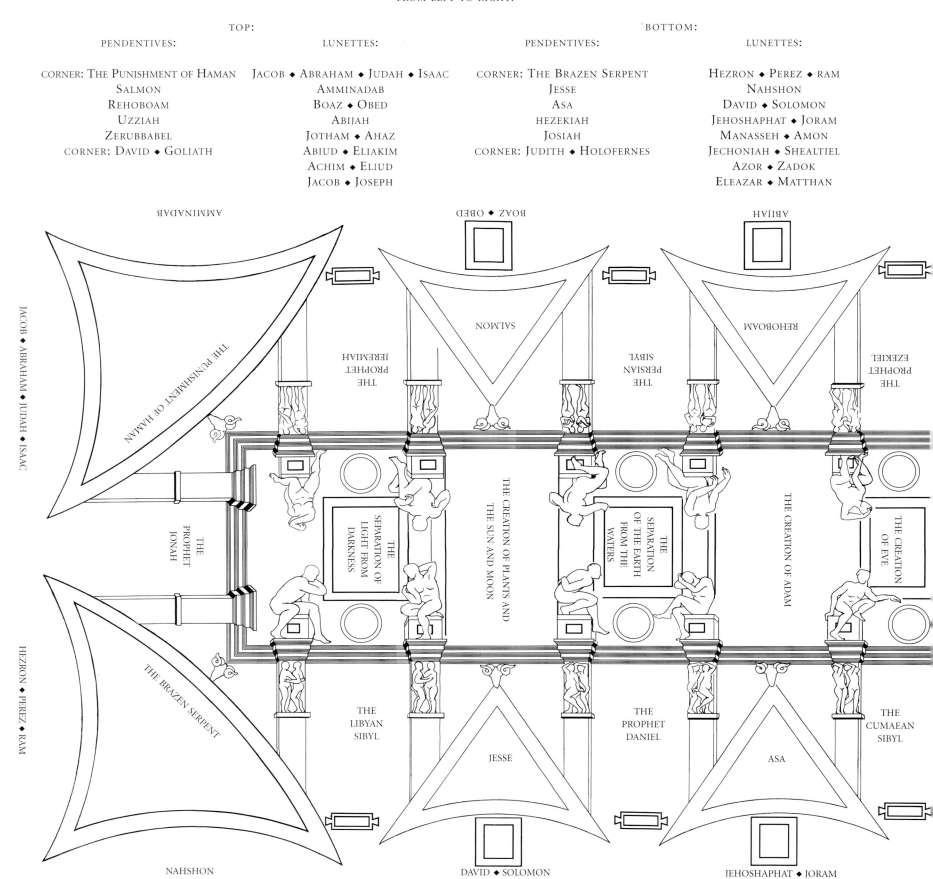

THE DRUNKENNESS OF NOAH

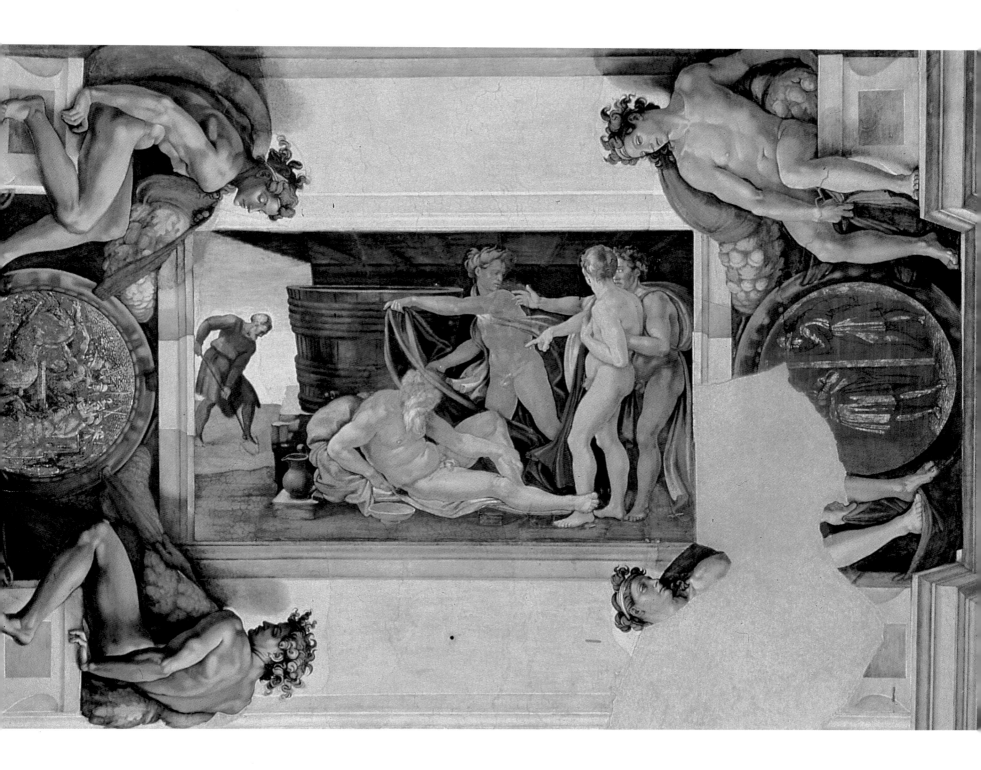

Many people find it difficult to focus on the first three scenes on the ceiling: *Drunkenness of Noah*, the *Deluge*, and the *Sacrifice of Noah*. This is partly because the Genesis narratives occupy merely the central spine of the densely populated vault; many other parts compete for our attention. Rather than looking at the ceiling in some sort of logical order, most visitors find themselves turning round and round: the mind becomes surfeited, the eyes begin to wander, the neck grows stiff. Moreover, the figures in the first three scenes are small and difficult to distinguish from the floor of the chapel, a problem that Michelangelo rectified in the subsequent scenes by enlarging the figures and simplifying the compositions.

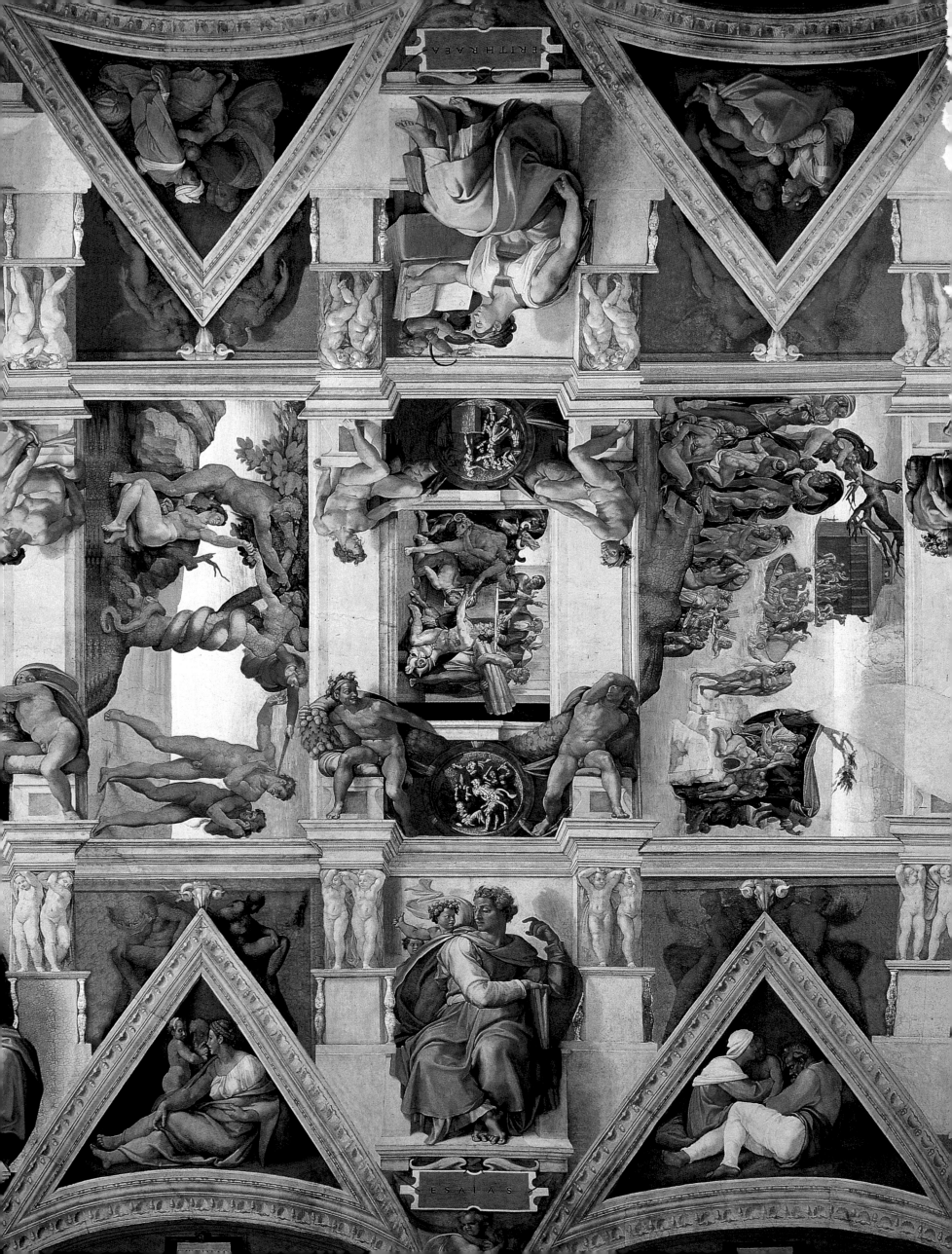

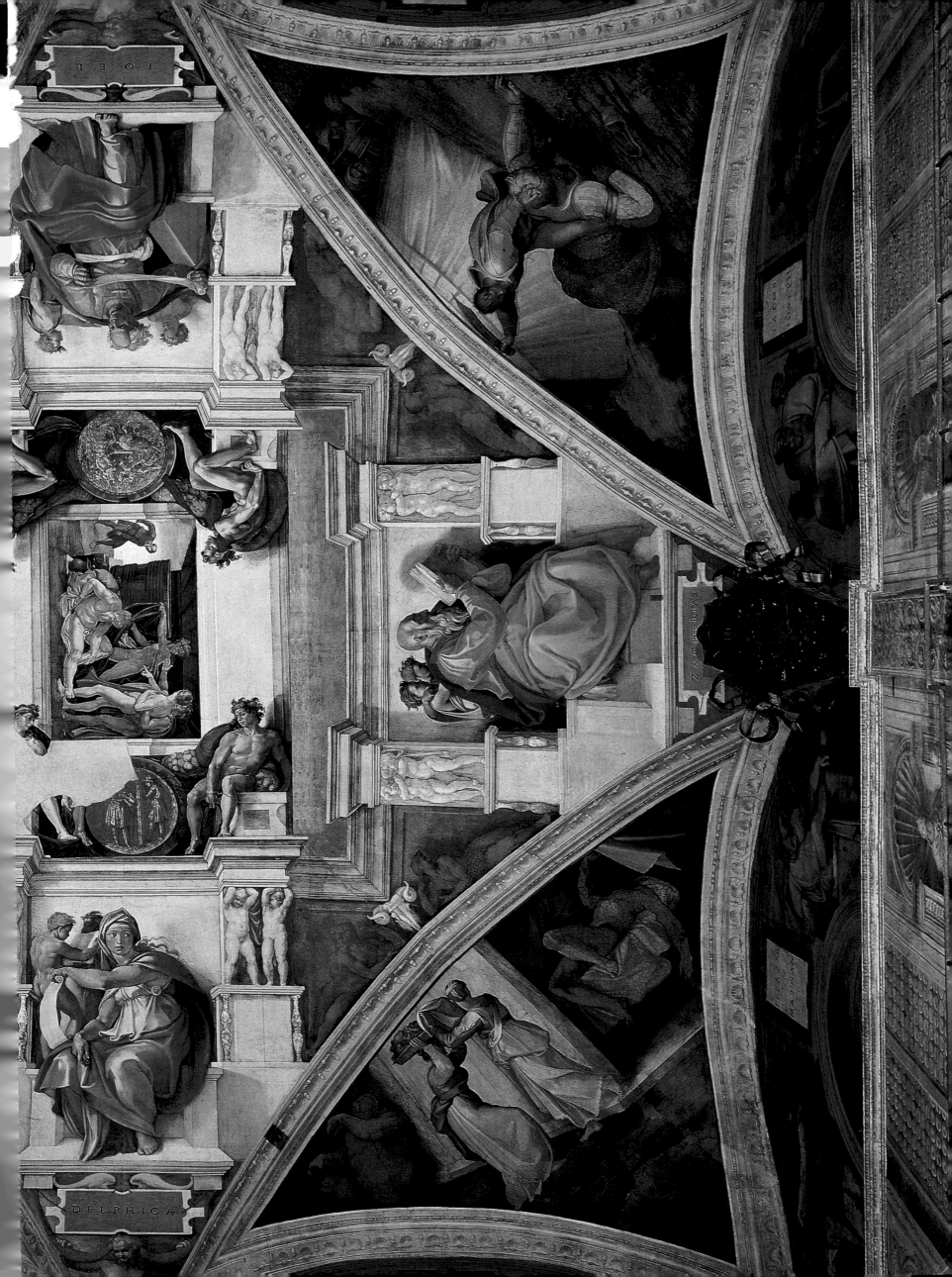

ON THE SISTINE CHAPEL CEILING

THE OLD TESTAMENT
CENTRAL CEILING FROM LEFT TO RIGHT:

The Separation of Light from Darkness
The Creation of Plants and the Sun and Moon
The Separation of the Earth from the Waters
The Creation of Adam
The Creation of Eve
The Temptation and Fall of Adam and Eve
The Sacrifice of Noah
The Deluge
The Drunkenness of Noah

PROPHETS AND SIBYLS
CLOCKWISE FROM FAR LEFT:

The Prophet Jonah
The Prophet Jeremiah
The Persian Sibyl
The Prophet Ezekiel
The Erythraean Sibyl
The Prophet Joel

The Prophet Zechariah
The Delphic Sibyl
The Prophet Isaiah
The Cumaean Sibyl
The Prophet Daniel
The Libyan Sibyl

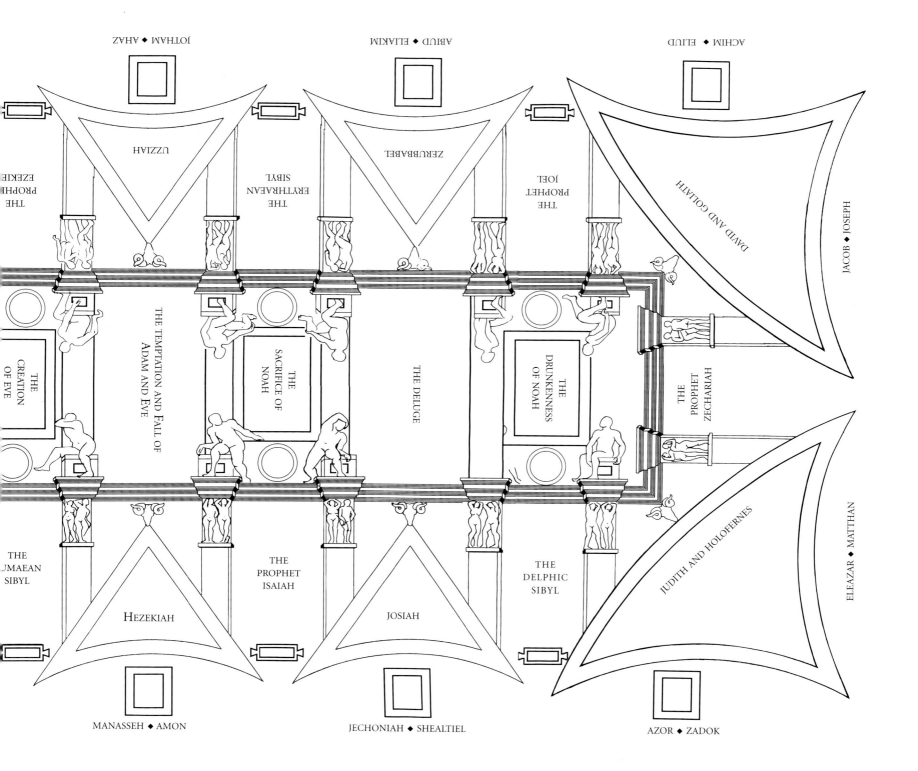

THE DELUGE

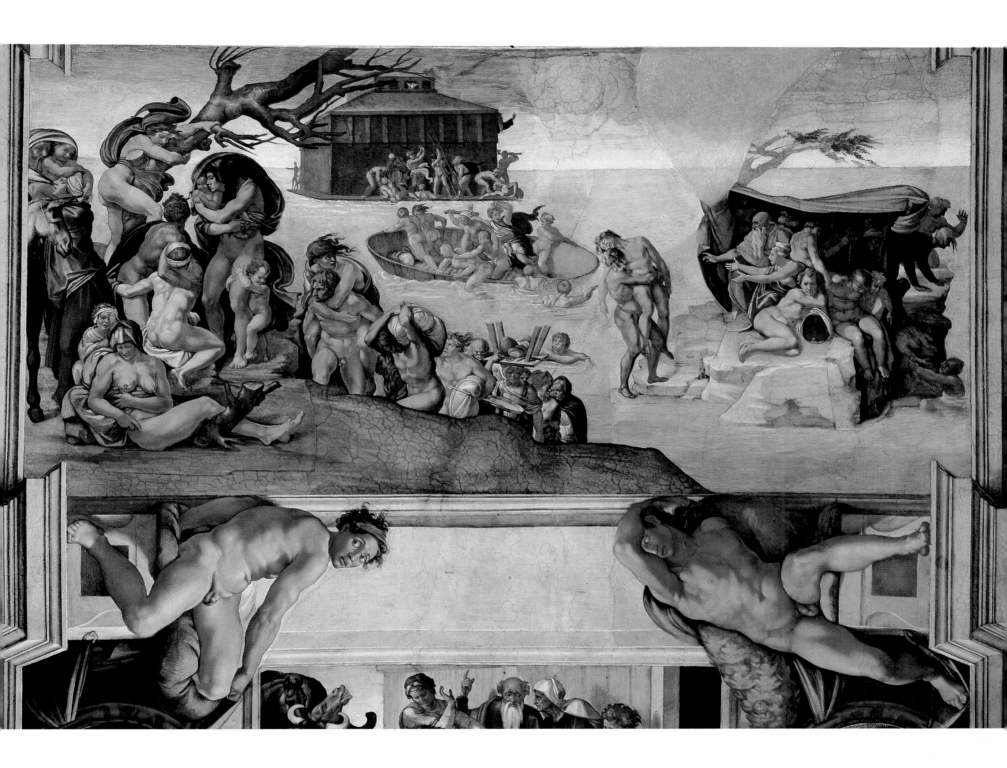

More than sixty figures populate the flood scene, ranging from the heroic effort of a naked father to rescue his drowned son to the ignoble fighting for a place aboard the boat precariously listing in the middle ground. As imaginative participants in the tragedy, the viewer is left with only a small patch of earth in the lower left. But even this green haven is threatened by the press of dismal humanity and the rapidly rising flood waters. We viewers see the small space on which the survivors cling and sense their inevitable fate. Although doomed, they still seek refuge in desperate measures, like the young man attempting to escape the inundation by climbing into a tree. While the stunted growth and naked limbs signal the futility of his effort and the eventual total destruction, those same finger-like branches also direct us to the background. There the ark floats on a more tranquil sea. A tiny sign of hope in the form of the white dove alights in the ark's window, and Noah leans forth and gestures to a brightening sky.

THE TEMPTATION AND
FALL OF ADAM AND EVE

In contrast to the three crowded scenes relating Noah's story, the next episode, the *Temptation and Fall of Adam and Eve,* is a large field with few figures. In fact, in a somewhat "old-fashioned" manner of presentation, the figures of Adam and Eve are represented twice, before and after the Fall. The two sides of the painting form an obvious visual contrast that also helps relate narrative; we move left to right, from the comparative verdancy and intimacy of the garden to the barren, endlessly expansive plain of the couple's exile. Life in innocence is to the left; life with sin and death to the right.

At the center of the garden, and appropriately central to Michelangelo's composition, is the Tree of Knowledge. Winding around the broad trunk are the iridescent coils of the serpent, seeming to strangle the remaining life from its already lopsided green growth. The serpent tempts Eve, yet at the same moment, Adam reaches towards the tree and, of his own accord, plucks the forbidden fruit. Thus, rather than woman being responsible for tempting man, he is the agent of his own fall from grace. Michelangelo, a profoundly religious and subtle thinker, takes no comfort in the misogynist version of the story which lays full blame on Eve; instead, he offers us a more nuanced meditation on the nature of sin and temptation. As is typical of Michelangelo, invention invigorates a traditional tale; his unorthodoxy is visible mainly to those whose faith is already unassailable.

Just prior to the awful moment of the Fall, Adam and Eve were closely entwined, thus recalling their creation from one flesh. Now in the loss of their innocence, that physical intimacy suggests a sexual embrace colored by sin. Adam and Eve, as yet, are unaware of their new situation, but Michelangelo implicates the viewer, who living long after the Fall has a nearly unlimited capacity for sinful thoughts—even imagining their prior embrace as fellatio. Turned to Adam, Eve is one with his flesh; turned away, she separates and begins time's march to death. Her twisted pose and reaching gesture are echoed by the ominously dead branch framed against the sky. Her youthful bloom and innocent body are transformed in the subsequent scene into the haggard and thickset frame of an aged woman who has suffered the pain of childbirth. The terrified and fearful countenances mark the beginning of emotions.

In the beginning God created heaven, and earth.
And the earth was void and empty. . . .

And God said: Be light made.
And light was made.
And God saw the light that it was good; and he divided
the light from the darkness. . . .

And God said: Let there be a firmament made amidst the waters:
and let it divide the waters from the waters. . . .

God also said: Let the waters that are under the heaven,
be gathered together into one place: and let the dry land appear. . . .

And he said: Let the earth bring forth the green herb,
and such as may seed, and the fruit tree yielding fruit after its kind,
which may have seed in itself upon the earth. . . .

And God said: Let there be lights made in the firmament of heaven,
to divide the day and the night, and let them be for signs,
and for seasons, and for days and years. . . .

God also said: Let the waters bring forth the creeping creature having life,
and the fowl that may fly over the earth under the firmament of heaven. . . .

And God said: Let the earth bring forth the living creature in its kind,
cattle and creeping things, and beasts of the earth,
according to their kinds. . . .

And he said: Let us make man to our image and likeness:
and let him have dominion over the fishes of the sea,
and the fowls of the air, and the beasts, and the whole earth,
and every creeping creature that moveth upon the earth.
And God created man to his own image:
to the image of God he created him:
male and female he created them.

GENESIS

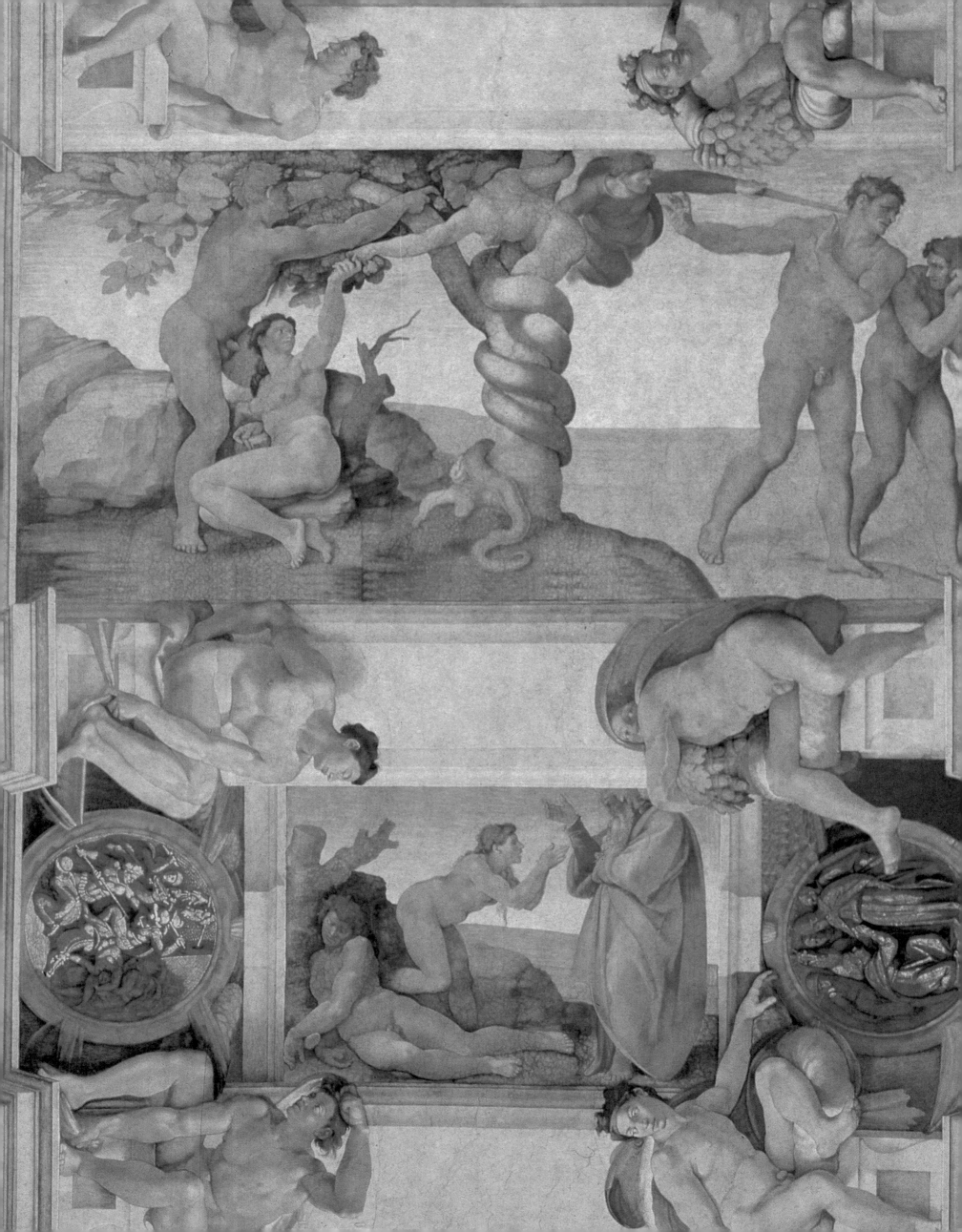

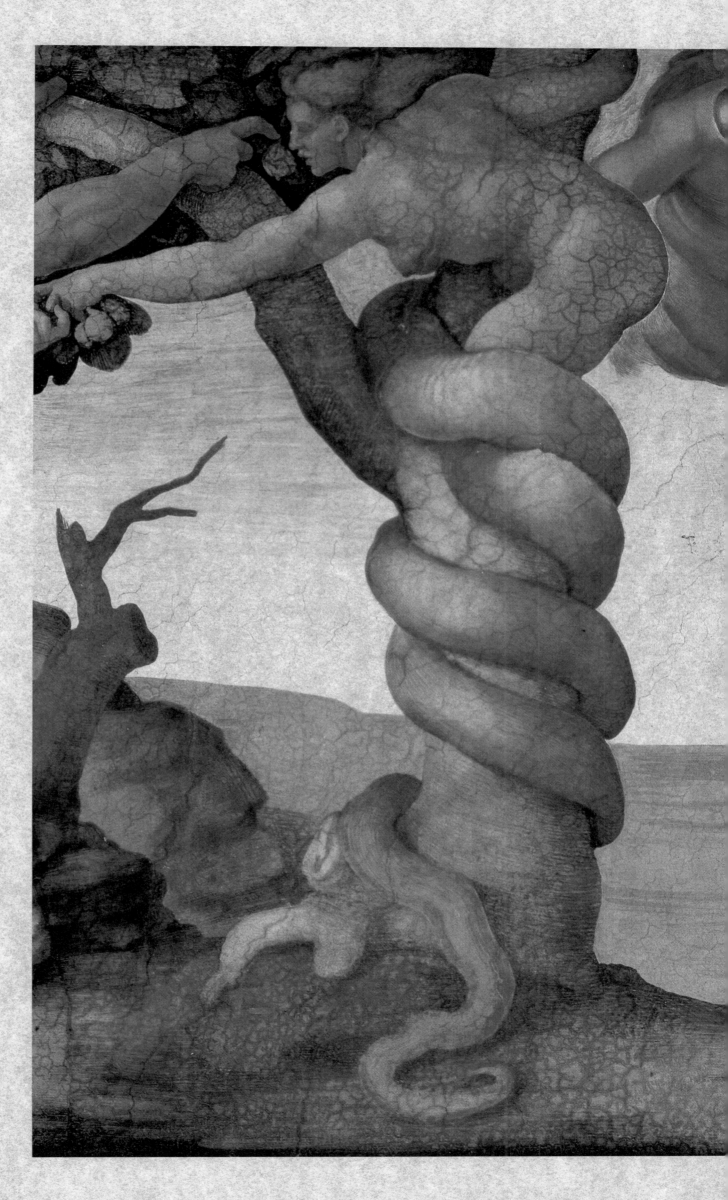

OPPOSITE:

TOP: THE TEMPTATION AND
FALL OF ADAM AND EVE

*. . . The two sides of the painting
form an obvious visual con-
trast that also helps relate
narrative; we move left to
right, from the comparative
verdancy and intimacy of the
garden to the barren, end
lessly expansive plain of the
couple's exile. . . .*

BOTTOM: THE CREATION OF EVE

RIGHT:

*. . . the iridescent coils of
the serpent, seeming to
strangle the remaining life
from its already lopsided
green growth. . . .*

The first person since the great days of Greek sculpture

to comprehend fully the identity of the nude

with great figure art was Michelangelo.

Before him it had been studied for scientific purposes—

as an aid in rendering the draped figure.

He saw that it was an end in itself,

and the final purpose of his art.

For him the nude and art were synonymous.

Here lies the secret of his successes and his failures.

BERNARD BERENSON

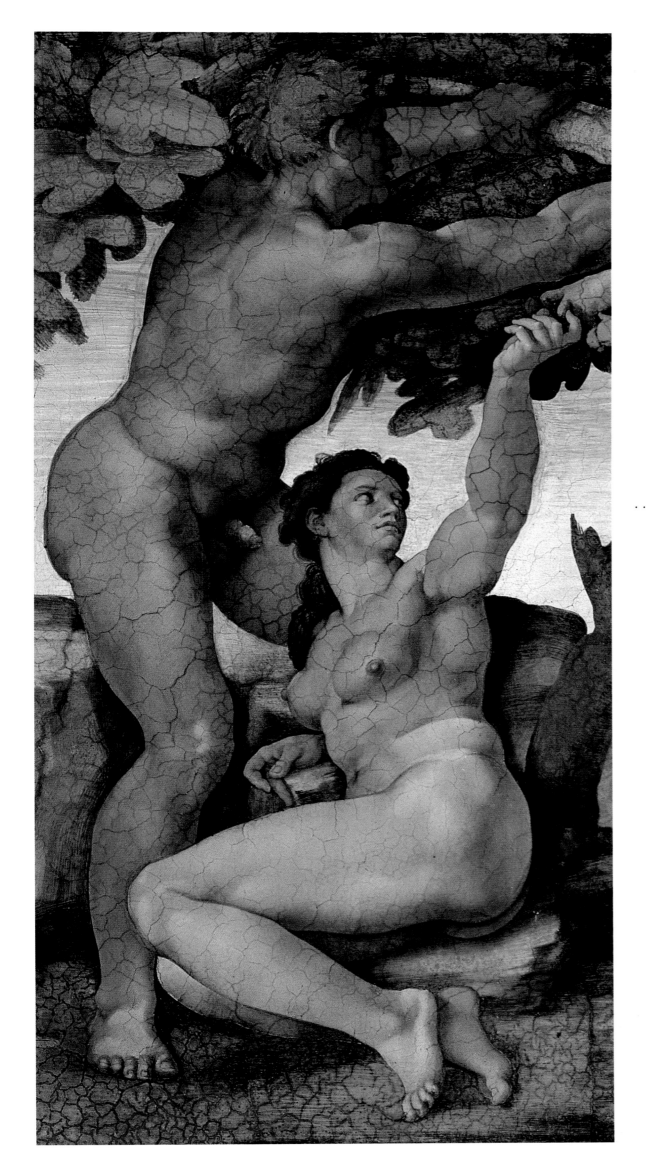

. . . Her youthful bloom and innocent body are transformed in the subsequent scene into the haggard and thickset frame of an aged woman . . .

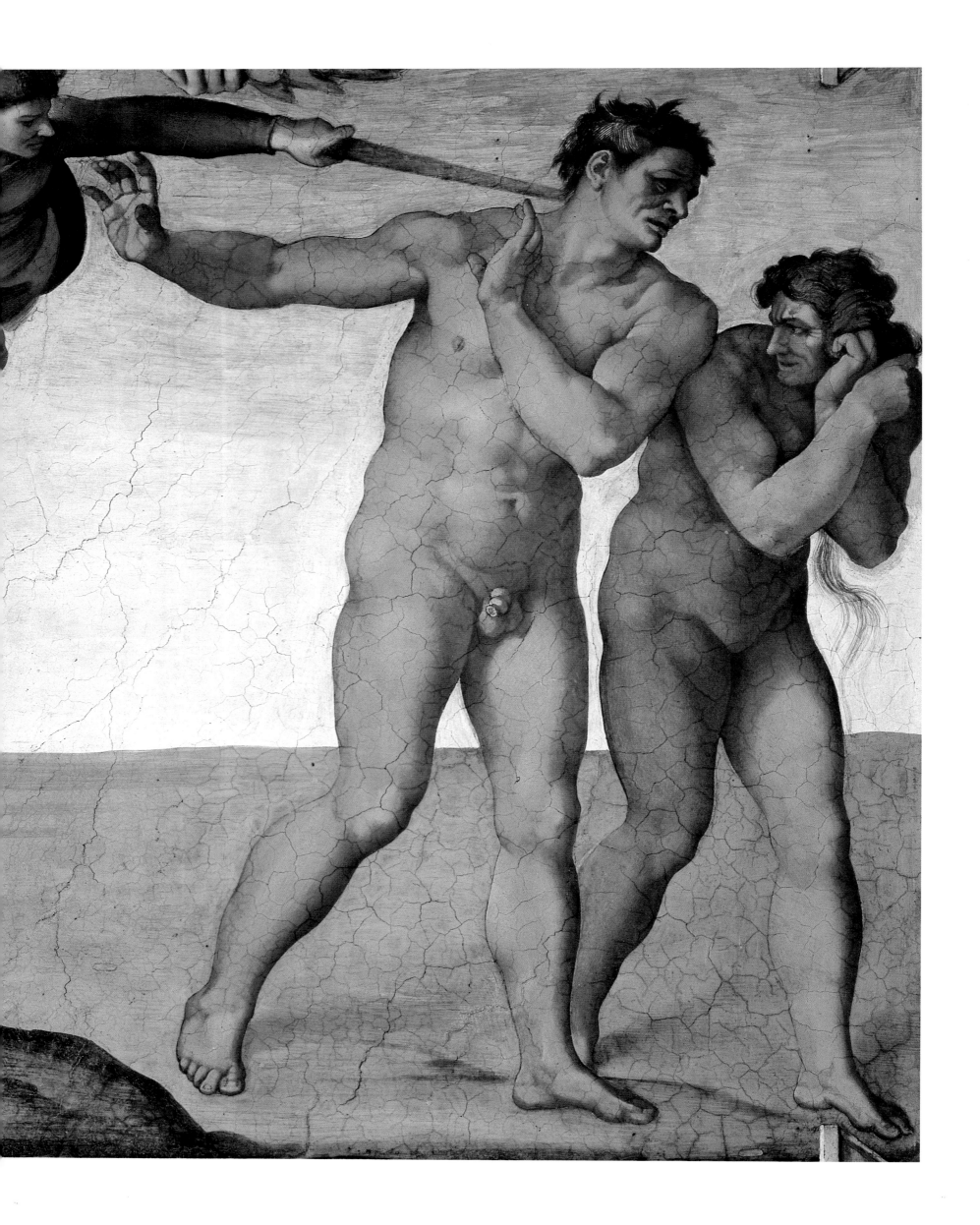

THE CREATION OF ADAM

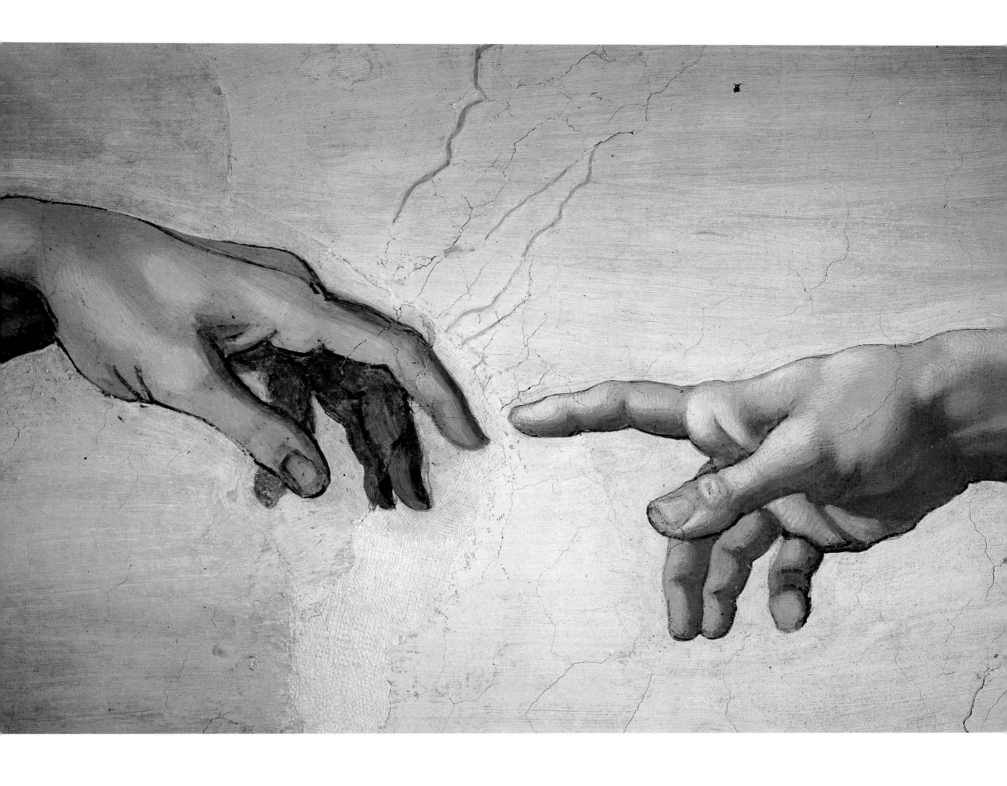

The next large narrative, the *Creation of Adam*, is an even more simplified composition although it includes many more figures. We tend to recall this scene as a two-figure composition, Man created by God, yet numerous figures—including perhaps the yet unborn Eve (or Virgin Mary) and the child Christ—and a host of angels are enclosed in the billowing folds of God's lilac cloak. The shape of God's mantle has been described as the cross-section of a human brain, which is imposing modern science too literally upon artistic imagination, but it does remind us that God is *nöus,* infinite mind from whom all creation flows.

In painting this scene, Michelangelo has reversed the Bible, creating God in the image of his artistic imagination, a bit of pride that must have emboldened the artist. God-like, Michelangelo has forged the image of the deity for all western Christianity.

The astonishing energy of God is in striking contrast to the passive Adam, formed of the mud on which he reclines. With inclined head set upon a muscular torso and body, Adam looks longingly towards his creator, who is about to invest his physical perfection with soul. In the few centimeters that separate their fingertips is the greatest suspension of time and narrative in the history of art. That gesture is the visual focal point, with a magnetic intensity, of the entire ceiling, perhaps the most universally recognized and one of the most frequently imitated images of all time.

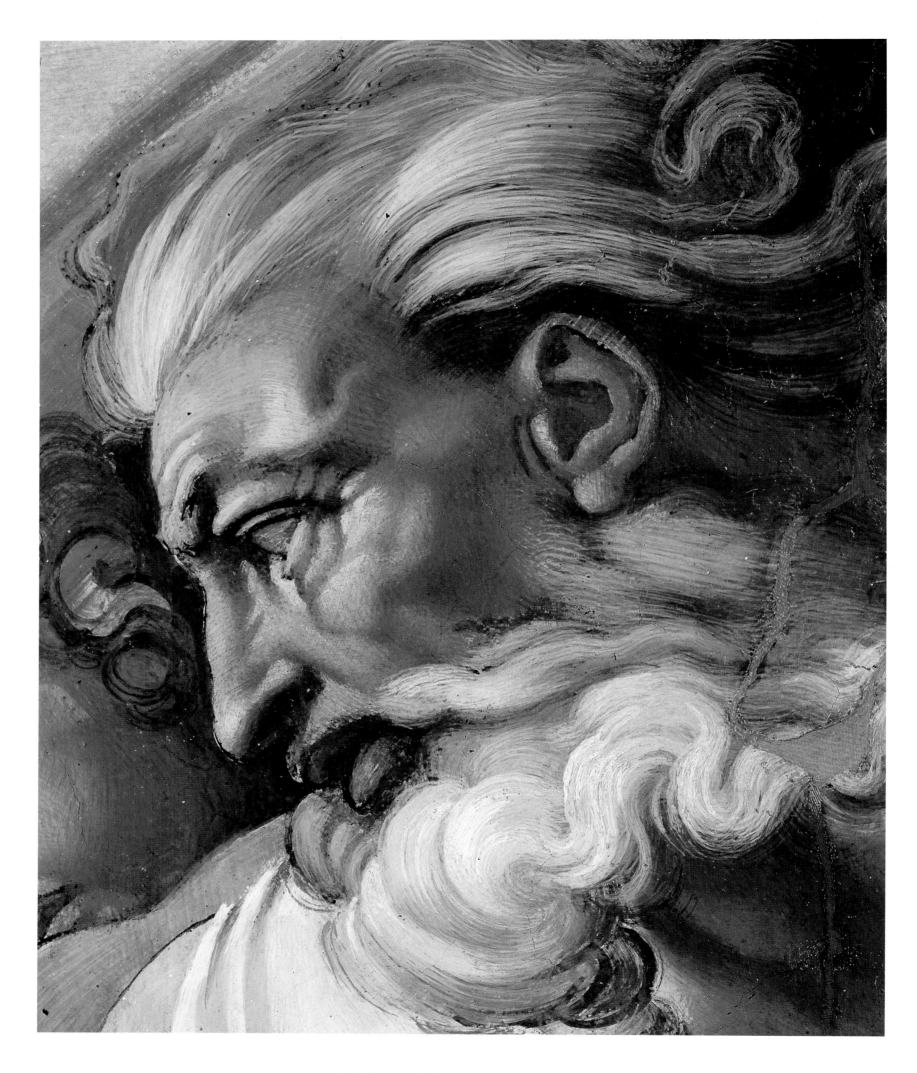

*. . . God-like, Michelangelo has forged the image
of the deity for all western Christianity. . . .*

There is unquestionably more genius

in the finger of God, calling Adam to life,

than in the whole work of any of

Michelangelo's forerunners.

JULIUS MEIER-GRAEFE

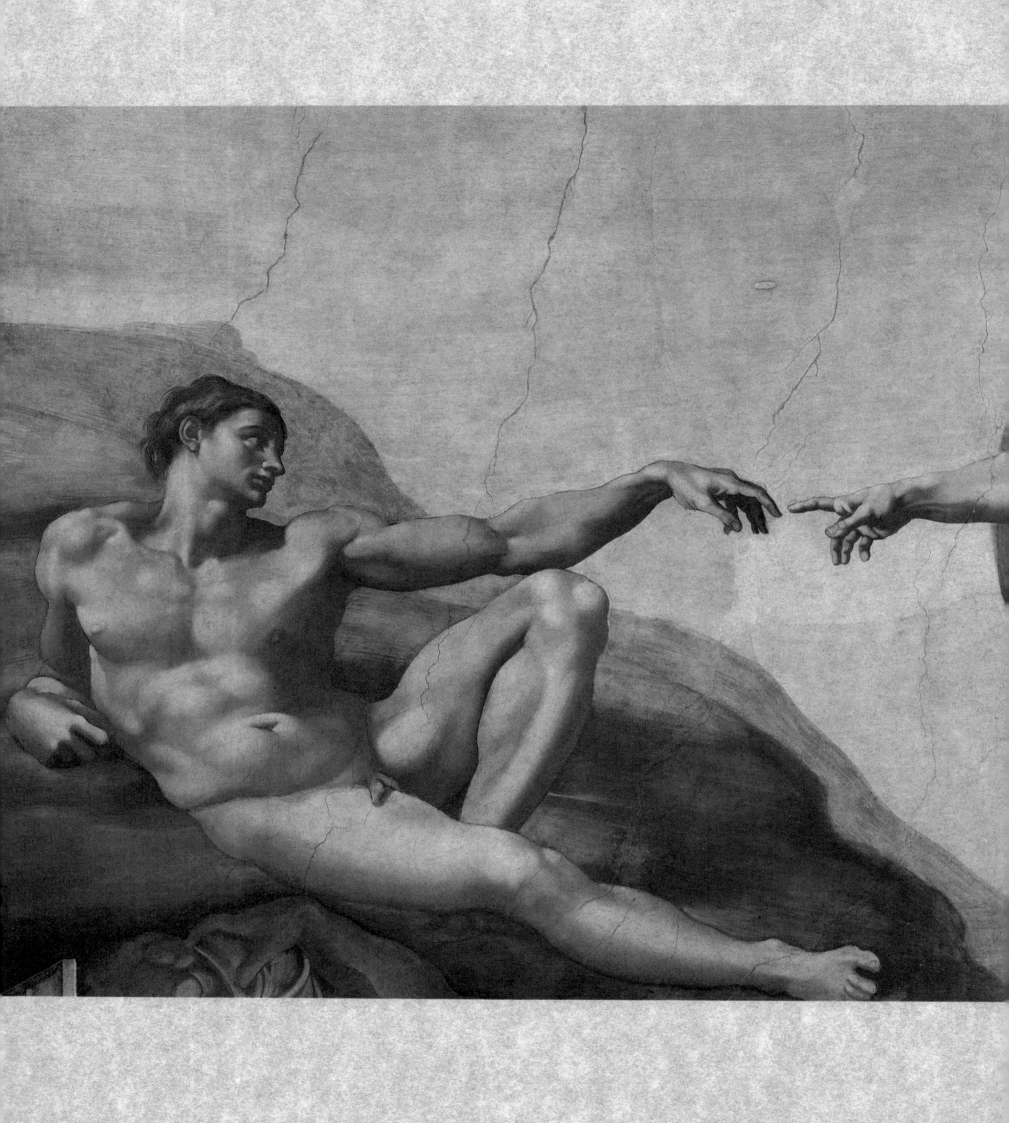

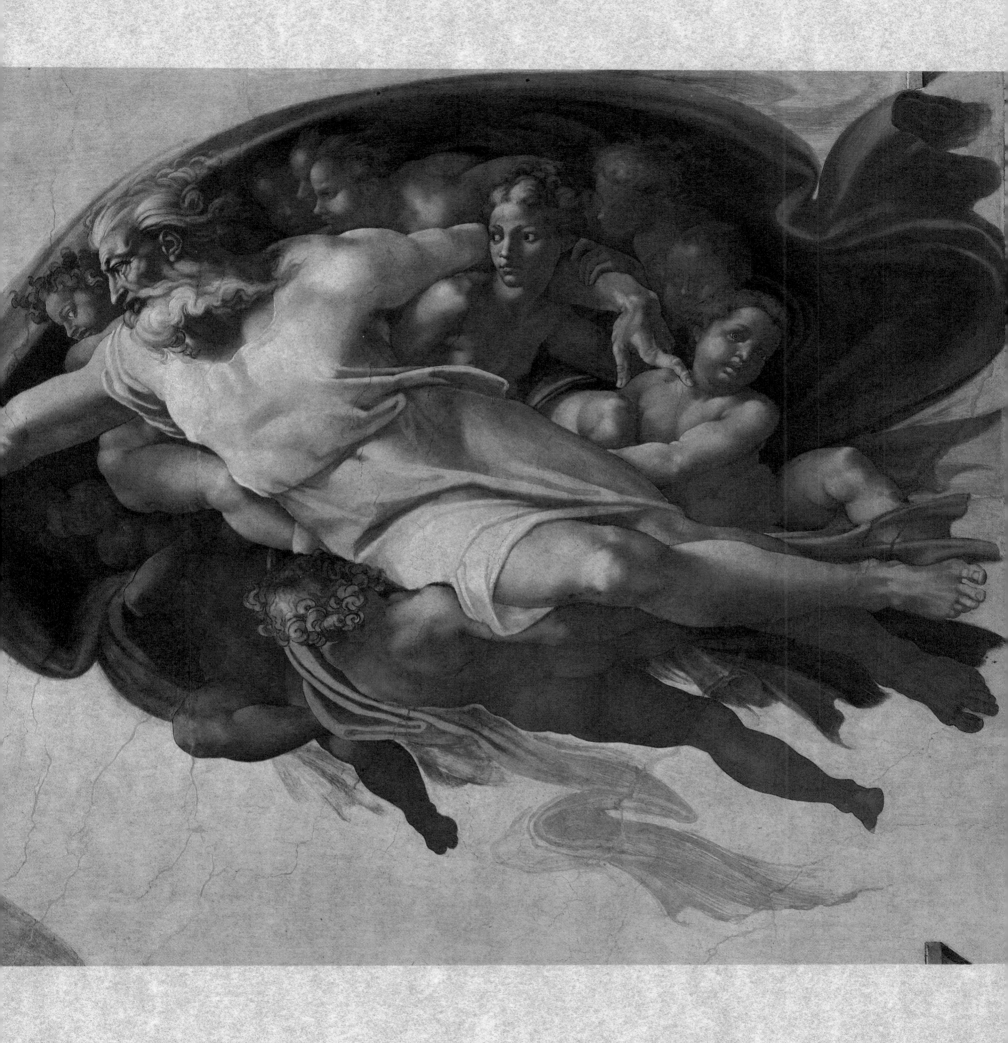

I would recommend young Artists

to study the works of Michael Angelo, as he

himself did the works of the ancient Sculptors:

he began, when a child, a copy of a mutilated

Satyr's head, and finished in this model

what was wanting in the original.

In the same manner, the first exercise

that I would recommend to the young artist

when he first attempts invention, is to select

every figure, if possible, from the inventions of

Michael Angelo.

SIR JOSHUA REYNOLDS

THE SEPARATION OF THE EARTH FROM THE WATERS

THE CREATION OF PLANTS, AND THE SUN AND MOON

THE SEPARATION OF LIGHT FROM DARKNESS

In the *Separation of the Earth from the Waters,* a dramatically foreshortened God hovers over the placid seas, but in the final two scenes, his creative force grows exponentially. Recalling the awe-inspiring features of *Moses,* God in the *Creation of Plants and the Sun and Moon* hurtles towards us in an awkwardly bent pose (although we scarcely have time or inclination to take cognizance of the Lord's posture). His outstretched fingers simultaneously bring into being the flaming orange and milk-white orbs of sun and moon. Turning sharply away, he gestures to bring forth the plants, leaving the creation of animals to our imagination. We are left with a most unusual glimpse of God's backside, a view of the deity described in the Bible but seen only by Moses on Mount Sinai (Exodus 34:21–23). It is the power of Michelangelo's imagination that places this extraordinary image before our eyes: God seen back and front, here and there—a visual equivalent of his omnipotence and omnipresence.

In the next and final scene, God whirls overhead and we glimpse only the underside of his neck and beard. The centrifugal body divides the scene in two, but the energy of primal creation is not confined to the small pictorial field. At the head of the chapel, for example, the much larger figure of *Jonah* bends away even as he turns and looks towards God in open-mouth astonishment. *Jonah*'s extravagant pose was highly praised by Vasari, who especially admired the complicated foreshortening on the multi-curved surface of the vault.

Jonah's muscular arms and pointing fingers direct us to the corner spandrel and the contorted gesture of the figure of *Haman,* whose punishment is a typological prefiguration of Christ's crucifixion. The subject is an instance of triumph over oppression, and like those of the other three corner spandrels—Judith and Holofernes, David and Goliath, and the Brazen Serpent—serves as an Old Testament analog for the triumph of Christ.

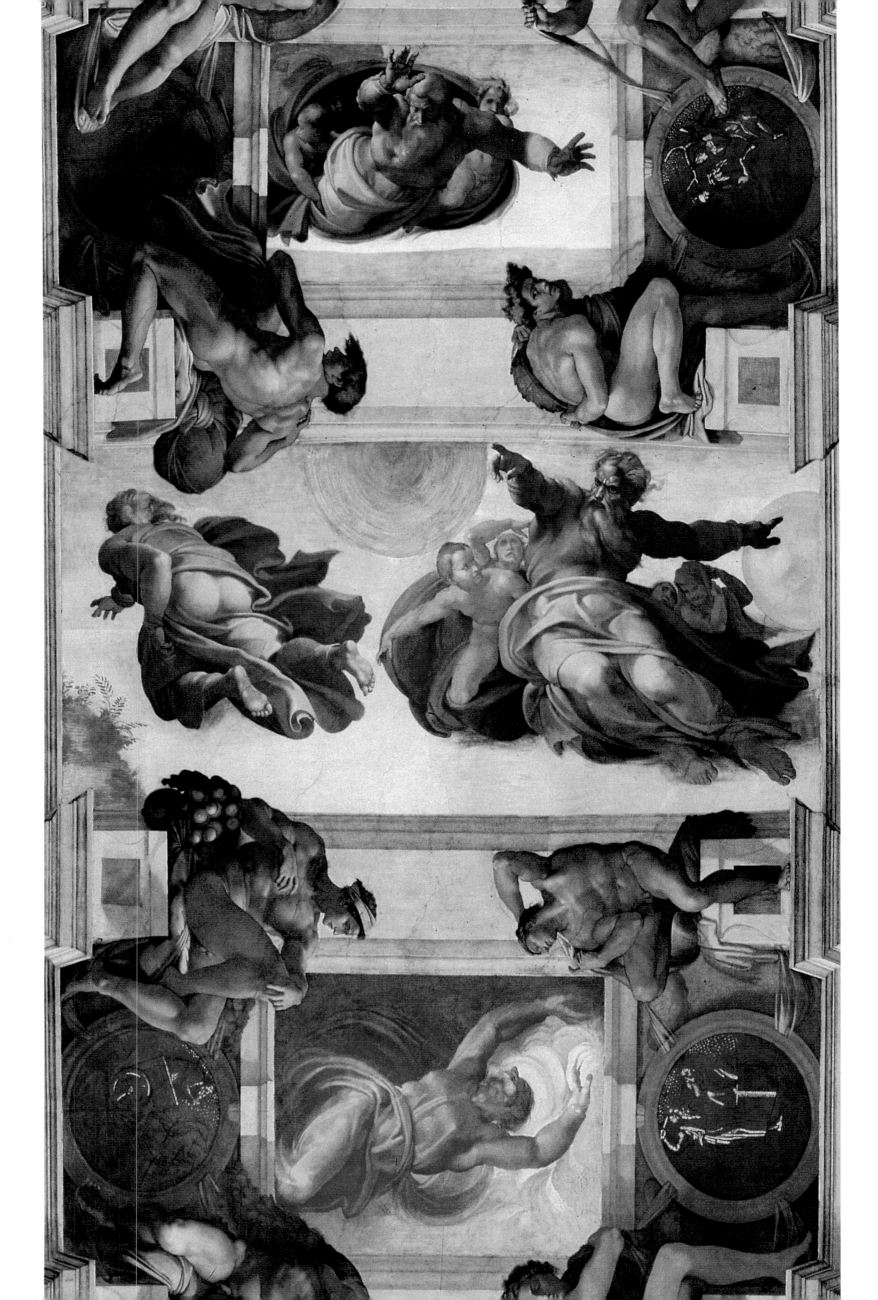

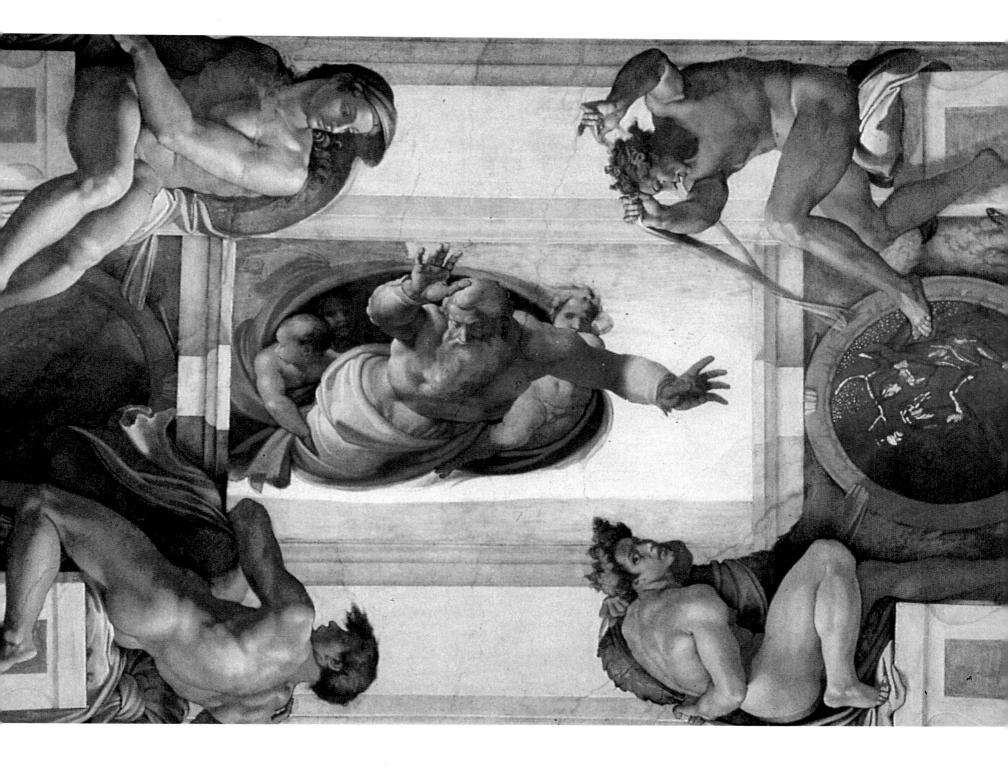

. . . a dramatically foreshortened God hovers over the placid seas . . .

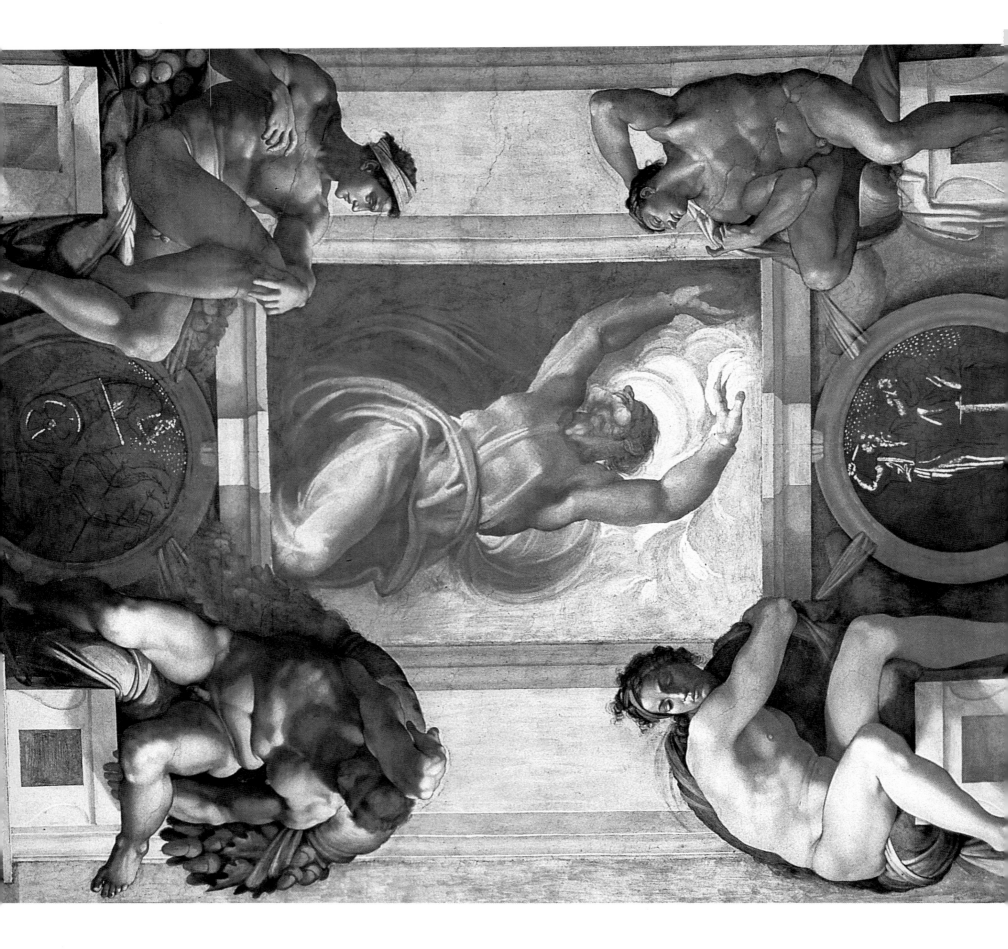

. . . God whirls overhead and we glimpse only the underside of his neck and beard. . . .

Of all the methods that painters employ, painting on the wall is the most masterly and beautiful, because it consists in doing in a single day that which, in the other methods, may be retouched day after day, over the work already done. Fresco was much used among the ancients, and the older masters among the moderns have continued to employ it. It is worked on the plaster while it is fresh and must not be left till the day's portion is finished. The reason is that if there be any delay in painting, the plaster forms a certain slight crust whether from heat or cold or currents of air or frost whereby the whole work is stained and grows mouldy. To prevent this the wall that is to be painted must be kept continually moist: and the colours employed thereon must all be of earths and not metallic and the white of calcined travertine. There is needed also a hand that is dexterous, resolute and rapid, but most of all a sound and perfect judgment; because while the wall is wet the colours show up in one fashion, and afterwards when dry they are no longer the same. Therefore in these works done in fresco it is necessary that the judgment of the painter should play a more important part than his drawing, and that he should have for his guide the very greatest experience, it being supremely difficult to bring fresco work to perfection.

GIORGIO VASARI

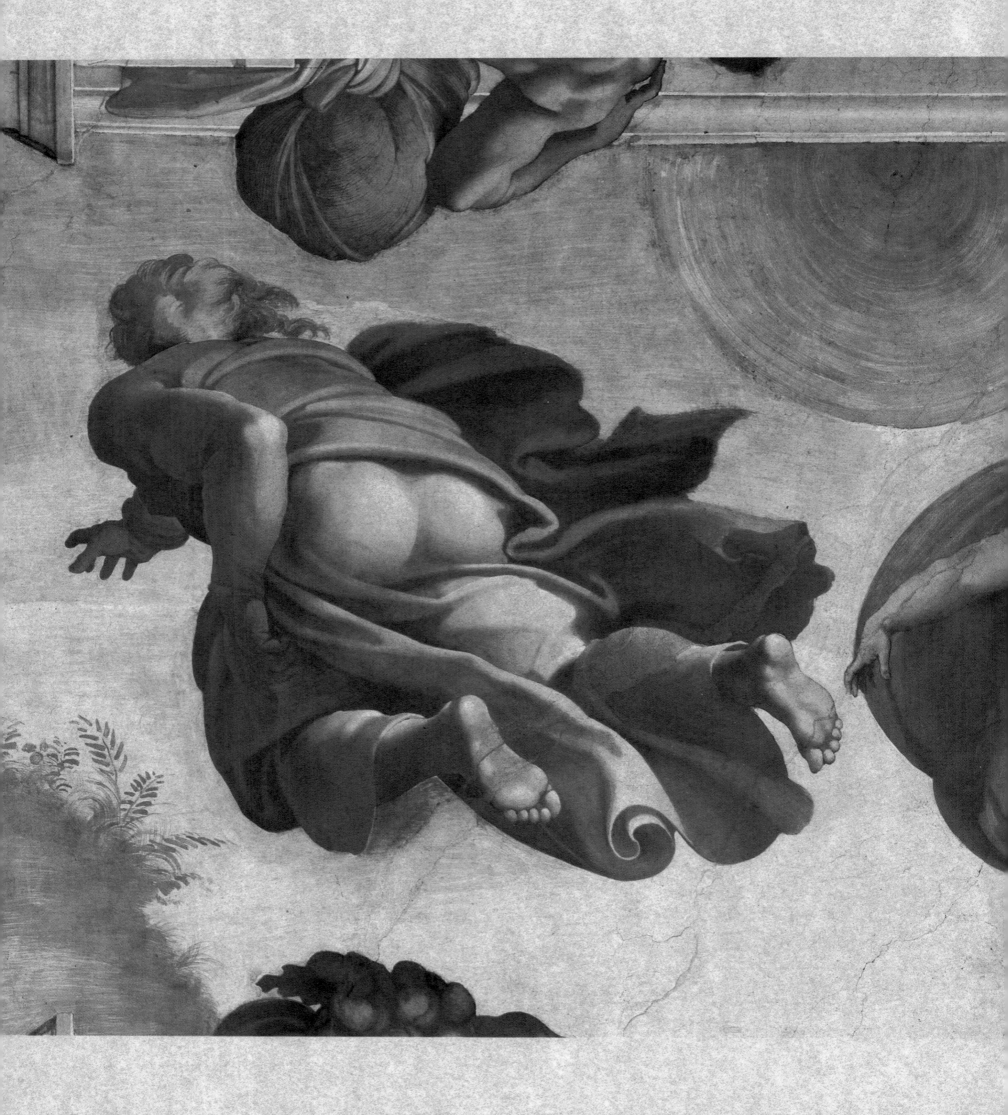

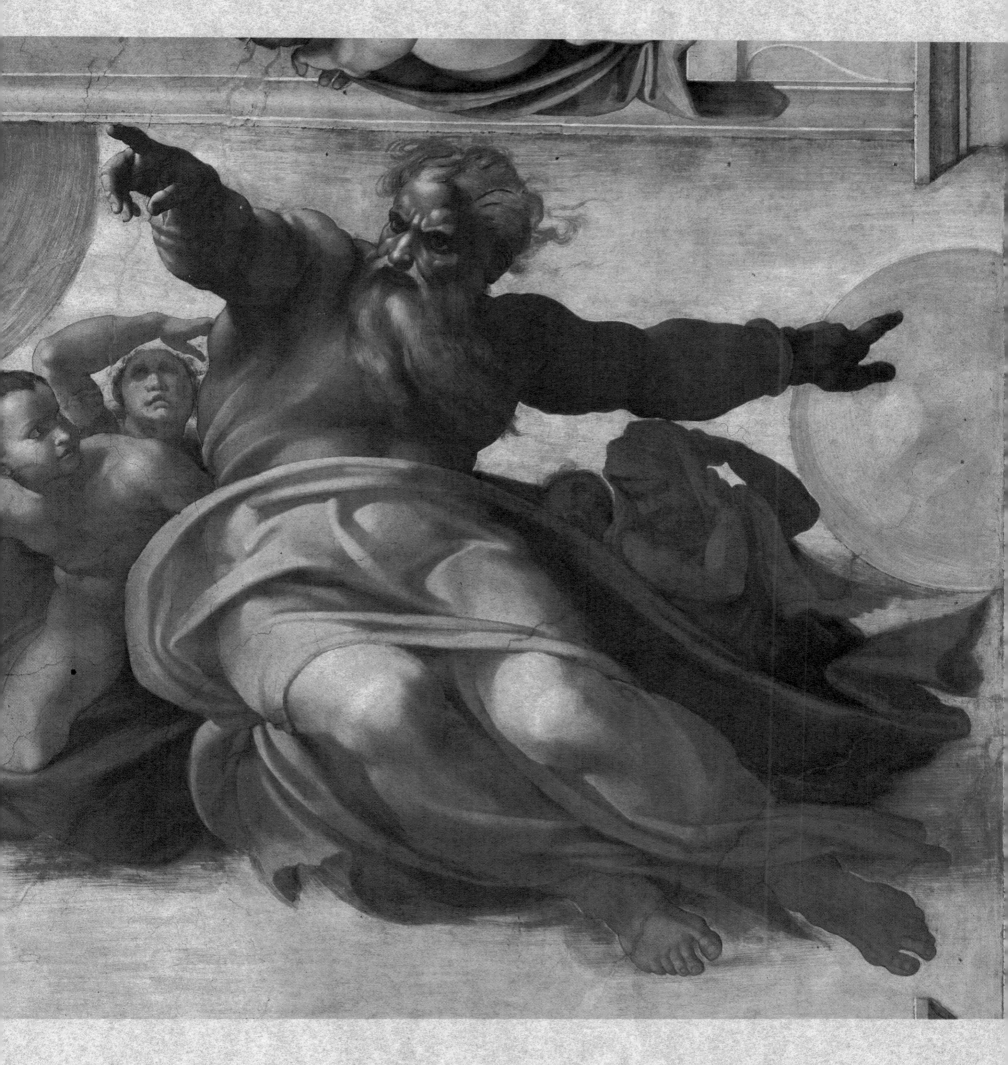

*. . . a most unusual glimpse of God's backside, a view of the deity
described in the Bible but seen only by Moses on Mount Sinai . . .*

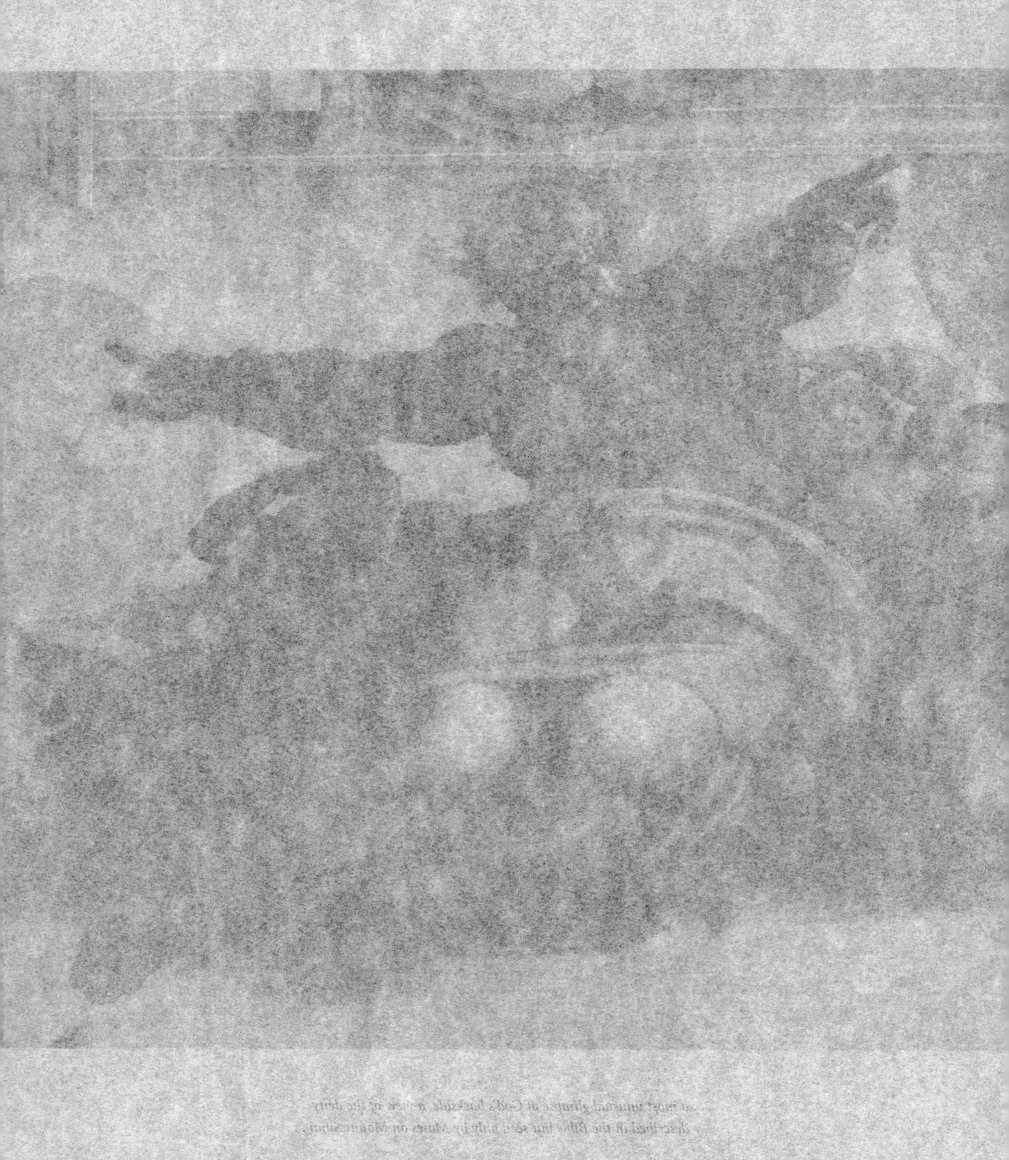

...a most unusual glimpse of God's backside, a view of the deity described in the Bible but seen only by Moses on Mount Sinai.

Michelangelo joined an ideal of beauty and force, a

vision of a glorious but possible humanity, which,

again, has never had its like in modern times.

Manliness, robustness, effectiveness, the fulfilment of

our dream of a great soul inhabiting a beautiful body,

we shall encounter nowhere else so frequently as

among the figures in the Sistine Chapel.

BERNARD BERENSON

THE SIBYLS AND PROPHETS

Jonah is one of seven Old Testament Prophets and five Sibyls, female seers of pagan antiquity who were thought to have foretold the coming of a Messiah. These large, alternating male and female figures are seated on broad marble thrones, and each is accompanied by two companions or genii who, like visible thoughts, assist the majestic Prophets and Sibyls in their scholarly labors of reading, writing, and cogitating.

Here Michelangelo gives full scope to his fecund imagination, inventing a race of beings superhuman in stature and full of prophetic wisdom. The *Erythraean Sibyl* turns the pages of her weighty tome, while her genius companion blows on the flames of a hanging lamp. At once the flame is light and truth, as well as analog for the thoughts that burn in her head. The *Delphic Sibyl*—oracle at the navel of the world—is the youngest and most comely of her com-

panions. She is priestess and Greek maiden whose startled sideways glance suggests she "sees" the ceiling's biblical narrative foretold on her unwinding scroll. Her sight is insight, full of spiritual illumination.

A youthful *Daniel* works with intense concentration on his prophetic book. He is assisted in his labors by a naked genius who, like a miniature Atlas, supports the great weight of the hefty tome upon his shoulders. Of the Old Testament prophets, Christians most frequently cited the book of Isaiah, especially for its prediction of the Virgin birth, a passage the prophet may be marking with a finger inserted in his book. Isaiah's agitated hair and billowing cloak, the deeply furrowed brow, and jerky turn in the direction of his gesturing genius all suggest his call from cogitation to action, for Christian writers believed Isaiah to have been a martyr.

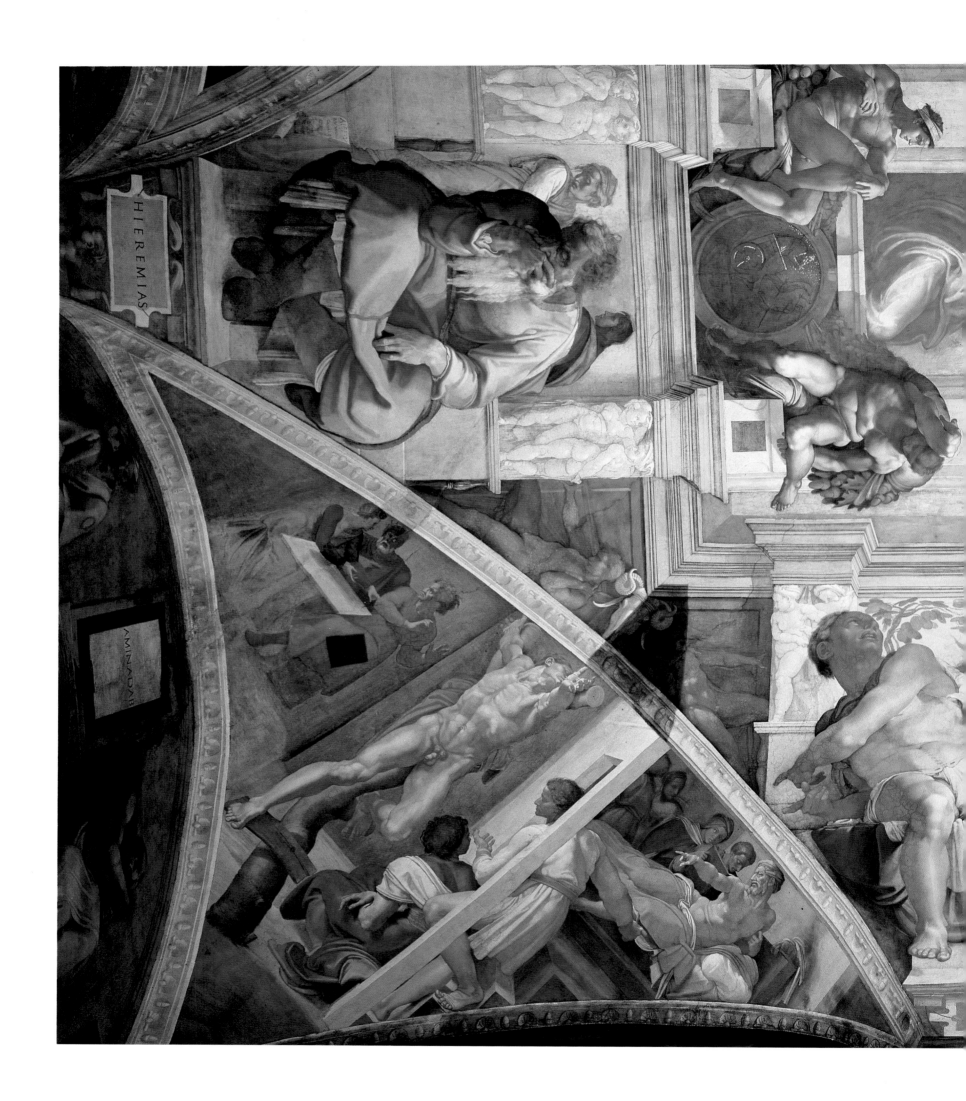

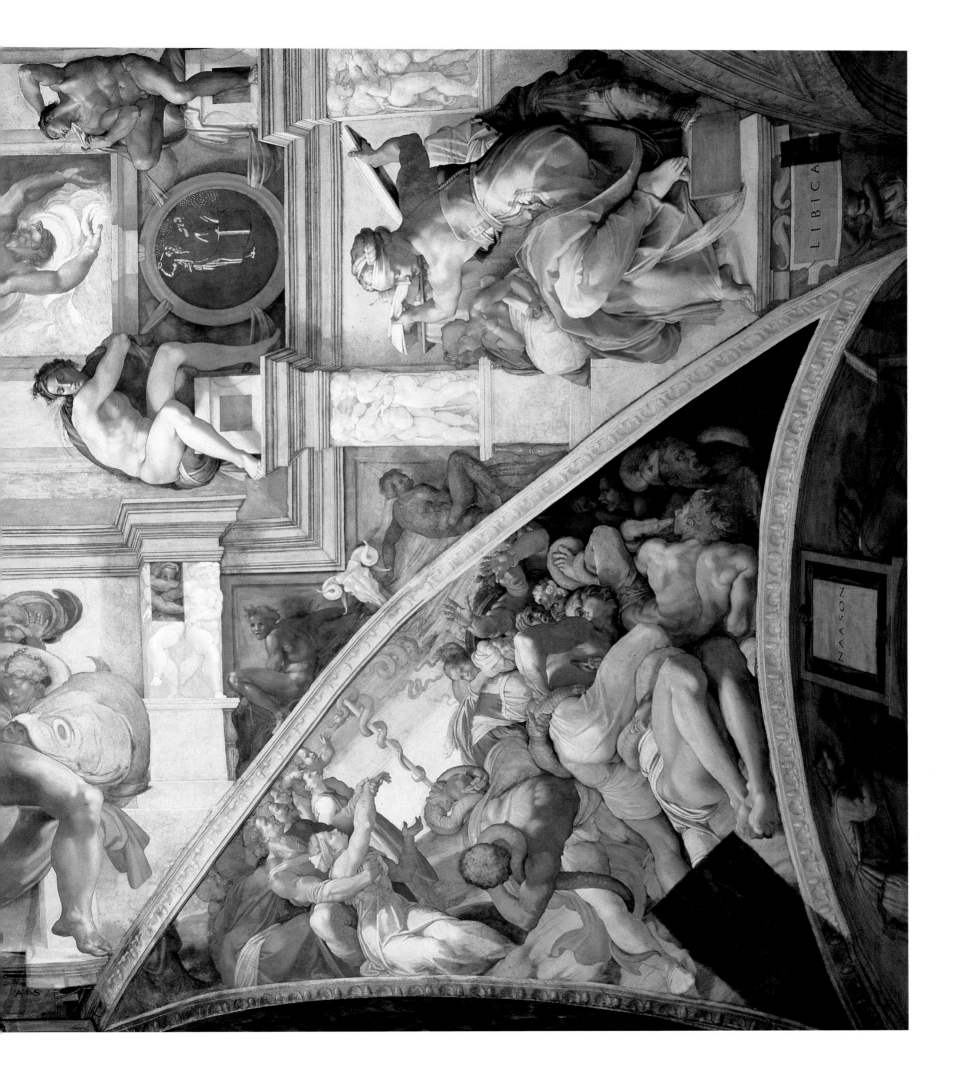

THE PROPHET JONAH *flanked by corner spandrels:* THE PUNISHMENT OF HAMAN (LEFT) *and* THE BRAZEN SERPENT (RIGHT)

THE LIBYAN SIBYL

The *Libyan Sibyl* is one of the most beautiful of all the Sibyls. Michelangelo captures her in the midst of an uncomfortable torsion as she either picks up or replaces the heavy tome that contains her sibylline prophecies. Michelangelo's drawing in red chalk for this figure is still extant and shows the artist's attention to such tiny and seemingly insignificant details as the turn of the left big toe. Although seen from more than sixty feet below, that small detail is critical for suggesting the imbalance and awkward turn of the body; the artist wanted to get it right and had to draw it three times before he achieved anatomical accuracy, and more importantly, the desired degree of animation.

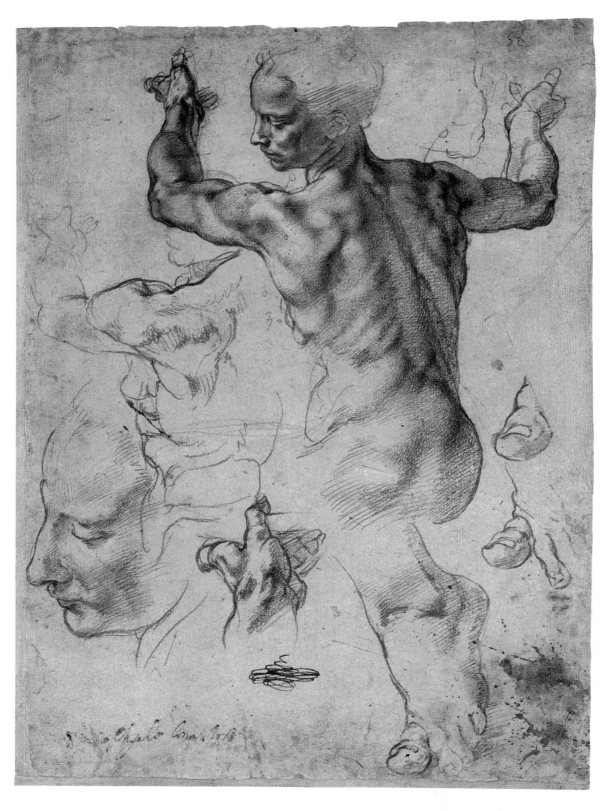

Studies for the LIBYAN SIBYL. *c. 1510. Red chalk on paper. 11³/₈ x 8⁷/₁₆ in.*
The Metropolitian Museum of Art,
New York, Purchase, Joseph Pulitzer Bequest, 1924

I have struggled more than any man ever has,

in bad health and with the greatest labor, and still

I remain patient in order to reach the desired goal.

MICHELANGELO

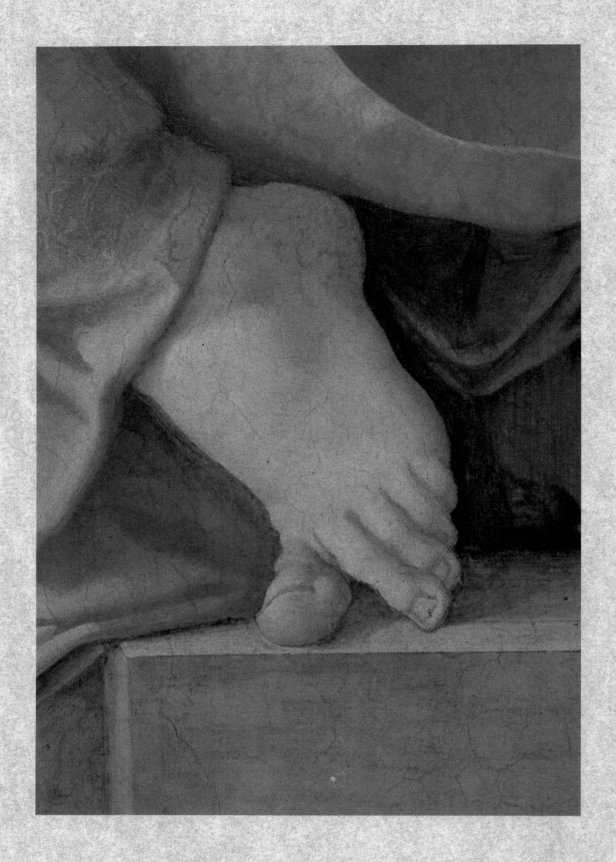

Detail of left foot of the LIBYAN SIBYL
. . . Michelangelo's drawing in red chalk for this figure . . .
shows the artist's attention to such tiny and seemingly
insignificant details as the turn of the left big toe. . . .

OPPOSITE:
. . . Michelangelo captures her in the midst of an uncomfortable
torsion as she either picks up or replaces the heavy tome that
contains her sibylline prophecies. . . .

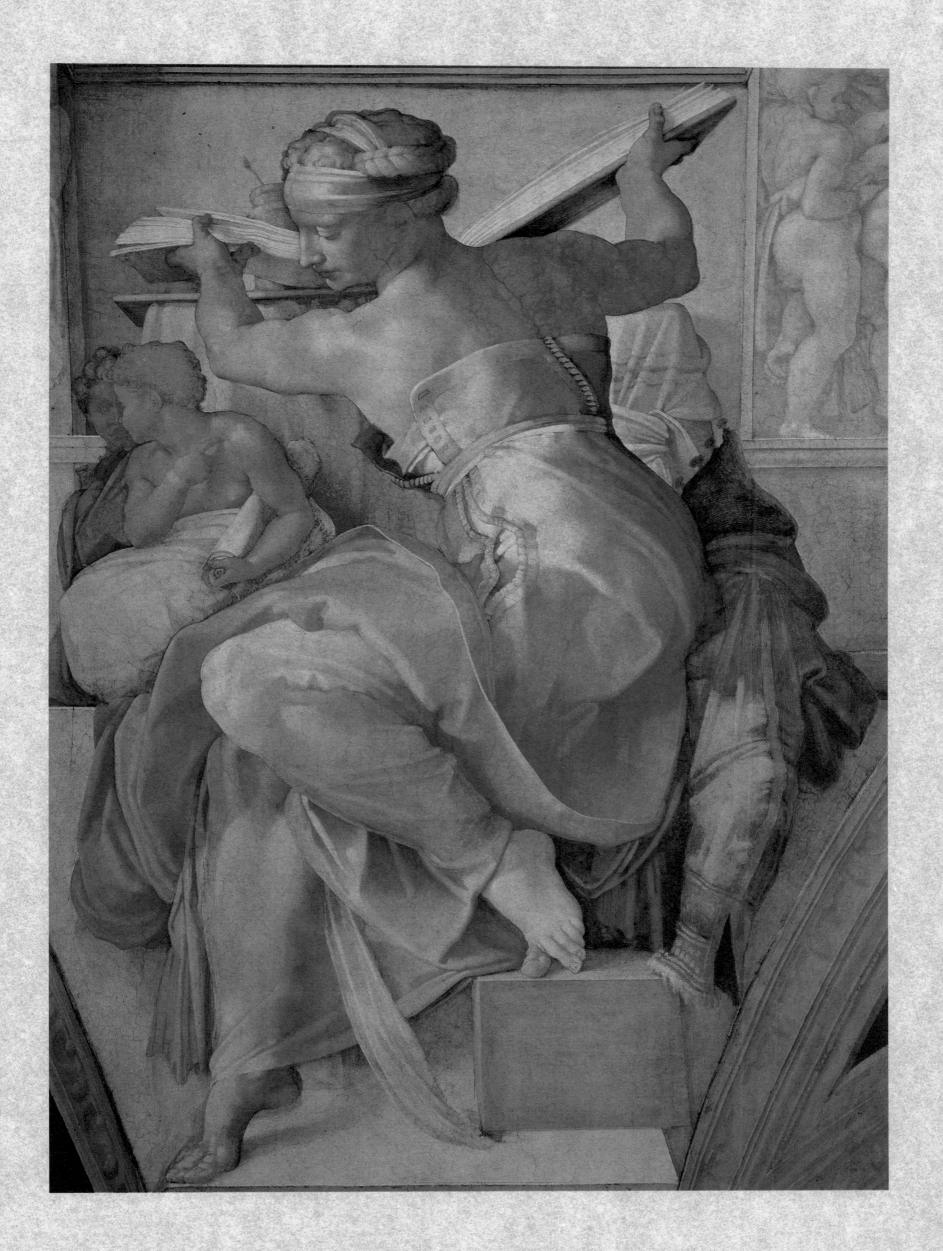

Now you do not,
I am well assured,
know one of Michael Angelo's sibyls from another;
unless perhaps the Delphian,
whom of course he makes as beautiful as he can.
But of this especially Italian prophetess,
one would have thought he might,
at least in some way,
have shown that he knew the history,
even if he did not understand it.
She might have had more than one book,
at all events, to burn.
She might have had a stray leaf or two fallen at her feet.
He could not indeed have painted her only as a voice;
but his anatomical knowledge need not have
hindered him from painting her virginal youth,
or her wasting and watching age,
or her inspired hope of a holier future.

JOHN RUSKIN

THE DELPHIC SIBYL

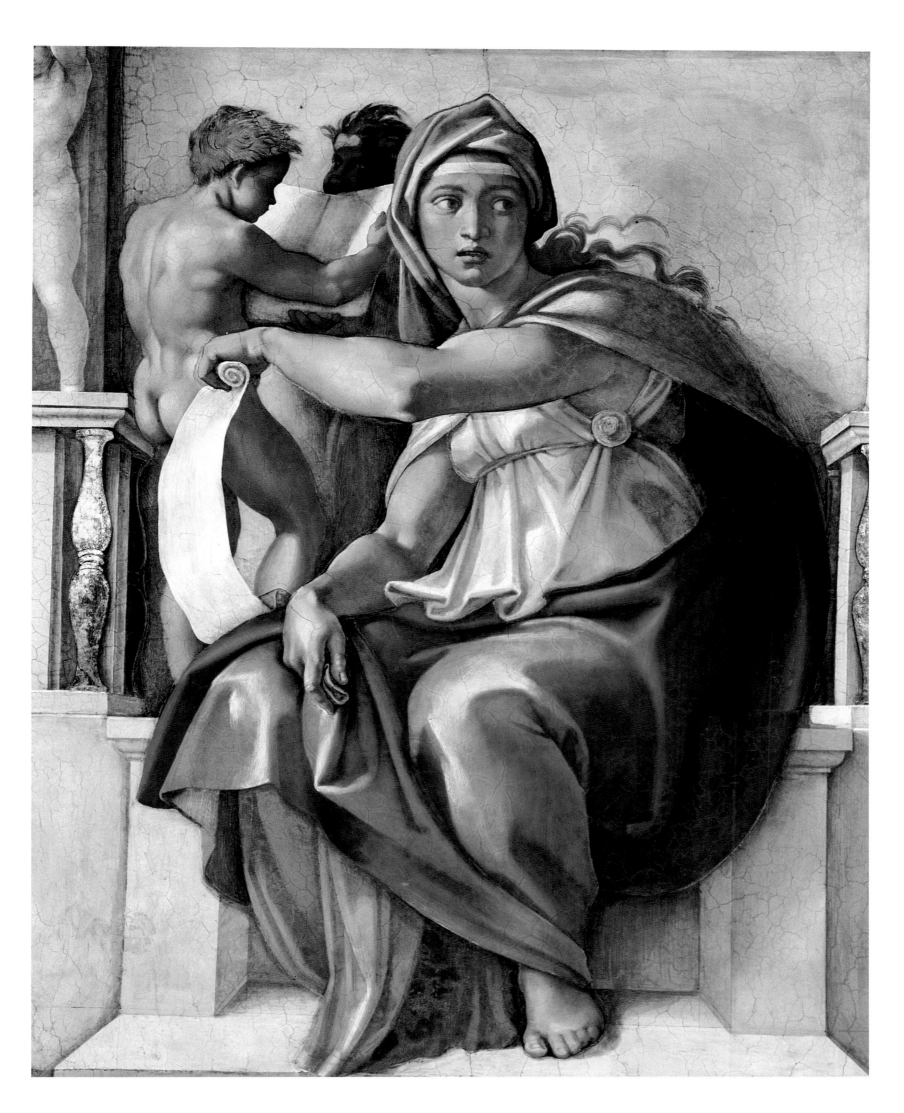

THE CUMAEAN SIBYL

The *Cumaean Sibyl* is quite possibly the most awesome figure on the ceiling. The giant's open mouth and craggy countenance carry us far from the world of polite society and ideal beauty. Her fearsome aspect is underscored by her mountainous shoulders, pendulous breasts, and an astonishingly long and powerful left arm. All contribute to suggest her awful majesty and great antiquity: her age is measured not in years but millennia. The masculinized upper body contrasts with her lower half, where toes rest lightly on the throne and legs are pressed together with a demure-like delicacy that contradicts expectations raised by her massive frame. It is a strange and unexpected fusion of genders that renders "her" larger than life. This great pile of ancient flesh is enough to startle us into believing her prophetic utterances.

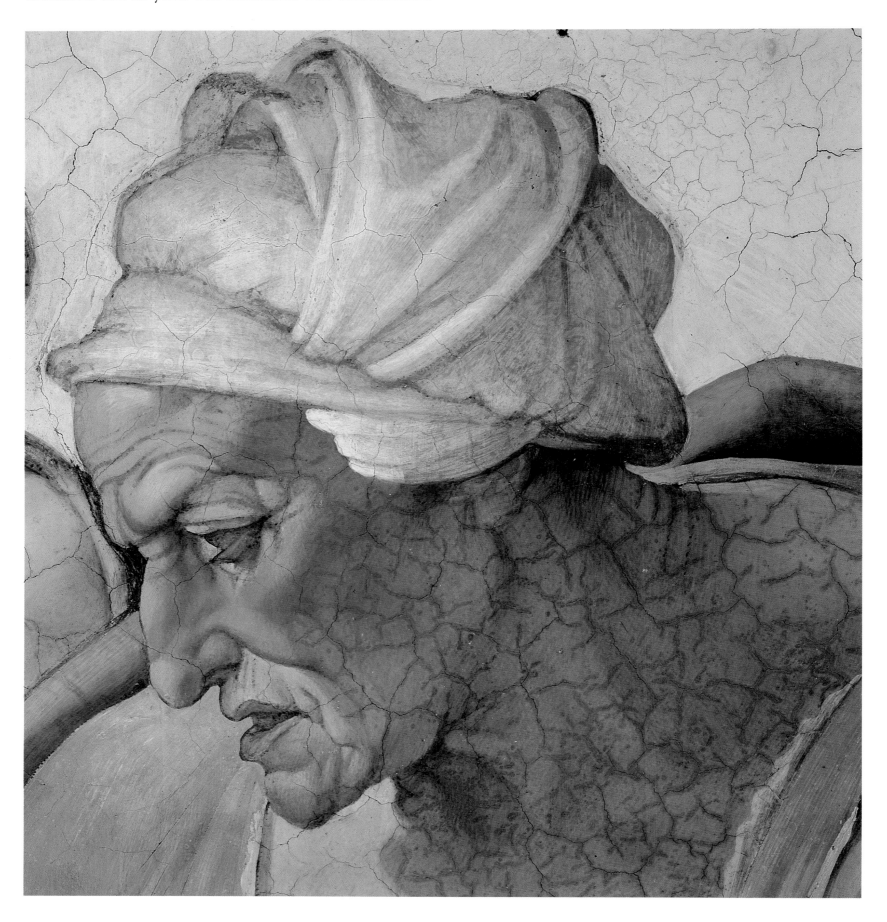

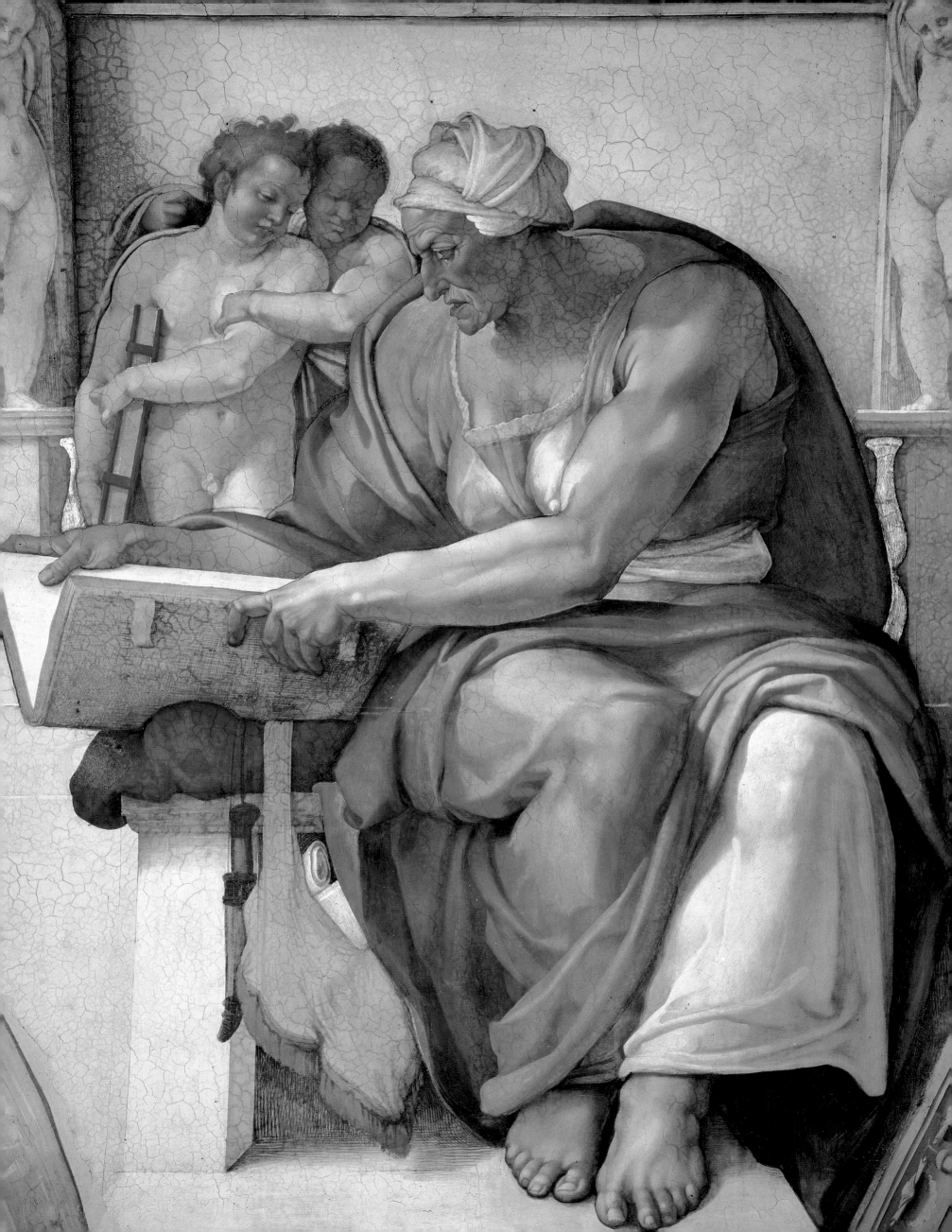

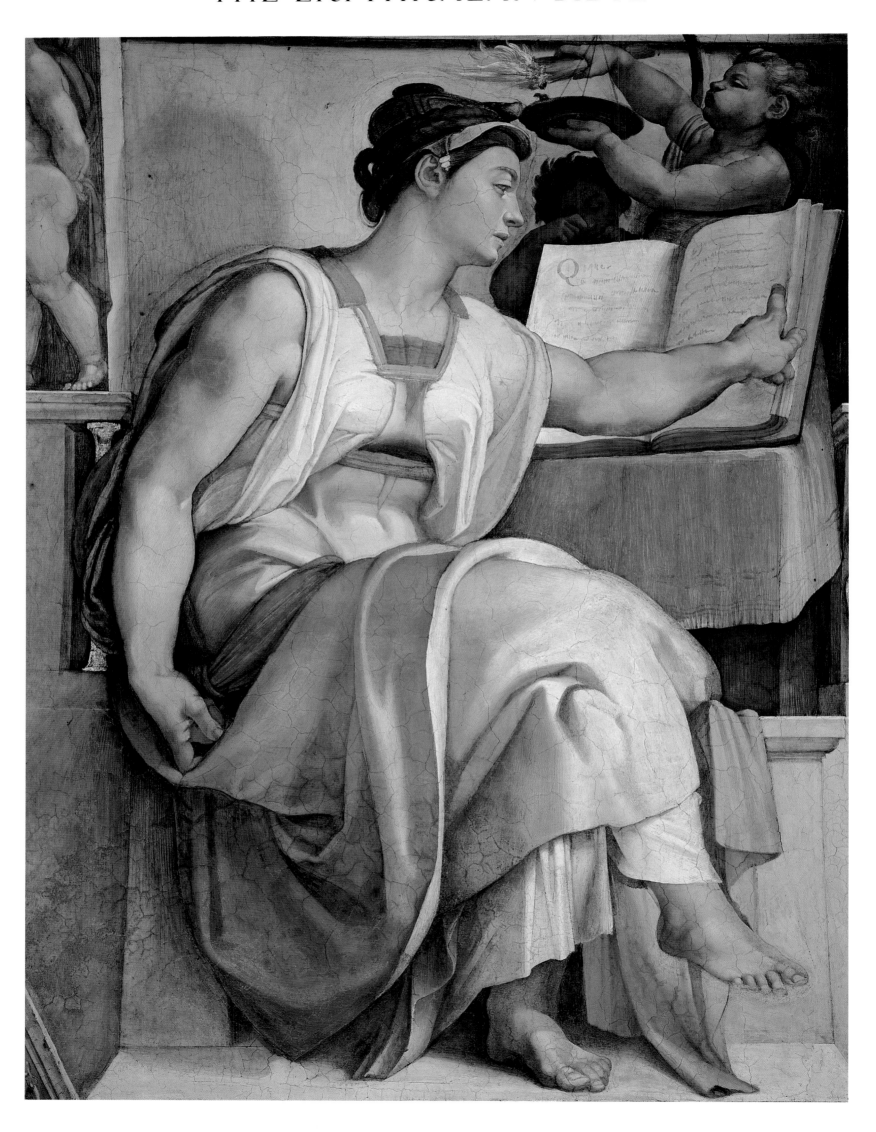

Michael Angelo's Cumaean Sibyl is wasting away.

It is by a grotesque and most strange chance

that he should have made the figure of this Sibyl,

of all others in the chapel, the most fleshly and gross,

even proceeding to the monstrous license

of showing the nipples of the breast as if the dress

were moulded over them like plaster.

Thus he paints the poor nymph beloved of Apollo

—the clearest and queenliest in prophecy

and command of all the sibyls—

as an ugly crone, with the arms of Goliath,

poring down upon a single book.

JOHN RUSKIN

THE PROPHET DANIEL

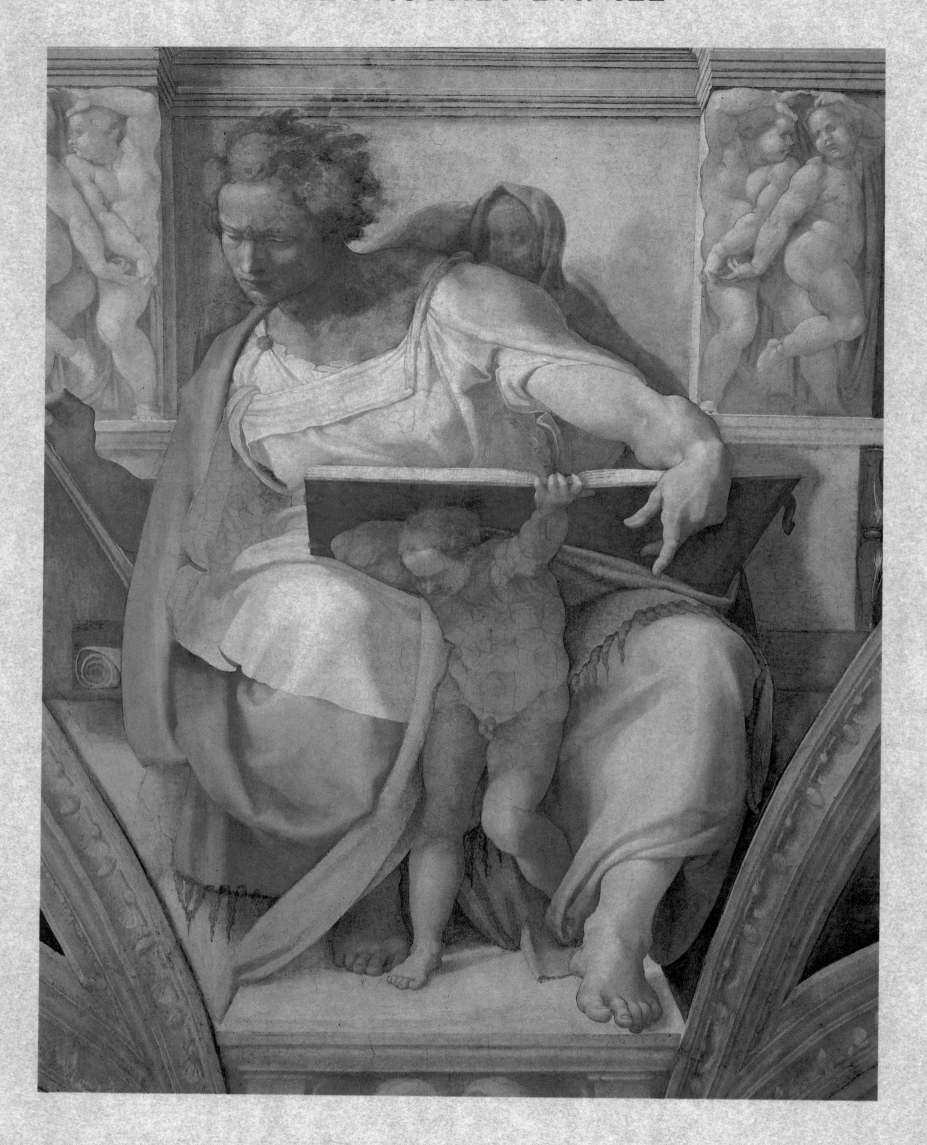

THE PROPHET ISAIAH

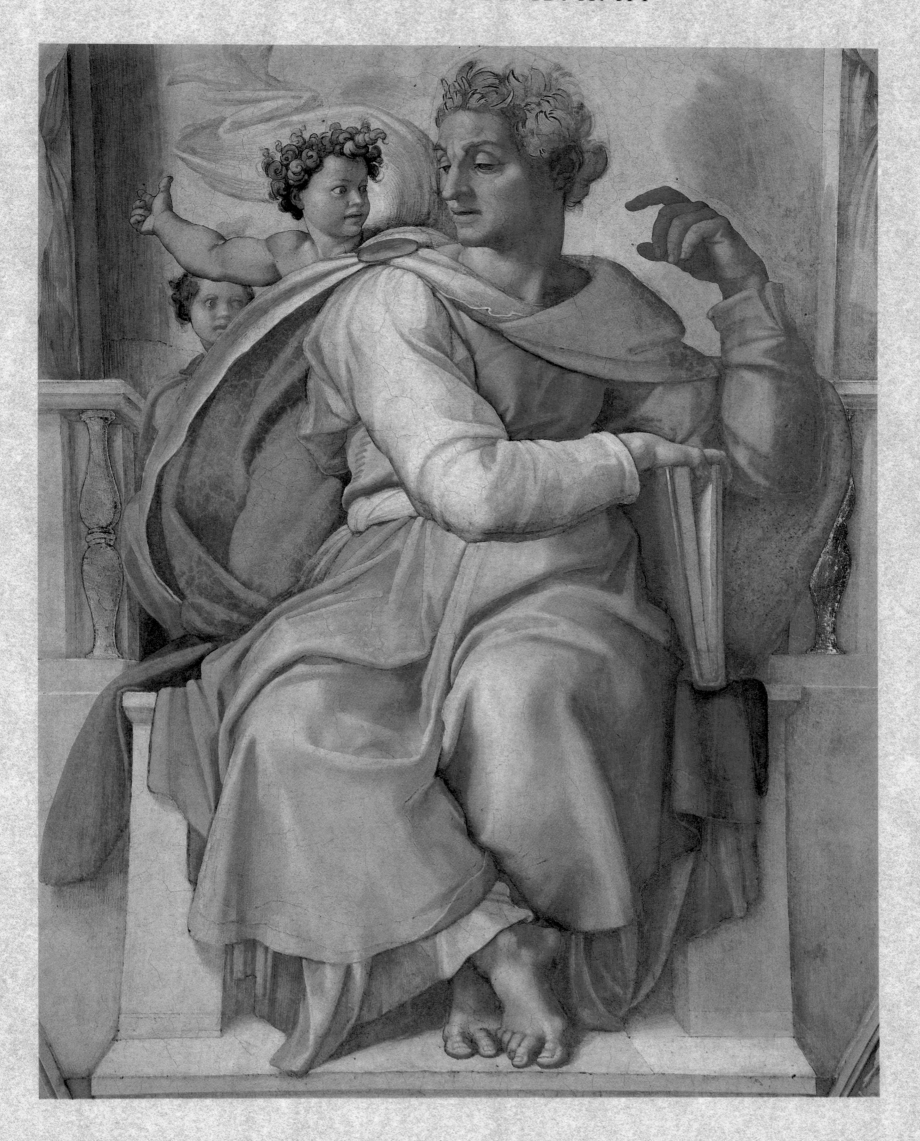

The work was executed with very great discomfort to

himself, from his having to labor with his face upwards,

which so impaired his sight that for a time,

which was not less than several months,

he was not able to read letters or look at drawings

save with his head backwards.

GIORGIO VASARI

THE IGNUDI

Between the narrative scenes, and frequently overlapping them, are twenty nude youths or *ignudi*. They belong to a different realm—and perhaps an antecedent time—from the Genesis scenes. They are intermediaries between narrative and decoration, the pagan and Christian worlds, flesh and spirit. Like animated sculptures sitting on the architectural frames of paintings, the *ignudi* are kin to the genii accompanying the Prophets and Sibyls: animate

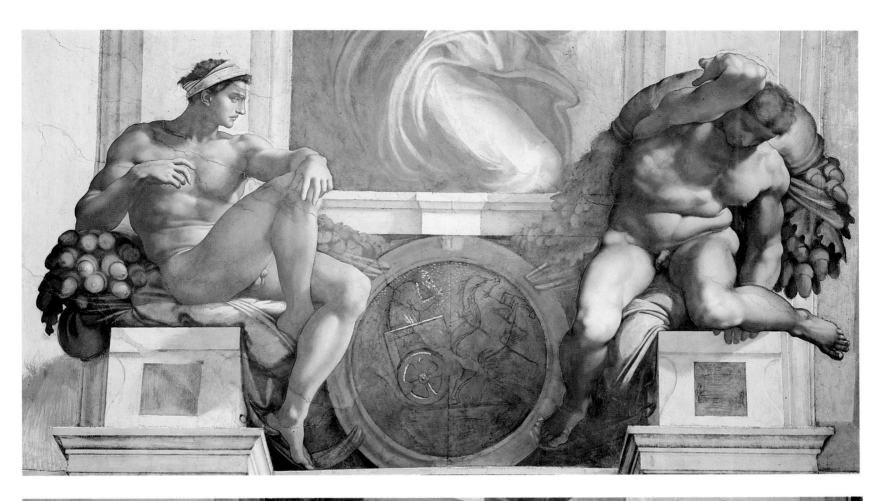

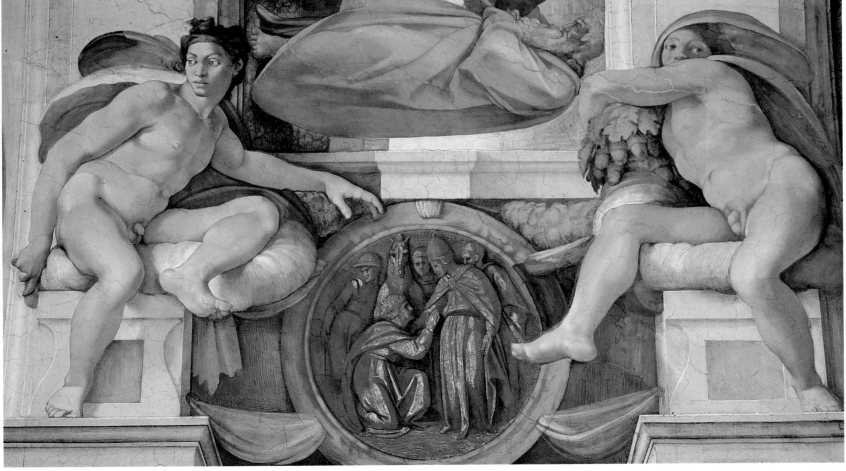

bodies without precise narrative justification or meaning. Arranged in every conceivable manner, they appear natural, even comfortable, but you will soon discover how impossible are their poses when you attempt to imitate them. As with the marble slaves, Michelangelo is capable of suggesting relaxed languor while inventing unlikely, even painful bodily contortions. In these figures—twenty painted reconstructions of ancient marbles—Michelangelo invented a repertoire of poses that would serve as a school of art for centuries.

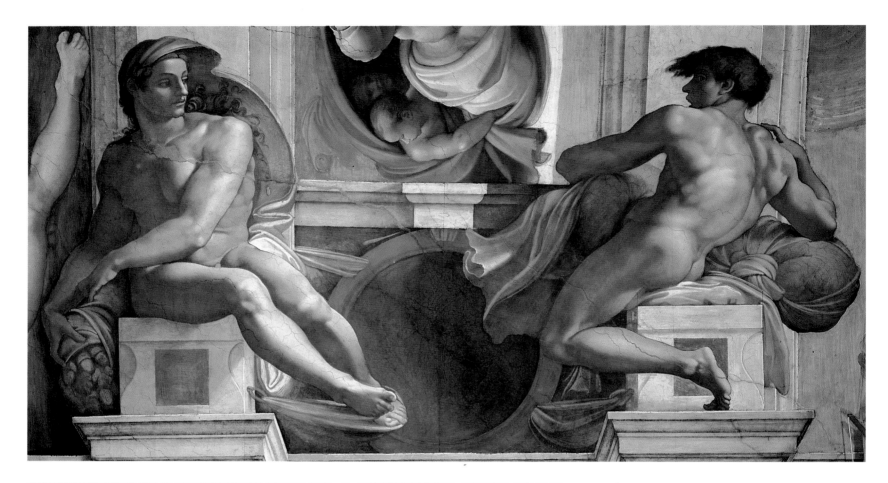

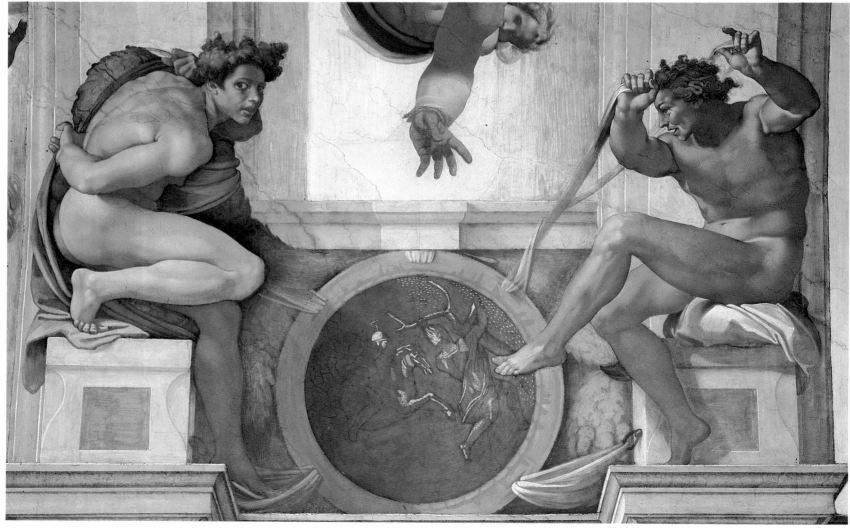

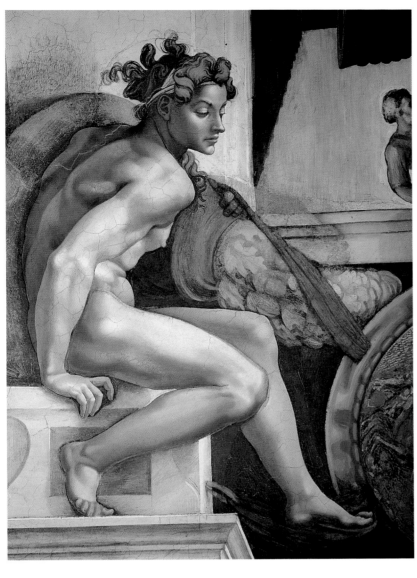

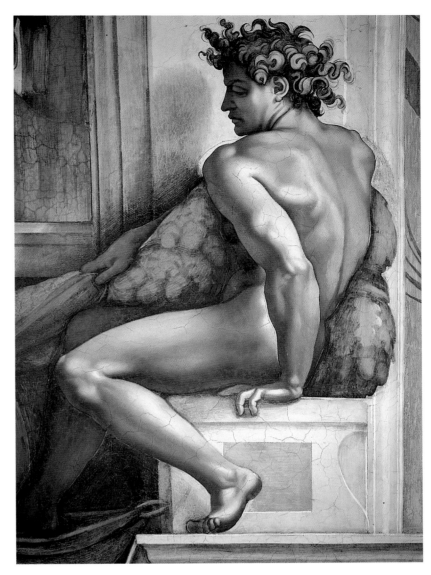

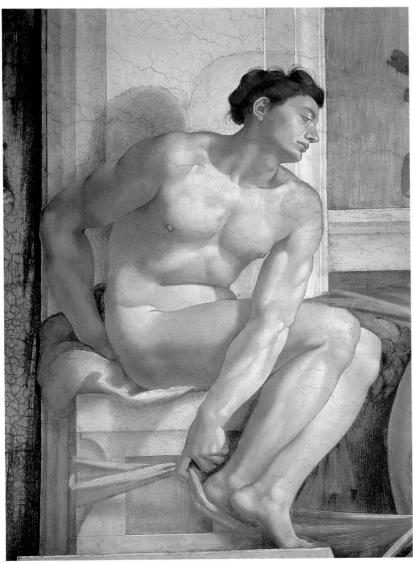

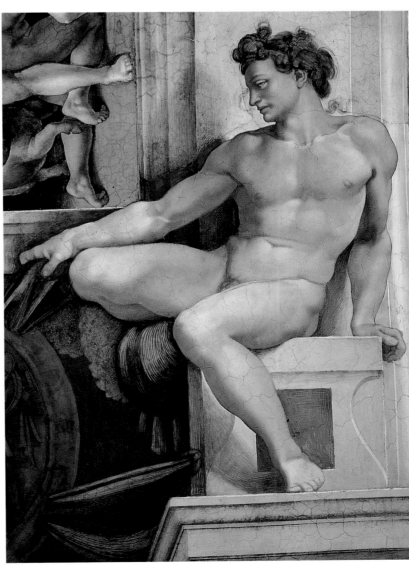

THE LUNETTES

In the lunettes Michelangelo represented the ancestors of Christ, thereby creating a sort of visual genealogy that begins with the Genesis narratives and continues through the Prophets and Sibyls to the earlier frescos below recounting the lives of Moses and Christ. Michelangelo painted each of the lunettes rapidly—in two or three days—and without the aid of cartoons, revealing his complete mastery of the fresco technique. Especially on these flat surfaces subject to *contraluce* light effects (looking into an incoming light), Michelangelo experimented with bold and brilliant color schemes. Until the 1980s the ceiling was mostly celebrated for the density and diversity of its figural repertoire. Since the cleaning of the vault, much discussion has centered on Michelangelo's use of color, to most a delightful surprise, to some a shock. The bright hues, *cangiante* (changing) colors, and unexpected color juxtapositions help create the visual equivalent to stereophonic sound, but also assist in reading the ceiling from a distance, an issue more obvious *in situ* than in reproduction.

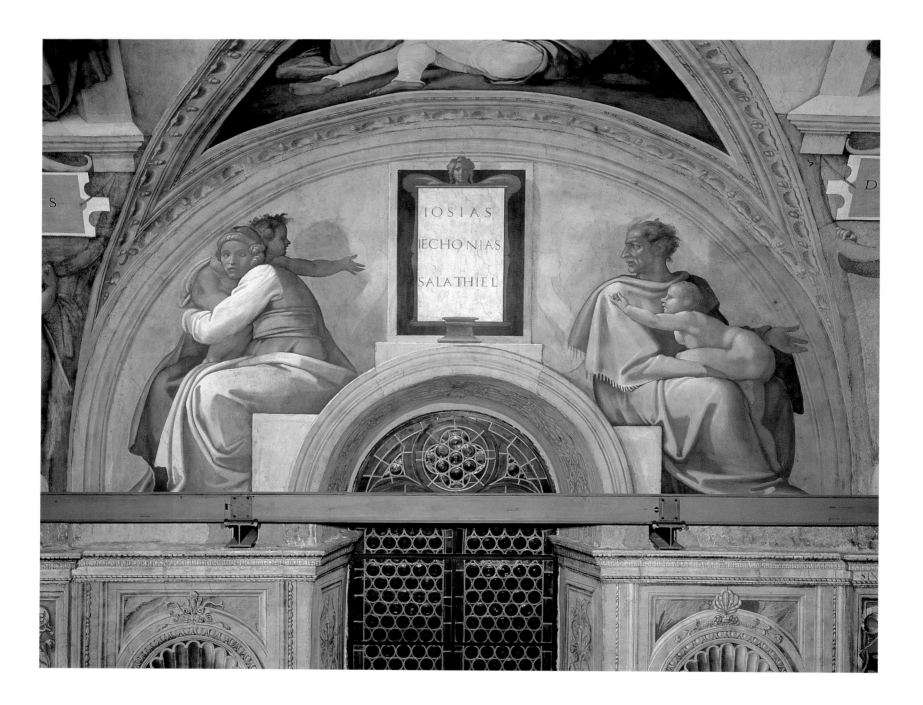

JOSIAH–JECHONIAH–SHEALTIEL LUNETTE

This work, in truth, has been and still is the lamp of our art,

and has bestowed such benefits and shed so much light on

the art of paintings, that it has served to illuminate a world

that had lain in darkness for so many hundreds of years.

GIORGIO VASARI

ASA-JEHOSHAPHAT-JORAM LUNETTE

JACOB-JOSEPH LUNETTE

ASA–JEHOSHAPHAT–JORAM LUNETTE

JACOB–JOSEPH LUNETTE

JESSE–DAVID–SOLOMON LUNETTE

SALMON–BOAZ–OBED LUNETTE

JESSE-DAVID-SOLOMON LUNETTE

SALMON-BOAZ-OBED LUNETTE

Some of those whom the gods love die young.

This man, because the gods loved him,

lingered on to be of immense, patriarchal age,

till the sweetness it had taken

so long to secrete in him was found at last.

Out of the strong came forth sweetness,

ex forti dulcedo.

WALTER PATER

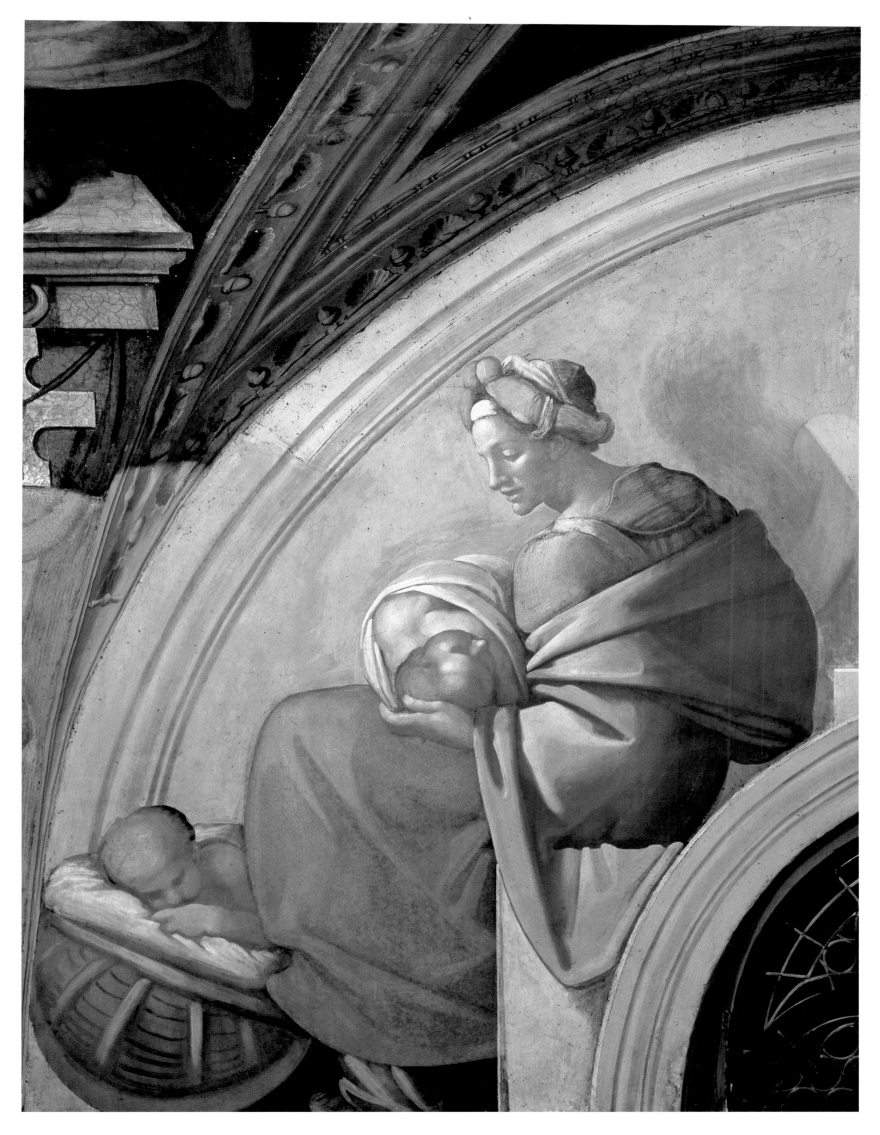

DETAIL OF HEZEKIAH–MANASSEH–AMON LUNETTE

PAINTING

183

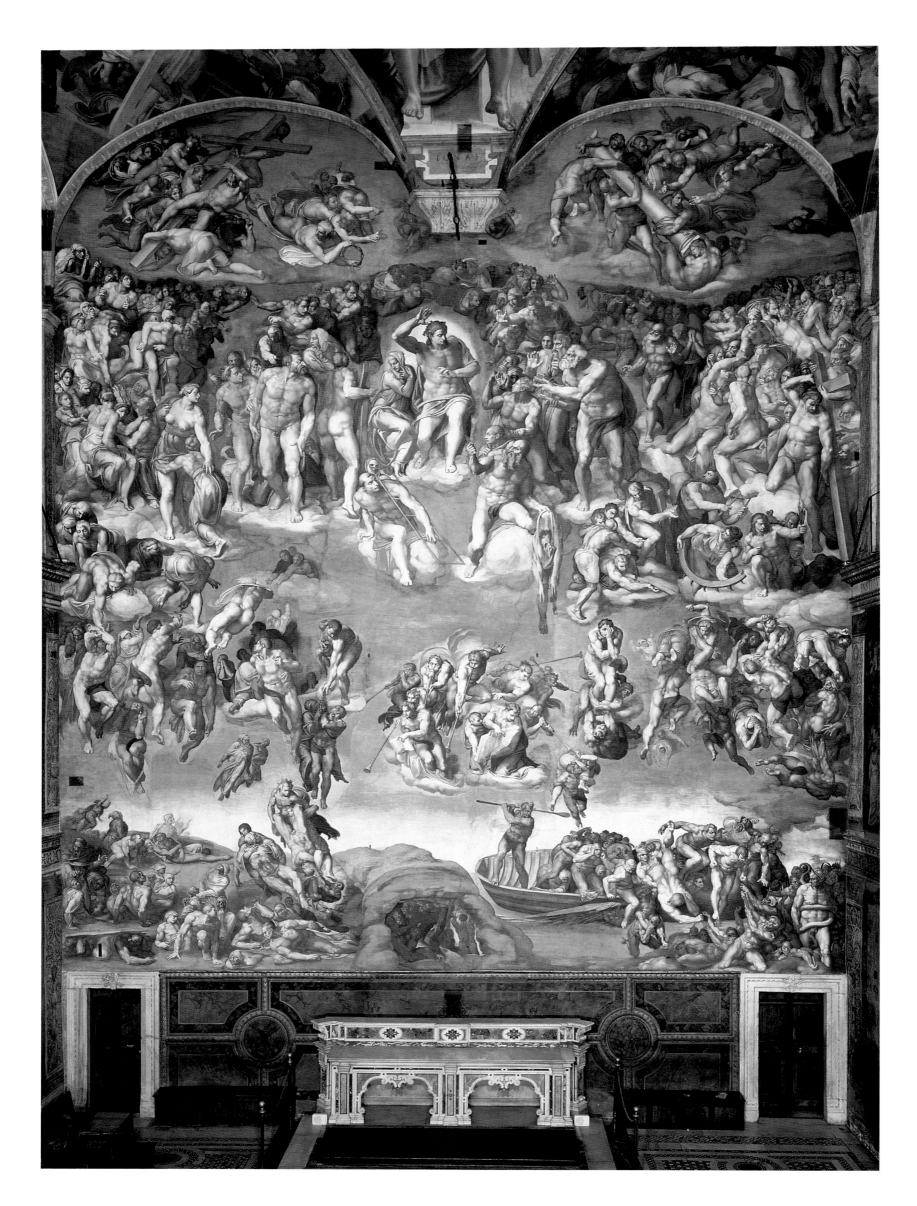

MICHELANGELO

184

THE LAST JUDGMENT

◆ ◆ ◆

1536–1541 ◆ FRESCO ◆ 48 X 44 FEET ◆ SISTINE CHAPEL, ROME

At the completion of the much publicized conservation campaign in 1990, the Vatican invited a group of restorers, curators, and art historians from around the world to assess and talk about the results. Two highlights from that week stand out vividly in my memory. One afternoon our group was leaving the chapel after a long visit to view the *Last Judgment* from the scaffolding erected to clean the wall. The electric lights were switched off, and suddenly the ceiling came to life. In the murky natural light of late afternoon—that is, without the artificial glare and inappropriate intensity of electric lights—the colors of the cleaned ceiling were deep and resonant, the forms grand, majestic, three-dimensional. Later that evening, the Sistine Chapel boys' choir sang in the chapel. Their transparent, transcendent voices rose to heaven, the perfect complement to Michelangelo's pictorial splendor. On the wings of that angelic sound, we were carried aloft.

In many ways the ceiling is a compendium, of Michelangelo's art, of the Renaissance, of Christian theology. Like Beethoven's *Ninth Symphony* or Shakespeare's *Hamlet*, the ceiling is a transcendent work of genius that can never be exhausted through looking or describing. In the words of Goethe: "Until you have seen the Sistine Chapel, you can have no adequate conception of what man is capable of accomplishing."

Few artists are forced to confront their work of twenty-five years earlier and, in a sense, asked to edit it. This was the case when Michelangelo received the commission in 1536 to paint the altar wall of the Sistine Chapel. Although he might have avoided doing so, Michelangelo even chose to eradicate two of the lunettes that he had previously painted as part of the ceiling decoration. Thus, while the two projects are dramatically different in style and subject matter, they are also closely related. Every day that Michelangelo mounted the scaffold to paint the *Last Judgment* he confronted his earlier labor. Beginning at the top of the wall in the normal manner of fresco painting, his new work directly abutted and partly obliterated the old. What thoughts passed through the mind of the artist now painting in the midst of the Catholic Reformation, four popes and twenty-five years later?

The composition is a vast sea of humanity rising and falling around the central figure of Christ who has come to judge the quick and the dead. Michelangelo ambiguously represents Christ as both seated and rising; his lower body recalling the pose of *Moses* in reverse, the upper body more like the *Risen Christ*. The thickset frame and powerful flexed muscles belie the serene look on the beardless, Apollonian face. Some viewers, mostly interpreting the gesture of the raised right arm, see Christ as vengeful, about to cast the damned into hell. But it is significant that Christ looks to the side of the damned, for these are the souls who are in need of salvation. The Lord looks with gentle countenance, as if hoping to save one more soul before the damned disappear into hell's maw. The saved he leaves in the care of his mother, who sits at his side and within the light of his glowing aureole. Her huddled pose recalls the near fusion of mother and son that Michelangelo will further explore in his late Crucifixion drawings and the *Rondanini Pietà*.

The subtle gesture of Christ's left hand first calls attention to the wound in his side and then, framed by the flesh of his body, initiates the resurrection of the dead. This is a good example of how Michelangelo's language of look and gesture has both local and more general geographies. In the lower left of the vast fresco, we see the dead issuing forth from graves. In a powerful visualization of the Catholic doctrine of the Resurrection of the body, we are made witness to a skeleton awaiting to rejoin its envelop of reawakening flesh. The reborn bodies are physically assisted in their ascent to heaven by angels (in one case hauled to salvation by a rosary), just as on the opposite side of the fresco, the damned are violently thrust into hell.

Hell is a fascinating compilation of torment. Partly inspired by Dante and medieval representations of damnation, Michelangelo is equally imaginative about the fallen state of humanity. Wielding his oar, Charon drives a torrent of doomed souls from his boat and into the lowest depths of a flaming hell. In the corner, ass-eared Minos is tormented by a serpent who circles his fleshy body and bites his genitals. What an indelible impression must have been imprinted on those exiting the chapel through the right portal!

But to look up at this point is to once again see the forgiving face of the Lord. On either side he is surrounded by the apostles and saints who intercede on our behalf. These figures are proportionally much larger than those in the

lower registers, partly to correct for seeing them from a great distance, but also because they are larger than life; they are the blessed who populate heaven. Departing from the convention of representing the apostles and saints as enthroned, complacent beings, these soldiers of Christ are still laboring to save sinners.

Just below Christ and helping to complete the mandorla of figures that surround him, are St. Lawrence holding the grill on which he was martyred and St. Bartholomew, who holds the signs of his horrific torture: a knife and his flayed skin. In a strange form of signature, Michelangelo has represented his own distorted features in the limp folds of Bartholomew's epidermis. Perhaps conscious of the incredible hubris of imagining and representing eschatological things, Michelangelo portrays himself as a discardable bit of flesh, tenuously held over hell but in saintly hands.

During these years of poetic fecundity, Michelangelo frequently alluded to a desire to achieve spiritual grace by sloughing off his earthly skin. Like the hundreds of figures represented by Michelangelo, we are rendered naked before our creator. Before the *Last Judgment* we are made painfully aware of our sins but also reminded that salvation is still attainable with the second coming of Christ.

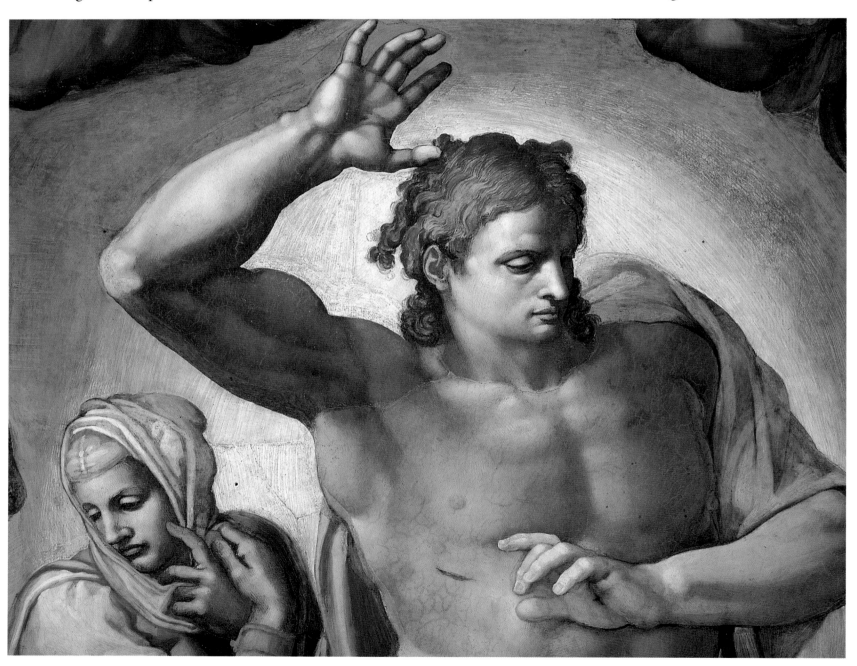

. . . The saved he leaves in the care of his mother, who sits
at his side and within the light of his glowing aureole.
Her huddled pose recalls the near fusion of mother
and son . . .

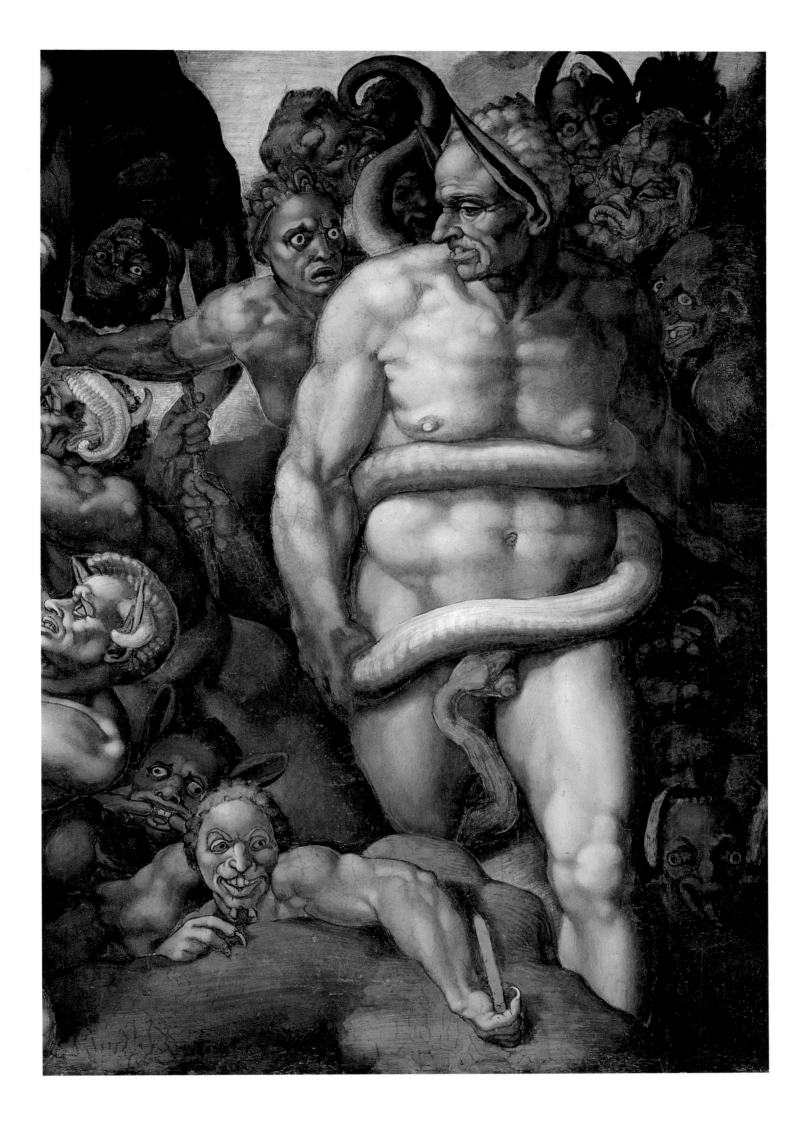

*. . . ass-eared Minos is tormented by a serpent who
circles his fleshy body and bites his genitals. . . .*

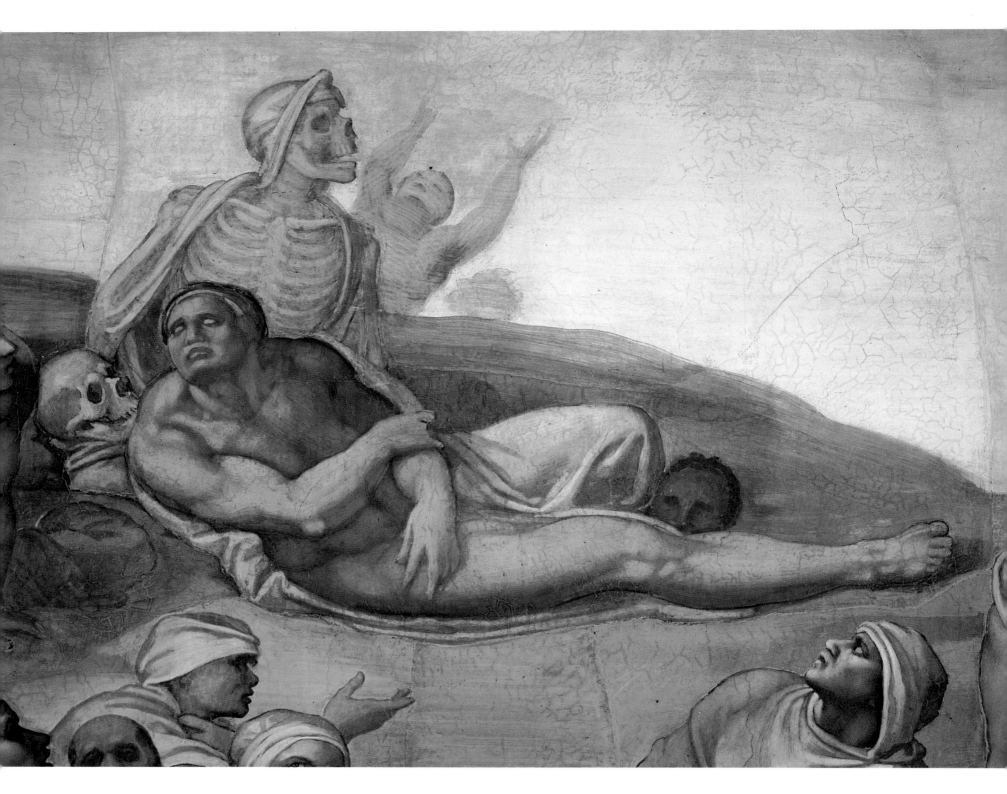

. . . In a powerful visualization of the Catholic doctrine of the
Resurrection of the body, we are made witness to a skeleton
awaiting to rejoin its envelope of reawakening flesh. . . .

OPPOSITE:

. . . St. Bartholomew holds the signs of his horrific torture:
a knife and his flayed skin. . . .

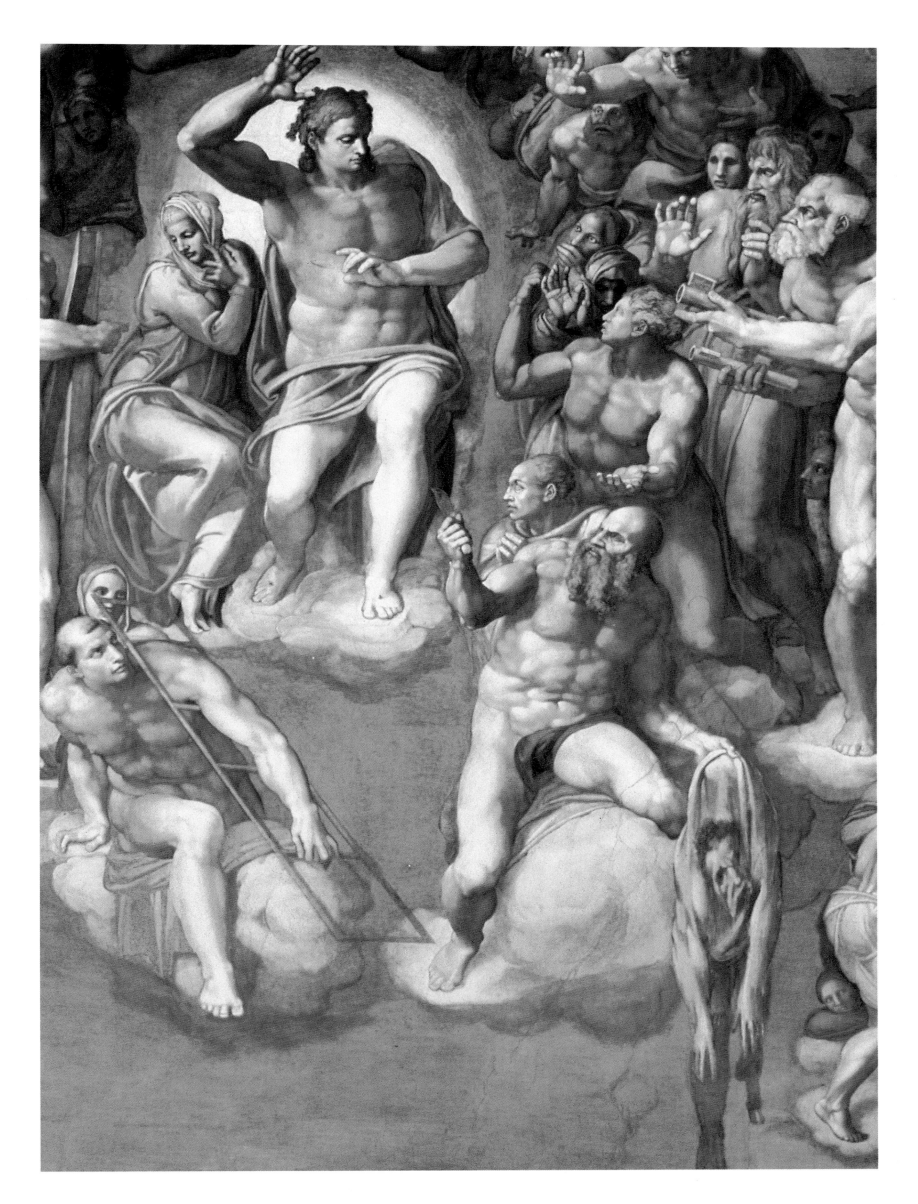

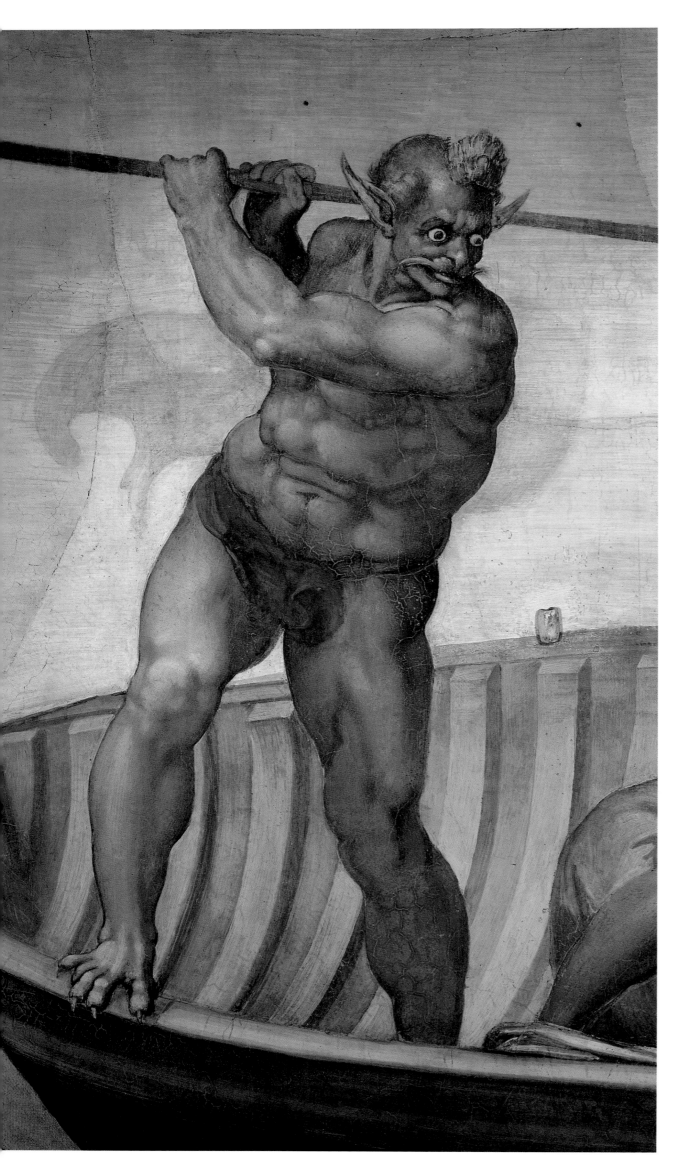

. . . Wielding his oar, Charon drives a torrent of doomed souls from his boat and into the lowest depths of a flaming hell. . . .

. . . the damned are violently thrust into hell.. . . .

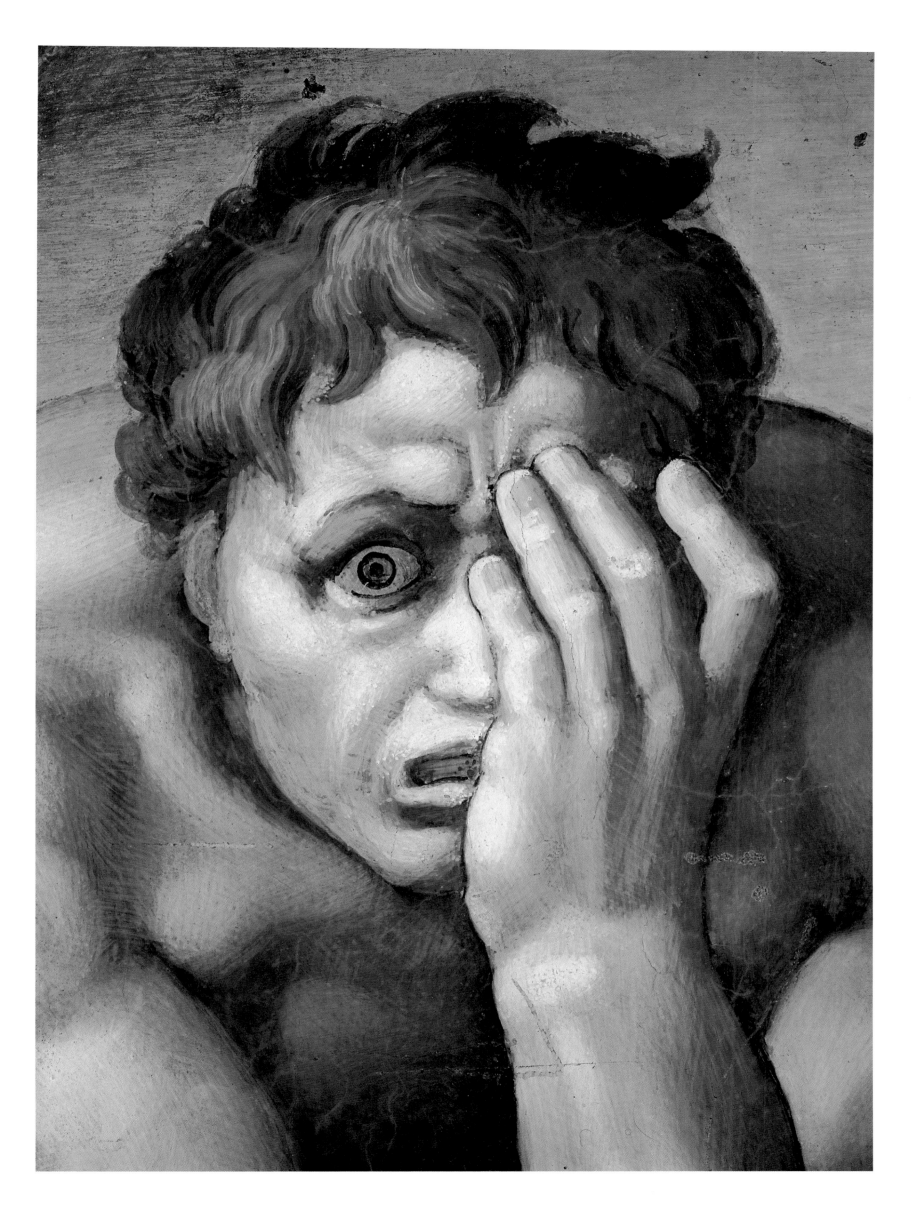

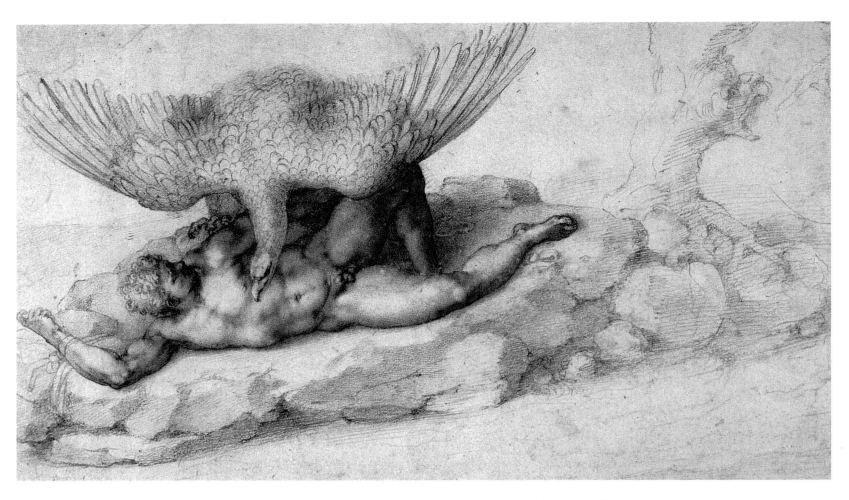

PUNISHMENT OF TITYUS. *Black chalk drawing. Royal Library, Windsor*

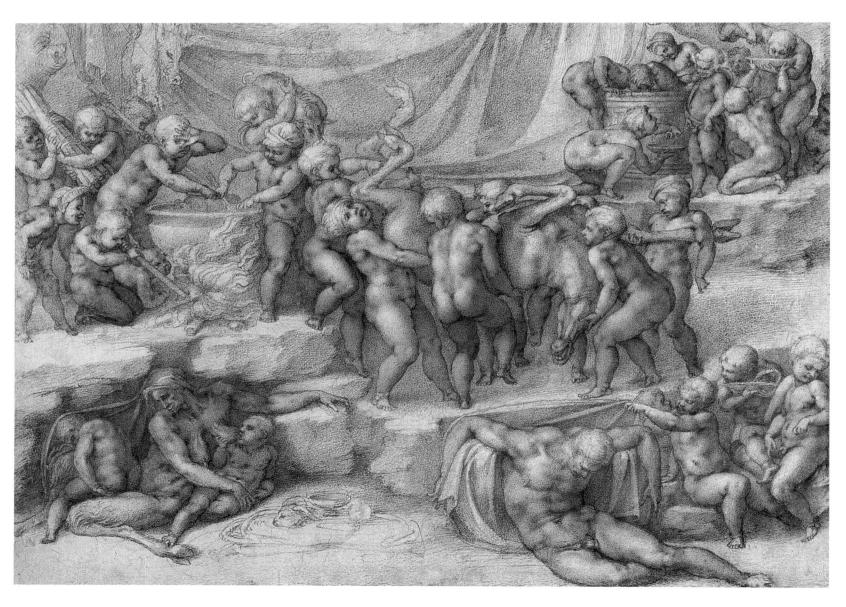

BACCHANAL OF CHILDREN. *Black chalk drawing. Royal Library, Windsor*

DRAWINGS FOR TOMMASO DE' CAVALIERI AND VITTORIA COLONNA

◆ ◆ ◆

1530S–1540S ◆ DRAWINGS ON PAPER

For two of the artist's closest friends, Michelangelo created some of the most remarkable drawings of all time. These highly wrought images were admired as finished works of art—drawings treated like paintings—thereby initiating a new chapter in the history of drawing and collecting. Vittoria Colonna, for example, once thanked Michelangelo for a gift of drawings by praising them as "perfectly painted" and "subtly and marvelously done."

These highly desirable objects were frequently copied and translated into prints, plaquettes, and paintings. Originally, they were probably intended for a more modest purpose, as drawing lessons for Michelangelo's young friend, the Roman nobleman Tommaso de' Cavalieri. In one instance, Michelangelo drew the *Fall of Phaeton*, now in the British Museum, because the two friends had just returned from inspecting an impressive ancient relief of the same subject. On the bottom of the sheet Michelangelo wrote: "Messer Tommaso, if this drawing doesn't please you tell my servant Urbino for I have time to make another by tomorrow evening as I promised you; and if it does please you and you would like me to finish it then send it back to me." The drawing evidently pleased the young man since Michelangelo did draw a finished version that is a miracle of the draftsman's art, now in Windsor Castle.

Shortly thereafter, Michelangelo made other drawings for Cavalieri, including the *Tityus* and the rather strange *Bacchanal of Children*. Their friendship was an intense, sublimated relationship that found its expression in love poetry, an impassioned but socially proper correspondence, and these exceptional drawings. The drawings instantly became topics of conversation in gossipy Rome, and have remained a locus of speculation ever since.

Some years later, Michelangelo found another outlet for his passions in the person of Vittoria Colonna. High born and exquisitely refined, Vittoria was an important poetess in her own right. Michelangelo was inspired by her to write some of his most fervent religious poetry, and he presented her with a few choice drawings. Theirs was a love tempered in the fires of religious exaltation.

Among the drawings Michelangelo made for Vittoria is one in the Gardner Museum in Boston which combines Michelangelo's recurring interest in the theme of the Pietà with his appreciation for Dante. Inscribed on the cross is a line taken from *Paradiso*, "No one thinks how much blood it costs."

In a drawing of the Crucifixion in the British Museum, the anguished cry of Christ is implied rather than inscribed: "My God, my God why hast thou forsaken me?" On receiving the Crucifixion drawing, Vittoria wrote to Michelangelo: "One cannot see a better made, more life-like and more finished image . . . I have never seen a more finished thing." Rarely has the world witnessed such a concentration of artistic excellence and religious fervor. These small and vulnerable objects are precious not for the humble materials of their manufacture, but for their exquisite artistry and the windows they open on Michelangelo's life, faith, and friendships.

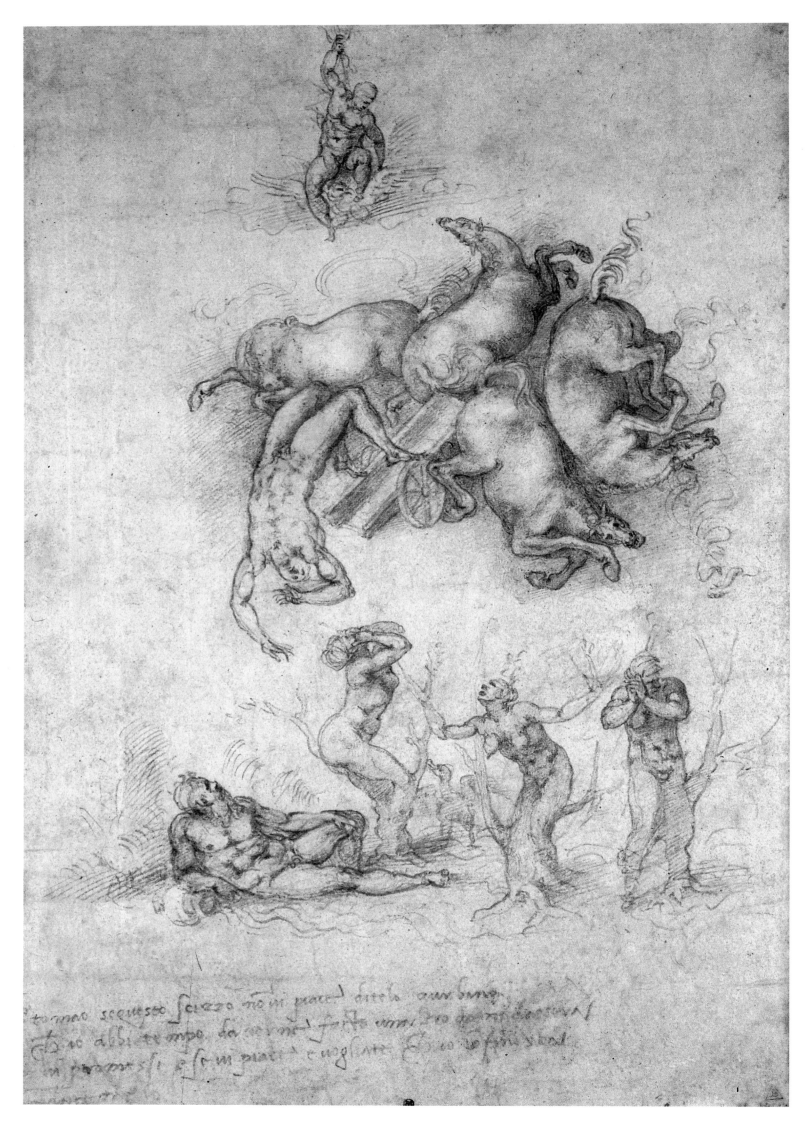

THE FALL OF PHAETON. *Black chalk drawing. British Museum, London*

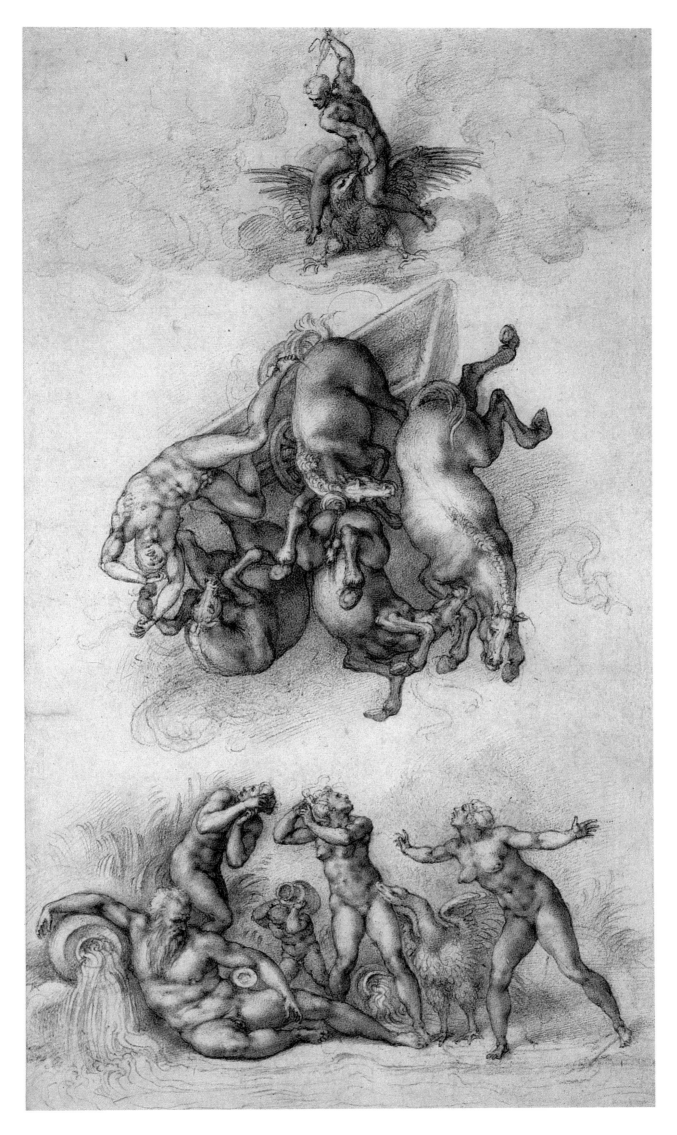

THE FALL OF PHAETON. *Black chalk drawing. Royal Library, Windsor*

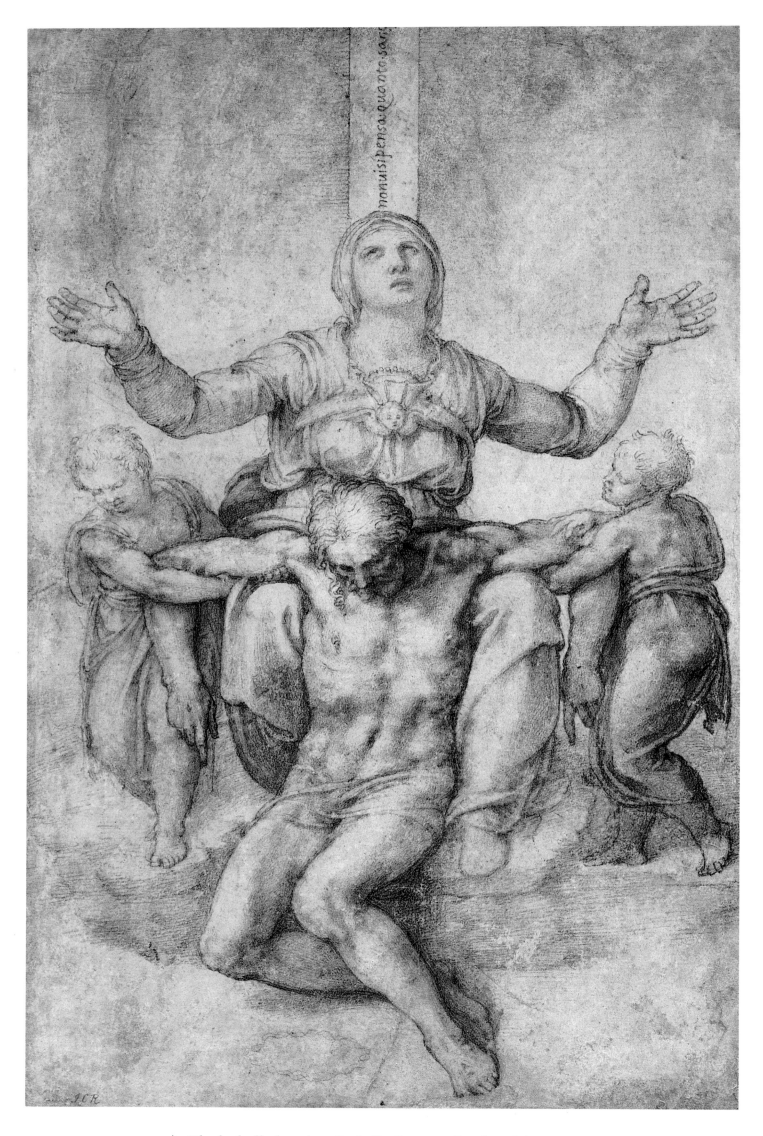

PIETÀ. *Black chalk drawing. Isabella Stewart Gardner Museum, Boston*

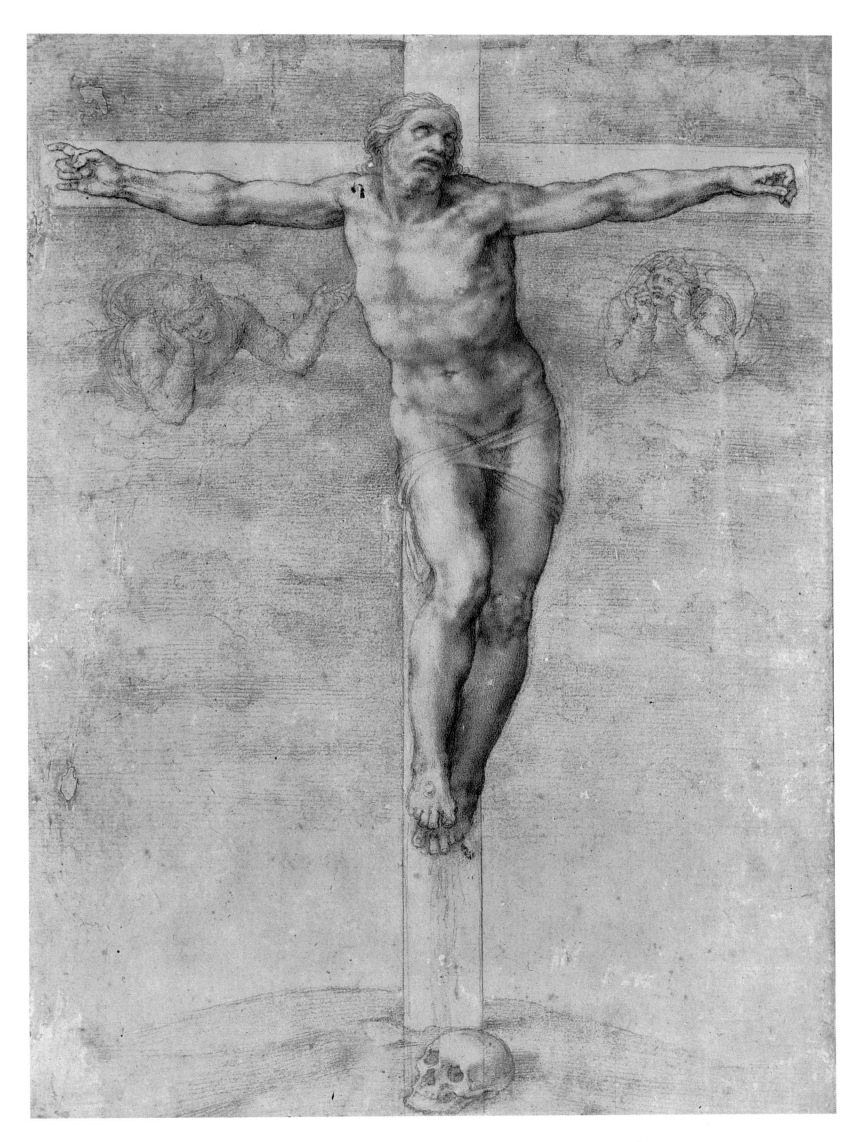

CRUCIFIXION OF CHRIST. *Black chalk drawing. British Museum, London*

THE PAULINE CHAPEL FRESCOS

◆ ◆ ◆

THE CONVERSION OF SAUL ◆ 1542–1545 ◆ 20 FEET 6 INCHES X 21 FEET 8 INCHES ◆ VATICAN, ROME
THE CRUCIFIXION OF ST. PETER ◆ 1546–1550 ◆ 20 FEET 6 INCHES X 21 FEET 8 INCHES ◆ VATICAN, ROME

In the Vatican complex, sandwiched between St. Peter's and the papal apartments, is a chapel with Michelangelo's last and least well-known paintings. The Pauline Chapel served a dual function as Chapel of the Sacrament and Chapel of the Conclave. Here the popes were elected (now this occurs in the Sistine Chapel) and began their mission as Peter's successor. Where once the College of Cardinals gathered, the current pope quietly prays. This is one of the innermost sanctums of the Christian religion. The choice of subjects for the chapel was significant, and so was the manner in which Michelangelo represented them.

Despite the importance of the chapel and its patron, Pope Paul III, the Pauline frescos have often been considered among Michelangelo's least successful works, products of his declining abilities in old age. The paintings disobey conventional rules of composition, ground planes appear oddly tilted, there are unexpected shifts in scale, figures are cut off arbitrarily, and many exhibit peculiar proportions. The paintings are sometimes discussed as if they had embarrassing faults requiring explanation.

In contrast to the well-known Sistine Chapel, the nearby Pauline Chapel is relatively inaccessible and is probably better known through photographs than first-hand experience. Yet Michelangelo's frescos have been ill served by reproduction. They were meant to be seen along the walls of the long, narrow chapel; the oft-remarked oddities of these two frescos are greatly exaggerated when they are seen from the "ideal" frontal view of most photographs. Michelangelo purposefully adjusted the arrangement and proportions of his figures so they would appear correct—as successive parts of an unfolding narrative—from a number of different viewpoints, mostly oblique.

As we enter the chapel, our attention is drawn first to the dramatic and well-lit *Conversion of Saul* on the left wall. Descending as a bolt of lightning from heaven, a *deux-ex-machina* Christ causes Saul, the oppressor of the Jews, to fall from his horse, which is now leaping in terror into the background. Although shielding his eyes from the glaring light and temporarily blinded, this is the moment that Saul first "sees" and converts to Christianity. As Paul, he will begin his mission in the city of Damascus, indicated by Christ, who points to it in the far right background.

Contrary to the norms of most Renaissance painting, Michelangelo placed the protagonists, Christ and Saul, along an emphatic vertical that is shifted far to the left of the compositional field. Thus, immediately upon entering the chapel our attention is arrested by the most dramatic moment, the bolt of light that links heaven and Earth. As we progress towards the altar, we notice the secondary figures in various states of confusion and disarray, only a few of which have the courage to look to heaven. Distracted by the events on Earth, we too find ourselves in confusion, uncertain where to look or how to proceed. Taking our cue from a few brave souls, we once again look up and see Christ. At the center of a burst of light and symmetrically disposed angels, he is the first and last figure we see, the alpha and omega of Michelangelo's pictorial narrative.

. . . Saul's dramatic conversion . . .

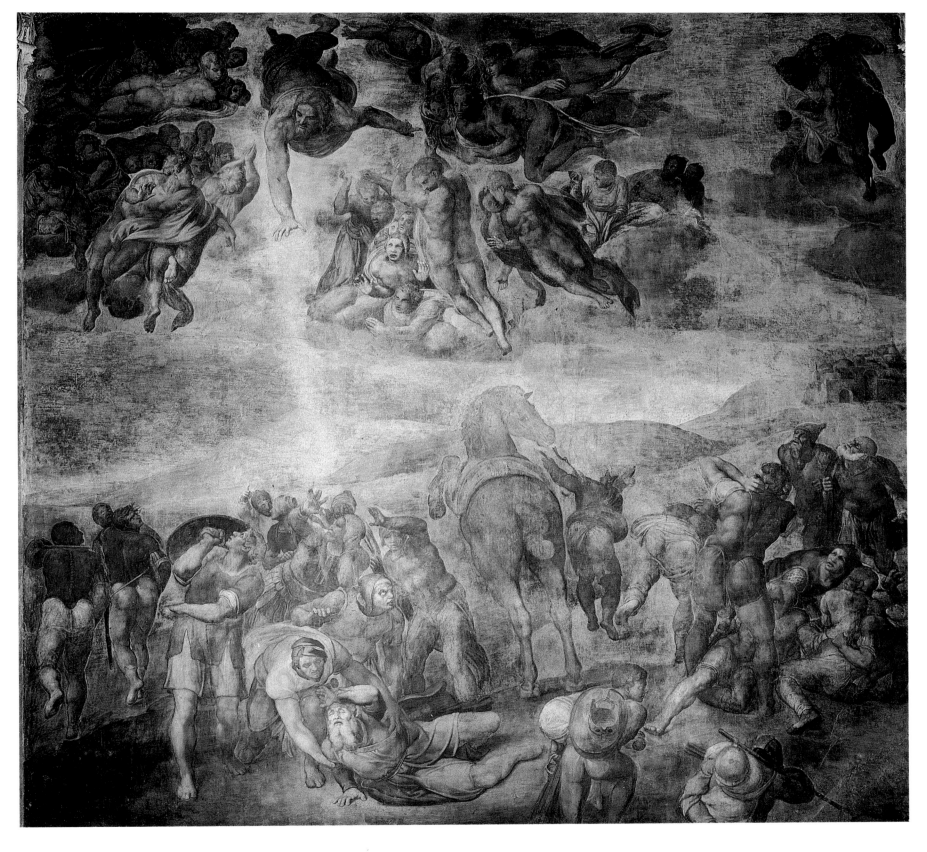

THE CONVERSION OF SAUL

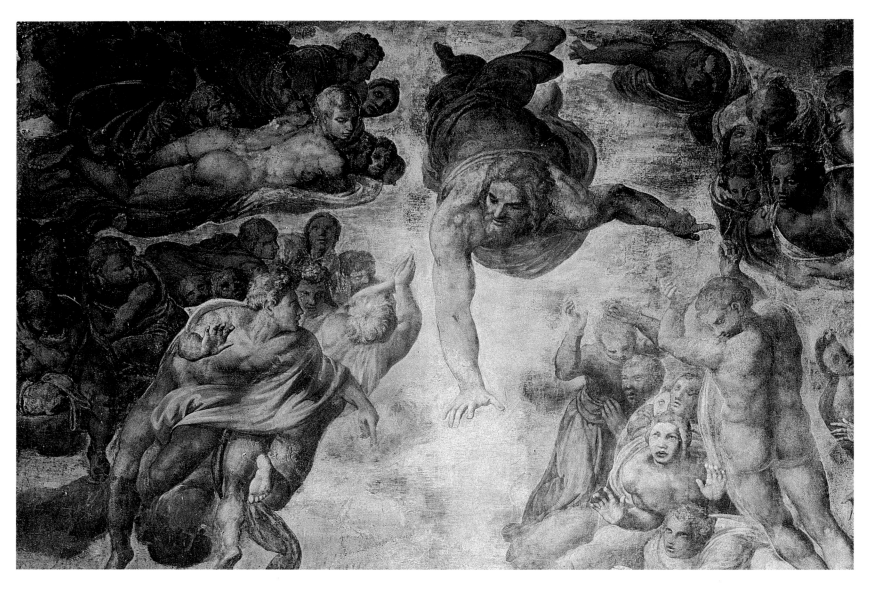

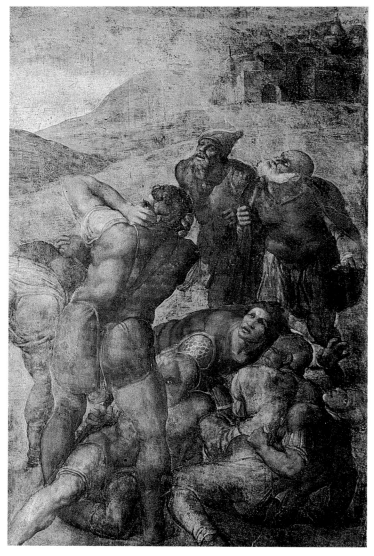

. . . [In the CONVERSION OF SAUL] *we notice secondary figures in various states of confusion and disarray, only a few of which have the courage to look to heaven . . .*

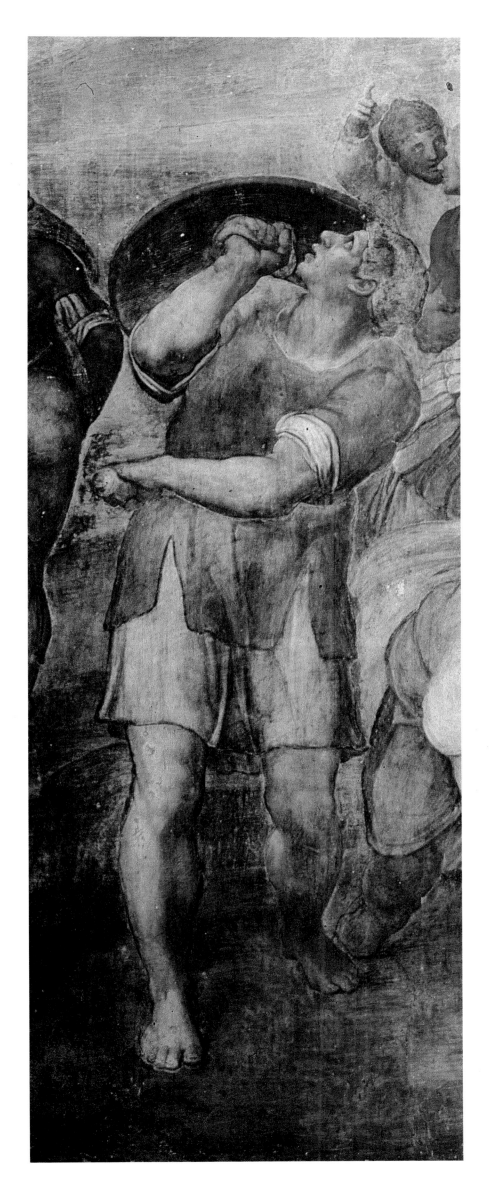

Taking advantage of the poor light on the opposite wall, Michelangelo located the "dark" subject—the *Crucifixion of St. Peter*—on the dark wall. The scene is depicted as occurring towards the end of the day (the undersides of the clouds are tinged with the failing light of a setting sun). Just as the *Conversion* scene is enhanced by the fall of natural light, so is the drama of the *Crucifixion* intensified by its absence. An atmosphere of foreboding and tragedy, heightened by the semi-darkness, enshrouds the slow-moving and ponderous figures. It is a disturbing subject that without the aid of modern electric lights is difficult to see and nearly impossible to grasp in its entirety. Our inclination is to penetrate the gloom by approaching closer to the wall where we discover, disconcertingly, a group of huddled women mourners, two of whom unremittingly stare back at us. In the words of Kenneth Clark: "They are like a Greek chorus, intermediaries between us and the tragedy."

A giant figure, sometimes identified as a self-portrait of Michelangelo, looms above us and appears to stride into our space. The unusual proportions of the figure have been frequently noted, but its size is dependent on our proximity to the scene and the angle from which we view it.

Towards the left side of the *Crucifixion* scene we join the cortege of soldiers that climb the hill to the place of Peter's torment. Mounting and descending in clockwise motion, the soldiers and witnesses create a slow, circular motion that echoes that of the cross itself as it is lifted with difficulty into place. Throughout, Peter's twisting head and piercing eyes transfix us.

The *Conversion of Saul* dramatically unfolds before the spectator as a rapid series of vignettes; the *Crucifixion of St. Peter* transpires with greater solemnity. Saul was converted instantly by dramatic external intervention; crucifixion, on the other hand, is a slow and agonizing death. The magnitude of Peter's act is comprehended as slowly as it takes us to view it. In both cases, but in significantly different ways, Michelangelo has convincingly and forcefully included us in the drama, guiding our perception as well as our understanding of the events before us.

The narratives that unfold to the left and right as the spectator walks down the central aisle of the chapel culminate at the altar, the view of the pope. The multi-figure compositions and separate narrative vignettes from this vantage are distilled to their essential elements. From the confusion of the crowds, we mainly distinguish the newly converted Saul and the crucified Peter. It is Peter's gaze that makes the single most powerful and long-lasting impression. For the spectator and for the cardinals who gathered in the chapel, Peter's look is an admonition and dispensation, bestowing a burden and a blessing. It reminds us that sacrifice is our Christian duty, and yet it is through devotion to Christ that we gain eternal life. The pope at the altar is encouraged to reflect on his forbears and his mission as Christ's vicar. And as Christian pilgrims, we are made witnesses to Saul's dramatic conversion and Peter's heroic martyrdom. We become more than mere spectators of the events of Christian history; we are made responsible participants. Clearly the Pauline frescos are evidence of Michelangelo's prodigious genius and sensitivity as a painter of Christian history.

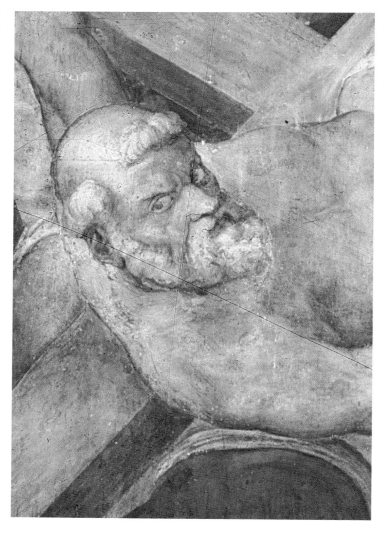

. . . we are made witnesses to Saul's dramatic conversion and Peter's heroic martyrdom. . . .

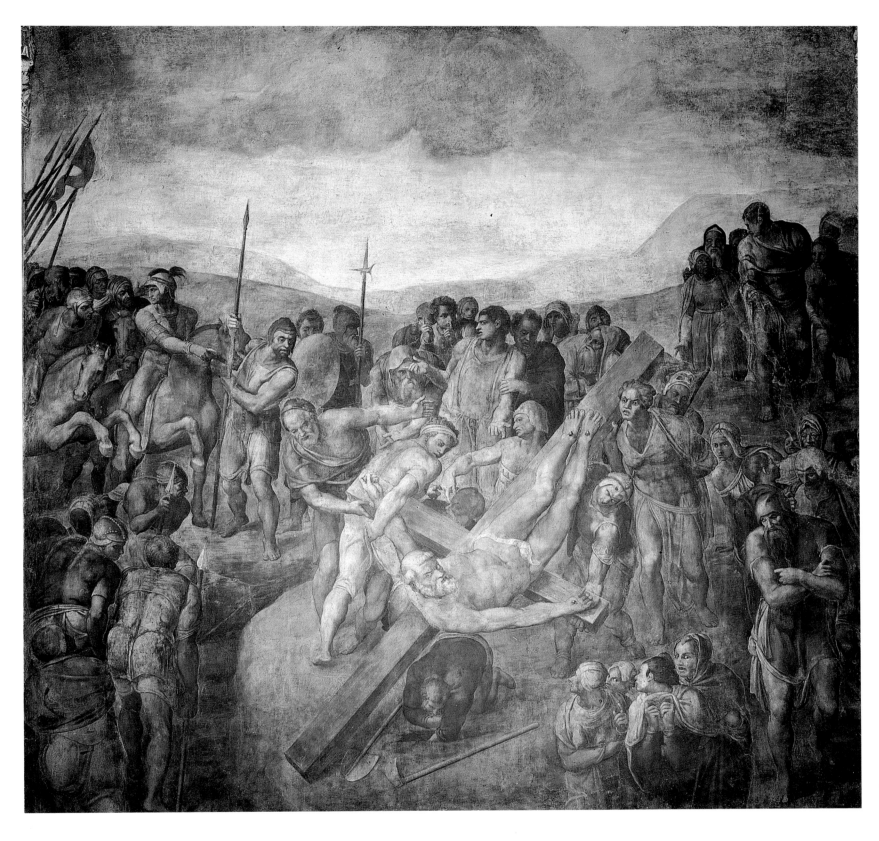

THE CRUCIFIXION OF ST. PETER

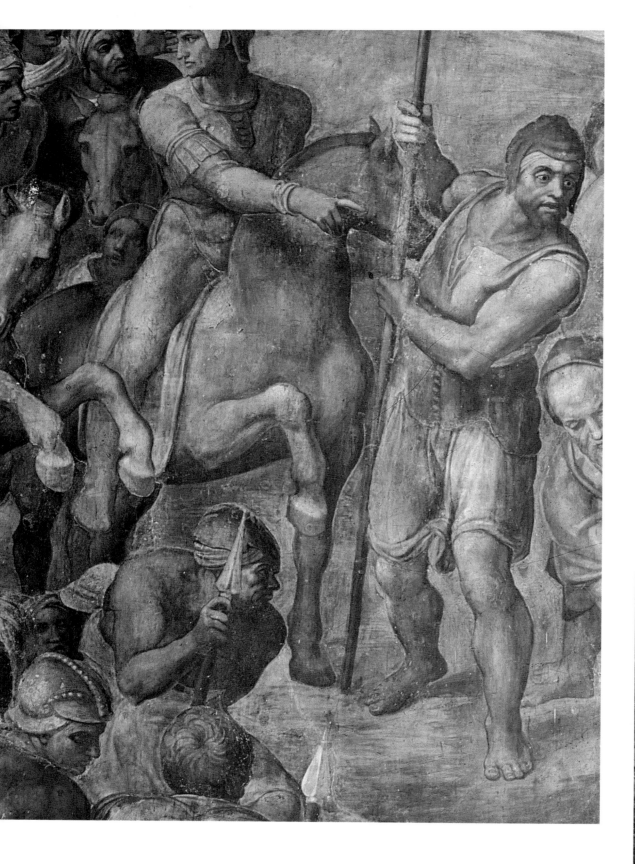

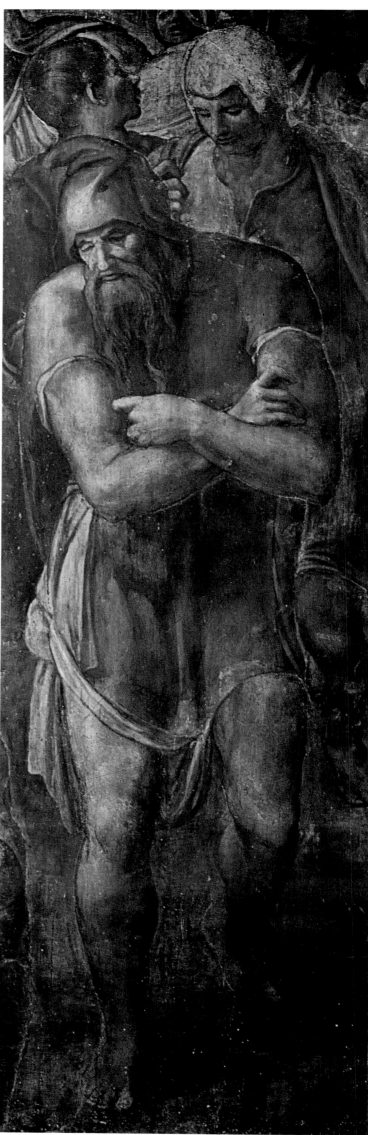

. . . [*In the* CRUCIFIXION OF ST. PETER,] *an atmosphere of
foreboding and tragedy, heightened by the semi-darkness,
enshrouds the slow-moving and ponderous figures.* . . .

LATE CRUCIFIXION DRAWINGS

◆ ◆ ◆

As the artist grew older, drawing and poetry became his most important vehicles of creative expression. In a series of moving and intensely personal drawings of the Crucifixion approximately contemporary with the Pauline Chapel, Michelangelo distilled matters of his faith. These haunting images are the visual equivalent of the artist's deeply felt religious poetry.

In one example, Mary and John huddle close to the cross as though seeking the last bit of warmth in the dying flesh of their savior. Christ hangs limply on the cross, his face obscured by the shadow of death. His drooping head and straggling, matted hair suggest his expiration, yet in his last living moment he commends his mother to John's care.

In another sheet, John appears ghost-like, walking toward us, hunched, and with fearful demeanor. On the other side of the cross the heavily cloaked Mary extends her right arm in a gesture that presents her son and expresses her extreme grief. At the same time, her arms are folded across her chest, a private clutching at sorrow. In the double set of limbs, as in the repeated shivering contours of the

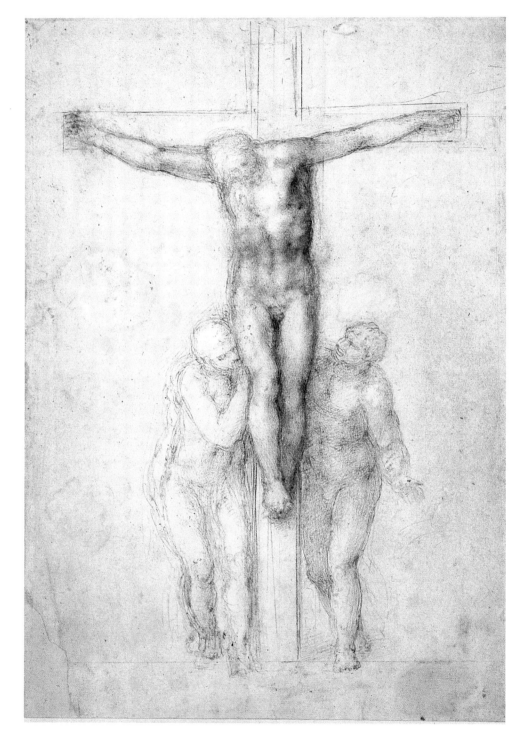

CRUCIFIXION
1540s–1550s. *Black chalk drawing. British Museum, London*

figures, we see not anatomical freaks but figures in motion, successive moments in a tragic drama. These are drawings that permitted Michelangelo to come closer to Christ. In the repeated contours we are witness to the artist's hand attempting to reach, to touch his Lord. In a perfect fusion of art and life, before these images, one is moved to prayer and to poetry, thus lending voice to their mute pain.

It is generally agreed that some of Michelangelo's late religious poetry complement—and perhaps even accompanied—these drawings. For example, Michelangelo once concluded a sonnet lamenting,

> *O Lord, in my last hours,*
> *stretch out toward me your merciful arms,*
> *take me from myself and make me one who'll please you.*

And in a different poem he wrote,

> *Let your blood alone wash and glaze*
> *and touch my faults. Let full pardon enfold*
> *me, abounding all the more, the more I grow old.*

The verses eloquently evoke the drawings and vice versa; they were probably made together. One imagines Michelangelo mentally composing sonnets as he drew, and visualizing these haunting images as he put the words to paper. Similarly, Michelangelo moved easily between poetry and sculpture. Each is simply a different form of carving, the fashioning of beauty from raw materials, whether words or stone. At times the poet and artist were one, divine, because, like God, Michelangelo created life from inert materials.

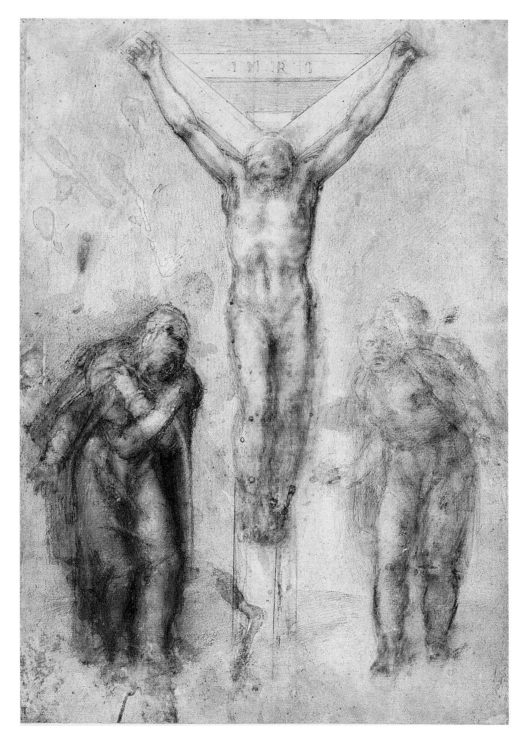

CRUCIFIXION
1540s–1550s. *Black chalk drawing. British Museum, London*

CHAPTER IV
THE ARTIST

ARCHITECTURE
FINAL TRIUMPH

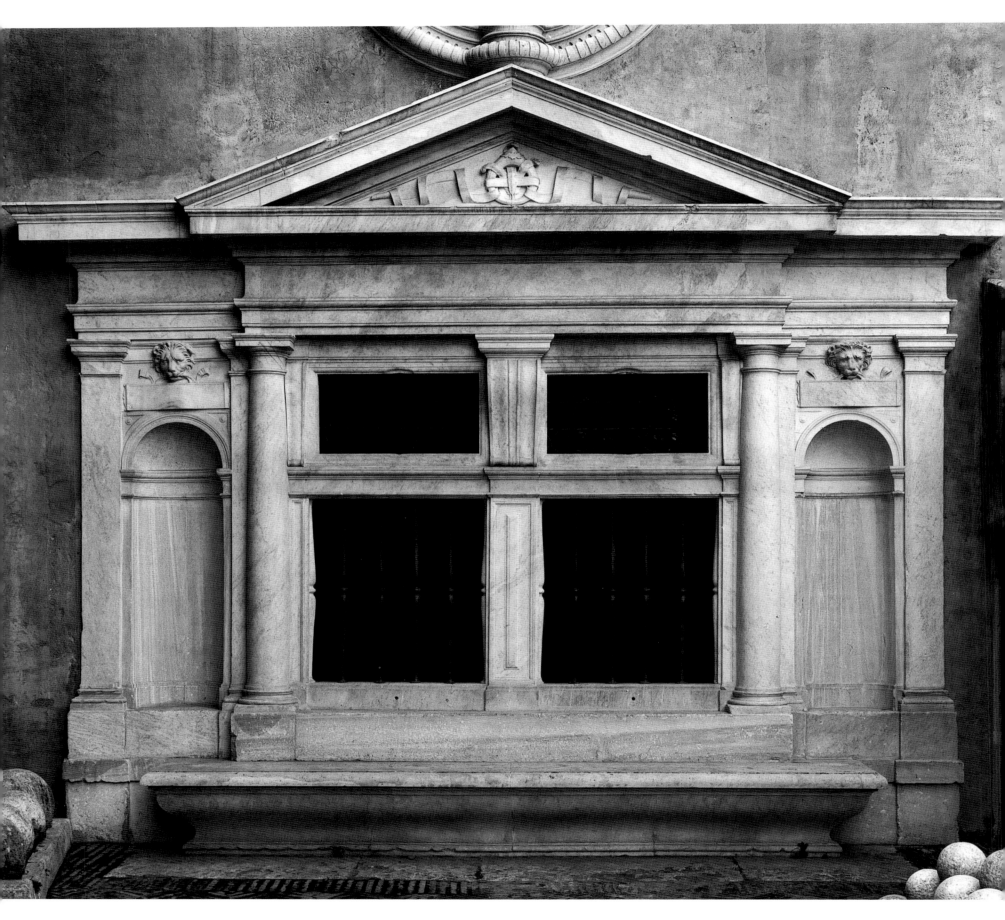

. . . Leo's personal emblems—the diamond ring and
feathers—decorate the triangular pediment, and
small lions' heads, playing on Leo's papal name, hold
the ribbons of fluttering inscription plaques. . . .

CASTEL SANT'ANGELO

◆ ◆ ◆

C. 1513–1516 ◆ MARBLE ◆ ROME

For the Medici, his early patrons and protectors, Michelangelo carried out his first works of architecture. Before leaving Rome in 1515, Michelangelo designed a façade for the chapel of Pope Leo X in Castel Sant'Angelo. The marble façade faces the long rectangular courtyard of the castello—a spot of color and ordered harmony in a militaristic environment.

Michelangelo used beautifully veined white marble; very likely it is material he had quarried for the temporarily suspended tomb of Julius II. A pair of cross-shaped mullioned windows are framed by semi-round columns, flanking bays with scooped niches, and enclosing flat pilasters. Leo's personal emblems—the diamond ring and feathers—decorate the triangular pediment, and small lions' heads, playing on Leo's papal name, hold the ribbons of fluttering inscription plaques. A long bench below offers repose, while visually serving as an emphatic base for the small and compact architectural composition.

In a nutshell, we see here many of the characteristics of Michelangelo's architectural vocabulary: the advancing and receding cornices, columns that appear partially sunk into the "skin" of the wall, the empty niches that suggest but do not house sculpture, and the restrained but constant use of inventive ornament. Even on a small scale, we see Michelangelo's relentlessly sculptural approach to architecture.

MEDICI PALACE WINDOWS

◆ ◆ ◆

C. 1517 ◆ MEDICI PALACE, FLORENCE

For the Medici Palace in Florence, Michelangelo designed his distinctive and much imitated "kneeling windows." The name derives from the elongated consoles that support the sill and reach nearly to the ground, thereby lending the windows their peculiarly anthropomorphic character. It is testament to Michelangelo's creativity that such a modest commission resulted in the most influential window design of all time.

The two windows filled in large arched openings that once permitted access to the Medici bank located on the ground floor of the family palace. Because of their large scale and extension to the ground, the windows retain cer-tain characteristics of doorways. Thus, Michelangelo brilliantly merged two architectural forms—the window and the door—while disguising a significant change in appearance and function of the Medici Palace: from commercial space accessible to the public to private domicile with an impregnable character.

While architectonic in scale and function, the windows nonetheless appear like pieces of refined sculpture set against the rugged backdrop of the Medici Palace rustication. Even in his earliest essays as an architect, Michelangelo was experimenting with the language, function, and rules of architecture. His well of invention never went dry.

THE MEDICI CHAPEL

◆ ◆ ◆

1519–1534 ◆ SAN LORENZO, FLORENCE

Michelangelo's commission to build an all marble façade for the Medici church of San Lorenzo never materialized. However, rather than a "failed" project, the façade was the first step in the realization of the Medici Chapel, which in many ways is Michelangelo's densely layered façade design folded in four and made into an interior space.

The Medici Chapel was initially based on Filippo Brunelleschi's Old Sacristy in the same church. Although similar in plan to the sacristy, Michelangelo significantly heightened the building and greatly increased the density of the wall articulation. The light-filled coffered dome was inspired by the famous Pantheon in Rome. Unlike its heavy-set ancient predecessor, however, the Medici Chapel dome is light and ethereal, an ensemble of seemingly floating circles, semicircles, and light openings. Wall surfaces are negligible presences, submerged by the elastic, springing lines of structural and decorative membering.

Beneath the dome, the chapel walls disappear behind the dense articulation of grey-green *pietra serena* (a fine-grained, durable sandstone) pilasters and cornices enframing milk-white marble tombs. Everywhere the two materials—stone and marble—seem to compete, squeezing, breaking, and pushing one another into layered, fragmented surfaces. Marble is made to behave like other materials—sometimes treated like complicated carpentry. Other times it appears transformed into malleable stuff that flows into any available cavity, even onto the floor according to the law of least resistance. Such architecture is more like sculpture, organic and alive. It comes as little

surprise to discover that the traditionally abstract language of architectural decoration, such as friezes and capitals, are suddenly transformed into living, grimacing faces. In the silent cackle of these unsettling grotesques, one is carried beyond the world of the living into the realm of shades.

The domed chapel is surmounted by an elegant marble lantern with a copper roof and multi-faceted gilt polyhedron. Despite its modest size, the tall, slender proportions and the coloristic contrast of the white marble lantern against the red-tile roof and drab exterior of the Medici Chapel make it a prominent architectural beacon in the Florentine streetscape. The light that is admitted through the eight tall windows—a number symbolic of the Resurrection—filters down to the Medici tombs situated far below.

A gloom rules the realm of the dead. Light is pervasive but muted, as if diffused through tissue. To experience the chapel through the full course of a day and without electric light is a privilege: the natural light waxes and wanes as it shifts from one part of the chapel to another. The sculptures seem to awaken in turn, then return to stone. For brief moments in a chapel dedicated to the Resurrection, light becomes the agent of resurrection, beckoning the dead to rise. As the light declines toward the end of the day, the chapel once again becomes a somber, silent, tomb-like space. The apparent warmth of marble becomes chilled within its darkened frames, the organic qualities of the chapel return to silent immobility. The dead rest, and the statues become statues once again.

. . . the tall, slender proportions and the coloristic contrast of the white marble lantern against the red-tile roof and drab exterior of the Medici Chapel make it a prominent architectural beacon in the Florentine streetscape. . . .

ARCHITECTURE

215

MICHELANGELO
216

. . . Beneath the dome, the chapel walls disappear behind
the dense articulation of grey-green pietra serena . . .

OPPOSITE:
. . . the Medici Chapel dome is light and ethereal, an
ensemble of seemingly floating circles, semicircles, and
light openings. . . .

ARCHITECTURE

217

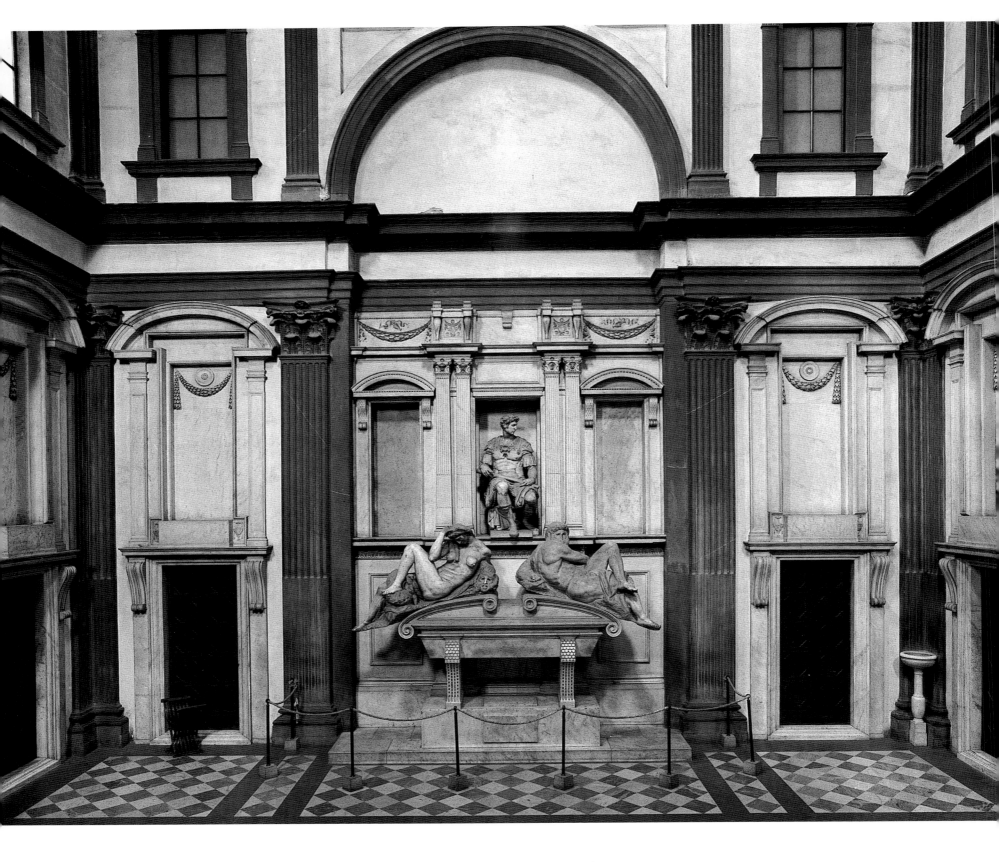

THE TOMB OF GIULIANO DE' MEDICI

ABOVE:
*Detail of a sarcophagus
support on Giuliano's tomb*

LEFT:
*Detail of the volute on the
right side of Giuliano's tomb
under* DAY

ABOVE:

The north wall with the altar apse, Medici Chapel

OPPOSITE:

*. . . Everywhere the two materials—stone and marble—
seem to compete, squeezing, breaking, and pushing
one another into layered, fragmented surfaces.
Marble is made to behave like other materials—
sometimes treated like complicated carpentry. . . .*

Corner doors and tabernacles, Medici Chapel

ARCHITECTURE

221

Overdoor tabernacle, Medici Chapel

ARCHITECTURE

223

THE LAURENTIAN LIBRARY

◆ ◆ ◆

Simultaneously with the Medici Chapel, Michelangelo erected the Laurentian Library, the building housing the books donated by the Medici to San Lorenzo. From a convoluted approach through an unexceptional monastic cloister and up a narrow flight of stairs, the visitor steps into an impressive volume of vertical space. As with the interior of the nearby Medici Chapel, one is greeted by a dense architectural orchestra.

The library entrance vestibule is one of Michelangelo's most famous architectural creations. Rising from the shoulders of giant anthropomorphic consoles, pairs of monolithic column shafts rise to meet sections of broken entablature. The casual visitor is made to feel small in their stately company. The columns stand firm against a malleable wall that advances and recedes around them, leaving the corner columns squeezed into deep recesses. The unexpectedly organic wall brackets have a vaguely equine appearance, and in the four corners they fuse together as if they were under terrific geologic pressure.

Filling most of the space is the famous staircase, a singular moment in the mostly bleak history of climbing from one level to another. This is an entire room, three stories high, devoted to the experience of moving from the noisy exterior to the quiet serenity of the library. To climb these stairs is a life-enhancing experience. A central flight is articulated by a balustrade barely high enough to be functional; the side flights bleed off into open space. The stairs appear like viscous material, or as Michelangelo described them, as a series of oval boxes set one upon the other. They flow into the space, expand, and threaten to fill it up.

The oft-described sense of enclosure and compression in the vestibule is felt mainly when, like a servant, one stands to the side of the monumental staircase or climbs its side wings. To mount the central flight—"reserved for the prince," wrote Michelangelo—is to feel like a nobleman, a person of elevated stature. From the center of the broad staircase, the vestibule is capacious, the prince its center, the columns at attention like so many ordered retainers.

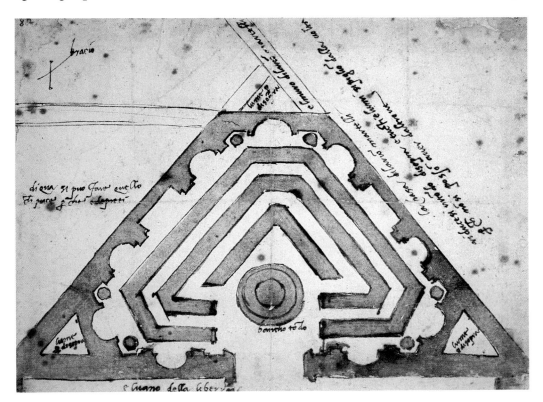

Plan for the rare book room of the Laurentian Library.
Pen and ink and wash. Casa Buonarroti, Florence

OPPOSITE:
. . . The library entrance vestibule is one of Michelangelo's most
famous architectural creations. Rising from the shoulders of
giant anthropomorphic consoles, pairs of monolithic column
shafts rise to meet sections of broken entablature. . . .

Beyond is the orderly world of the library proper. Statements of princely patronage are made in the quieter language of books. As Frank Lloyd Wright did centuries later, Michelangelo considered a building's furniture to be an integral part of its design. The regularly spaced reading desks reiterate the room's simple geometry. Likewise, the wall articulation depends on and is coordinated with the furnishings: the pilasters rise from a stringcourse that runs along at the level of the reading desks. Thus, the furniture is a necessary support for the wall membering. The desks are spaced two to a bay, with light falling over a reader's shoulders from the large stone-framed windows. The measured rhythm of repeating bays creates a harmonious space conducive to quiet study. In the reading room, building, furniture, and books—that is, architecture, decoration, and function—are seamlessly integrated. To sit at one of the carved walnut desks—at once comfortable seat, reading stand, and storage facility—is to become a part of the building.

The reading room was to culminate in a triangular rare book room. As we see from the still extant drawings for this unusual space, Michelangelo experimented as much in architecture as in sculpture and painting. How many triangular rooms have there been in the history of architecture? How would such a space feel and function? Had it been completed, movement through the library would have been a sequence of geometries—square, rectangle, triangle—and a metaphor for a life of learning: one mounts to knowledge, but through ordered and diligent study one arrives at the greatest wisdom, here contained in a sanctuary-like, perfectly regular geometric space.

According to Vasari, Michelangelo's Medicean architecture was a significant departure from classical orthodoxy; it was a display of "license" that overturned rules and expectations. But history has judged Michelangelo's unorthodoxy as originality, and his Florentine inventions excersied a profound influence on the subsequent course of architecture.

The Laurentian Library vestibule

ABOVE AND OPPOSITE:

. . . In the reading room, building, furniture, and books—that is, architecture, decoration, and function—are seamlessly integrated. To sit at one of the carved walnut desks—at once comfortable seat, reading stand, and storage facility—is to become a part of the building. . . .

. . . the regular spaced reading desks reiterate the room's simple geometry . . . The measured rhythm of repeating bays creates a harmonious space conducive to quiet study. . . .

RELIQUARY BALCONY

◆ ◆ ◆

C. 1531–1532 ◆ SAN LORENZO, FLORENCE

Along with his other projects at San Lorenzo, Michelangelo was given additional commissions by his patron, Pope Clement VII: a crystal cross and ciborium for the high altar of the church, designs for papal tombs for the Medici Chapel, a reliquary tribune balcony (the only project actually completed), and a giant colossus to sit opposite the basilica. The latter extravaganza tried the limits of Michelangelo's patience.

After at least four letters and some expressions of surprise that the artist was silent regarding the pope's idea to erect a forty-foot-high statue, Michelangelo finally was goaded into responding to the pope's outlandish but insistent request. In a masterpiece of ironic and ridiculing wit, Michelangelo proposed a much larger seated statue, eighty feet high, with a barbershop under its rump, a cornucopia for a chimney, and bells ringing from its stupidly gaping mouth. He concluded with some ingenious proto-Shakespearian gibberish that only thinly disguised his impatience:

> To do or not to do the things that are to be done,
> which you say are not now to be done,
> it is better to let them be done by whoever will do them,
> for I will have so much to do that
> I don't wish to do any more.

The brilliant wordplay and its singsong quality is more evident in the original Italian, reminding us that Michelangelo was a poet as well as sculptor, painter, and architect. The subject of the colossus was quietly dropped.

Meanwhile Michelangelo did design a reliquary tribune for Clement, a balcony for the safekeeping and ceremonial display of the large collection of relics donated to San Lorenzo by the two Medici popes, Leo X and Clement VII. The balcony is a massive structure yet it blends unobtrusively with Brunelleschi's fifteenth-century church. As with the exactly contemporaneous Medici Chapel, Michelangelo sensitively complemented the work of his predecessor at the same time he created an original design.

The long balcony is supported on two monolithic columns over the main portal on the inside façade of the church. A massive corbel is carved into an equine-shaped escutcheon thereby proclaiming the Medici as patrons and knights (a knight, *Eques*, rides a horse) at the same time it supports the heavy balcony. The enframing pilasters are decorated by garlands of fruits supported from Medici ring devices. These are the fruits of the earth; inside the central door is the reliquary treasury, the fruits of heaven. As with much of his architecture, Michelangelo designed but did not personally execute the project; however, when he saw the completed balcony he proclaimed it a "beautiful thing" (*"bella cosa"*).

We tend to think of Michelangelo's personality in particularly forceful terms—as an artist full of *terribilità* and unique ideas. But as the reliquary tribune amply attests— as do his contributions to St. Peter's, the Farnese Palace, and the Baths of Diocletian— Michelangelo was sensitive to and perfectly capable of working within boundaries. Such situations seemed to stimulate rather than hamper his imagination. Confronted by preexisting buildings and the dense fabric of the modern city, we can still benefit from Michelangelo's example.

. . . A massive corbel is carved into an equine-shaped escutcheon thereby proclaiming the Medici as patrons and knights . . .

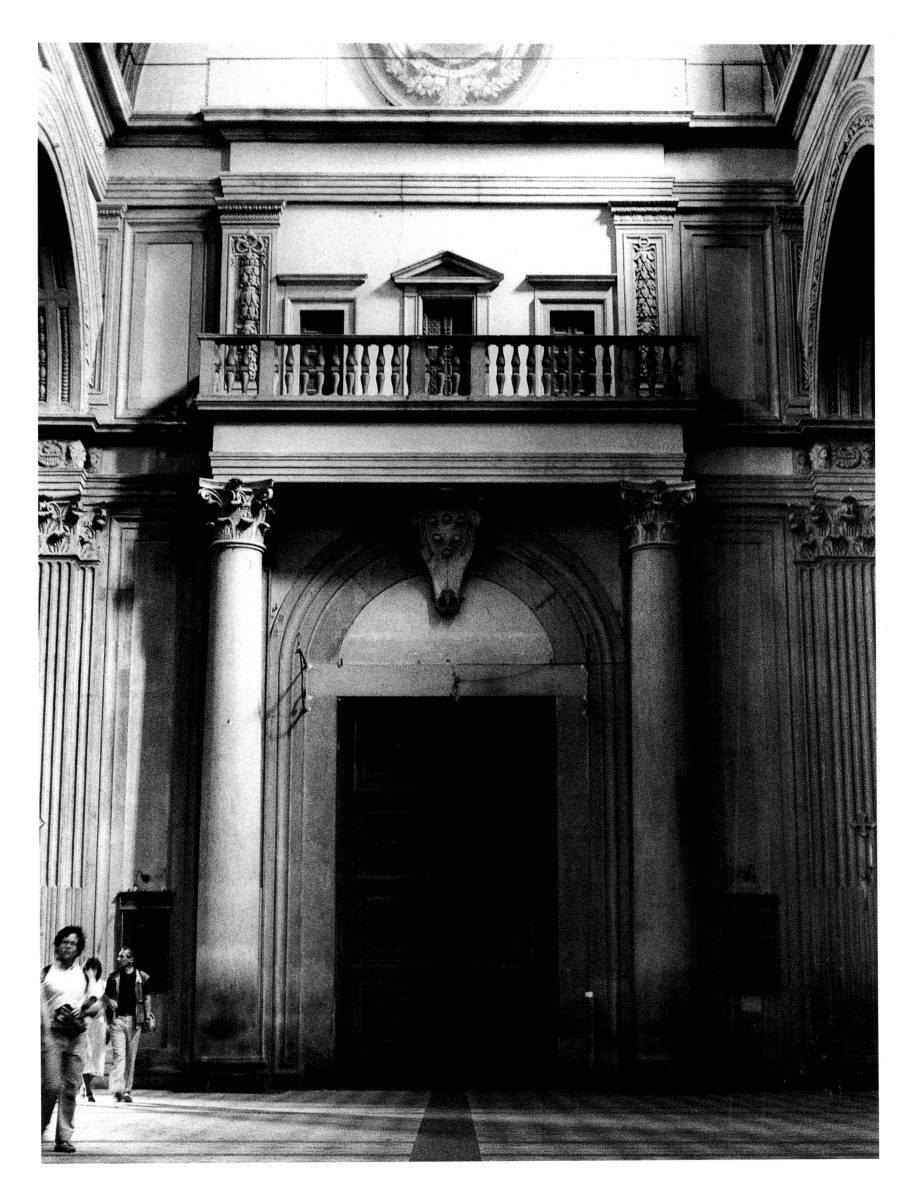

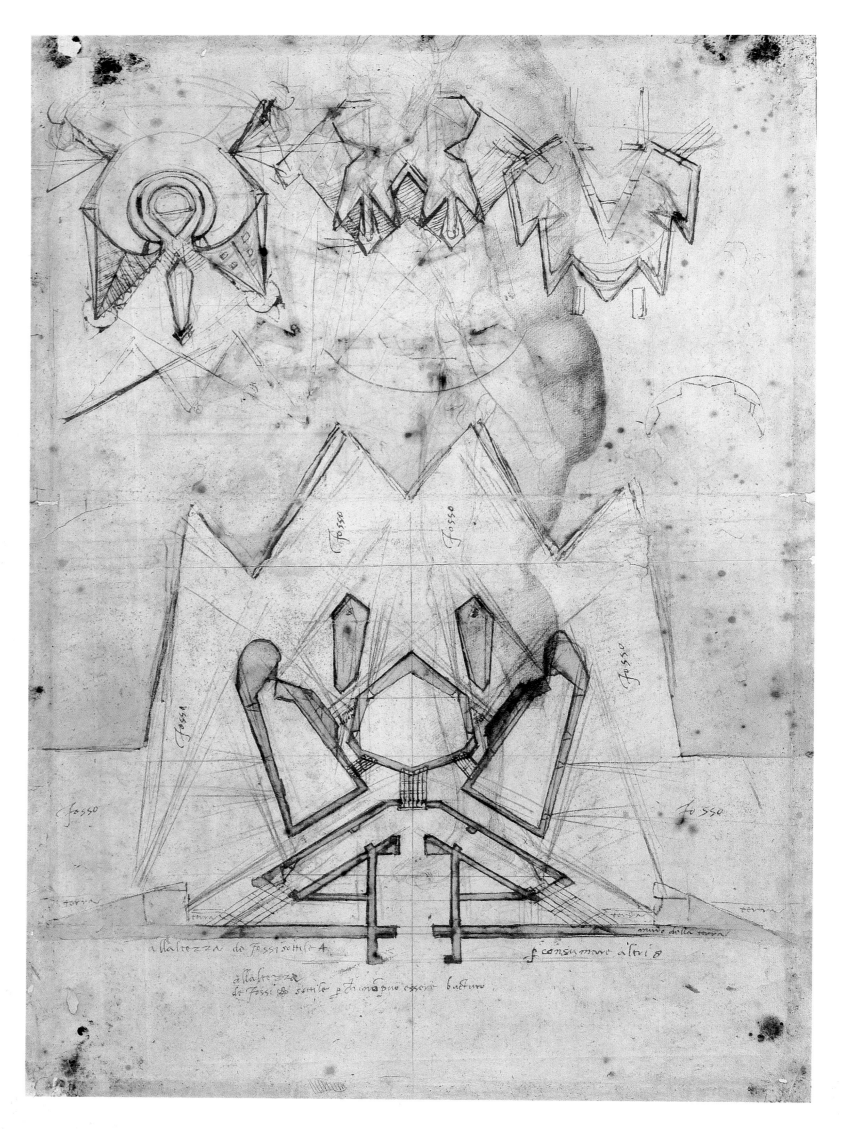

Design for fortification no. 27A

DESIGNS FOR FORTIFICATIONS

◆ ◆ ◆

C. 1528–1529 ◆ PEN AND INK AND RED CHALK DRAWINGS ◆ CASA BUONARROTI, FLORENCE

In the Renaissance, military engineering was an important aspect of the profession of being an artist. According to Vasari, Michelangelo remarked that he knew little of painting and sculpture but considered himself an expert on fortifications. Unlike most Renaissance artists and innumerable military theorists, he had the opportunity not only to design fortifications but to build them, and further, to prove their efficacy in time of war.

Michelangelo and Leonardo both took great pride in their engineering abilities; indeed, these were often the skills most sought after by patrons. Michelangelo's originality as a designer should not obscure the fact that he was also an accomplished engineer. Unlike Leonardo, who mostly imagined impressive engineering feats, Michelangelo actually carried them out. This is particularly true of the quarrying and transport of a vast amount of marble for the San Lorenzo façade, and the erection of the piers and dome of St. Peter's basilica. It is also true of fortifications, which Michelangelo designed, built, and help defend.

None of the fortifications built by Michelangelo in 1529 and 1530 are still extant, but his surviving drawings eloquently attest his intense interest in the project and the originality of his designs. The drawings reveal that Michelangelo considered the offensive potential of defense. On star-shaped and angled bastion designs, he traced firing lines in order to provide maximum protection for the curtain walls and concealed entrances. Although designed primarily for the small-arms ordinance that characterized most Renaissance warfare, Michelangelo's star traces and angle bastions were also very effective protection against the new offensive power of artillery.

By inventing and proving the efficacy of the use of the angle bastion, Michelangelo initiated the longest chapter in the history of fortification design. The same essential principles were still in effect during the American Civil War and behind the building of the French Maginot line.

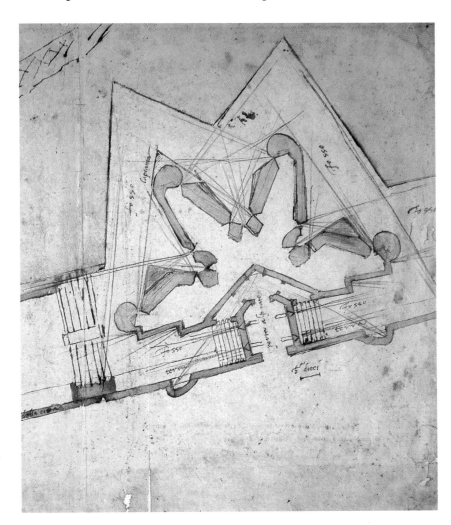

Detail of design for
fortification no. 14A

THE CAPITOLINE HILL

◆ ◆ ◆

BEGUN C. 1538 ◆ ROME

The Capitoline Hill was the geographical and ceremonial center of ancient Rome: from here all roads departed to the far reaches of the empire. Throughout the Middle Ages, executions took place on the hill, but the magnificent site overlooking the Roman forum was by the Renaissance a messy conglomeration of mostly ruinous buildings. When in 1536 the Holy Roman Emperor Charles V wished to visit the once-famous Capitoline, contemporary Romans were made fully aware of just how badly the site had been neglected: the slopes were so muddy that the emperor and his entourage were unable to mount the hill. Michelangelo was entrusted with reinvesting the Capitol with dignity and a magnificent architectural presence.

He began in brilliant fashion, by placing the equestrian statue of the roman emperor Marcus Aurelius at the center of the site. This ancient bronze survived the Middle Ages in the mistaken guise of the first Christian emperor, Constantine the Great. By the Renaissance, the correct identity of the emperor was well established; nonetheless, the statue continued to be revered as a rare antiquity. It was then a symbol of ancient authority and imperial might expropriated by the Christian popes. Moreover, Marcus Aurelius' great work of stoic philosophy, the *Meditations*, earned him respect as a proto-Christian thinker. Thus to move the equestrian statue to the Capitoline was a means of reinvesting the place with a venerated symbol of ancient and Christian Rome, fused in one important monument. Around the sculpture, Michelangelo designed an architectural setting, at once sober (appropriate to its new civic functions) and magnificent (similar to what it was more than a millennium earlier). As with many of Michelangelo's architectural projects, most of the Capitoline was realized after his death, but the force and clarity of his design ensured that the final result is largely his intention, and properly attributed to him.

Similar to other projects—notably St. Peter's and San Giovanni dei Fiorentini—Michelangelo looked to the middle to locate a solution for the Capitoline Hill. In these projects, as with his sculpture, Michelangelo began by defining the torso; the rest was just appendage. The equestrian statue gave the Capitoline a center and a focus; the buildings, like the epidermis of a marble block or the structural skeleton of a body, gave definition to the torso. In architecture, the torso is space, and it is space as much as the buildings that is the impressive achievement of St. Peter's or the Capitoline Hill. Like a giant outdoor room, the Capitoline piazza feels protected and enclosed although it is open to the sky and accessible through five entrances.

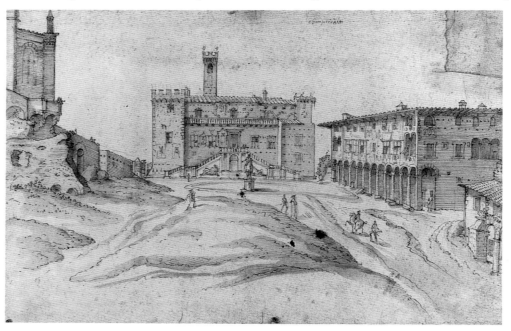

Drawing by Marteen van Heemskerck:
. . . the magnificent site was by the Renaissance a messy conglomeration of
mostly ruinous buildings. . .

OPPOSITE:

. . . A long tapering ramp (the cordonnata) *rises to the*
broad piazza. . . .

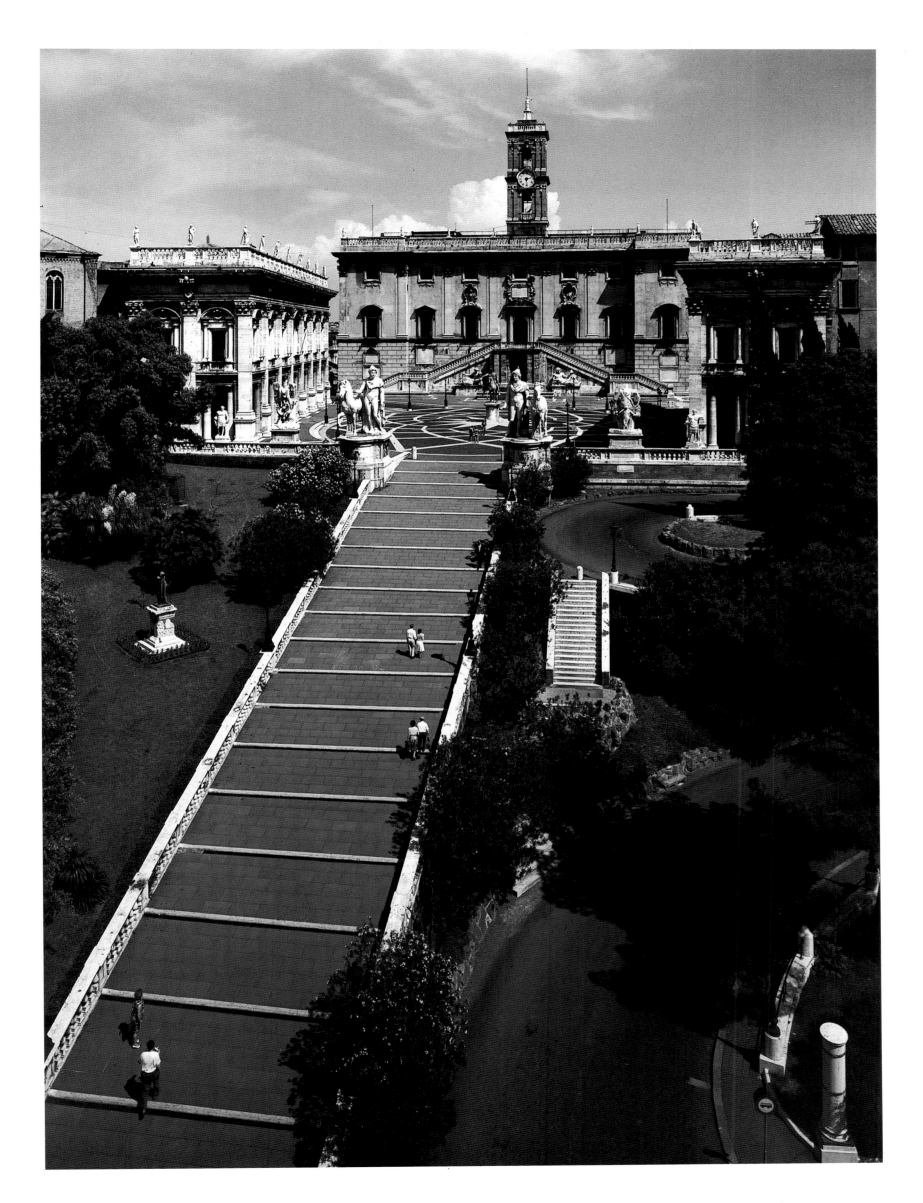

A long tapering ramp *(the cordonnata)* rises to the broad piazza. The center of the piazza is slightly sunken with a rising domed oval and a star-burst pavement pattern. In a sort of elastic movement, both real or visual, the dynamic lines of this design throw us outward to one of its twelve points only to return us to Marcus Aurelius at its occupied center. The paving mirrors our actual movement through and around the piazza, along arched and curvilinear paths, constantly circling.

Enclosing either side of the trapezoidal space are the Conservators Palace (Conservatori) and a new wing (Braccio Nuovo) at an irregular, splayed angle to one another and to the central Senate building. Michelangelo designed a façade for the dilapidated Conservatori, and he built the Braccio Nuovo to be its mirror complement, thereby giving coherence to the ragged ensemble of extant structures. For the palace façades, Michelangelo invented his famous "giant order," wide pilasters on substantial bases that rise and unite both stories. The resulting vertical rhythm is continued by the statues set along the balustraded cornice and is balanced and counteracted by the long horizontal lines and squarish bays of the arcaded building. Surfaces are layered, the articulation dense and multiple. The building appears strong and simple but has polyphonic richness.

The Senate building has a prominent central bell tower (relocated by Michelangelo to this position) and two broad exterior stairs flanking the main door. The building is distinguished from its more robust neighbors by great expanses of buff brick, densely layered surfaces, and details that are more florid but less concentrated. The broad wall surface billows against the architectonic restraints; like a slightly over-inflated cushion, windows appear like buttons about to pop off the taut surfaces.

Ornament endows a building with eloquence, but verbosity can undermine integrity. As an architect, Michelangelo learned how to balance strength with oratory, structure with ornament. His buildings characteristically speak forcefully and with great clarity but they also continue to engage us on a more subtle and nuanced level long after the strong first impression. Ornament is a constant surprise and an enduring quality of his architectural vocabulary.

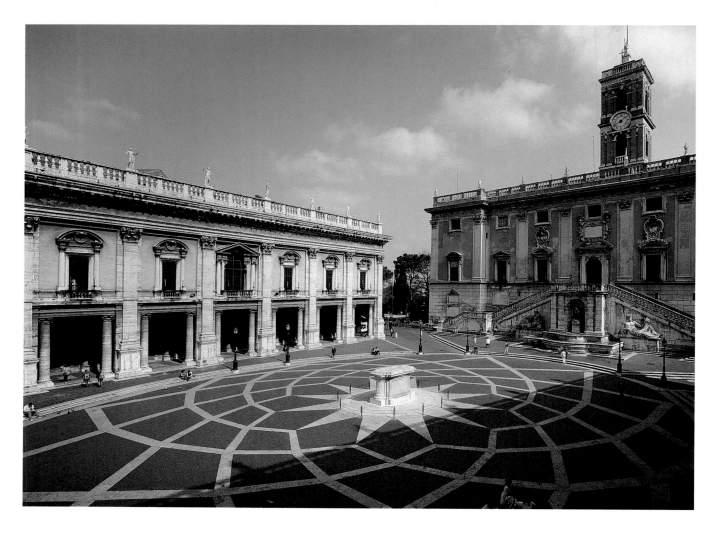

. . . The center of the piazza is slightly sunken with a rising domed oval and a star-burst pavement pattern. In a sort of elastic movement, both real or visual, the dynamic lines of this design throw us outward to one of its twelve points only to return us to Marcus Aurelius at its occupied center. . . .

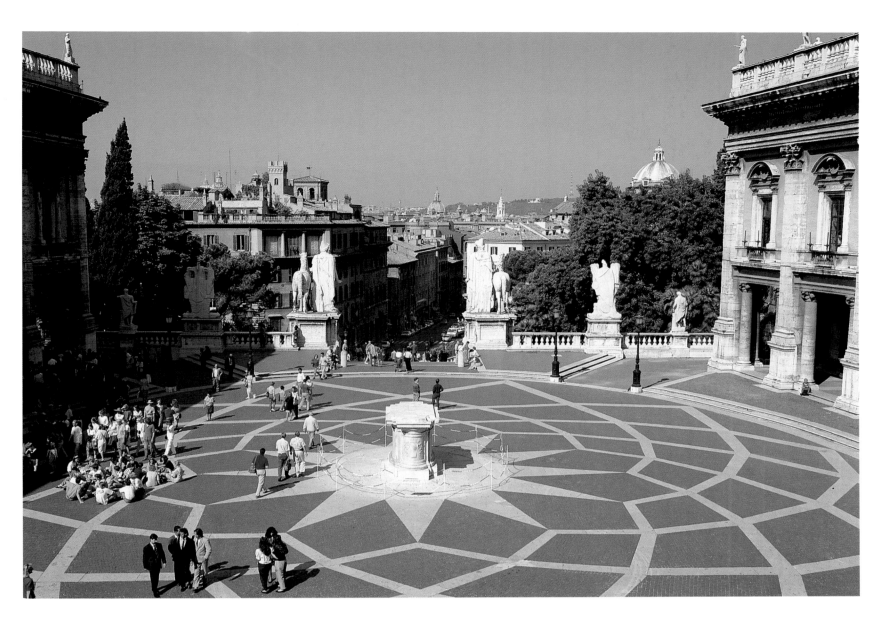

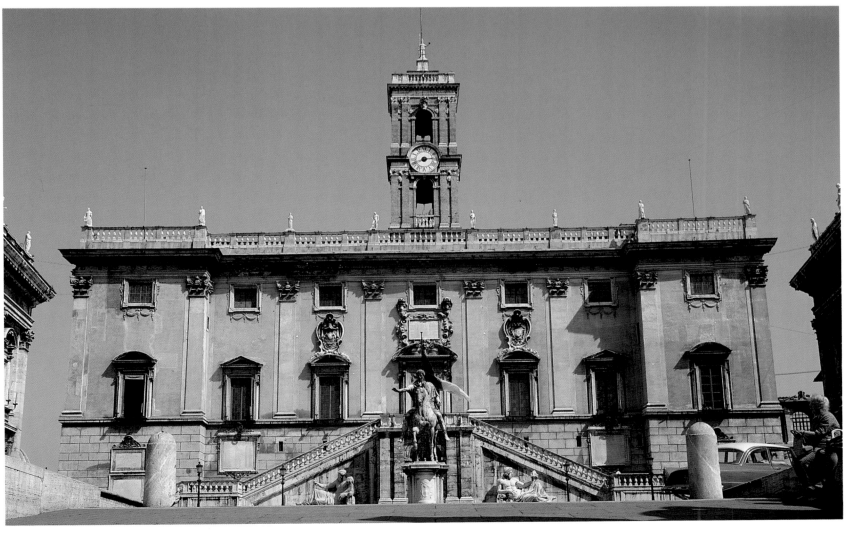

ABOVE:
The portico of the Conservatori

ABOVE RIGHT:
Pilaster and supporting columns on the Braccio Nuovo

RIGHT:
View of the stairs of the Palazzo dei Senatori

OPPOSITE:
TOP LEFT: *The statue of Marcus Aurelius*
TOP RIGHT: *View of the façade of the Braccio Nuovo*
BOTTOM: *The stairway of the Palazzo dei Senatori*

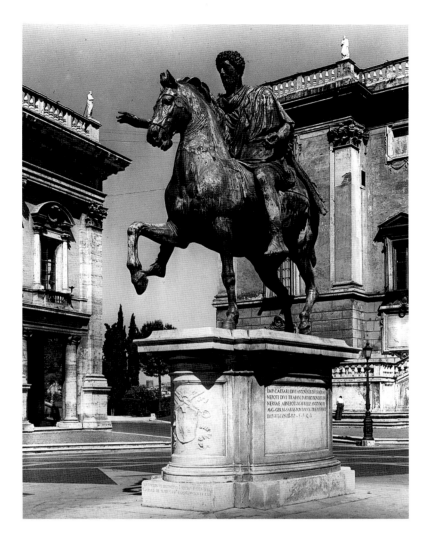

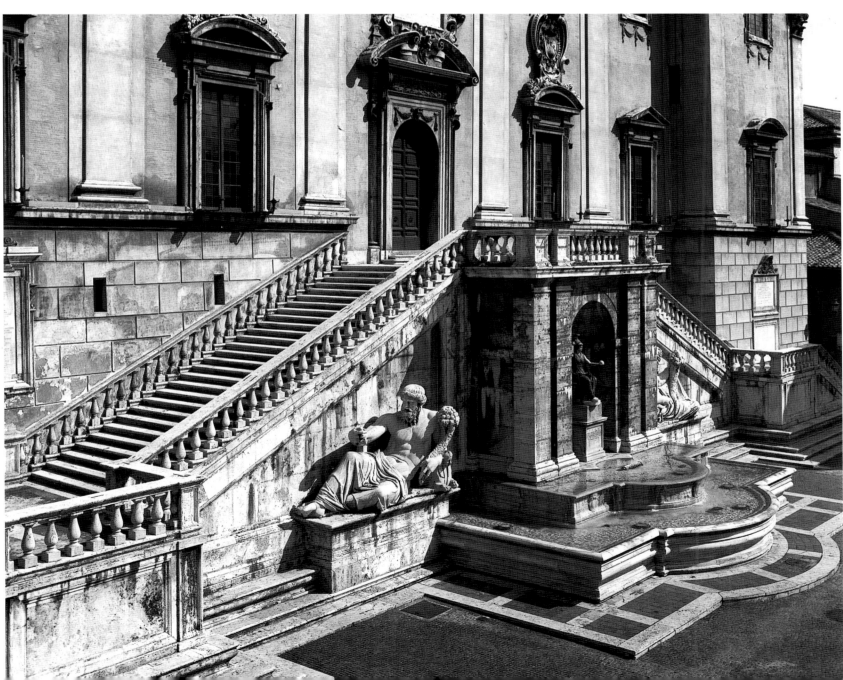

FARNESE PALACE

◆ ◆ ◆

BEGUN 1546 ◆ ROME

The dense, layered surfaces that Michelangelo essayed in the Capitoline buildings were further explored at the Farnese Palace. Michelangelo's rival, Antonio da Sangallo, began the building, but when he died in 1546 Michelangelo took over as chief architect. Michelangelo's contribution was mainly confined to the third story of the courtyard façade and to the cornice of the main façade.

The courtyard windows reveal Michelangelo's willingness to invent a new vocabulary of architecture using remnants inherited from classical antiquity and contemporary practice. At first, his windows seem only a mild departure from those of Sangallo—another case of Michelangelo's ability to integrate his innovative designs with an inherited project. On closer inspection, however, we note the layered and ornamented pediment floating on guttae-adorned triglyph brackets—strange and original. The window cornice has sprouted lions' heads and anthropomorphic corbels, and sections of the box-like window frame slip downward, as if the whole ensemble were loosely nailed carpentry.

One imagines a stonemason attempting to carve these innovations according to Michelangelo's verbal or drawn directions. Probably the craftsman worked from a wooden model, but then the model maker had to comprehend Michelangelo's highly individualized vocabulary. In a surviving drawing for the Farnese windows, the multiple ruled lines and dense overlays are probably not evidence of Michelangelo changing his mind as much as the artist finding a graphic means to express his highly original, sculpted ideas.

When Michelangelo recommended raising the height of the third story and greatly increasing the size of the main façade cornice, he was accused of contravening the rules of classical architecture and proportion. Precisely. The upper cornice is massive, but it is successful visually, closing and containing the monumental palace block. It is correct according to the eye rather than correct by the book. In order to make sound judgments, Michelangelo once remarked, "one must have compasses in the eyes." For Michelangelo classical architecture was not a prescribed set of rules and models to be slavishly imitated, but was the starting point for his own fecund invention and imaginative solutions to problems.

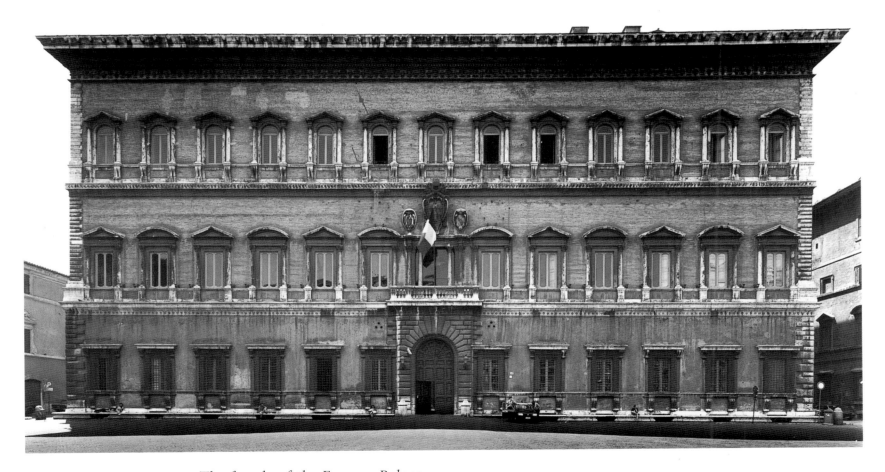

ABOVE: *The façade of the Farnese Palace*

OPPOSITE: *The Farnese Palace courtyard showing the third story by Michelangelo*

Michelangelo's study for the window of the Farnese Palace courtyard (OPPOSITE).
Chalk, pen and ink and wash drawing. Ashmolean Museum, Oxford

ST. PETER'S

◆ ◆ ◆

St. Peter's is the largest church in Christendom, the most imposing symbol of papal authority, and a crowning achievement of the Renaissance. But for nearly six decades of Michelangelo's life it was a complete mess. Throughout much of his career, as he worked on the tomb of Julius II, painted the Sistine Chapel ceiling and the *Last Judgment*, and designed the Capitoline Hill, Michelangelo witnessed the insensitive destruction of Constantine's venerable basilica and the sometimes incompetent, mostly inarticulate efforts to replace it with a new church.

Pope Julius' first architect, Donato Bramante, was a brilliant designer and a sloppy engineer. In his haste to erect the new building, Bramante pulled down the fabulously beautiful marble columns of the ancient church. And in constructing the four massive piers that were to support the central dome he significantly underestimated the weight and thrust they would be asked to sustain. He cut corners in construction that seriously impaired the structural integrity of the new church. After Bramante's death a succession of artists attempted to advance the building but succeeded only in muddling Bramante's original design.

After more than thirty years of building destruction and construction, the church of St. Peter's was a depressing sight to any visitor in Rome, as we see in numerous drawings by

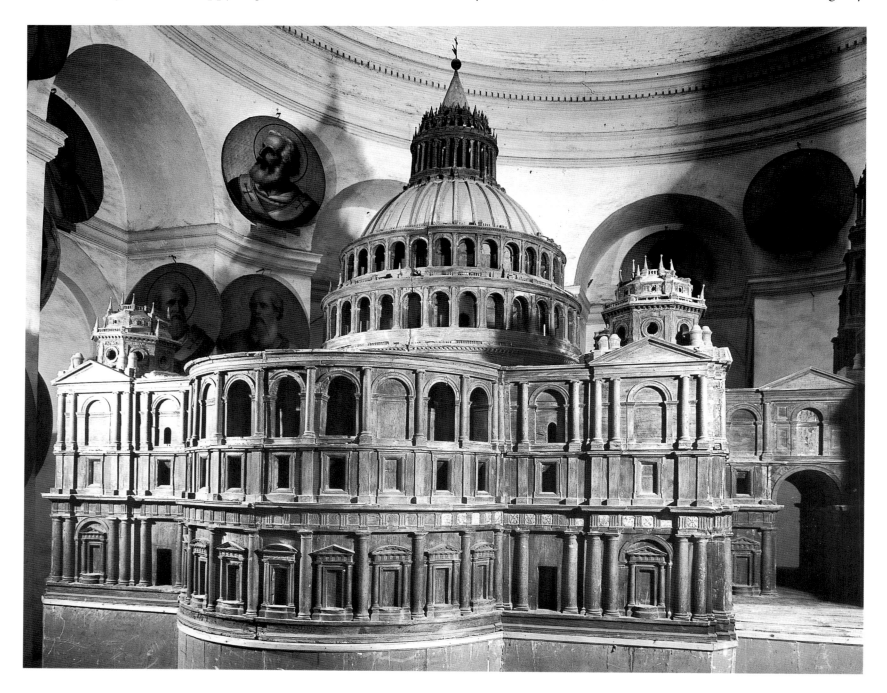

Antonio da Sangallo's wooden model for the new church of St. Peter's (never executed)

the contemporary witness from the north, Marteen van Heemskerck (1496–1574). In the 1540s, the current architect, Antonio da Sangallo, devoted years to constructing a truly stupendous model, an object that excites wonder as the world's largest and most expensive miniature building. But it is an utter horror as a design for a future church. Michelangelo commented that Sangallo's extravaganza was like a pasture for dumb oxen and silly sheep who knew nothing about art. He noted that there were now "so many dark lurking places above and below that they afford ample opportunity for innumerable rascalities, such as the hiding of exiles, the coining of false money, the raping of nuns and other rascalities, so that at night, when the said church closes, it would require twenty-five men to seek out those

who remained hidden inside." Into this quagmire of clouded vision and colossal waste of resources stepped Michelangelo.

Setting aside his personal dislike of Bramante, Michelangelo noted that the first architect of St. Peter's had a plan that was "not full of confusion, but clear, simple, luminous . . . a beautiful design . . . so that anyone who has departed from Bramante's arrangement, as Sangallo has done, has departed from the true course." True to his word, Michelangelo returned to Bramante's initial conception while correcting its engineering deficiencies. This is all the more remarkable given that Michelangelo began by reversing thirty years of building history by actually removing much recent construction. It was yet another cam-

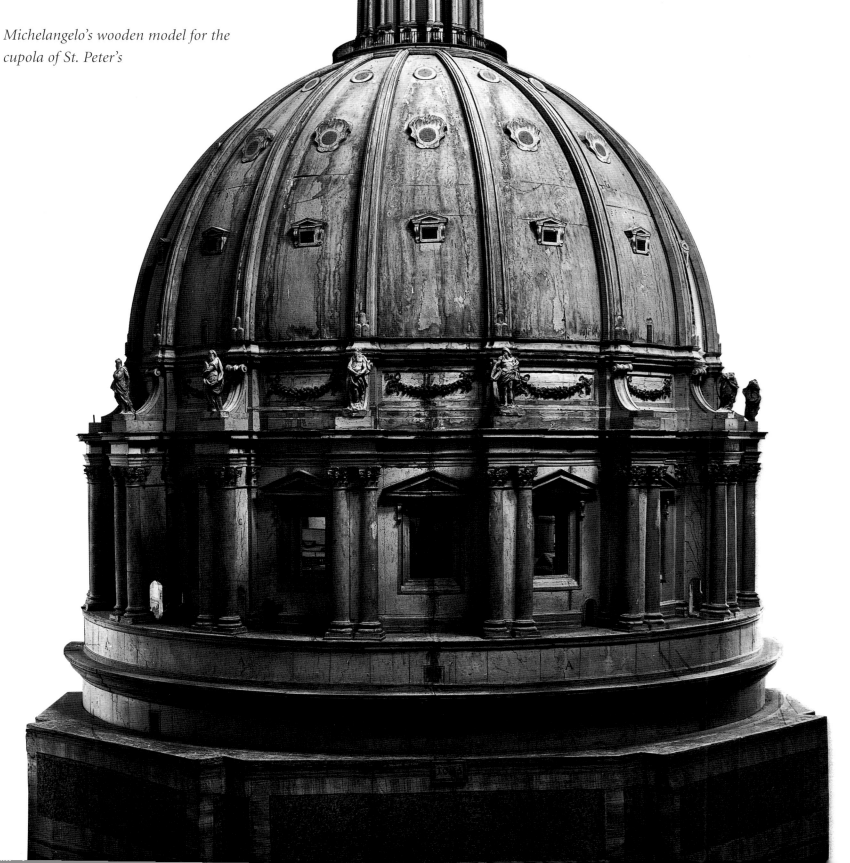

Michelangelo's wooden model for the cupola of St. Peter's

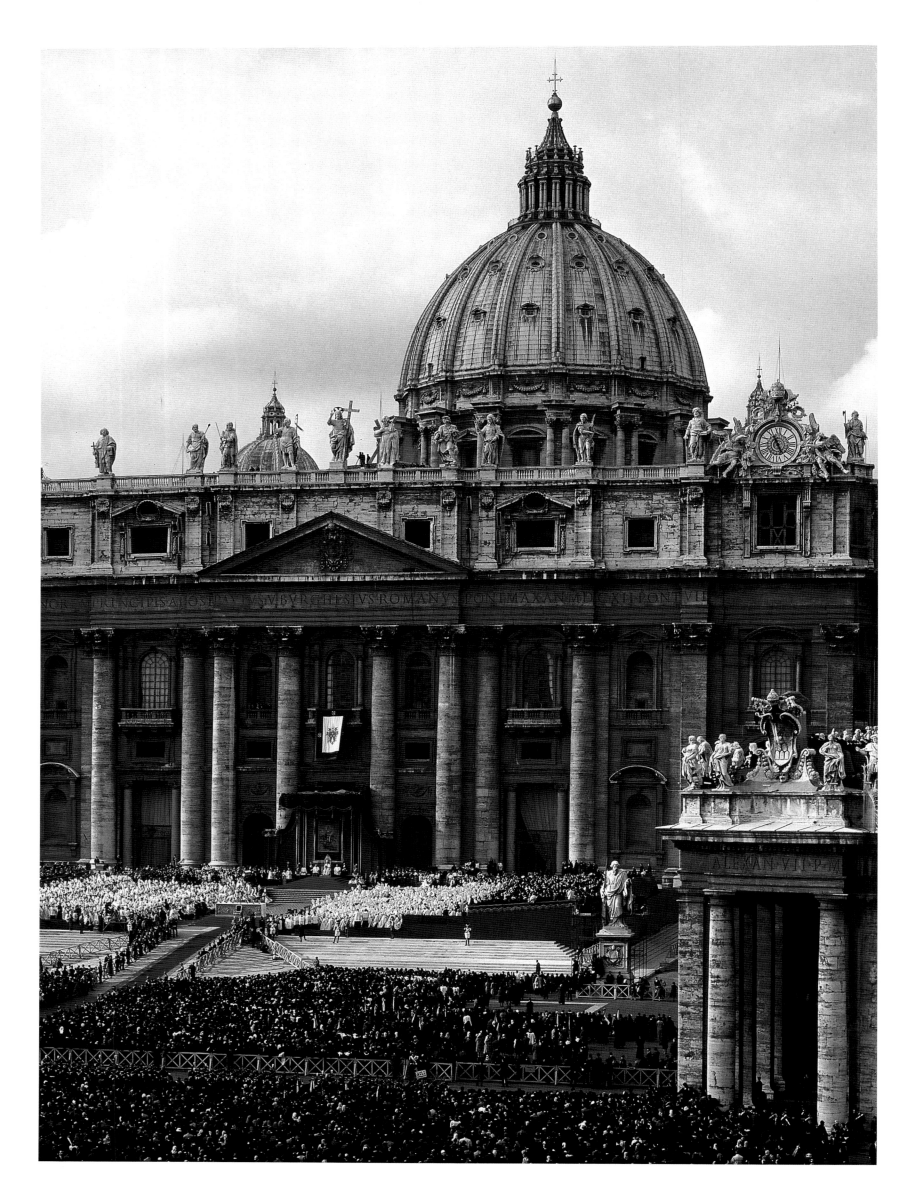

MICHELANGELO

paign of destruction that must have demanded enormous faith, courage, and vision on the part of both artist and patron alike.

Over the years, the succession of architects prior to Michelangelo had allowed St. Peter's to grow in size, accreting like the rings of an aging tree. Despite Michelangelo's propensity to grandiosity, one of his greatest contributions to the new church was to actually shrink the overall size of the building by removing the ragged husks that had grown around Bramante's core. The resulting concentration reinvested the church with a clarity of interior space and exterior form. From the outside, the church is a compact sculptural mass; inside it is an expansive, light-filled, and uplifting spatial experience.

Michelangelo's giant order has grown to exponential proportions. Each monumental travertine pilaster stretches upwards to vast vertical dimensions, past two giant windows in one bay and three in the next. The vertical thrust is so great that it requires a cornice and attic of enormous weight to contain the upward surge. The dome both continues and contains these vertical forces. From ground to lantern the building rises in one concentrated sweep.

At the same time, the densely layered wall surfaces ripple horizontally. Michelangelo invented a sort of architectural geology. The walls behave like giant tectonic plates, sliding and grinding against one another. Great slabs of slow-moving stone are thrust to the surface while others subside, especially in the "corners" where the collision of glacial-like masses results in squeezed and buckled forms. The densely packed pilasters and numerous blind and open niches virtually obliterate all wall surfaces. Although the simple geometry of the building is clearly evident from the

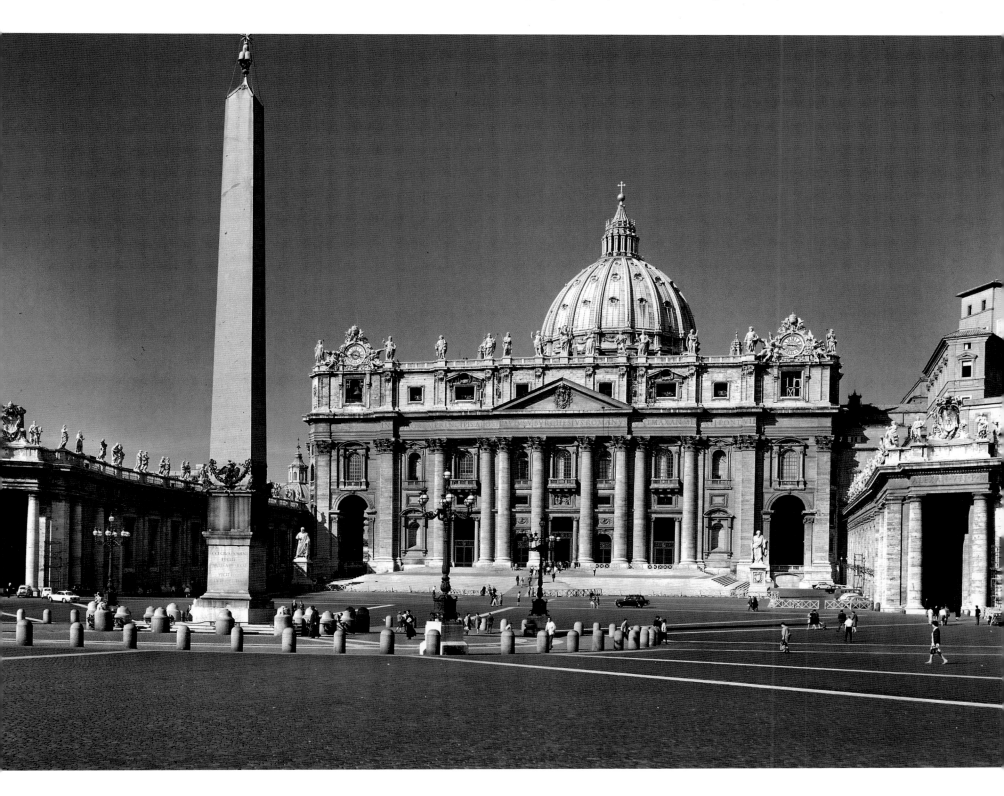

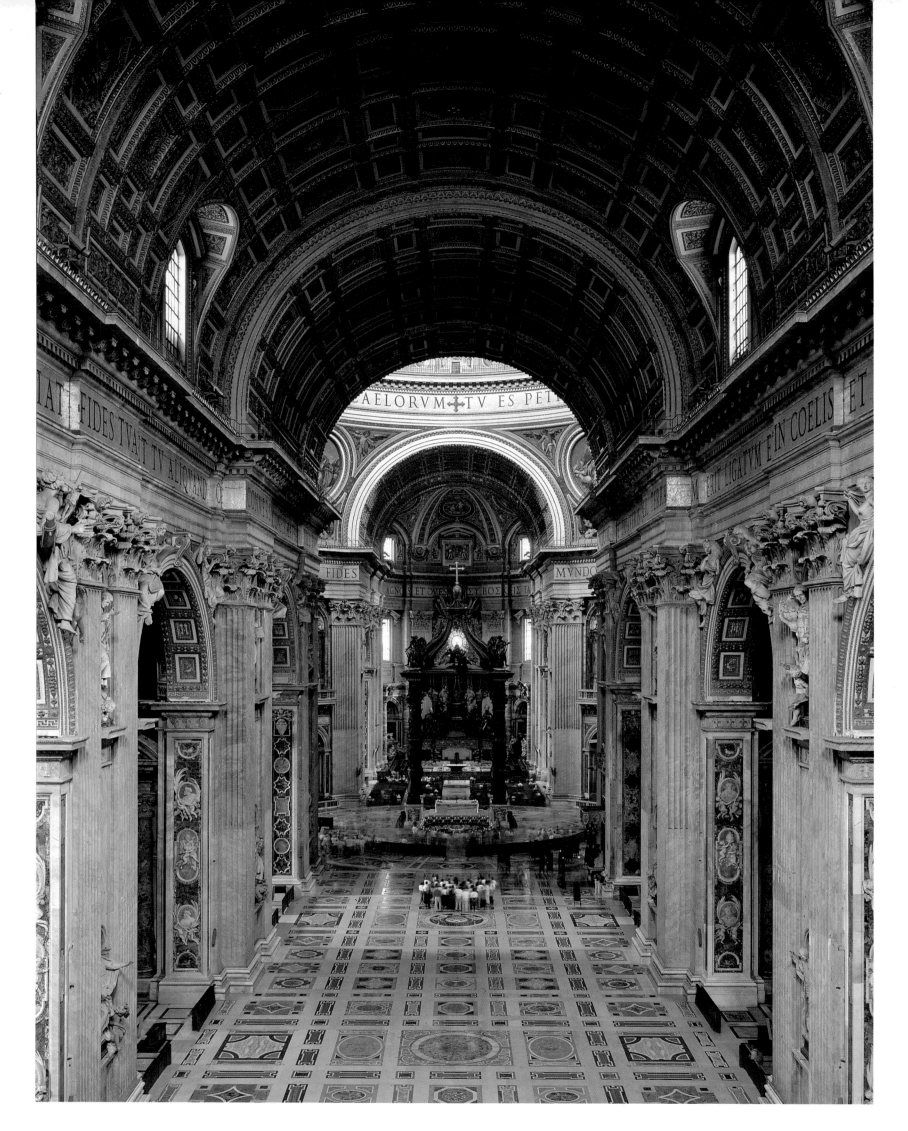

ABOVE:
View of the nave, St. Peter's

OPPOSITE:
Interior view of the cupola, St. Peter's

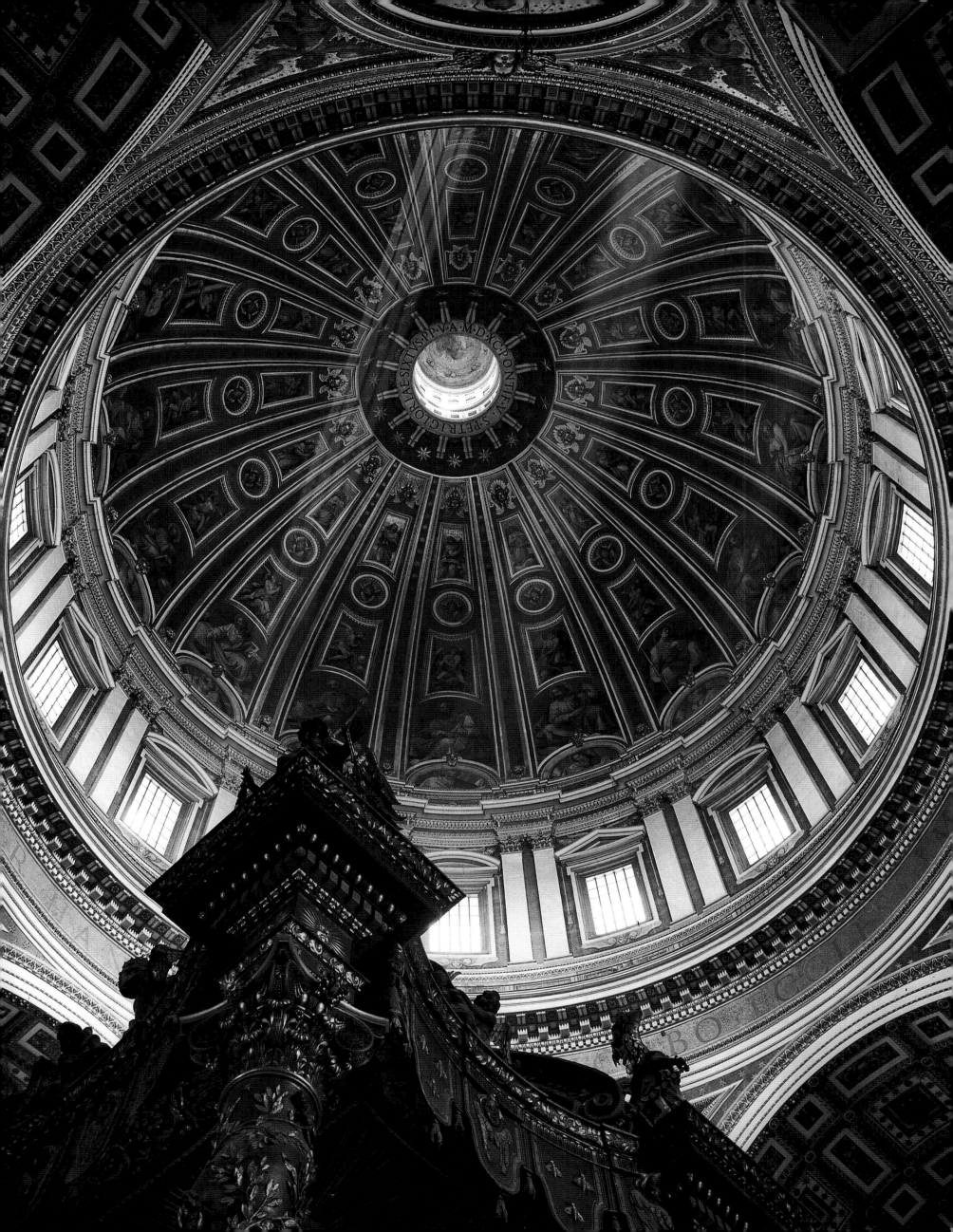

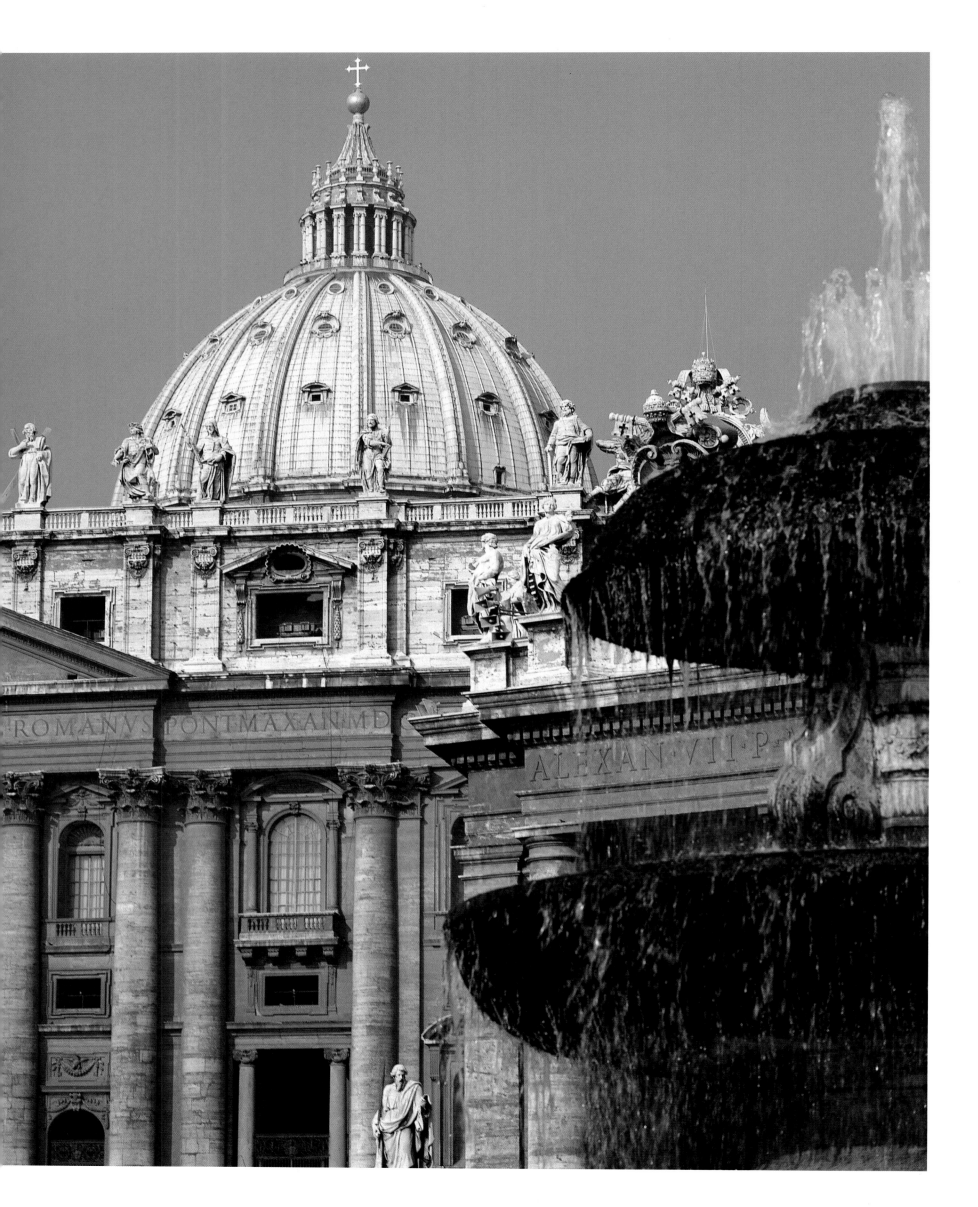

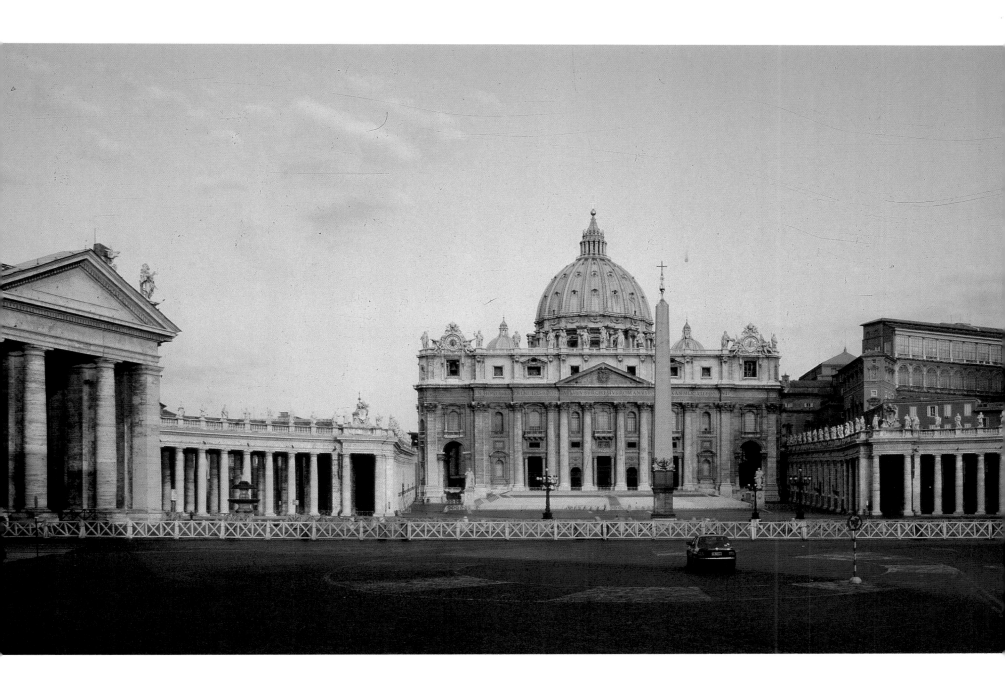

ABOVE:
The piazza of St. Peter's

OPPOSITE:
The dome of St. Peter's

air and from inside, it is not nearly so apparent when one stands close to the dynamic external wall.

Similar to the experience of a Gothic cathedral, the solid masses of the external structure heighten the contrast with the spacious, luminous interior. Our eyes rise, our hearts quicken, we are dwarfed by the largest interior space in the world. We are even smaller than the pilaster bases, smaller than the smallest stucco angel. It is, therefore, impossible to gain an accurate measure of the space for there is nothing to immediately compare it to; everything is in proportion but on a greatly exaggerated scale.

At the center of the immense building is the grave of St. Peter, the rock on whom Christ built his church. Over this venerated spot soars the majesty of the light-filled dome. The dome was Michelangelo's greatest contribution yet it was scarcely begun during his lifetime. A beautiful drawing shows Michelangelo's intention to create a broad, semicircular dome—the Pantheon raised high on a ring of paired columns and a thick cornice. Before his death, Michelangelo agreed to have a model of the dome built so that subsequent architects would abide by his design.

Despite changes inflicted on the building and its approximately 150-year construction history, we properly think of the church as Michelangelo's. In less than twenty years, Michelangelo corrected what had gone before and largely shaped what came afterwards. St. Peter's is the greatest architectural monument of the Renaissance, and surely Michelangelo's crowning achievement as an artist.

SAN GIOVANNI DEI FIORENTINI

◆ ◆ ◆

1559–1560 ◆ ROME

Unfortunately, Michelangelo's designs for San Giovanni dei Fiorentini were not used to construct the church of the Florentine community in Rome. In comparison to Michelangelo's dynamic conception, the church that rises prominently on the Tiber embankment is a banal pile. Fortunately, a group of drawn plans, three in particular, amply attest Michelangelo's imaginative ideas and his design process. Approaching architecture as dynamic space rather than enclosing box, the drawings offer good evidence of his manner of proceeding from the core of a building to its outward skin. In the three drawings we see Michelangelo going through a similar process of condensation and consolidation as at St. Peter's.

The plan of Casa Buonarroti no. 120A was mainly generated by corridors of space emanating from the four points of a central square. The design clearly reveals Michelangelo's tendency to think, architecturally, from the inside out. The plan is a distinct advance in clarity and spaciousness over the more linear and cluttered radial plan of Casa Buonarroti no. 121A, which was inspired by early Christian precedent. The former design is characterized by an accumulation of unarticulated piers and fragmented wall segments. There is some question whether the extremely thin external shell and inadequate interior piers could ever support the projected central dome. The plan is clear at the center, from where it was generated, but not towards the edges where there are many unresolved elements.

But questions of planning and structural integrity aside, these are fascinating drawings with the geometric regularity and spindling beauty of snowflakes. The experiments of these two drawings bore fruit in the most finished of the series.

The drawing in the Casa Buonarroti (no. 124A) is surely one of the most impressive architectural drawings by Michelangelo or any Renaissance draftsman. For all its familiarity and frequent reproduction, the sheet is visually stunning and still a surprise when seen "in the flesh." As in no. 120A pairs of parallel diagonal lines define broad corridors of space that radiate from the center and extend all the way to the building's periphery. However, in contrast with his earlier designs where space was barely contained within a thin shell, the interior space of this design seems to have been excavated from a solid block of material. Thus the building appears massive and sculpted—the space a symmetrical explosion well contained by the structure's thick epidermis.

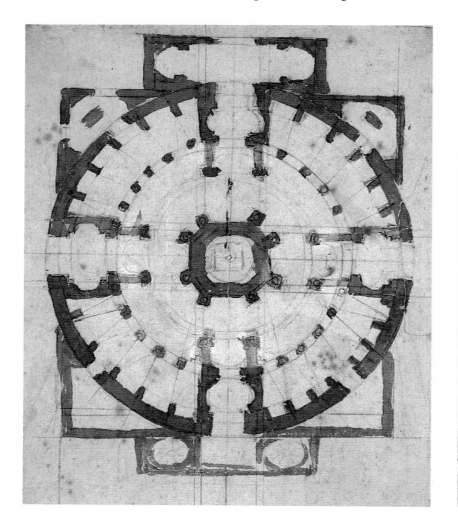

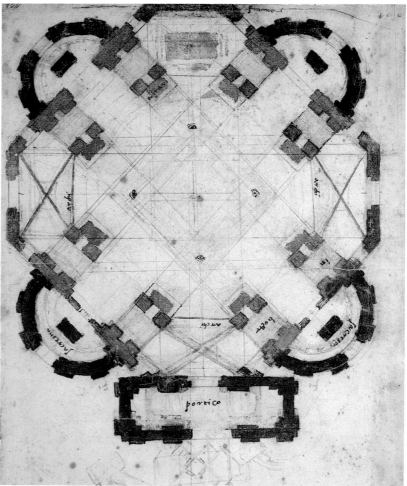

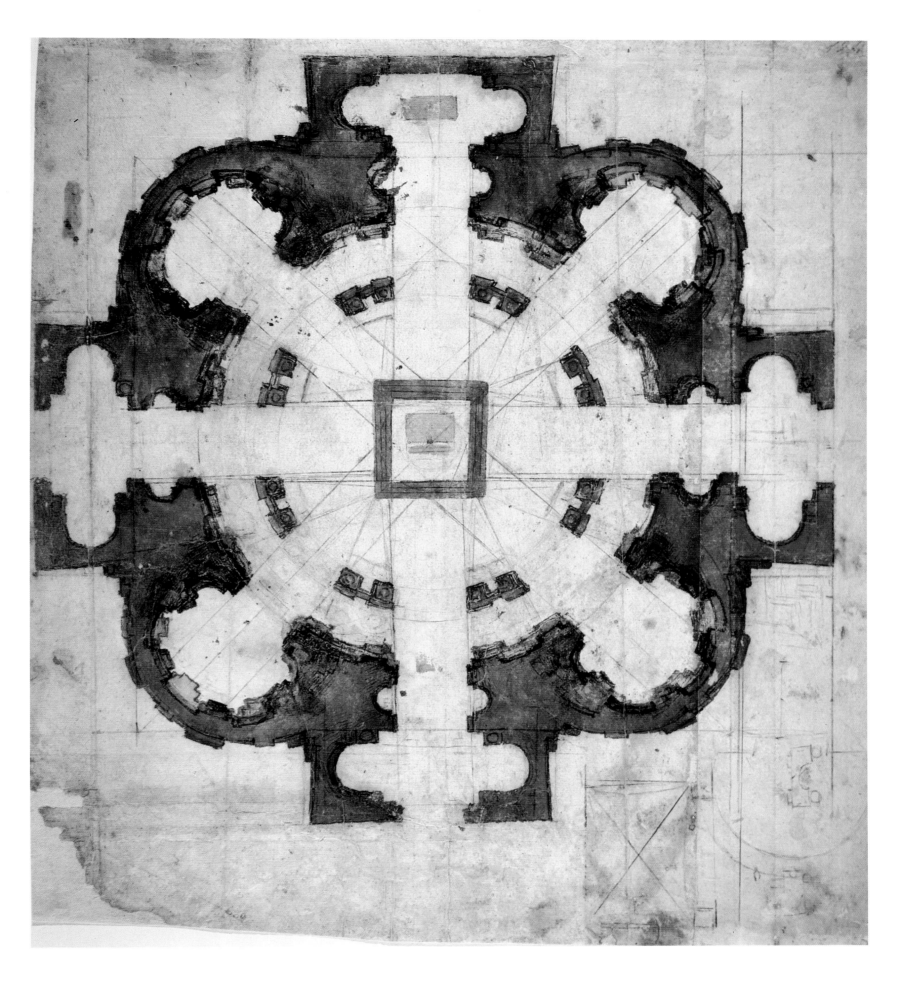

Michelangelo's drawn design for San Giovanni.
Casa Buonarroti, no. 124A. Pen, ink, and wash

OPPOSITE:
LEFT: *Michelangelo's drawn design for San Giovanni.*
Casa Buonarroti, no. 121A. Pen, ink, and wash
RIGHT: *Michelangelo's drawn design for San Giovanni.*
Casa Buonarroti, no. 120A. Pen, ink, and wash

ARCHITECTURE

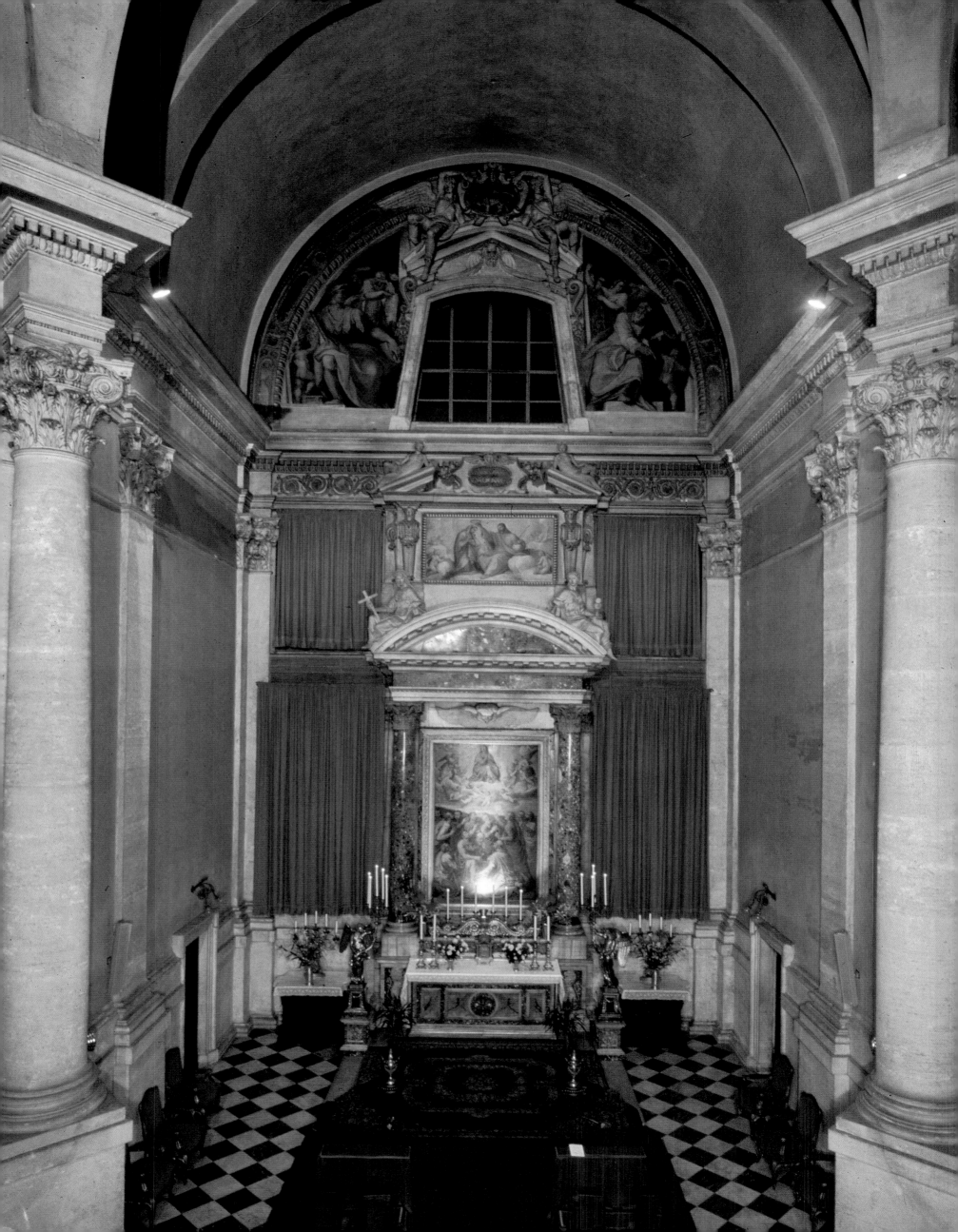

THE SFORZA CHAPEL

◆ ◆ ◆

C. 1560 ◆ SANTA MARIA MAGGIORE, ROME

The Sforza Chapel in the ancient basilica of Santa Maria Maggiore in Rome is probably the least familiar work by Michelangelo. Reflecting some of the ideas adumbrated in the designs for San Giovanni dei Fiorentini, it is a proto-Baroque architectural jewel. It is easy to imagine the great architects of the next century, Bernini and Borromini, finding inspiration in the small but dynamic space.

The unusual plan is formed of a circle—visible only in the actual building as quarter segments of curving wall—and three squares, one of which forms the altar recess. The geometry of the plan is sensed rather than immediately apparent to the visitor. Instead, one is drawn to the prominent sail vault billowing forth from pieces of shattered entablature. The four piers supporting that central vault are responsible both for the dynamism and the stability of the chapel. The giant monolithic columns mark the corners of a perfect square, even while they appear to advance to the middle of the centralized space. Stretched pieces of wall membrane, protuberant pedestals, and portions of fractured entablature are pulled like taffy along with the forceful advance of the columns.

The transepts are curved recesses left over from these architectural tectonics. They provide quiet if shallow refuges for prayer and for the Sforza monuments at the center of each bowed wall. As in so many of Michelangelo's architectural projects, there is much more than meets the eye: an initial appearance of simplicity quickly becomes an indescribable experience of molded space and solid dynamics.

Column projecting into the main space of the Sforza Chapel

Central ceiling vault in the Sforza Chapel

THE PORTA PIA

◆ ◆ ◆

C. 1561 ◆ ROME

Michelangelo made the elevation drawing illustrated below in 1561 in response to a commission from Pope Pius IV to build a new city gate at the end of the modern Via XX Settembre in Rome. A number of drawings for the Porta Pia survive, but this is certainly the most fully developed and densely worked of the group. The sheet reveals Michelangelo's characteristically intense concentration on a problem, his manner of combining alternative solutions, and his tendency to enlarge a design in the course of drawing (he tended to shrink back when it came to actual building). The physicality of the drawing and the constant revision find a counterpart in Michelangelo's contemporaneous figural drawing, especially some of his late religious works, where the hand appears reluctant to abandon the sheet.

The portal design was drawn over some figures in black chalk that were all but obliterated by Michelangelo's forceful architectural drawing. In this single sheet, we can trace the rapid evolution from a conservative to an extravagant design, from an architecture that obeys rules and employs a classical language to a new and highly original conception with its own rules and few easily described elements. From the layered reworking of the sheet and the dense skein of alternative and successive designs, Michelangelo was able to extract a remarkably coherent

Study for the Porta Pia. Casa Buonarroti, Florence

and vigorous portal design. Seldom before or since has the three-dimensionality of architecture been so powerfully evoked in the medium of drawing.

The gate as executed retains many of the qualities anticipated in the preliminary design: a rusticated flat-arched opening is topped by a semicircular, window-like form decorated with a grotesque embossed keystone. Giant, multi-layered pilasters with ear-like appendages are crowned by a triangular pediment whose profile is disrupted by a cacophony of other elements including a projecting inscription tablet and two curved pediment fragments that look like springs under tension. The gate sports numerous other novel features such as the boxy, top-heavy versions of Michelangelo's kneeling windows, the extravagantly over-framed blind windows floating in broad expanses of brick, travertine dishes with scarf-like drapes pretending to be windows, and the carnival-like crenelations topped by travertine cap and ball motifs.

The Porta Pia metamorphoses the genre of fortified city gate. Rather than asserting military might, the gate is a porous diaphragm signaling the edge of "civilization," between city and country, between urbanity and rusticity. The traditional purposes of both protecting the city and marking its boundary are still present but subverted, whimsically, through fancy (*fantasia*) and the grotesque.

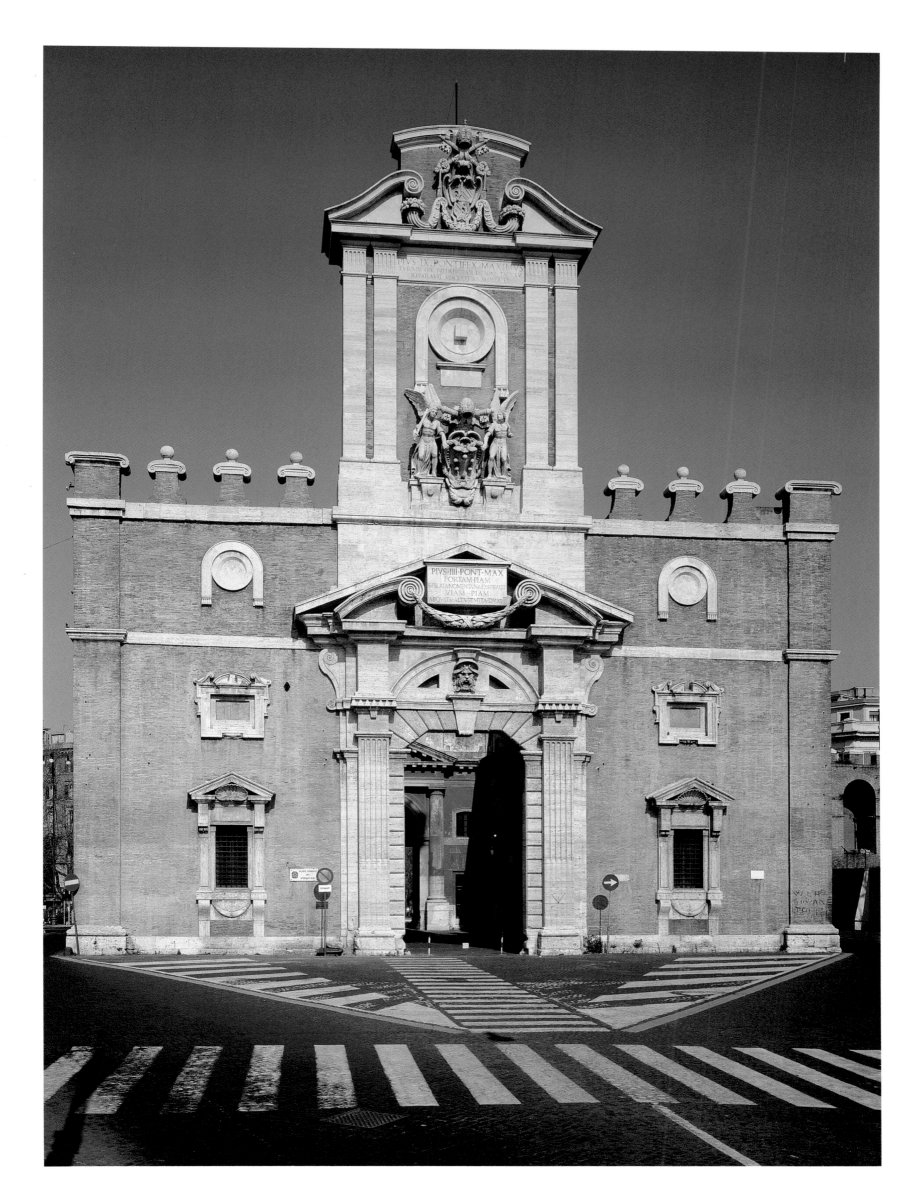

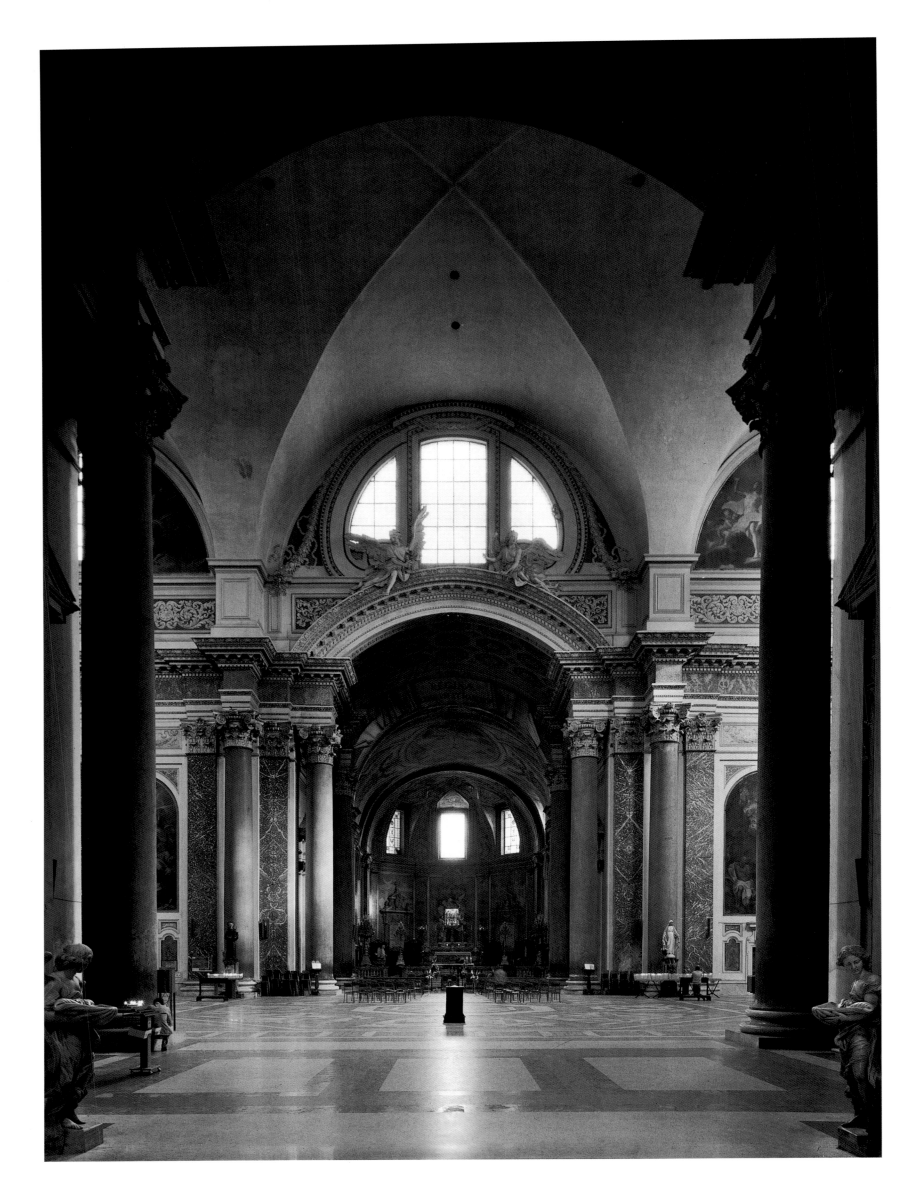

SANTA MARIA DEGLI ANGELI

◆ ◆ ◆

BEGUN 1561 ◆ ROME

While San Giovanni dei Fiorentini and the Sforza Chapel gave Michelangelo the opportunity to design new and highly original architectural space, no such license was granted by the commission to transform the Roman Baths of Diocletian into a Christian church. The place was a vast complex of open courts and vaulted chambers, mostly in ruins. Approaching the baths as if it were a ragged hunk of marble, Michelangelo could see the figure imprisoned in the block. At the core of all the raw material lay a building: it was left to Michelangelo to give it form and coherence, and most remarkably to change a pagan institution of pleasure into a holy sanctuary.

Michelangelo inserted curtain walls into the well-preserved central hall to create a coherent cruciform plan. But quite ingeniously, Michelangelo used the huge volume of the central hall not as the church's nave but as an oversized transept. Instead, the nave is formed from the sequence of smaller cross-axial spaces beginning with a round vestibule and culminating in the deep, barrel-vaulted choir. Different from the strictly axial approach to the altar usual in most Christian churches, the experience in Santa Maria degli Angeli is much more digressive. After entering from the dark entrance rotunda (the ancient tepidarium or warm-water pool), most visitors pause or wander about the spacious and light-filled crossing, before once again proceeding towards the darkened ambiance of the choir.

In the congested modern city of Rome, it is oftentimes convenient for pedestrians to pass through rather than to walk around the large building. Thus, when so many ecclesiastic structures are little more than quiet refuges, if not deserted, Santa Maria degli Angeli retains some of the bustle that typified its original function as a large public institution. Concentrating his efforts on the sublime interior space rather than the external façade, there is little from the street that signals that this is a church. While Michelangelo has forged a Christian monument from the pagan past, he has also firmly maintained a continuity with the classical tradition.

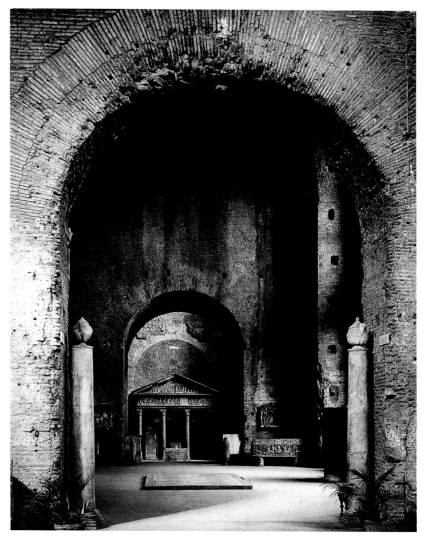

A portion of the Roman Baths of Diocletian (3rd–4th century A.D.)

Plan showing (IN BLACK) *Michelangelo's additions to the existing structure of the Baths of Diocletian*

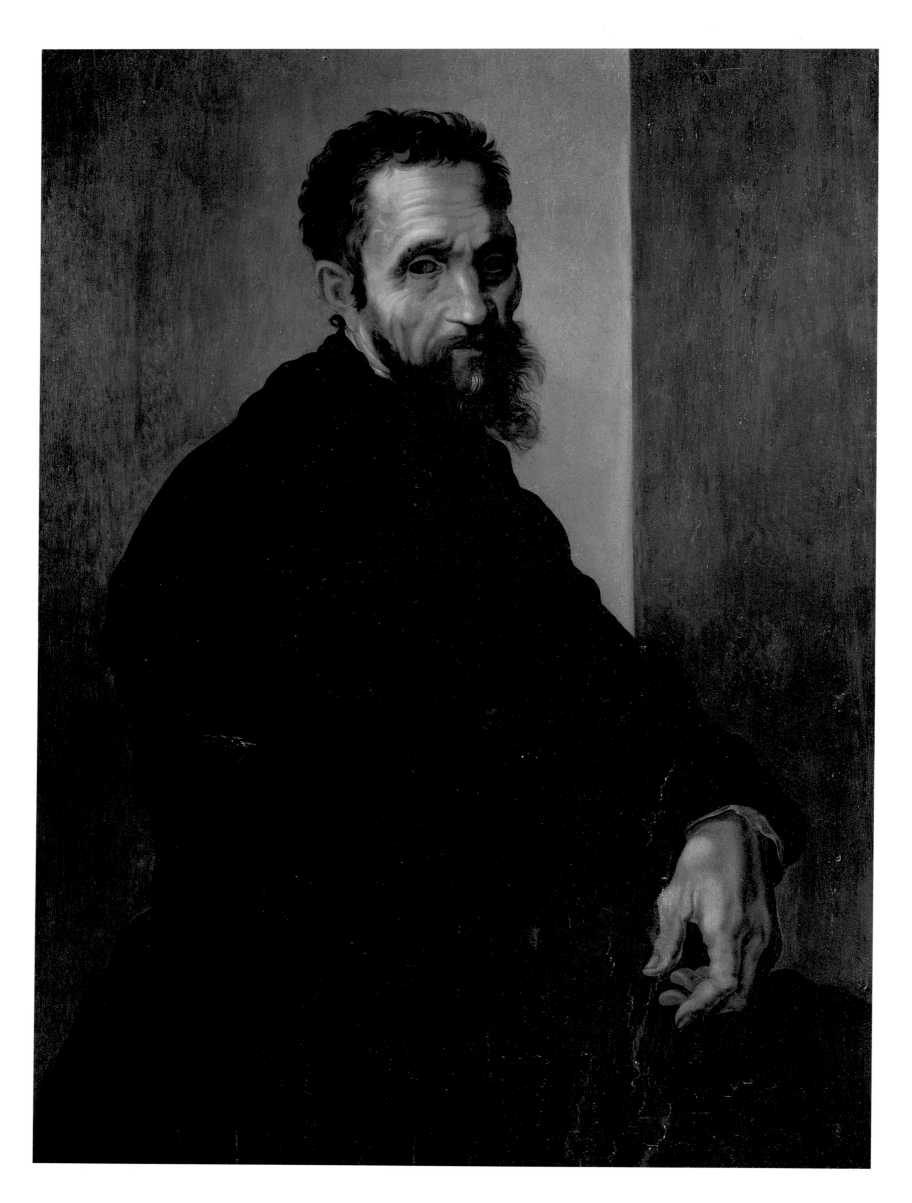

MICHELANGELO

262

EPILOGUE

And so, Michelangelo's sculpture, painting, and architecture continue to inspire wonder. We cannot help but marvel at the humanity, tenacity, and transcendent accomplishments of a man who lived twice as long as most of his friends and contemporaries. His contribution to the future course of art lay in the scale and audacity of his imagination, as well as the vast number of projects he undertook: the Campidoglio, the Farnese Palace, the Porta Pia, Santa Maria degli Angeli, the Sforza Chapel, and St. Peter's—most still under construction at the time of the master's death. His final legacy to Rome was an urban transformation on a scale we normally associate with the Baroque and subsequent centuries. Indeed, Michelangelo dominates the cultural landscape of Italy, of the Renaissance, of artistic achievement.

Michelangelo's legacy to the world, however, is more than the sum of his many works. Has any artist ever achieved so much in so many different fields of endeavor, so fully plumbed the depth of faith, sin, and salvation, so completely transformed our very notion of what is an artist—and a genius?

It was a deep well from which he drew energy and inspiration. From a highly successful marble sculptor, Michelangelo became an architect and artistic impresario, transforming himself into an aristocrat of art whose humble origins as a stone-carver are obscured by myth and his greatest accomplishments. At the same time he was eminently human, capable of weeping at his servant's death, and occasionally taking pleasure in the company and conversation of friends. He was suspicious, kept his money hidden in socks, and died a millionaire though he scarcely lived like one. In his later years,

excruciatingly painful kidney stones sometimes prevented him from appearing at St. Peter's, but he went every day he could, riding his horse from his house near the forum of Trajan across the city to the building works of the giant new church. In his eighties, Michelangelo was still in the habit of taking walks and riding every evening when the weather was pleasant. He was caught in inclement weather just four days before his death. When his faithful friend and assistant, Tiberio Calcagni, admonished him to take better care of himself, Michelangelo, with wavering voice and unsettled spirit, replied: "What do you want me to do? I am not well and I cannot find peace and quiet anywhere." Not even in his beloved marble carving, nor his poetry.

The life of such a titanic individual is prey to the embellishments of myth and our romantic imaginations, but at the heart of most fiction is a broad vein of truth. Both fact and fiction about Michelangelo are fascinating, and sometimes the truth is every bit as astonishing, and illuminating, as the wildest embellishments of a romantic novelist. At the summit of his illustrious career, for example, Michelangelo was paid to gild eight knobs on two bedsteads of Pope Julius III. To the unknown Vatican functionary who made the payment, this seventy-five-year-old man was merely "Michelangelo pittore." Such is the everyday world, even of the great persons of the past. Although he too was sometimes forced to undertake humble tasks, Michelangelo rose above mundane circumstance, employing his incomparable gifts and a transcendent imagination to create sublime works of art, for the world and for all time.

OPPOSITE:

Jacopino del Conte. PORTRAIT OF MICHELANGELO.
After 1535. Casa Buonarroti, Florence

INDEX

Page numbers in *italics* indicate illustrations.

PHOTO CREDITS